Julie Emerson

Jennifer Chen

Mimi Gardner Gates

PORCELAIN STORIES

FROM CHINA TO EUROPE

Seattle Art Museum

IN ASSOCIATION WITH

University of Washington Press
Seattle and London

Copyright © 2000 by the Seattle Art Museum

Project Manager: Zora Hutlova Foy
Managing Editor: Suzanne Kotz
Manuscript Editor: Lorna Price
Proofread by Laura Iwasaki
Index by Norma Roberts
Designed by Susan E. Kelly
Typeset by Christina Gimlin
Maps by Melanie Milkie
Produced by Marquand Books, Inc., Seattle
Printed by CS Graphics Pte., Ltd., Singapore

Distributed by University of Washington Press
P.O. Box 50096
Seattle, WA 98145

Library of Congress Cataloging-in-Publication Data
Emerson, Julie.
 Porcelain stories : from China to Europe / Julie Emerson,
Jennifer Chen, Mimi Gardner Gates.
 p. cm.
 Published in conjunction with an exhibition held at the
Seattle Art Museum, Feb. 17–May 7, 2000.
 Includes bibliographical references and index.
 ISBN 0-932216-52-8 (alk. paper)
 1. Porcelain, Chinese—Exhibitions. 2. Porcelain,
European—Exhibitions. 3. Porcelain, European—Chinese
influences—Exhibitions. 4. China—Commerce—Europe—
Exhibitions. 5. Europe—Commerce—China—Exhibitions.
I. Chen, Jennifer. II. Gates, Mimi Gardner. III. Seattle Art
Museum. IV. Title.
NK4565 .E46 2000
738.2'0951'074797772–dc21 99-059508

Page 1: Plate, Japanese, late 17th century (detail, pl. 12.29)
Page 2: Tankard, German, c. 1735 (detail, pl. 13.4)

Photo Credits:
Primary photography by Paul Macapia. Additional photography by
Susan Dirk (pls. 2.2, 2.5, 7.1, 7.3, 9.4, 9.5, 11.2, 11.6, 12.7, 12.45, 13.14,
14.13, 14.21, 14.22); courtesy of National Museum of Ireland (chap. 2,
fig. 1); courtesy of The Metropolitan Museum of Art (chap. 2, fig. 2,
and pls. 6.3, 8.7); courtesy of the Staatliche Kunstsammlungen
Dresden (chap. 2, fig. 3); courtesy of the Percival David Foundation
of Chinese Art (chap. 3, fig. 2 and chap. 5, fig. 1); Bruce M. White,
courtesy of The Art Museum, Princeton University (pl. 6.5); courtesy
of Ho-Am Art Museum (chap. 8, fig. 1); courtesy of Shanghai Mu-
seum (chap. 8, fig. 3); Eduardo Calderón (pl. 9.1); Josef Szaszfai and
Carl Kaufman, courtesy of Yale University Art Gallery (chap. 10,
figs. 1 and 3); courtesy of the Asian Art Museum of San Francisco
(pl. 10.1); courtesy of Stiftung Preussische Schlösser und Gärten
Berlin-Brandenburg Bildarchiv (chap. 11, fig. 1); courtesy of Conte
A. Valmarana (chap. 13, fig. 1); courtesy of LuEsther T. Mertz Li-
brary of the New York Botanical Garden, Bronx, N.Y. (chap. 14, fig.
3); courtesy of Mint Museum of Art, Charlotte, N.C. (chap. 14, fig. 4);
courtesy of Regina Krahl (app. 1, fig. 1); Jay Xu and Mimi Gardner
Gates (app. 1, figs. 2–15); courtesy of the Oriental Ceramic Society
and Nigel Wood, after Paul Sharpe (app. 1, fig. 16); courtesy of the
British Museum (app. 1, fig. 17).

This book has been published in conjunction with the exhibition
Porcelain Stories: From China to Europe, on view at the Seattle Art Museum
from February 17 through May 7, 2000.

Publication of the book was made possible by a major contribution
from Ruth J. Nutt, with additional funds from The Foster Foundation.

The exhibition and the symposium have been generously
supported by the following funds, organizations, and individuals:

Endowment Support
Guendolen Carkeek Plestcheeff Endowment for the Decorative Arts

Presenting Sponsor
Seattle Arts Commission

Exhibition Sponsor
PONCHO (Patrons of Northwest Civic, Cultural and Charitable Organizations)

Corporate Sponsor
Sotheby's

Museum Sponsor
Seattle Art Museum Supporters (SAMS)

Installation Sponsor
Corporate Council for the Arts/Guendolen Carkeek Plestcheeff
Decorative Design and Arts Fund

Additional Support Provided by
Barbara Duncan Himmelman
Asian Cultural Council
Asian Art Council and Decorative Arts and Painting Council of the Seattle Art Museum

TABLE OF CONTENTS

———— ❖❧❖ ————

IMPERIAL PATRONAGE AND PRINCELY ENTERPRISES

WEST MEETS EAST

THE AGE OF PORCELAIN

ACKNOWLEDGMENTS

—◆∾◆—

The past is hidden somewhere outside the realm, beyond the reach of the intellect,
in some material object (in the sensation which that material object will give us)
which we do not suspect.

—Marcel Proust, "Overture," *Swann's Way* (1913)

The anonymity of the vast majority of porcelain specialists leaves a gap in the historical record, in our knowledge of the past. First and foremost, the creators deserve recognition—those who produced these exquisite porcelains century after century in Asia and Europe. In the service of Chinese emperors, European royalty, and commercial markets, they advanced our world artistically and technologically through their myriad acts of genius and endless hours of hard labor.

The many collectors instrumental in forming the Seattle Art Museum's fine porcelain collections also deserve our sincere thanks. The founder and director of the Seattle Art Museum for forty years, Dr. Richard Fuller (1897–1976) avidly pursued his lifelong passion for Asian art, including porcelain. The Eugene Fuller Memorial Collection Fund honors his father and reflects the fine taste of Dr. Fuller and Associate Directors Sherman Lee (on staff 1948–52) and Henry Trubner (on staff 1968–87), as well as the connoisseurship of Asian porcelain by the curatorial staff. To assure the display of Chinese porcelain, The Foster Foundation endowed the Chinese galleries at the Seattle Asian Art Museum and named them after Evelyn W. and Albert O. Foster.

The Seattle Ceramic Society, founded in the early 1940s, established a vital tradition of collecting European porcelain. Inspired by Blanche M. Harnan, the Seattle Ceramic Society stimulated the collecting of European porcelain through study groups and no fewer than five exhibitions of European porcelain at the Seattle Art Museum between 1949 and 1964.

The credit lines recognize the many individuals active in the Seattle Ceramic Society who generously donated their treasured objects to the Seattle Art Museum. Especially noteworthy are Martha and Henry Isaacson, whose gift of some 350 porcelain objects provided the foundation of the collection of European porcelain; Dorothy Condon Falknor, who donated rare Italian porcelain; and DeEtte McAuslan Stuart, whose bequest funded European porcelain galleries. Kenneth and Priscilla Klepser's superb collection of Worcester porcelain further strengthened the Seattle Art Museum's holdings. These collectors and many others who donated porcelain to the Seattle Art Museum over decades inspired this project. We also thank our lenders, both individuals and institutions, whose objects greatly enhance this exhibition and the publication.

Essential financial support for the exhibition was provided by the Guendolen Carkeek Plestcheeff Endowment for the Decorative Arts at the Seattle Art Museum, the Seattle Arts Commission; Patrons of Northwest Civic, Cultural and Charitable Organizations (PONCHO); Sotheby's; Seattle Art Museum Supporters (SAMS); and the Corporate Council for the Arts/Guendolen Carkeek Plestcheeff Decorative Design and Arts Fund.

Publication of the book was made possible by a generous contribution from Ruth J. Nutt, a long-standing supporter of decorative arts at the Seattle Art Museum. The Foster Foundation joined Mrs. Nutt in sponsoring the publication in honor of Evelyn W. Foster and her love of Chinese art.

Trevor Fairbrother, Deputy Director for Art and Jon and Mary Shirley Curator of Modern Art, deserves special credit for his involvement in the conception of this project, specifi-

cally his suggestion of multiple narratives. We thank him for his encouragement and support.

Many colleagues have generously given of their time and expertise. We are indebted to many specialists on European porcelain whose work is gratefully acknowledged in the endnotes. Through the years, Antoine d'Albis, Armin Allen, Maureen Cassidy-Geiger, Clare Le Corbeiller, Kate Davson, Aileen Dawson, Malcom Gutter, Graeme Keith, John Mallet, Adrian Sassoon, Simon Spero, Sheila Tabakoff, Bernard Watney, and Raymond C. Yarbrough have visited Seattle's porcelain collection and directly contributed their time and scholarship. Virginia Bower, Julia Curtis, Fan Dongqing, Stephen Little, Jan Stuart, Henry Trubner, and Susan Valenstein advised on Chinese porcelain, as did Wang Qingzheng, Senior Deputy Director, Shanghai Museum. William J. Rathbun, recently retired John A. McCone Foundation Curator of Asian Art at the Seattle Art Museum, patiently advised on Japanese and Korean porcelain, and Jay Xu, The Foster Foundation Associate Curator of Chinese Art, gave us the benefit of his knowledge of Chinese ceramics. Chiyo Ishikawa, Curator of European Painting, provided guidance concerning attribution of the Ca' Rezzonico door. To all we owe our gratitude.

Special thanks go to Ann Wagner of the Seattle Art Museum's Decorative Arts department, who managed details of the project, including loans, maps, and copyrights. Mary Hirsch of the Chinese Art department also contributed greatly, as did librarians Jan Hwang and Elizabeth de Fato.

Zora Hutlova Foy, Manager of Exhibitions and Curatorial Publications, provided budgetary oversight and good-naturedly shepherded the manuscript from inception to publication. Michael McCafferty was responsible for the exquisite design of the exhibition. For artful photography we are indebted to Paul Macapia. Suzanne Kotz, acting as managing editor, coordinated all processes of the complex production. Editor Lorna Price, a lover of ceramics, vastly improved our writing, expertly knitting together three distinctive voices. Proofreader Laura Iwasaki provided essential support and unfailing accuracy of detail. Susan Kelly of Marquand Books designed the book with sensitivity and imagination. Christina Todd labored extensively to prepare the manuscript files for typesetting, which task Christina Gimlin performed efficiently and creatively.

For love, understanding, and support, we thank our families: Julie Emerson's parents James and Elizabeth McHenry, husband Steve Emerson, and children Jake and Lauren; Jennifer Chen's parents Zhang Xiajuan and Chen Kaoen, husband Jay Xu, and daughter Toni; and Mimi Gates's mother Elizabeth Gardner, son Casey Neill, and husband William H. Gates. To them we dedicate this book.

JULIE EMERSON
Ruth J. Nutt Curator of Decorative Arts,
Seattle Art Museum

JENNIFER CHEN
Guest Curator and
Independent Researcher of Chinese Art

MIMI GARDNER GATES
Illsley Ball Nordstrom Director,
Seattle Art Museum

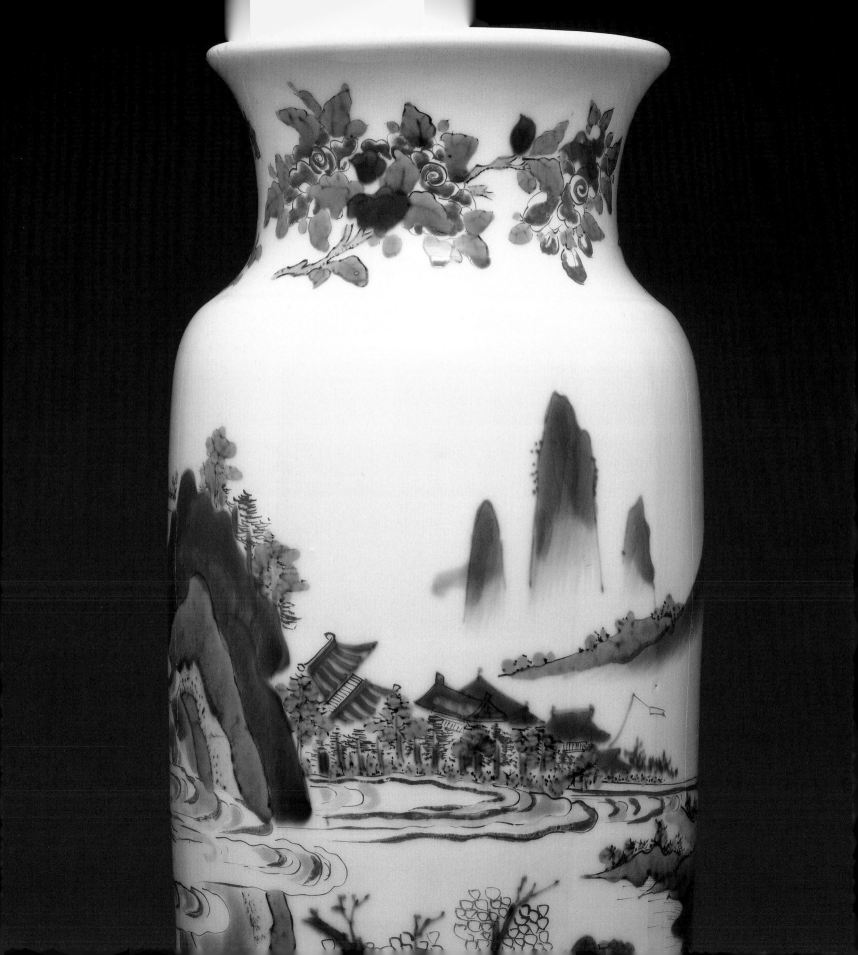

INTRODUCTION

———— ❖❖ ————

Porcelain graces our homes worldwide, a central feature of our dinner tables, cabinet shelves, and mantels. It is also the medium of choice for bathroom fixtures, and it has many industrial uses. So common, in fact, is porcelain that today we take for granted its striking beauty and functionality. And yet, historically, the attainment of true porcelain was a remarkable technological feat: making it once seemed an act of magic and remains a process that still demands considerable skill.

Porcelain requires the type of clay and stone that turns white when fired and also extremely high kiln temperatures, at least 1250°C or higher. By thus vitrifying these raw materials, the potter creates porcelain, a ceramic unequaled for its hardness, impermeability, whiteness, and translucence.

Where did porcelain originate? Who first discovered it? The interchangeability of the terms 'porcelain' and 'china' provides an unmistakable clue. China, building on its long and distinguished tradition of creating high-fired ceramic wares, by A.D. 600 was producing a white ceramic that satisfies most definitions of porcelain. The exact time and place of the creation of the first Chinese porcelain has not been firmly established; additional information about its origins may yet come to light, however, through the continuing excavation of kiln sites and tombs in China.

If the stories of the earliest Chinese porcelain prove fascinating, even more intriguing are the stories of porcelain as a vehicle for global and cross-cultural encounters century after century.[1] It was porcelain that conveyed designs and ornamental motifs between Asia and Europe, and it also influenced intermediate artistic traditions in the Middle East and Africa.[2] Many of the porcelain stories in this book span time and vast distances to explore the engaging dialogue among diverse cultures.

If artistic traditions engaged in a sustained dialogue of cultural transmission and assimilation, what about technology, and specifically, porcelain's technology? In *Guns, Germs and Steel,* Jared Diamond states:

> The transfer of Chinese porcelain technology to Europe provides an instance of long-drawn-out idea diffusion. Porcelain, a fine-grained translucent pottery, was invented in China around the 7th century A.D. When it began to reach Europe . . . many unsuccessful attempts were made to imitate it. Not until 1707 did the German alchemist Johann Böttger, after lengthy experiments with processes and with mixing various minerals and clays together, hit upon the solution and establish the now famous Meissen porcelain works. . . . Thus, European potters had to reinvent Chinese manufacturing methods for themselves, but they were stimulated to do so by having models of the desired product before them.[3]

Europe's search for the secret of porcelain, an engaging historical tale, extends from the sixteenth-century creation of soft-paste porcelain under the patronage of Francesco de' Medici to the early eighteenth-century discovery of hard-paste porcelain under the patronage of Augustus the Strong, Elector of Saxony and King of Poland.

Why was porcelain so desirable? Was it the whiteness, the translucence, the extreme thinness, or perhaps some other attribute? These provocative questions lack definitive answers. Porcelain's hardness certainly enhances its functionality, extending its life and making it durable and thus superior to more friable, lower-fired ceramics. As a material for dinner plates, porcelain is superior because its brilliant whiteness attests its cleanliness, and unlike metal, it does not impart a peculiar taste to food.[4] Moreover, its translucence and the

reflective shine of its glazed surface have a charm akin to the sheen of polished gold or silver. Porcelain also provides the perfect ground for color, which can be applied under the glaze, over the glaze, or in the glaze. Its visual attractiveness, from pure white to richly decorated, is undeniable.

Where did porcelain rank in the hierarchy of art forms and materials in China and Europe? In China, only painting and calligraphy were highly esteemed as fine arts. Among the hierarchy of crafts, those elite connoisseurs, the Chinese literati, favored the carving of seals and bamboo because of their closeness to painting and calligraphy. Seal and bamboo carvings often bear the names of their makers, whereas the names of those who excelled at porcelain and furniture-making are, with few exceptions, lost to history.[5] The Chinese valued jade and precious metals more highly than porcelain. Nevertheless, the finest Chinese porcelain, exquisitely potted and decorated, was reserved for the imperial palace, while less refined porcelain wares became items in common use by the Chinese populace as well as a lucrative export commodity.

In Europe, by contrast, porcelain was scarce, a rarity, a miraculous substance. It was not replicated in the West until the first decade of the eighteenth century. Yet, whether it was imported from Asia or created in the manufactories of European principalities, porcelain was a social signifier. A luxury good bespeaking wealth and status, it was known in Europe as "white gold" and was priced accordingly.[6] It was displayed in rooms devoted entirely to porcelain, where stunning blue-and-white and polychrome plates, vases, and bowls covered shelves and walls, floor to ceiling. Elaborate porcelain dinner services, often comprising hundreds of pieces, graced the tables of the exalted, reserved exclusively for royalty, the nobility, and their most honored guests. Porcelain was a material considered as prestigious, if not more so, as gold and silver. Europeans, passionate about porcelain and intrigued by visions of Asia, delighted in the beauty of this novel material whose properties proved especially well suited to the ebullient rococo style.

If high-quality porcelain could be imported from Asia in large quantities, why did Europeans find it so important to master porcelain's technology? International prestige and commercial gain, as well as curiosity about the properties of materials and an unbounded enthusiasm for porcelain, motivated the creation of Europe's competing princely manufactories.

This book helps to unravel porcelain's complex and fascinating history, not with a single story line, but rather with multiple narratives that explore some of its stories, particularly those focusing on China, Europe, and trade between East and West. The majority of objects illustrating these narratives are drawn from the Seattle Art Museum's fine Asian and European porcelain collections; many are published here for the first time.

Guest Curator Jennifer Chen's narratives cover China's first porcelain and early porcelain in China's northern and southern regions. She goes on to tell the fascinating stories of the porcelain trade, its effect in Asia, and of Chinese made-to-order porcelain for Europe.

Curator Julie Emerson takes up the stories of porcelain in Europe: Europe's first porcelain and early attempts to produce it, early trade between the West and Asia, Europe's princely collectors and the establishment of porcelain manufactories at Meissen and Sèvres, European porcelain's height of renown in the rococo period, and the eventual shift of interest away from it during the eighteenth century.

Seattle Art Museum Director Mimi Gardner Gates relates the enormous impact of the advent of blue-and-white porcelain, considered revolutionary in its time, and traces the development of fine porcelain as a commercial product and as the choicest objects of emperors. Her story of porcelain production in Jingdezhen (Appendix 1) is illustrated by Curator Jay Xu's photographs of contemporary potters working there on porcelain in all stages of production, from preparing the clay to the finished, fired ware.

How much did a piece of porcelain cost at any moment in time? What role does porcelain play in the histories of eating and tea drinking in Asia and Europe?[7] These are among the many intriguing stories of porcelain. Some stories are told here only in part; others are told elsewhere or remain to be fully explored. The choice of stories here and their art historical emphasis necessarily reflect the expertise of the three authors and is not intended as a statement of relative importance. The stories of Korean and Japanese porcelain, in all their fullness, richness, and depth, are best told by specialists knowledgeable in the porcelain of those countries.

Finally, why did we close these narratives with the eighteenth century? That century was an era in which patronage of porcelain as both an art form and a social signifier reached

its apogee. In China, vigorous imperial patronage by the emperors Kangxi, Yongzheng, and Qianlong (that is, the years from 1662 to 1795) demanded high artistic standards, while in Europe, princely patrons vied to produce and import the finest porcelain.

By the late eighteenth and early nineteenth centuries, however, social, political, and economic changes in Europe and in China led to the democratization of porcelain. In France and elsewhere in Europe, democratic forms of government replaced monarchies and hereditary aristocracies, and patronage patterns shifted from luxury items for the elite to goods more widely affordable, such as the less expensive British creamware and Wedgwood's pearlware.[8] As industrial capitalism took hold, porcelain production rapidly lost its novelty and artistic distinction.

China, too, was entering a new era.[9] Qianlong's successors, more frugal and less interested in the arts, decreased imperial patronage, and foreign incursions and domestic instability took a further toll as well. In 1856, during the Taiping rebellion, a battle in Jingdezhen destroyed the imperial kiln. Although it was rebuilt, the Chinese porcelain industry never fully recovered its earlier vigor and impetus.

Today, great centers of porcelain production, among them Jingdezhen and Arita, Meissen and Sèvres, continue production as they revive traditional styles and also explore new directions. Difficult to recapture, however, is the artistic brilliance of earlier centuries.

Mimi Gardner Gates

The First Porcelain

I

CHINA'S FIRST PORCELAIN

Raise the green *ci* cup to drink that sweet wine.

—Pan Yue (247–300),
Rhapsody of a Reed Pipe

Light and hard, the white *ci* bowl of yours is whiter than snow.

—Tu Fu (712–770),
Supplicating Mr. Wei Again for His Porcelain Bowl from Dayi

More than 2000 years ago, in the early Western Han period (206 B.C.–A.D. 8), a Chinese servant was preparing an inventory of burial provisions for the tomb of his master's wife. On the bamboo slips, he wrote the word *zi* many times, to specify a certain type of utensil: one *zi* of fish sauce, one *zi* of salt, two *zi* of rice wine, two *zi* of plum. . . . He went on and on. Then, a world apart, in 1972 at Mawangdui in Hunan province, the tomb he had so meticulously helped to prepare accidentally came to light and was found to be intact, including the bamboo-slip inventory and the objects it describes. The *zi* are all stoneware utensils with brownish-green or yellowish-green glazes.[1]

Stoneware and Porcelain: A Common Ancestry

A seemingly magical invention, stoneware first appeared in China in the mid-Shang period (16th–11th century B.C.). It was made from a peculiar type of clay that can be fired at temperatures above 1200°C without melting. High firing gives stoneware a body of unprecedented strength and density and makes it impervious to liquid, a quality further enhanced by the glaze, which was likely invented together with the stoneware. Thus it is not surprising that the *zi* wares in that Han tomb contained both dry materials and liquids.

By the third century, the term *zi* had evolved into *ci*, which has since become the common term used in China for all types of stoneware and later also for what is recognized in

the West as porcelain, which appeared around A.D. 600. The word *ci* is used as the opposite of *tao*, or earthenware, a low-fired, often unglazed, permeable pottery. That the Chinese divide ceramics into only these two basic types, without further differentiating between stoneware and porcelain, is significant. It not only marks the fundamental difference between *ci* and *tao* but also indicates the close relationship between stoneware and porcelain in material and technology as well as aesthetics. A story of the first porcelain in China cannot be well told, therefore, without alluding to stoneware.

From the outset, green in various tones was the primary color for stoneware glazes; the natural presence of iron oxide and titanium oxide in the glaze gives such coloration under reduction (low oxygen) firing. Green-glazed stoneware was produced widely, but the leading center for it was the southeastern coastal region in today's Zhejiang province, traditionally called Yue after the ancient kingdom that once existed there. As in many other countries, ceramics in China generally are named after their place of manufacture, so the stoneware from that region has been known as Yue ware. Yue ware is characterized by its fine grayish body, yellowish-green glaze, elegant shapes with clean profiles, and frequent incorporation of elements from life as decoration (pl. 1.1). Green-glazed stoneware produced in other regions all seem to have been influenced by Yue ware. It is fair to say that the history of stoneware from the Han dynasty up to the

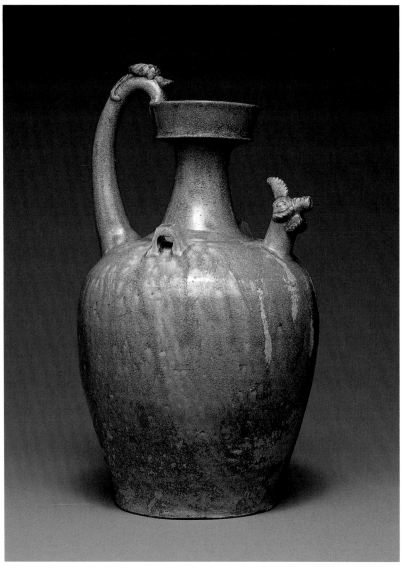

PL. 1.1

Chicken-headed ewer

Chinese, Southern Dynasties, 6th century
Yue ware, stoneware with incised lotus-petal decoration
H. 15¼ in. (38.7 cm)
Eugene Fuller Memorial Collection, 44.6

The chicken-headed ewer was a hallmark product of the Yue kilns. It first appeared in the third century and soon became ubiquitous, literally documenting the evolution of Yue ware over the course of more than 400 years, while the chicken head changed back and forth from being a decorative device to a functional spout, at the same time the ewer's shape became increasingly elongated and graceful. This ewer, probably from the Jiuyan kilns in Shaoxing, Zhejiang province, is a typical example of its time. Its curious chicken head adds a humorous touch to the quiet shape, evoking a carefree, homely atmosphere. The remarkable longevity of this one vessel type epitomizes the great popularity of green-glazed Yue ware. Although produced mainly in the south, imitations were made in the north from the fifth century on, combining Yue features with distinctive northern characteristics.

sixth century was basically a history of green-glazed ware, a history of Yue ware dominance.

In northern China from the late sixth century, however, the momentum of change began to gather, for there emerged a new ci with a white, dense body and white, smooth glaze. It was porcelain. The distinction between porcelain and stoneware is actually a European notion originating in Italy, where the word *porcellana* was used to describe imported Chinese ware with a shiny, white, shell-like surface similar to that of cowries. Clearly, whiteness was the defining quality of porcelain. Later the definition of porcelain was refined to

mean a high-fired ceramic ware of hard and dense texture, impermeable to liquid, white in color, translucent when thin, and resonant when struck. Since the fourteenth century, porcelain has so fascinated Europeans that it commands a prestige far greater than that of stoneware.

By contrast, the Chinese have regarded porcelain as ci, as simply green Yue ware: one is white ci, the other green ci (*qingci*). They intuitively tend to emphasize the shared nature of porcelain and stoneware. Even though the finished products have drastically different colors, they were prepared by similar techniques and, most important, were fired in the

same kiln in a similar atmosphere and thus share their familial origin. It is interesting to note that both the European and Chinese notions are empirical perceptions, but one seems to be that of the beholder emphasizing the visual difference, and the other that of the maker recognizing the technical similarity. Both are laden with cultural values: for the Europeans, porcelain reigns supreme; for the Chinese, emergence of white ci broke down the dominance of green-glazed stoneware and ushered in an era of greater diversity in ceramics, but it did not establish a new dominance because green ci was never out of favor.

In retrospect, the invention of porcelain requires two essential conditions that China uniquely satisfied. First is a rich supply of raw material, a white-firing clay, which in northern China comes in the form of kaolin (or china clay), a soft and well-weathered clay lying near the earth's surface.[2] Kaolin is poor in iron, the most versatile colorant among minerals. When its impurities are well washed away, it contains less than 1 percent of iron. At this diminished concentration, iron fails to produce color, and so clay appears white in its dense and compact state. The second is the technical capability of generating temperatures above 1250°C, the lowest temperature at which kaolin can be fired into porcelain. This ability had certainly been honed in the long history of green-glazed stoneware production. That porcelain was invented in northern China rather than in the south calls for some cultural explanation, however. Although lacking the same type of kaolin that could be easily quarried, southern China is rich in another white-firing material, porcelain stone. And there was certainly no difficulty with kiln technology, given the superiority of Yue ware. Perhaps the preeminence and popularity of Yue ware prevented the south from developing a new ware type: its long history clearly betrays a fascination with a favorite color and a desire to continuously improve it. The idea of creating a white ware does not seem to have occurred to people in the south; on the contrary, even when southern China followed the northern example and produced porcelain, iron-rich ingredients were sometimes added to the glaze to give the porcelain a greenish or bluish tinge.

By contrast, the desire to make white ware seems to have long existed in northern China. White earthenware was once made in the Shang dynasty (16th–11th century B.C.), but unfortunately it was not a successful experiment (pl. 1.2). Kaolin

PL. 1.2

Shard

Chinese, Shang dynasty, 12th–11th century B.C.
White earthenware with molded decoration
H. 3½ in. (8.9 cm)
Eugene Fuller Memorial Collection, 41.2

The molded rectilinear spirals seen on this shard from the village of Xiaotuan near Anyang, Henan province, are the same as the background pattern commonly used on contemporary ritual bronze vessels. A few intact white earthenware vessels also reveal a similarity to bronze shapes. It is clear that such vessels were made in imitation of bronzes, and it is reasonable to assume that the potters who made those complex ceramic molds for bronze casting may have been the same people who produced white earthenware. The artistry and close relationship with bronzes indicate the high status of white earthenware.

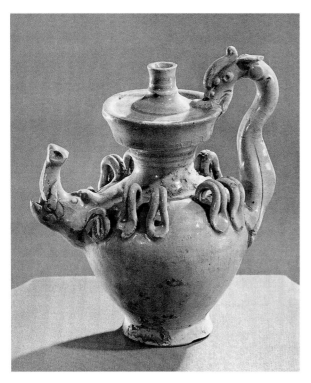

FIG. 1. Elephant-headed ewer, Sui dynasty, c. 594. From the dated tomb of Zhang Sheng in Anyang, Henan province. Porcelain with molded decoration, h. 5⅛ in. (13 cm). Henan Provincial Museum.

PL. 1.3

Kendi

Chinese, Tang dynasty, 7th century
Northern white ware, porcelain with white slip and transparent glaze
H. 6¾ in. (17.2 cm)
Eugene Fuller Memorial Collection, 49.140

Kendi is the Malay name for a water vessel used both for drinking and for cleansing the hands. The utensil was popular in Southeast Asia and was part of the paraphernalia for Buddhist or Islamic rituals there. The earliest examples of *kendi* so far known, however, were found in China and date from the beginning of the Tang dynasty.[4] Typical of the early Tang form is the globular body, long neck, and short vertical spout, as seen on this example.

has a high alumina content and therefore requires temperatures above 1250°C to flux and form the latticelike structure that gives the ceramic body strength and to achieve translucency. In Shang times, kaolin was fired at only 1000°C, resulting in a weak white earthenware hardly practical for use; it soon disappeared. Nearly 1500 years passed before porcelain finally developed in northern China, in around A.D. 600.[3] It is not difficult to imagine that during this long span of time, there may have been repeated experiments to discover alternatives to the dominant Yue ware and green color. By 600, the technical obstacle to high temperatures had been overcome; the horseshoe-shaped kilns unique to the north were able to generate temperatures as high as 1350°C.

The first porcelain in northern China is not perfectly white but often retains a pale yellowish or greenish tinge in the glaze, showing an affinity with green-glazed stoneware. This first porcelain has well-established shapes and decoration. Two distinctly different trends can be discerned. One is marked by sculptural shapes or elaborate decoration often

PL. 1.4

Incense burner

Chinese, Sui dynasty, early 7th century
Northern white ware, porcelain with reticulated decoration
H. 4½ in. (11.4 cm)
Loan from the Jiurutang Collection

A team of figurines depicting girl attendants with various toilet utensils in hand was unearthed in Henan province from a Sui dynasty tomb dated to 595. One of them holds an incense burner very similar in shape to this one. The use of aromatics and incense for bathing or fumigating clothes and rooms was popular among the elite class and considered a necessary part of good manners. In this context, the incense burner also represented prestigious status.

derived from metal wares bearing exotic shapes and complex decoration (fig. 1). The other displays simplicity and elegance, as seen in the *kendi* (water vessel) and incense burner (pls. 1.3, 1.4). Decorated with only a few grooves or simple geometric patterns, their clean, curvilinear contours blend naturally, imparting a restrained grace to the overall design.

The Rise of Porcelain

Revolutionary as it was, the first rudimentary porcelain was not yet able to challenge the supremacy of green-glazed stoneware, and it was produced in far lesser quantities than Yue ware. We do not yet know just where in northern China those first porcelain wares were produced, though it is commonly attributed to the general region of today's Henan province. Porcelain had to wait for a new era, which dawned soon after A.D. 600, for its fortunes to change dramatically. In the seventh century, China entered a period of unsurpassed peace, prosperity, and power. The country had recently been reunified after more than 300 years of division and ravaging wars. A sense of strength pervaded the society of the new Tang dynasty (618–907), and national wealth had accumulated to an unprecedented degree. The energy to break fresh ground was abundant. In such an environment, porcelain progressed by leaps and bounds, soon producing name brands like Xing ware and Ding ware. These two wares ended the supremacy of Yue ware, giving rise to the situation historically known as "northern white rivaling southern green." From then on, Chinese ceramics forever left behind the monopoly of a single type, entering a period marked by increasing diversity in products and aesthetic taste. The story of Xing and Ding wares will be told in chapter 3.

The success of the first porcelain in northern China soon had its impact on the south. By the Five Dynasties period (907–960), southern kilns had been making porcelain as well. The earliest examples of southern porcelain so far known are a few white wares and shards found in Jing county in Anhui province as well as in Jingdezhen, in Jiangxi province, and dating from that period, but some historical accounts claim that porcelain produced at Jingdezhen was shipped to the north as early as the seventh century.[5]

Early southern porcelain wares were made from white, crushed porcelain stone, the material local to southern China; the best of it was mined in the Jingdezhen area. Porcelain stone has a high silica content but is low in alumina, exactly

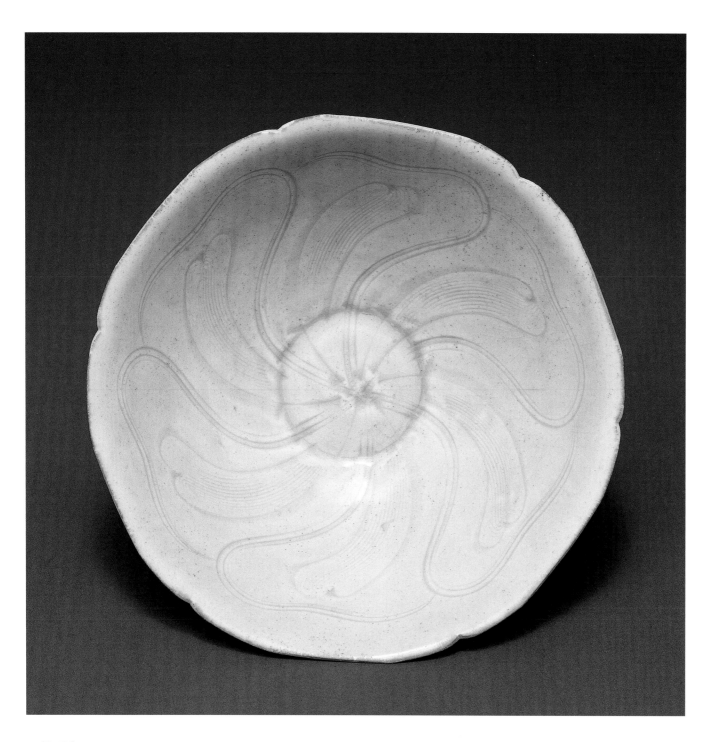

PL. I.5

Bowl

Chinese, Song dynasty, early 12th century
Jingdezhen *qingbai* ware, porcelain with light bluish-toned glaze
and carved decoration
Diam. 7½ in. (19.1 cm)
Gift of Mrs. John C. Atwood, Jr., 59.119

In this example, the glaze has flowed through and filled the
fluid incised lines of the swirling petals, making the image dis-
tinct and at the same time creating a pleasing contrast between
the bowl's overall tranquil quality and the floral design's sense
of freehand motion.

the opposite of the kaolin in the north. The southern porcelain wares were therefore fired at a somewhat lower temperature. Compared to the dense and compact quality of northern porcelain, their texture is usually glassy and "sugary."

The *qingbai* (bluish white) wares of the Song dynasty (960–1279) represent early southern porcelain (pl. 1.5). The porcelain stone–based clay contains high amounts of potassium oxide, which functioned as a natural flux during firing to help the clay quickly vitrify. Porcelain was thus fired properly at around 1250°C. The glaze on *qingbai* is thin and tends to pool; it often has bluish tones. They are the result of the deliberate increase in the amount of calcium and iron oxides in the glaze. This practice clearly reflects the influence of the prevailing preference for green colors in the south. The wood used as fuel in southern kilns also contributed to making the greenish color of *qingbai,* for wood burns quickly and readily reduces oxygen in the firing atmosphere, which causes iron to yield green colors. The pooling of the glaze and its bluish tinge produced charming effects in *qingbai,* imparting its unique sense of lightness and grace.

Soon after its genesis, *qingbai* became a mainstream product in Jingdezhen, turning a little-known town into an increasingly sprawling industrial complex. One primary reason for Jingdezhen's success was its rich natural resources of both high-quality porcelain stone and abundant pine. Another was the huge market demand during the Song dynasty, both within and outside China, for porcelain. Jingdezhen satisfied such needs with massive amounts of beautiful but inexpensive wares and, in doing so, became a pillar of the national economy, even though its *qingbai* hardly attained the same prestige as that of contemporary northern Ding ware.

Yet the earth could not continue forever to yield what the potters at Jingdezhen wanted most—the easily quarried porcelain stone near the surface. As potters were forced to dig deeper, in the thirteenth century, they encountered a crisis—not so much difficulty in mining, but with the products made from the less mature stone. They found that their objects warped easily or even collapsed during firing. Modern analyses have revealed the reason for the problem: the porcelain stone from deeper layers is higher in potash and soda feldspars but lower in alumina because it has been weathered less by the natural elements. This insufficiency in alumina made the porcelain stone–based clay vulnerable to high temperatures. The Jingdezhen potters certainly did not understand

the cause in scientific detail, but they proved they knew how to turn a crisis into a blessing.

At a place called Macang near Jingdezhen, the potters found a type of clay different from the porcelain stone they had been using. They mixed it with the alumina-deficient Jingdezhen porcelain stone and discovered that the clay from Macang miraculously solved their problem. Once again, wares could be fired at a high temperature to attain a porcelain body. Even more pleasing, the new wares made from this mixture were actually superior to the old ones.

Laboratory analyses again revealed the secret: the clay at Macang is alumina-rich primary kaolin. The mixed porcelain stone and kaolin has the high silica content necessary to ensure vitrification, hence translucency, and also the elevated alumina content that results in hardness at high temperatures. In addition, kaolin is more plastic than porcelain stone because its mineral particles are smaller and admit more water between them, allowing a more easily shaped clay. But highly plastic material tends not to hold its shape and therefore cannot be used to make large objects. Porcelain stone has just the opposite qualities. It has less plasticity and is therefore better able to hold its shape. The new, two-ingredient compound clay achieved at Jingdezhen thus attained the best of both worlds: potters could make more intricate shapes as well as larger objects.

If the invention of porcelain in northern China qualified as a revolution, the discovery of the porcelain stone–kaolin mixture in the south is by no means less important an event. Today many people still regard only those Jingdezhen wares made from the new two-ingredient clay as true porcelain, and there is certainly some degree of truth on their side. The historical importance of this compound clay is beyond measure. From the time it was put into use in the late thirteenth century, the compound clay enabled Jingdezhen to continue to satisfy the great needs of ordinary consumption and also to enter the arena of producing expensive wares. With its unsurpassed utility and aesthetic appeal, Jingdezhen porcelain successfully outstripped all competition. The invention of porcelain ended the dominance of green-glazed stoneware and made Jingdezhen the capital of porcelain. Perhaps it is ironic that kaolin has been commonly known by its sixteenth-century mine site Gaoling (Kaoling) near Jingdezhen, even though the clay was first utilized in northern China, but Jingdezhen undoubtedly deserves the credit.

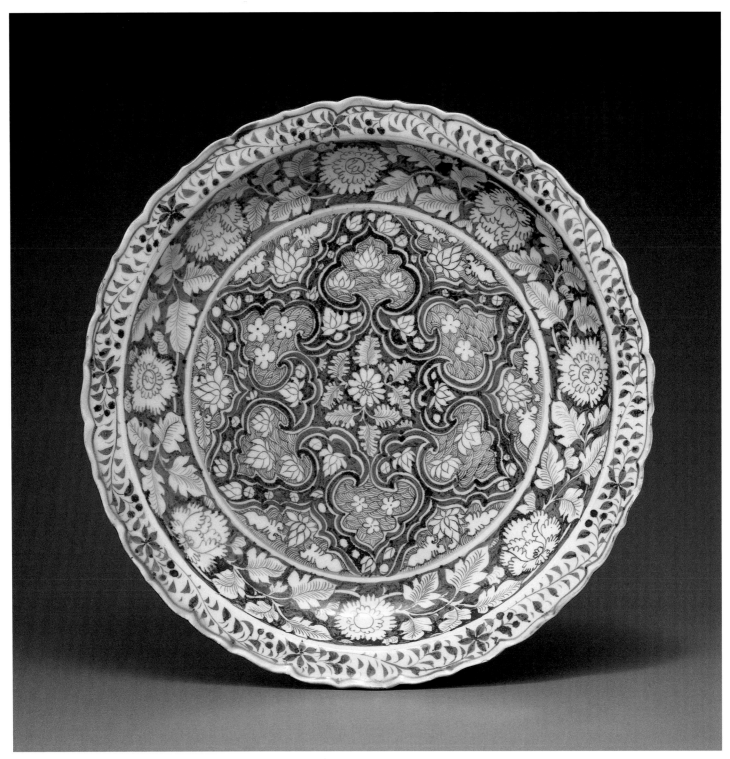

PL. 1.6

Contemporarily with the two-ingredient compound clay at Jingdezhen came a new product, blue-and-white porcelain. Its production boomed around the middle of the fourteenth century, largely because of the prosperous export business catering to Muslim markets in the Middle East. The custom of communal eating in the Muslim world required durable and large plates and bowls. White porcelain material had long fascinated but frustrated Muslim potters, because they lacked suitable resources to make their own. The Muslims found China a willing supplier of porcelain wares, and China found the Middle East a ready market. The Muslims favored the brilliant blue color of cobalt, of which the Middle East had the best grade and an abundant supply. Now, for the first time, a foreign material actively entered porcelain-making in China, bringing with it the influence of the aesthetic ideas of Islamic art. A superb example of this collaboration is the plate in the Jinglexuan Collection (pl. 1.6), remarkable for its great size, consummate painting skill, and rich and dense decoration inspired by Islamic art. With such imposing appearance and visual appeal, blue-and-white porcelain soon claimed the Chinese domestic market as well, and painting became the primary method of decorating porcelain. Beyond China, this great porcelain also proved a source of endless fascination and inspiration for porcelain production in other regions, and particularly Europe.

—J.C.

PL. 1.6

Plate

Chinese, Yuan dynasty (1279–1368)
Jingdezhen ware, porcelain with underglaze-blue decoration
Diam. 18⅜ in. (46.7 cm)
Loan from the Jinglexuan Collection

Rarely found in China, the massive size and form of these plates suited Muslim eating customs in the Middle East and India, such as the imperial banquets of Muslim rulers where diners gathered around massive plates and ate communally.[6] The painting of this handsome plate, composed of both blue designs on white and white designs reserved in blue, creates a vibrant and complex surface. The unpredictable black spots, naturally present in iron-rich Persian cobalt, burst randomly into the blue areas and add shadowy depths to the decoration. Underlying this erratic effect, the perfect concentricity of the design embodies the mathematical precision typical of Islamic art.

2

Europe's First Porcelain

As early as the thirteenth century, Arabian and European travelers to Asia returned with stories of a white, thinly potted, and most importantly, translucent ceramic ware unlike anything they had ever seen. The source of this luminous, magical ware was China, known in the travelers' accounts as "land of the Chinamen" and later the "Celestial Empire." It was a land shrouded in mystery and legend, located in a distant region of the world famed for heavenly treasures such as silk and spices. Porcelain joined the stream of exotic rarities that began to arrive in Europe over difficult land routes that looped across central Asia, linking China and the Roman Empire, and which were known collectively as the Silk Road. Trade increased when the Portuguese explorer Vasco da Gama discovered a sea route around the Cape of Good Hope to India and returned from his journey in 1499 with fine examples of porcelain.[1] The sea offered safer transport for fragile wares, and greater numbers of porcelain items from China filtered through the ports in India and ultimately to the West. They were respected treasures, coveted princely gifts.

The Earliest Porcelain

Porcelain came as a revelation when it encountered the well-established regional and aesthetic ceramics traditions of Europe. Since Neolithic times, Europeans had known how to produce ceramics, an ingenious technical innovation that employs the two classical elements, earth and fire. These early peoples fired clay into ritual figures and useful pots. Through the years, technological advances, cultural needs, and artistic expression became intertwined and molded into the history of European ceramics as they progressed from the simplest unglazed earthenware vessels to more refined stoneware. This medieval European pottery and stoneware seemed thick, oversized, and bulky next to the translucent, shell-like Chinese porcelain. Considered objects of wonder imbued

with magical qualities, porcelain was thought to crackle and discolor if it came into contact with poison. As valuable as gold, it was seen as the highest achievement of ceramic art. As gold forms naturally in igneous rocks associated with quartz, one of the last elements to be forged from the heat of the earth, so, too, did porcelain slowly develop in China, evolving out of earlier stoneware traditions. The secret of its manufacture was locked in China.

The Fonthill Vase

The earliest documented example of Chinese porcelain in Europe is the Fonthill vase (fig. 1), dating from about 1300.[2] Around 1381, silver-gilt and enameled European mounts transformed this bottle-shaped vase, just over 11 inches tall, into a ewer for Ladislas the Great, King of Hungary (r. 1348–1382), who gave it to Charles III of Durazzo on his ascent to the throne of Naples. Since that time, it has been traced through the collections of the Grand Dauphin, son of Louis XIV of France, and the French antiquarian Roger de Gaignières, to around the time of the French Revolution, when it became a prized possession of the English collector William Beckford of Fonthill Abbey.[3] By the time the tenth Duke of Hamilton sold the vase at the Hamiliton Palace sale in 1882, it had been stripped of its mounts. (Seattle's Qianlong tea-dust vase, plate 10.13, bears a sticker, no. 1224, from this important sale.) The Fonthill vase vanished from sight until 1959, when the ceramics scholar Arthur Lane rediscovered it, tucked away in the holdings of the National Museum of Ireland.

The Fonthill vase is *qingbai* ware noted for its blue-tinted glaze (see bowl, pl. 1.5). Because it features three-dimensional molded decoration, it probably represents the stronger, heavier porcelain formula developed by the potters of the Yuan period (1279–1368) in Jingdezhen. These

<small>FIG. I. The Fonthill vase. Dublin, National Museum of Ireland.</small>

thirteenth- and fourteenth-century white wares of China were called porcelain in Europe.

The term 'vase' is often a catchall for wares whose former functions have been lost in time. Though often referred to as a porcelain bottle, and thought to have been used only for wine and liquor, the Fonthill vase may have actually served to hold flowers. A pair of similarly shaped bottles holding peony sprays, depicted in a tomb mural dating from the early Southern Song (discovered in 1987 in Jiangxi province), are seen flanking an incense burner on an altar. So at least in the Song period, this shape was used as a vase as well as a wine bottle.[4]

The Fonthill vase arrived in Europe at just about the time that the intrepid Venetian traveler Marco Polo returned from the East with tales of porcelain. Varying accounts describing his arrival with exotic luxury goods, including porcelain, are contradicted by others stating that he came empty-handed, with nothing but the clothes on his back. Polo joined the Venetian forces embroiled in a conflict with Genoa and was imprisoned there from 1296–98. During his captivity, he dictated the accounts of his travels to his prison-mate, Rustichello of Pisa, a well-known romance writer of the day.

Whether or not Marco Polo actually returned with examples of Chinese porcelain, he certainly had seen the translucent ceramic ware during his journey. His description of azure bowls refers to the bluish glaze that also characterizes the Fonthill vase and other *qingbai* wares. He tells of further qualities of porcelain and relates misleading methods for its manufacture in his *Description of the World*.[5]

Marco Polo used the French *porcelaine* and the Italian *porcellana* interchangeably to describe both cowry shells, treasured as currency in parts of Asia, India, and Africa, and the white and azure ceramic wares he encountered on his travels. The etymology of the word 'porcelain' is still debated, but it most likely derives from *porcellana,* a term from the Latin *porcella* (sow), which Italians used for the little piglet-shaped cowry shells that arrived in Europe as curiosities, and thus was used to describe the glossy, hard, shell-like ceramic ware from China.

From the end of the thirteenth century, porcelain existed as a great rarity, serving as gifts for potentates and kings. In 1487, the sultan of Egypt presented the Italian merchant-prince and patron of the arts Lorenzo de' Medici (1449–1492) with a menagerie of exotic animals and "large vessels of porcelain the like of which had never been seen, nor of better workmanship." By 1553, the Medici Chinese porcelain collection, now overseen by Cosimo I de' Medici (1519–1574), numbered close to 400 pieces. The fascination with this mystical material and its staggering price inspired a concentrated effort among princely European collectors to discover the secret of making porcelain. Cosimo's son, Grand Duke Francesco I de' Medici (1541–1587) was the first to produce a recognized porcelain.

Medici Porcelain

Some historians trace the beginnings of the powerful Medici family's decline to the tenure of Francesco, a person more interested in alchemy (the ancient search for a magical compound that would change base metals into gold) and other technological and artistic pursuits than in affairs of state. With the assistance of the court artist Buontalenti, a mysterious person known as the Levantine (a person from the eastern shore of the Mediterranean), and a potter from Urbino who assisted with the firing process, Francesco de' Medici produced a translucent white ware. Though other experiments are known, only the Medici ware has documented

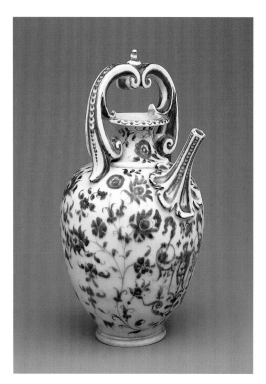

FIG. 2. Medici factory ewer, c. 1575–87. The Metropolitan Museum of Art, gift of J. Pierpont Morgan, 1917.

pieces surviving today (fig. 2). In limited production, and probably for Francesco's personal use and for state gifts, it was manufactured in the court workshops in Florence from about 1575 and tapered off after Francesco's death in 1587.

Technically, Medici ware is classified as porcelain, but it is a very different material from the high-fired porcelain of China, which became known in Europe as hard-paste porcelain. Medici porcelain is a soft-paste or "artificial" porcelain. It combined *marzacotto*—a heated frit mixture of sand, wine lees (sediments), and salt—with fine white sand and white clay. Made into a paste and formed into shapes, it was first given a biscuit (unglazed) firing of about 1100°C. This lower temperature was at that time the limit of Italian kiln technology.[6] After the wares were decorated and glazed, they received a second firing of 900–950°C. Their manufacture was fraught with difficulties, particularly loss during firing, so production was limited; only sixty to seventy examples are known today. In light of Renaissance aspirations to unite scientific research and artistic tastes, Medici porcelain was a great princely enterprise and achievement. Yet this short-lived endeavor had little effect on the continuing search in

Europe for a formula that would result in a product comparable to Chinese porcelain.

Pursuing the Quest in France and in Saxony

After Francesco de' Medici's attempts, more than a century passed before a formula for hard-paste porcelain was discovered in Europe. In France, a soft-paste porcelain (*pâte tendre*) first evolved from early experiments at Rouen and was in production at Saint-Cloud late in the seventeenth century. Through the years, aristocratic patrons all over Europe continued to fund research projects to reproduce an elusive formula for porcelain comparable to the Chinese product. The honors were finally claimed by the great porcelain devotee Augustus the Strong (1670–1733), Elector of Saxony and King of Poland.

As a young man, Augustus had visited the court of the Sun King, Louis XIV of France. He greatly admired the many cultural and intellectual activities supported by the court, and his personal desires were piqued by the abundance of paintings, sculpture, tapestries, lavish metalwork, and carved and gilded furnishings at Versailles, attesting to Louis's royal splendor and might. Louis and Augustus shared a love of opulent, jewel-encrusted metalwork in the grand baroque style of the day. Augustus commissioned lavish delights as additions to the Green Vault (das Grüne Gewölbe), the repository of treasures for Saxony's kings and princes since the mid-sixteenth century.[7] His contribution to the collection included a golden coffee service, carved rock crystal and serpentine vessels, and extravagant sculptural works that encased exotic coconuts, ostrich eggs, and rhinoceros horns in jeweled, silver-gilt mounts. The source for much of the precious metals and stones with which the master jewelers and sculptors of his court created these fantasies for Augustus was the Erzgebirge, the mountain range that had played a major role in the country's mining industry since the thirteenth century. Augustus soon possessed European objets d'art to rival Louis.

In the princely fashion of the day, Louis XIV had a collection of Asian wares, but unlike Augustus, he never developed a grand passion for porcelain. The greatest European collector of Asian porcelain, Augustus was a fanatic who spent large sums of money from the state treasury for his purchases. To stem the flow of funds leaving Saxony, and to outdo Louis XIV, he desperately wanted to discover the secrets of creating porcelain. Now, at the dawn of the Age

of Enlightenment, scientific methods and the ancient "art" of alchemy joined once again, as they had earlier, in the Medici porcelain endeavor, to bring about the results Augustus craved.

A Collaboration in Saxony

A scientist and mathematician, Count Ehrenfried Walther von Tschirnhaus (1651–1708), and an alchemist, Johann Friedrich Böttger (1682–1719), became the two key players during the final stages of the European quest for true porcelain. Count von Tschirnhaus, like his sovereign, traveled to view the wondrous technological, scientific, and artistic achievements of Louis XIV's France. Jean-Baptiste Colbert (1619–1683), Louis's clever finance minister and a leading patron of the arts and sciences, was the primary instigator of French advances. Using royal subsidies, he supported the Royal Academy of Painting and Sculpture and promoted additional venues by personally founding the academies of dance, music, and architecture. As the founder of the Academy of Sciences in 1666, Colbert was an important contact for Tschirnhaus during his studies in Paris. Tschirnhaus's affiliation with the French Academy of Sciences, first as a student and then as an elected member, brought him into contact with the Dutch scientist Christian Huygens. From Huygens, who discovered Titan, the first known moon of Saturn, and recorded his discovery of the polarization of light in 1678, Tschirnhaus learned techniques for grinding and polishing glass lenses. Tschirnhaus's interest in optics would play an important role in his later research of porcelain production.

Both Augustus and Tschirnhaus were intrigued by Colbert's implementation of a mercantile fiscal policy under which the arts were established as industry in the great royal manufactory at the Hôtel des Gobelins. Just as scientists came from throughout Europe to work at the well-funded French Academy of Sciences, some 250 French, Italian, Dutch, and Flemish artists were employed in the workshops of the Gobelins to create glorious furnishings for the Sun King's residences. Having participated in the French academy system that favored a mingling of arts, science, and industry, Tschirnhaus, when appointed by Augustus as a councilor of the court, put into practice some of the scientific and industrial advances he had studied during his travels. In his efforts to locate mineral deposits in Saxony and

establish new manufactories, Tschirnhaus caught the porcelain fever. He knew that discovering the secret of making porcelain would help curtail the flow of funds to the East —Tschirnhaus described porcelain as the bleeding-bowl of Saxony.[8] It would also catapult Saxony onto the world economic stage in a way not yet achieved by France.

Tschirnhaus studied experiments in soft-paste, or artificial, porcelain production in Saint-Cloud, France, and in Holland, he learned how to construct a kiln.[9] From his research in the field of optics, Tschirnhaus realized the potential for producing high temperatures using large, floor-standing, glass burning lenses of the type he first encountered in France. His experiments with lenses and mirrors to concentrate solar energy led him toward an understanding of the fusing of minerals, an essential step in the production of porcelain. His lenses would also become a crucial element in attaining a kiln temperature sufficient to fire hard-paste, or true, porcelain (fig. 3). From about 1686 onward, while establishing

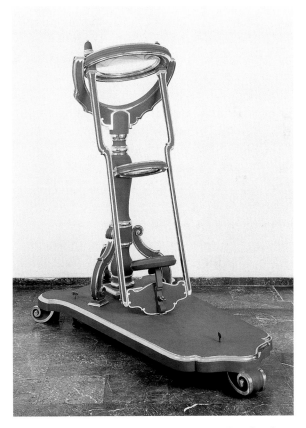

FIG. 3. Double burning-lens apparatus, c. 1690. Dresden, Staatliche Kunstsammlungen Mathematisch-Physikalisher Salon.

glassworks, a faience manufactory, and other industries for Saxony, Tschirnhaus worked to discover a formula and to develop the necessary firing techniques to create porcelain.

Mercantilism, the primary economic system of the major trading nations of Europe at this time, was based on industry and exports to gain precious metals, especially gold. As trade increased in the seventeenth century, there was a universal demand for gold in exchange for exotic foreign commodities that Europeans of means had come to expect. With the establishment of gold bullion as the standard of a nation's power and wealth came increased emphasis on mining technology and world exploration in search of this valuable metal. Because its importance was so great, rational methodologies to find gold were undertaken concurrently with European rulers' continued support of alchemists in their search for the fabled, mystical philosopher's stone—the compound in the presence of which base metal turned into gold.

The arrival in 1701 of a renegade alchemist, Johann Friedrich Böttger, in Augustus's realm served as a catalyst in the discovery of a European porcelain formula. In Prussia, where he had performed convincing but bogus transmutations of lead into gold, Böttger was summoned to the court of Frederick I to display his talents. Realizing his precarious situation, Böttger fled south into Saxony, where he was snared by Augustus, who refused to extradite so valuable a fellow. Böttger, imprisoned in Augustus's castle, was equipped with a laboratory and ordered to produce gold.

After tolerating several years of Böttger's failed attempts, a disappointed and exasperated Augustus decided that his knowledge of chemistry could be put to more constructive use as an assistant to the physicist Ehrenfried von Tschirnhaus. Rather than gold, Tschirnhaus sought to forge clay in the fire and create porcelain. In 1705, Böttger, on whose efforts Augustus had invested considerable funds, was incarcerated in a larger establishment, the Albrectsburg, a drafty hilltop castle in Meissen, outside of Dresden.

While not completely abandoning alchemy's dream of gold, Augustus also now supported Böttger's research for the development of porcelain. In the Albrectsburg, equipped with twenty-four new furnaces for his use, the disgruntled Böttger, who still considered himself an alchemist, not a potter, focused his research on detailed analyses of various clays and minerals. As a frequent visitor and adviser, Tschirnhaus shared with him knowledge gleaned from his years of por-

celain research. He knew that French soft-paste porcelain produced since the early 1690s, made with calcareous clay, chalk, and glass frit, was not comparable to the Asian wares in Augustus's collection. It is unclear whether Tschirnhaus or Böttger, or both, realized that pulverized rock, not glass, was the necessary ingredient to add to fine white clay. Tschirnhaus had experimented with fusing minerals using solar energy, but it may have been Böttger, drawing on his alchemical research with metals, who thought to experiment with various rocks that sinter and melt at high temperature, fusing the clay and giving porcelain a vitrified, impermeable body.

During 1706–7, Böttger's and Tschirnhaus's experiments with stone produced a dense, red stoneware (*steinzeug*). Considered a precious ware in its own right, it was called red porcelain. This special stoneware required a higher firing than traditional German stoneware, but Tschirnhaus's burning lenses, which concentrated solar heat, and also his improved kiln designs, boosted the heating capacity of the wood-burning kiln to the high temperature needed to fire red stoneware. Refinement in kiln technology and the production of red stoneware, proving that certain clays could fuse only when mixed with a calcareous flux, brought Tschirnhaus and Böttger ever nearer to the secrets of porcelain. Just as Asian porcelain developed from the stoneware tradition (see pl. 1.1), European porcelain evolved from experiments with stoneware.

In 1707, Böttger sent Augustus a tantalizing message: "It is my great hope that with the help of Herr von Tschirnhaus, I can within two months present something great."[10] Böttger returned to Dresden, this time to a new and larger laboratory at the Jungfernbastei, along the Elbe River. In these dungeonlike rooms, Böttger worked on formulas using kaolin. Finally, in January 1708, test firings of kaolin mixed with alabaster produced small, white, translucent plaques that maintained their shape in the high-fire kiln. The triumph of an arcanum, a secret formula, for European hard-paste porcelain was at hand.

The roles Tschirnhaus and Böttger played during the final three years of research and discovery are debated. After a more than twenty-year odyssey, the ailing Tschirnhaus died in October 1708, leaving the final stages of development, such as perfecting a glaze, to Böttger. By March 1709, Böttger announced to Augustus that he could produce a good white porcelain with a very fine glaze (pl. 2.2, right). On the

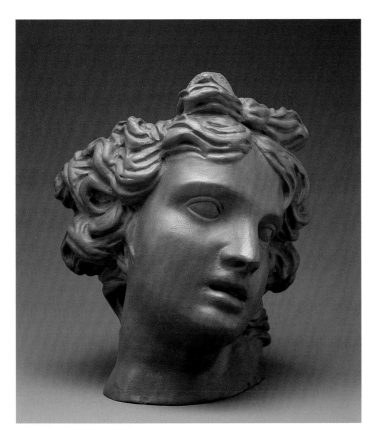

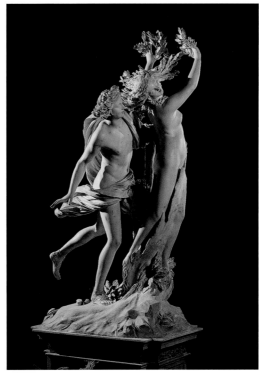

PL. 2.1

Head of Apollo

German, Meissen factory, c. 1710–15
Model by Paul Heermann (1673–1732)
Böttger stoneware (Böttgersteinzeug)
H. 4⅛ in. (10.5 cm)
Gift of Martha and Henry Isaacson, 69.179

The model for the Böttger stoneware *Head of Apollo* was created for the Meissen factory by the independent sculptor Paul Heermann[11] from sketches and models he made of Bernini's marble group when he visited Rome. Meissen's highly valued red stoneware—tankards, vases, tea caddies, and sculptural figures—was the factory's primary production during the early years of 1710–12.[12] Sales provided needed revenue while the newly discovered porcelain medium was perfected and promoted. During this period, Johann Böttger, the arcanist who possessed porcelain's secret formula, and who was the administrator of the Meissen factory, continued his work on formulas and firing techniques. Court and independent artists were brought in to give form and decoration to these desirable and costly ceramic wares. The *Head of Apollo* was made in two dif-

ferent molds. A seam or mold line, a common feature of Böttger molded stonewares, is visible where the two halves meet.[13]

Although small in scale, the red stoneware head of Apollo evokes a dynamic, nervous energy characteristic of the baroque style of the seventeenth century. Looking at Bernini's large marble group, *Apollo and Daphne* (1622–25; see fig. 4), after which this head was modeled, we understand the open-mouthed, stunned look on Apollo's face. His beloved Daphne is undergoing a startling transformation—she is turning into a laurel tree. Pursued by the amorous Apollo, the reluctant nymph Daphne had called upon her father, the river god Peneus, to save her. In art, she is often depicted just as Apollo is about to catch her, as her arms turn into branches and her feet into roots.

strength of these discoveries, the first European hard-paste porcelain factory was established at Meissen in 1710.[14] Through the years, recognition of Tschirnhaus's role in the discovery of the arcanum has waxed and waned. But certainly because Tschirnhaus was dead by the time the factory was founded and porcelain was established as an important monopoly for Saxony, Böttger received the lion's share of the credit. The stoneware and porcelain developed during Tschirnhaus's tenure as a court scientist and economist are known as Böttger stoneware and Böttger porcelain (Böttgerporzellan).

In the second decade of the eighteenth century, eleven centuries after the Chinese first produced a white, thin, translucent ware, Europe finally had its own true porcelain. The secret formula for porcelain, not for gold, brought fame to Saxony.

The Early Wares

One of the earliest glazes developed during Böttger's tenure at Meissen was a black glaze containing manganese and cobalt. When applied to the stoneware, it created a brilliant finish reminiscent of Asian lacquer (pl. 2.2, center). The red stoneware to which this glaze was applied was sometimes made with a lower-fired, more porous clay body than the Böttger unglazed stoneware. This body shrank more in firing, thus accounting for its slightly smaller size compared to the unglazed stoneware tea caddy (pl. 2.2, left). The painted decoration of unfired lacquer red and gilding on the black-glazed stoneware is attributed to the workshop of Martin Schnell, the famous court lacquerer for Augustus. Schnell, recorded on the Meissen staff in 1712, was another important artist recruited to work at the new factory. The low-fired gilding on this tea caddy remains in fairly good condition, but because the red color was unfired, much of it has deteriorated through the years, and only remnants survive.

Böttger's early porcelain is a creamy, mellower white than later Meissen paste because it contains lime or alabaster as the flux, rather than stone. In the early 1720s, a feldspathic stone was substituted, which gave Meissen porcelain a whiter body, more like Chinese hard-paste porcelain. Porcelain shrinks more in firing than does stoneware.[15] The porcelain tea caddy (pl. 2.2, right) is three-fourths of an inch shorter than the unglazed stoneware caddy from the same mold.

— J.E.

PL. 2.2

Hexagonal tea caddies

German, Meissen factory
Unmarked
Gifts of Martha and Henry Isaacson, 69.177, 69.178, 69.183

from left:

Unglazed Böttger stoneware, c. 1710–15; h. 5½ in. (14 cm)
Böttger stoneware with black glaze, unfired enamel colors, and gilding, c. 1710–15; h. 5 in. (12.7 cm)
Böttger porcelain, c. 1715–20; h. 4¾ in. (12.1 cm)

Scholars once believed that the shape of these tea caddies followed a Chinese original, but in fact, Japanese hexagonal and octagonal shapes inspired them. They were probably designed by the Saxon court's goldsmith, Johann Jacob Irminger (1635–1724), who became affiliated with the factory in 1711 to assist with models for stoneware and the new medium, porcelain. Asian porcelain, red stoneware models from Yixing, and his own metalwork in silver and gold influenced Irminger's imaginative shapes. In the early years of the factory, Irminger's designs, such as these tea caddies decorated with Asian-inspired motifs of molded flowering trees and phoenixes, were produced in both Böttger stoneware and porcelain.

PL. 2.3

Bowl

German, Meissen factory, c. 1715–20
Decorated outside the factory about 1730
Böttger porcelain with impasto gold
Diam. 7 in. (17.8 cm)
Gift of Martha and Henry Isaacson, 69.191

Scenes of huntsmen chasing wild game were a popular decoration on early Meissen porcelain. The hunt was a favorite pastime of Augustus the Strong and other rulers of the day. Accompanied by horses, packs of dogs, riders in hunting coats, and beaters to start the game, they lived an illusion of being warriors of old. After he became king of Poland, Augustus roamed the great Lithuanian primeval forest in search of noble European bison, elk, and wild boar.[16]

This style of decoration, rendered in thick gold and tooled relief, has long been attributed to Christoph Conrad Hunger, a painter and gilder at the Meissen factory from 1715 to 1717, though no documentation supports Hunger's association with this work.[17] Similar decoration, thought to be by the same hand, has been identified on Saxon glassware of this period.[18] Decorators, or *Hausmaler,* who worked independently outside the factory, often painted glassware as well as porcelain.

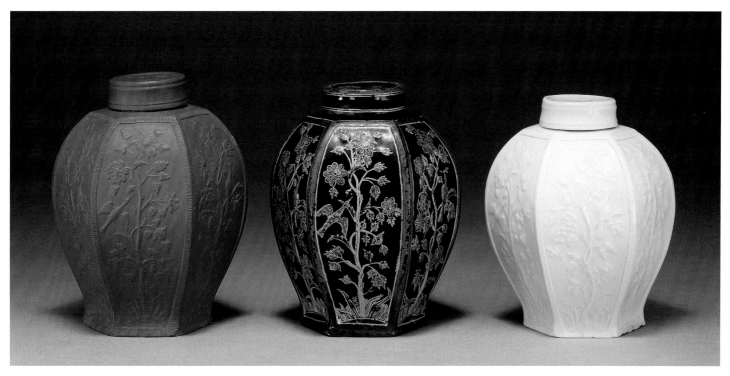

PL. 2.2

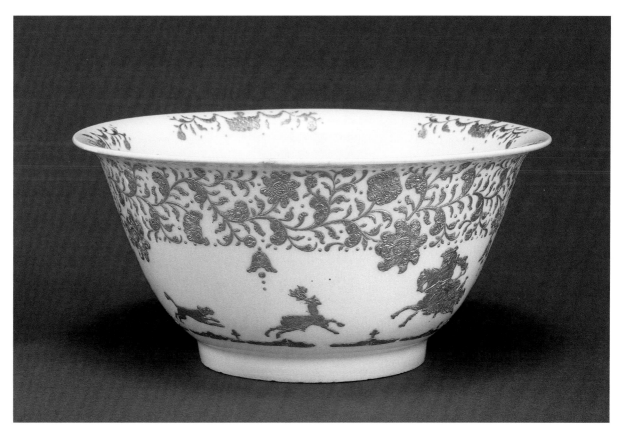

PL. 2.3

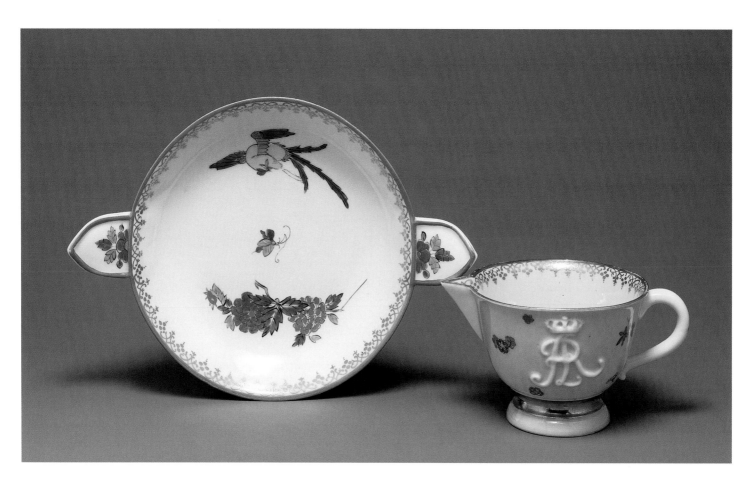

PL. 2.4

Spouted cup and double-handled saucer

German, Meissen factory, c. 1720–25
Hard-paste porcelain with enamel colors and gilding
Mark: crossed swords in underglaze blue
Saucer: diam. 3¼ in. (8.3 cm)
Cup: h. 2¾ in. (7 cm)
Gift of Martha and Henry Isaacson, 69.198

The crowned AR monogram in molded white relief on the cup stands for Augustus Rex, Elector of Saxony and King of Poland. This cup and saucer came into the Seattle collection catalogued as the probable candidate for Item 176 in a sale conducted by Rudolph Lepke's Kunst-Auctions-Haus in 1919, when "duplicates" from the royal collection were sold to raise cash for the new German Republic. Close comparison with the photograph from the sale refutes this claim; the description of the cup in the sale also states that it has been repaired, but the Seattle cup has no repairs.[19]

Meissen porcelain of the experimental pinkish, buff-colored paste that comprises the main body of the cup and saucer is rare.[20] The handles, spout, monograms (AR appears on both sides of the cup), and applied floral decoration on the outside of the saucer are all in white porcelain.

PL. 2.5

Tea caddy

German, Meissen factory, c. 1723–24
Böttger porcelain with gilding
Decorated, c. 1724–26
Mark: enameled crossed swords in blue
H. 4 in. (10.2 cm)
Gift of Martha and Henry Isaacson, 69.193

This tea caddy's form evokes the Far East, which was also the regional source of the tea it held. Its molded and gilded decoration is European. The elegant, symmetrical scrollwork and molded, stylized leaves derive from metalwork and stem from popular designs of the late baroque period.[21]

During the period in which this tea caddy was made, the Meissen factory was undergoing great change. In 1719, Johann Friedrich Böttger died, ultimately a victim of years of imprisonment, stress, and exposure to toxic chemicals as he labored to produce porcelain and to maintain his alchemical illusions. Even though this tea caddy was produced in Böttgerporzellan, it probably dates after Böttger's death.[22] In the second decade of production, Böttgerporzellan began to be replaced by a porcelain mixture containing feldspar and a higher kaolin content, which gave Meissen porcelain a cool white color. Böttger's early formula containing lime or alabaster, the one used in this tea caddy, also continued to be produced throughout the 1720s.

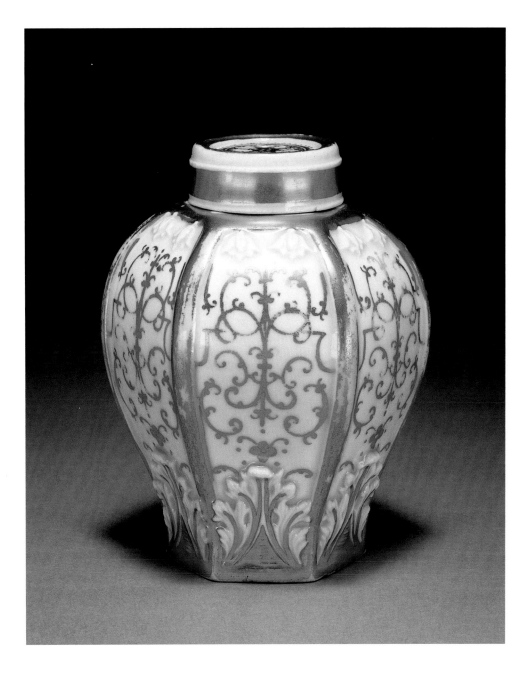

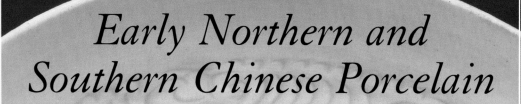

Early Northern and Southern Chinese Porcelain

Northern Porcelain: Xing and Ding Wares

The dream of producing white porcelain had haunted Chinese potters for millennia after their unsuccessful early attempts with white earthenware. When porcelain finally became a reality in the late sixth century in northern China, production flourished and very soon started to challenge the dominance of green-glazed stoneware. The locations of most porcelain production centers fell naturally along the geological seam of kaolin deposits. More than ten kiln groups of the Tang period have been found, attesting the considerable scale that porcelain production had attained by this time.[1] They were located largely along the Taihang mountain range that borders Hebei and Shanxi provinces and stretches southward to Henan province, where, in the foothills, lay rich accumulations of kaolin just thinly covered by loess. The kilns produced porcelain ranging from inexpensive utensils for daily use by common folk to exquisite wares sent to the imperial court as provincial tribute. Among them, porcelains from the Xing and Ding kilns were the most popular.

Xing Porcelain

> Round as the soul of a falling moon,
> light as the spirit of floating clouds
>
> —Pi Rixiu (c. 834–883), *Poem for Tea Bowls*

The Xing kilns were situated in Neiqiu and Linchen, two neighboring counties in today's Hebei province. In the Tang dynasty (618–906), the Neiqiu area belonged to Xing prefecture, hence the name for the porcelain produced there. Xing porcelain first appeared in the late sixth century, and after a hundred years of development, its production boomed during the eighth and ninth centuries to command a large share of the porcelain market. The contemporary historian Li Zhao claims: "The white *ci* tea bowls from Neiqiu were popular among all the folks under heaven, rich or poor."[2] Li's remark is validated by mounds of shards in the Neiqiu and Linchen area. A considerable amount has also been found in sites in southern China, and in Southeast Asia and the Middle East, which traded with China. By the mid-tenth century, however, the Xing kilns had ceased porcelain production.

As Li implied, Xing porcelain comprised both coarse and fine products. Fine Xing wares epitomize the best of Tang porcelain in all aspects: body, glaze, firing, and form. The high quality of local kaolin was no doubt a major factor in the wonderful whiteness of Xing porcelain, which is often likened to snow or silver. Its purity derives from its unusually low content of iron and titanium oxides, two prime colorants (or contaminants) common in clay materials. The purest kaolin was reserved for glaze. As a result, the Xing glaze has the lowest titanium content among the northern porcelains. With a little fluctuation in iron oxide, the Xing glaze would present either a snowy, slightly matte appearance or a silvery look with a touch of gray, both imparting a cool sensation. The clay was also very fine grained, which gave the body a dense and compact texture and helped to enhance the smooth appearance of the glaze. The objects were often simple and robust forms without surface decoration. The inviting glaze and wholesome shapes create a strong tactility, making it hard to resist the temptation to pick up a Xing object when we encounter one (pl. 3.1).

The new clay material not only generated fresh aesthetic appeal, it also allowed porcelain new functions. The high-fired porcelain of northern China is more durable than stoneware. This practical advantage is well demonstrated by a small grater in Seattle's collection (pl. 3.2): the hardness of porcelain transforms the edges of the carved fishnet pattern into sharp grinding teeth.

Beautiful and practical, Xing porcelain naturally caught the attention of the Tang imperial court, which eventually

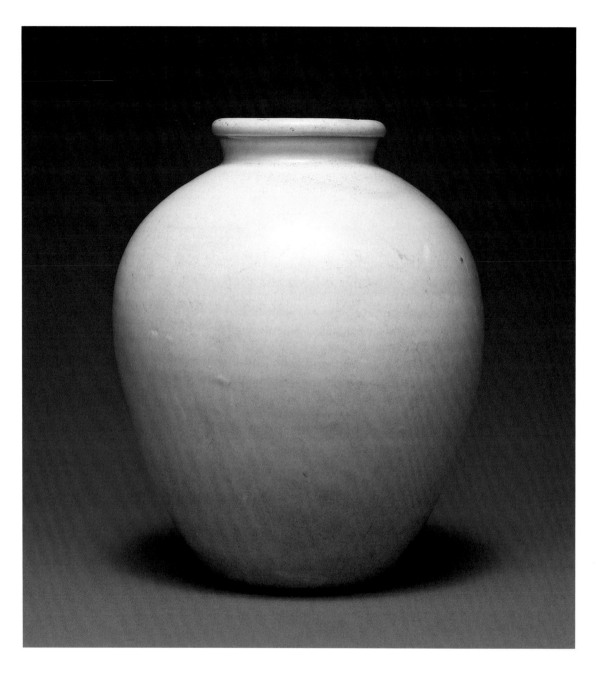

PL. 3.1

Jar

Chinese, Tang dynasty, 9th century
Xing ware, porcelain with white glaze and a *ying* mark at the bottom
H. 8¾ in. (22.2 cm)
Silver Anniversary Fund, 59.121

This jar's gently curved, sensuous contours and plain, elegant surface impart a graceful charm special to Xing porcelain. Its unaffected beauty appeals directly to the heart.

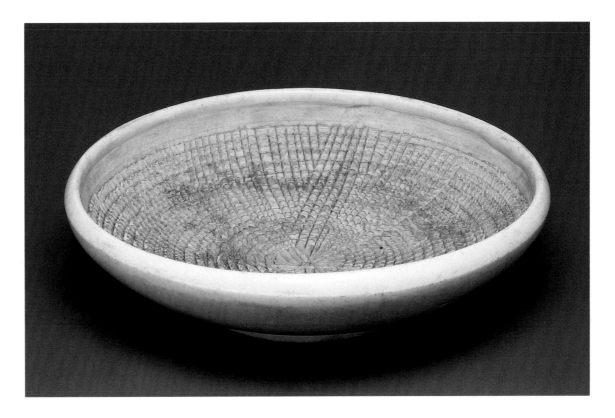

commissioned special production from the Xing kilns. Both jar (pl. 3.1) and grater have the character *ying* inscribed at the base, an abbreviation for the name of the imperial warehouse, Baibao dayingku, where objects reserved for use in court banquets or as imperial gifts were stored.[3] Other surviving inscriptions include *hanlin* (Hanlin yuan, the imperial academy of literature, art, and technology). Although very few extant objects so inscribed are intact, a good number of fragments have been unearthed at the Xing kiln sites and also at the Daming Palace in the Tang capital in Xi'an, Shaanxi province.

As well as fine porcelain, the Xing kilns put out a huge amount of coarse wares made from clay with a higher content of impurities and often roughly prepared; blackish dots in the porcelain body are a good indication of this condition. Even then, however, Xing potters still ardently pursued whiteness. To compensate for the clay's lower quality and to increase its attractiveness, a layer of white slip (clay thinned with water to the consistency of cream) was routinely applied to the body before the glaze. The outcome was a decent white surface, though hardly comparable with that of the fine pots. These coarse wares met the needs of ordinary consumers and

PL. 3.2

Grater

Chinese, Tang dynasty, 8th–9th century
Xing ware, porcelain with white glaze and a *ying* mark at the bottom
Diam. 4¾ in. (12.1 cm)
Silver Anniversary Fund, 59.120

Used to grind pigment for paint or cosmetics, this grater demonstrates the unprecedented strength achieved by porcelain. Not many such pieces have survived; this is the only extant intact Xing grater so far known. One grater shard of similar quality, found at the Xing kiln site, is datable to the same mid-Tang period.[4]

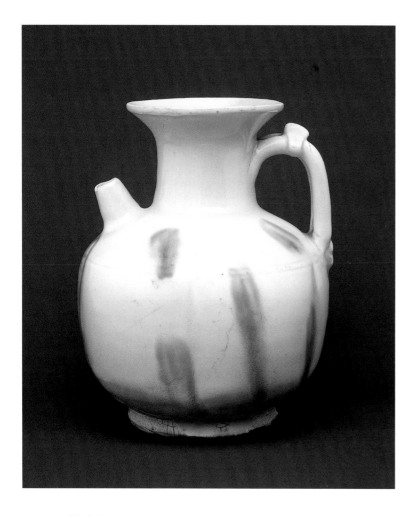

PL. 3.3
Ewer

Chinese, Tang dynasty–Five Dynasties, 10th century
Xing ware type, from an unknown northern kiln, porcelain with
greenish-brown splashed decoration
H. 5½ in. (14 cm)
Thomas D. Stimson Memorial Collection, 51.122

This ewer cannot be readily compared to any known ware types
or archaeological findings, but its overall shape, including the
short tubelike spout and double-coil handle with a clamp and
rivet imitating those of metal ware, are features of late Tang.
The bulbous body has five shallow lobes and an unglazed foot-
ring in the style of a narrow, jade *bi* disk, both typical of the
Five Dynasties period. The greenish-brown splashes on the
white body are striking and rare. So far, only one other example,
a shard from a Xing kiln site at Qicun near Neiqiu, bears sim-
ilar decoration.[5] Ewers of this type would have been used as
wine bottles.

undoubtedly broadened Xing porcelain's share of the ceram-
ics market. Archaeological findings over a wide range of
regions attest Xing porcelain's popularity and document its
domestic trade, from the central plains in northern China to
Guangdong and Fujian in southern China, and international
trade extending all the way to Iraq and Egypt via overland
and maritime routes. In foreign lands, Xing wares became
both exotic commodities and prized collectibles.

Xing wares also exerted great influence on porcelain pro-
duction in other regions across northern China, but none
attained similar fame. For that reason, today there is a group
of Tang white wares very similar to yet somewhat different
from Xing wares, whose origins can no longer be ascertained.
The ewer in the Seattle collection falls easily into this cat-
egory: its form and glaze are close to those of Xing porcelain,
but the clay texture differs (pl. 3.3). The existence of these
other porcelain kilns inevitably led to intense market com-
petition, posing a threat to the leadership enjoyed by Xing
porcelain. Nearly 400 years of massive production at the
Xing kilns, to keep up with market demand and competition,
gradually exhausted the supply of good-quality local clay
materials. Then, in 835, a terrible flood devastated the area,
greatly diminishing the capacity of the Xing kilns.[6] In the
mid-tenth century, the Ding kilns, one of Xing's competitors,
assumed the lead. Ding porcelain had begun by emulating
Xing wares, but it soon eclipsed Xing's fame with its own
distinctive styles.

Ding Porcelain

A boy dressed in white, with a blue-patterned cloth in hand,
 is holding a white *ci* jar, selling hot pickled vegetables.

—Meng Yuanlao (early 12th century),
The Eastern Capital in My Dreams

This enticing image rose suddenly before Meng Yuanlao's
eyes when he was busy listing more than a hundred mouth-
watering dishes and desserts in his *Dongjing menghua lu* (The
Eastern Capital in My Dreams).[7] Here, rather than the food
itself, he was obviously more attracted by the unforgettable
mixture of colors—hot red pickles in white porcelain with
a boy in white and blue.

The shiny white surface of porcelain proves to be both
practical and attractive. It makes the ware easy to clean after
use, it produces a background capable of accommodating

every other color, and its twinkling reflection of light recalls the surface of silver. These charming characteristics were utilized to the best effect on Ding porcelain.

Ding kilns were situated in Jianci village in Quyang county, which belonged to the Ding prefecture during the Song dynasty (960–1279) and is part of modern-day Hebei province. Porcelain production at the Ding kilns started during the mid-Tang period in the eighth century and continued until the Yuan dynasty (1279–1368) in the fourteenth century. In the course of more than 600 years, the Ding kilns developed both a new style and a new firing technique, which not only distinguished Ding porcelain but also exerted significant influence on much porcelain production elsewhere. Most Ding porcelain was produced during the Northern Song (960–1127) and Jin (1115–1234) periods. The wares are often neatly formed, with thin walls, elegantly carved or molded with decorative designs, and coated with a transparent glaze of ivory or creamy tinges. In its heyday, Ding porcelain enjoyed enormous fame, outshining Xing porcelain to become one of the most coveted ceramic wares of its time.

The foundation of Ding porcelain's great success was its close relationship with Xing porcelain. Located less than 100 miles north of the Xing kilns, the Ding kilns started production by faithfully copying Xing wares. Close imitation was possible because the kaolin came from the same geological seam, and the same horseshoe-shaped kilns were used. By the late tenth century, wares from these two kilns had become increasingly hard to distinguish. A good example is the bowl with five shallow lobes and foliated rim (pl. 3.4). Its softly raised veins and curved contour express a subtlety typical of fine Xing porcelain. Also similar are its dense white body and smooth, light-grayish glaze. This bowl could easily have been accepted as a Xing product if one overlooks the footring and the sand adhering to it, two features that reveal the native Ding cutting method and firing technique.

By the time the Song dynasty was established in 960, Ding porcelain had developed its own style, and its production had become the largest and finest in northern China. Its exceptional quality is plainly visible in the more than 150 Ding wares discovered in 1969 in the underground cells of two early Song pagodas, one dated to 977 and the other to 995, not far from the Ding kiln sites.[8] They were among Buddhist treasure offerings that also included many precious materials such as gold, silver, jade, and glass. The interred porcelain

PL. 3.4
Bowl
Chinese, Five Dynasties (907–960)
Ding ware, porcelain with white glaze
Diam. 5⅝ in. (14.3 cm)
Gift of Charles H. McClintick, 88.127

wares have a rich variety of finely formed shapes, but they all share the slight ivory tone that remained a classic feature of Ding porcelain glaze from then on. This new tone was caused by the peculiar kiln atmosphere in which Ding porcelain was fired. Starting in the early Song, coal replaced wood as the standard fuel in the Ding kilns. Coal has a shorter flame length than wood and burns slower, thereby making it more difficult to maintain a full reduction atmosphere, but easier to provide an oxidizing one. In this new environment, the small amount of iron in the glaze turned into ferric oxide (Fe_2O_3), producing the ivory tint. The glaze of Song period Ding porcelain also had a low viscosity, that is, a strong tendency to flow. Where the glaze ran down and pooled, long drips, or "tears," appear, giving Ding porcelain

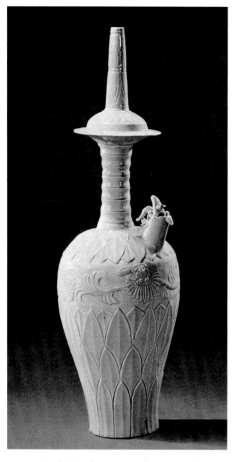

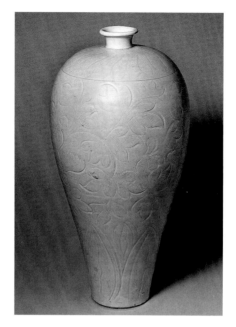

FIG. 2. Vase (*meiping*). Northern Song dynasty, 11th–12th century. Ding ware, porcelain with carved decoration, h. 14⅜ in. (36.5 cm). London, Percival David Foundation of Chinese Art.

PL. 3.5

Bowl

Chinese, Northern Song dynasty, late 11th–12th century
Ding ware, porcelain with carved decoration
Diam. 9 in. (22.9 cm)
Eugene Fuller Memorial Collection, 48.168

A spray of lotus blossoms covers the bowl. A popular motif in ceramic decoration, the flower symbolizes purity and is often associated with Buddhism.

FIG. 1. *Kendi.* Northern Song dynasty, 10th century. Ding ware, porcelain with carved decoration, h. 24 in. (61 cm). Dingzhou Municipal Museum.

of that period another of its classic features. Naturally the ivory tint is most obvious on pieces with tears.

Ding porcelain of the early Song also began to use carved decoration, adopting motifs from metal wares and carving technique from the Yue ware of southern China, on which carved decoration had been used regularly. Layers of patterned lotus petals adorn some of the most special Ding wares from the pagodas, and such wares often retained much of the appearance of metal wares (fig. 1).

In the eleventh century, or mid–Northern Song period, Ding porcelain began to present a dramatically different style in surface decoration. Motifs became naturalistic, and both carving and incising were done in a highly expressive, spontaneous manner. Contours were often delineated by one or two thinly incised lines on one side and beveled lines on the other, the latter adding a third dimension to an otherwise flat design and thus creating depth and liveliness (pl. 3.5). At the same time, simple, natural ceramic forms were emphasized and built through consummate potting that imbued an object with easy grace but barely left its traces behind. In this superb *meiping* (prunus vase), a wonderful sense of rising or growth is conveyed by its gently elongated curvilinear contours (fig. 2). Adding to this effect is the symbolic meaning encoded in the lively image of the lotus. Such artistry gained Ding porcelain the recognition of the imperial court; it was included among utensils used by the imperial household. Today a few intact Ding wares and a good many Ding shards carry inscriptions such as *guan* (official), *shangshiju*

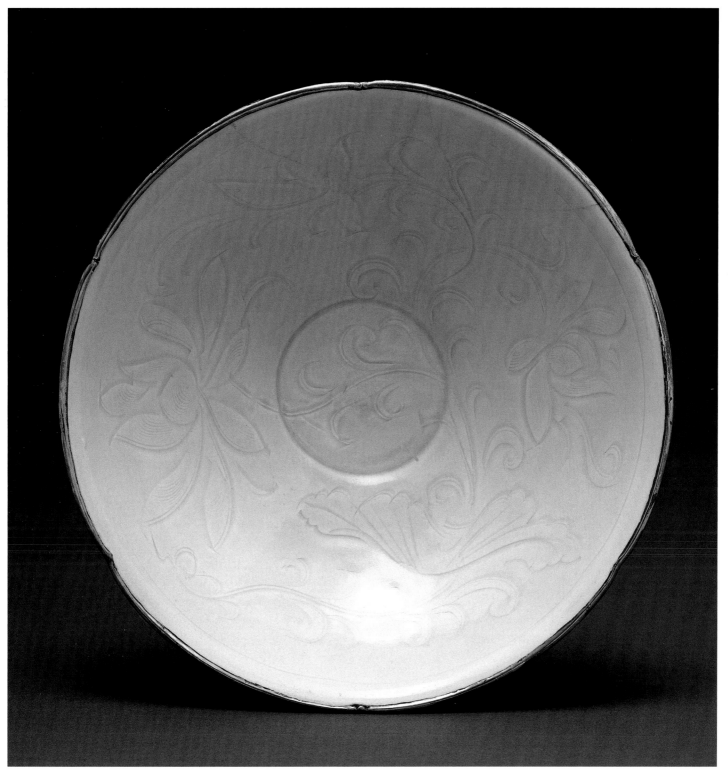

PL. 3.5

PL. 3.6
Bowl

Chinese, Northern Song dynasty, 11th century
Ding ware, porcelain with reddish-brown glaze and traces of
overglaze gold decoration
Diam. 5 in. (12.7 cm)
Thomas D. Stimson Memorial Collection, 49.64

The majority of surviving dark Ding wares are plain mono-
chromes, though some have additional surface decoration. This
small conical bowl is an extremely rare example of the latter.
The light traces of floral sprays and butterflies, faintly visible in
the interior, reveal that it once had overglaze gold-leaf decora-
tion. Fewer than ten reddish-brown Ding wares bearing similar
decoration survive today.

(Office of Imperial Cuisine), *shangyaoju* (Office of Impe-
rial Medicine), and *fenghua* (Fenghua Palace), altogether
about twenty different marks. For the same reason, connois-
seurs of later ages have hailed Ding porcelain as one of the
"Five Great Wares of Song," which comprise Ding, Ru, Jun,
Guan, and Ge types of *ci;* of these, only Ding is white *ci,* or
porcelain.

The Ding kilns also produced porcelain decorated with
dark glazes, such as reddish brown, black, or even tea-dust
green during the late eleventh century (pl. 3.6). It was the
first time a porcelain ware appeared in colors other than
white, intruding into the territory traditionally occupied by
stoneware. The inspiration for these dark glazes likely came
from contemporary lacquerware, for the visual effect of the
thick, slightly matte glaze shows a close resemblance to lac-
quer, and sometimes even vessel shapes are similar. The dark
colors result from varied amounts of iron oxide present in
the glaze, all exceeding 5 percent. Ding production of dark-
glazed porcelain was apparently much smaller in scale, how-
ever, for there are far fewer contemporary records of them
and far fewer archaeological data and extant wares. By the
late fourteenth century, dark Ding wares were already con-
sidered rare, and they have always fetched much higher
prices than the more common white wares.[9]

A latecomer in the repertoire of Ding decorative tech-
niques was molding—pressing a piece of leather-hard clay
over a shaped, decorated mold to receive the imprint of the
decoration. The potential for mass duplication of designs
by this technique was enormous. Introduced toward the end
of the eleventh century, molding immediately became highly
popular and was the most used method up to the end of
Ding porcelain production. Even in this mechanical process,
the hallmark spontaneity of eleventh-century Ding carved
designs at first managed to prevail, in organic motifs drawn
from life or the imagination, such as dragons, lions, and
various plants; the more static assemblages of varied patterns
came later (pl. 3.7).

Owing to the nature of the technique, molded decoration
is generally denser in composition. Carving individual bowls
directly required speed for efficiency, but carving a mold took
time and deliberation; the mass duplication made possible by
the mold easily compensated for the lengthier process. Molds
tended to have complex designs. In Ding molded decoration,
artists were stimulated by designs of contemporary textiles,

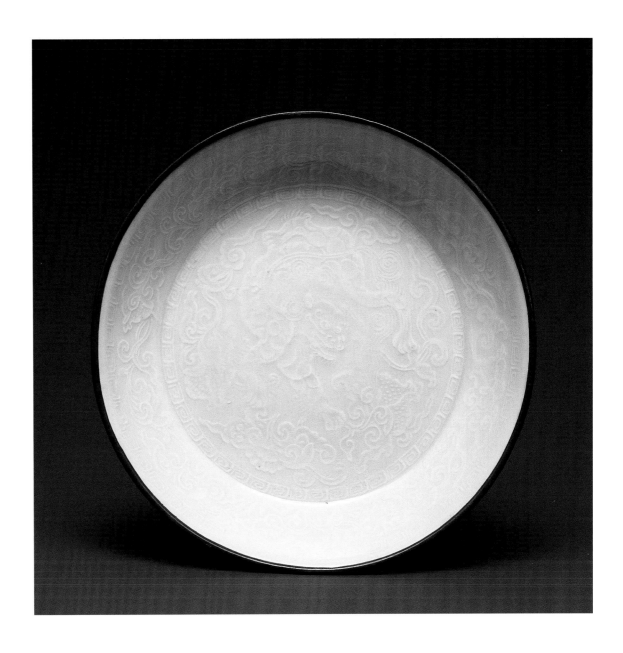

Dish

Chinese, Jin dynasty, 12th century
Ding ware, porcelain with molded decoration
Diam. 5½ in. (14 cm)
Eugene Fuller Memorial Collection, 33.645

It is interesting to note that a desire to emulate the decoration or shape of metal wares seems never to have ceased in Ding production. This dish clearly shares an affinity with metallic shapes with its angular profile of an inverted trapezoid and thin walls that rise at a 60-degree angle from a broad, flat base. A silver bowl of identical form was found in a famous early Song pagoda.[10] The molded decoration shows a key-fret-bordered medallion of a lion amid clouds and pomegranate scrolls in the well, circled by two bands of pomegranate scrolls and key frets around the cavetto. The lion and the pomegranate are auspicious motifs conveying good wishes for high-ranking official-dom and abundant offspring.

Northern Porcelain: Xing and Ding Wares 43

particularly *kesi* (woven silk tapestry), for which the Ding area was also renowned.[11] Moreover, the slightly raised impression of Ding molded decoration seems reminiscent of repoussé on silver wares, indicating another possible influence.

One major feature of Ding porcelain is the metal band, often silver, fitted to the rims of many bowls or plates (see pls. 3.5, 3.7). Such metal bands, like later European metal mounts, obviously enhanced the prestige of the objects and perhaps also implied the high status of its owner. In the tenth century, many ceramics sent to the court were decorated with bands of gold, silver, or copper.[12] On Ding porcelain, however, the metal band has a unique significance, for it conceals a technological innovation of major consequence in Ding production. Beneath the metal band is an unglazed rough mouth caused by firing the object upside down on the mouth rim instead of traditionally, on the foot. The mouth rim thus had to remain unglazed to prevent it from fusing with the saggar on which it sat. This inverted firing method permitted dishes or bowls of various sizes to be stacked in a bowl-shaped saggar as well as in a bowl-shaped, multiple, stepped saggar, with smaller pieces under larger ones (fig. 3a); or if of identical size, each was placed in a ring-setter, which would then be stacked up to form a large, straight-walled saggar (fig. 3b). By either method, productivity

greatly increased.[13] Moreover, sometimes a bowl-shaped saggar and a straight-walled saggar could be stacked to form yet another composite saggar, making maximum use of kiln space (fig. 3c). This new technique was invented in the Ding kilns in around the late eleventh century, and it revolutionized production by allowing kilns to be filled to unprecedented density. In addition, the technique also effectively prevented easy warping of the thin-walled wares fashionable at the time by providing a larger, more stable area to bear weight during firing.

The effect of molding and inverted firing, by dramatically increasing the capacity of the Ding kilns, no doubt lowered cost of production and increased the popularity of Ding porcelain, at least among the common people. In the twelfth century, copies and imitations of Ding wares thrived. Some northern kilns even specialized in copying Ding. The small flanged bowl (pl. 3.8) was made in a Huozhou kiln in Shanxi province, southwest of the Ding kilns. It imitates closely Ding porcelain's thin wall (even thinner here), glaze, and body, though it differs in potting method and how it was placed in the saggar. The Huozhou bowl sat on five spur-setters and in turn supported another bowl with five spur-setters placed inside it. It thus fired with five fine marks both in the well and on the bottom of the footring.

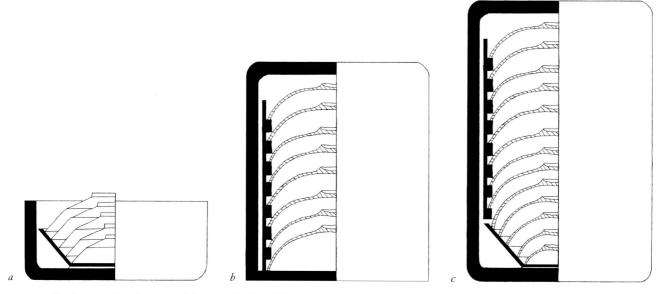

FIG. 3a–c. Stacking method for inverted firing at the Ding kilns.

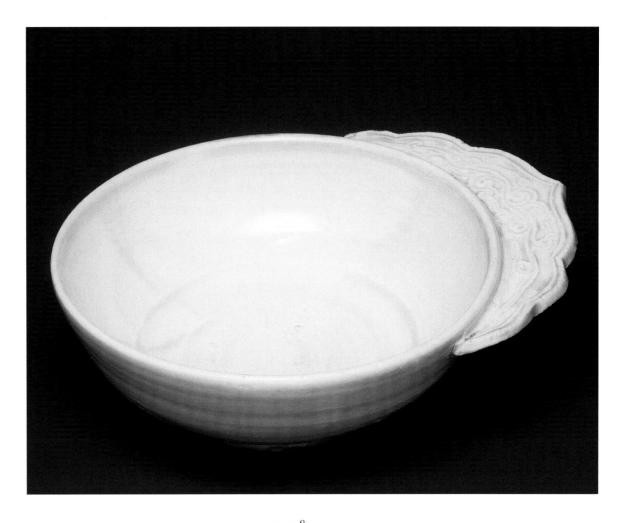

Despite their great advantages, molding and inverted firing also had drawbacks. While they generated high-volume output, the artistic quality of molded wares tended to be compromised, and the rough rim was, after all, an undesirable element. The high quality of Ding porcelain started to decline in the thirteenth century and later was completely outshone by *qingbai* porcelain, its direct beneficiary in the south. In the fourteenth century, Ding porcelain eventually failed in every area of competition, and consequently its production ceased. By that time, a new center of porcelain production had been established at Jingdezhen, in Jiangxi province in southern China, where new types of Chinese porcelain of unprecedented richness, starting with *qingbai,* were to be created.

—J.C.

Flanged bowl

Chinese, Jin dynasty, late 12th–13th century
Ding ware type, Huozhou kilns, porcelain with a flange of molded decoration
Diam. 3½ in. (8.9 cm)
Gift of Mrs. Frank H. Molitor, in memory of her mother,
Mrs. Stanley A. Griffiths, 74.9

This shape seemed to be popular in the north; many examples were made in stoneware.

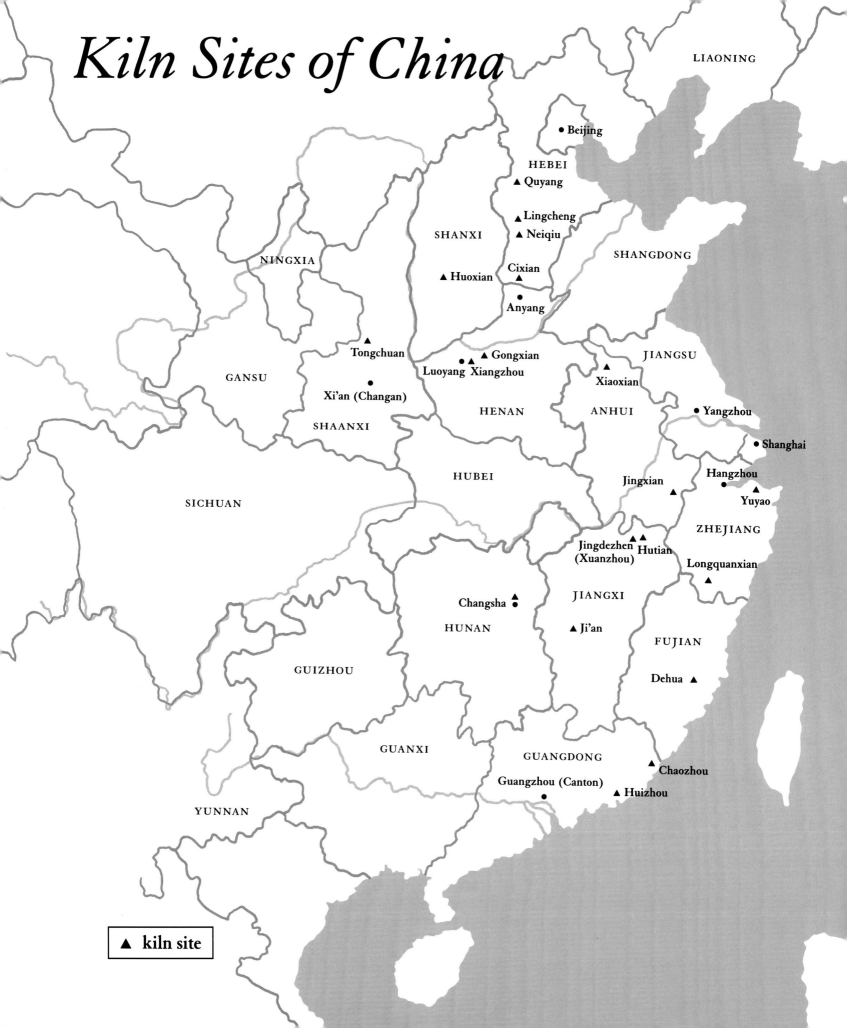

Kiln Sites of China

LIAONING

● Beijing

HEBEI

▲ Quyang

▲ Lingcheng

SHANXI

▲ Neiqiu

SHANGDONG

Cixian

▲ Huoxian ▲

● Anyang

▲ Tongchuan

● ▲▲ Gongxian

JIANGSU

Luoyang Xiangzhou

NINGXIA

GANSU

● ▲ Xiaoxian

● Xi'an (Changan)

HENAN

ANHUI

● Yangzhou

SHAANXI

● Shanghai

HUBEI

Jingxian

Hangzhou

SICHUAN

▲ ●

▲ Yuyao

ZHEJIANG

▲▲

Jingdezhen Hutian

(Xuanzhou)

Longquanxian

▲

Changsha ▲ ●

JIANGXI

HUNAN

▲ Ji'an

FUJIAN

GUIZHOU

Dehua ▲

GUANXI

GUANGDONG

▲ Chaozhou

Guangzhou (Canton)

● ▲ Huizhou

YUNNAN

▲ kiln site

4

Southern Porcelain: Qingbai and Luanbai Wares

———— ⟨⟩ ————

A good cup of tea is essential nourishment for both body and mind, so Lu Yu (733–804) tells us in his famous *Cha jing* (The Classic of Tea), the first systematic discourse on tea cultivation, preparation, and drinking.[1] Among the many conditions necessary for serving tea was possession of a fine tea bowl. What to use? In Lu Yu's time, the Tang dynasty, precious and exquisite metal wares were held in high esteem, particularly in the court, but Lu Yu opted for ceramics; he tells us in a convincing voice that green-glazed Yue ware is the best for presenting the brownish-colored broth. A hundred years later, poet and connoisseur Pi Rixiu (c. 834–883) endorsed Lu Yu's choice but added that snow-white Xing ware was equally desirable. Lu's and Pi's preferences uncannily singled out the two best *ci* of the time: both Yue and Xing wares peaked in the eighth and ninth centuries. And the two masters' evocative words have forever imbued these wares with lasting images: Lu likened the Yue ware to green jade and ice for its cool color and feel, while Pi described the perfect Xing ware as being round as the moon and light as clouds.

Still, a hundred years later, in the late tenth century, a new type of *ci* emerged, which seemingly combined the virtues of Yue and Xing wares. Its body is white, dense, and translucent; it is often thinly formed and thus light and graceful; and it is covered with a transparent glaze clearly tinged with light bluish tones. This is *qingbai* porcelain. Although it is hard today to prove whether *qingbai* porcelain was conceived as a marriage of the two, it was nevertheless a marriage of the two distinct aesthetic ideas. This union took place in southern China, and it initiated the era of southern porcelain.

Qingbai Porcelain

> When traded to other places, it was called jade from Rao. It was truly an extraordinary thing, comparable to the rare red Ding wares and green Longquan celadon wares.
>
> —Jiang Qi (13th century),[2] *Taoji* (Notes on Pottery)

The term *qingbai* literally means bluish white. As the name implies, this type of porcelain is most remarkable for the lustrous bluish-white color of its glaze, which is stronger where the glaze has pooled, for example, in the intaglio lines of the two Seattle bowls (see pls. 1.5, 4.1). The bluish tint is caused by about 1 percent iron oxide in the glaze. In the reduction atmosphere generated toward the end of firing, each iron oxide molecule lost an oxygen atom to the kiln atmosphere. Reduced to ferrous oxide (FeO), the glaze turns light green or blue. The presence of iron oxide in the *qingbai* glaze could not have been accidental, for the earlier simultaneous production of green stoneware and white porcelain in the same kilns in Jingdezhen well demonstrated that the southern potters knew and were able to manipulate this colorant. There may have been several reasons for potters to create this particular visual attribute. To emulate jade was likely one of them, as the texture of *qingbai* certainly evokes the sense of cool translucency often associated with jade. Jiang Qi stated that *qingbai* was acclaimed as "jade from Rao," Rao being the prefecture of Jingdezhen. Related to this phenomenon was the prevailing influence of Yue green stoneware, which had dominated southern China for ages and was part of the aesthetic sensibility of the region's potters and their patrons.

The shape and decoration of this southern porcelain were also clearly influenced by Ding porcelain from the north. Many shapes directly copy Ding prototypes, or, like their Ding counterparts, imitate metal wares (pl. 4.2). The manner of decoration also followed Ding evolution, from plain

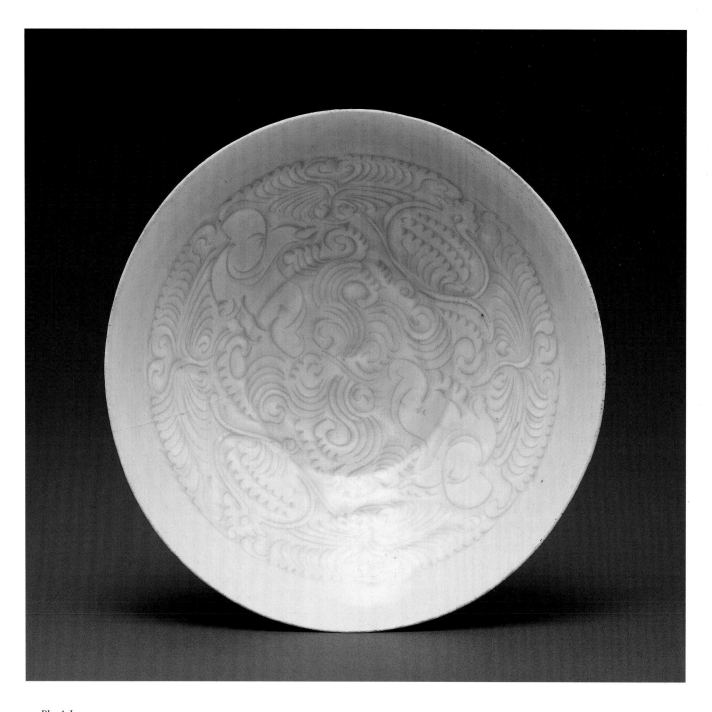

PL. 4.1

Bowl

Chinese, Song dynasty, 12th century
Jingdezhen *qingbai* ware, porcelain with light bluish-toned glaze
and carved decoration
Diam. 7⅝ in. (19.4 cm)
Eugene Fuller Memorial Collection, 44.100

The wide, V-shaped conical profile of this bowl is designed so that tea broth, prepared like thin gruel, could be easily drunk. The bowl's interior is skillfully incised with a symmetrical design of a chubby boy and pomegranate scroll, symbolizing good wishes for male offspring. Similar shape and motifs, frequently found on Ding wares of the eleventh century, indicate this *qingbai* bowl's artistic sources.

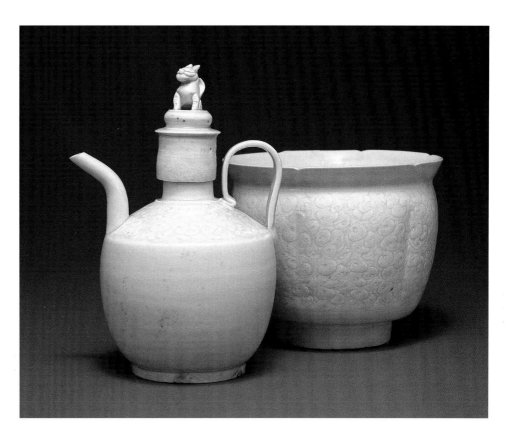

surface to carved to molded decoration. The Ding influence was particularly clear in the case of inverted firing technique, which *qingbai* faithfully adopted in the twelfth century.[3]

Though heavily influenced by Ding porcelain, *qingbai* porcelain nevertheless has an irrepressible freshness. It is made from porcelain stone, a clay material unique to southern China. It is less plastic than kaolin and therefore harder to throw, but it holds its shape better. Complicated forms could be built up through molding or articulation. As a result, sophisticated shapes such as this wine set (pl. 4.2) were more successful in *qingbai*. A more unusual example is the mortuary jar, whose lid is rendered as a sculptural model of a bell tower, attesting the great stability and strength of this clay made from porcelain stone (pl. 4.3). To make thrown objects like the bowl shown here (pl. 4.1), the potters compensated for difficulty of throwing with a secondary shaping. When the initial shape was leather hard, it was returned to the potter's wheel, and excess thickness was trimmed away.[4] The resulting bowl, remarkably regular in profile and thin in wall section, has an airy grace entirely new and truly special to *qingbai*. It looks familiar, yet utterly fresh.

PL. 4.2

Ewer and warmer

Chinese, Northern Song dynasty (960–1127)
Jingdezhen *qingbai* ware, porcelain with light bluish-toned glaze
and carved decoration
Ewer: h. 8½ in. (21.6 cm)
Warmer: h. 5¾ in. (14.6 cm)
Loan from the Jiurutang Collection

Pouring beverages from a ewer warmed in a large bowl filled with hot water was a common act in the restaurants of the Northern Song capital, Dongjing. The ewer and the bowl could be made together as a set, like the present example, or separately. In any case, such a set was a necessity for a luxurious dinner in a restaurant, as described in Meng Yuanlao's *The Eastern Capital in My Dreams*.

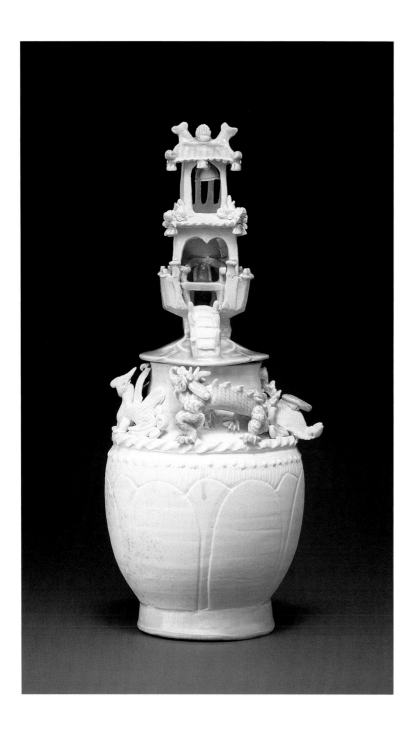

PL. 4.3

Mortuary jar

Chinese, Southern Song dynasty (1127–1279)
Jingdezhen *qingbai* ware, porcelain with light bluish-toned glaze,
appliqué, and carved decoration
H. 14¼ in. (36.2 cm)
Loan from the Jiurutang Collection

The tradition of using specially made ceramic jars as grave
goods prevailed from the third until the fourteenth century.
Such mortuary jars are often elaborately decorated with three-
dimensional figures, but their designs varied over time. A com-
mon feature of Song mortuary jars is the design of the four
modeled animals amid clouds, seen here on the jar's shoulder.
These four mythological animals represent the four cardinal
directions: the green dragon of the East, white tiger of the West,
red phoenix of the South, and black tortoise of the North. Here,
only the dragon (in *qingbai* glaze) and the white, unglazed tiger
have their proper colors. The other two uncolored animals and
the jar's unfinished surface imply that it may be an unfinished
piece.[5]

The dramatic sculptural quality of this jar is seen in its archi-
tectural components: a lid in the form of a two-story tower. The
tower appears to float on its small base, an effect enhanced by
its straight profile, which contrasts with the soft, curved outline
of the vessel's body. The tower's upper story has a bell; the lower
one has a staircase that leads to an armchair. The tower most
likely represents a reception hall in the paradise for the souls
of the deceased. The flying birds on the ridgepole aid the soul's
ascent, as does the bell, which announces the deaths of promi-
nent people to the celestial lord of the afterlife.

The modeled armchair is possibly the earliest known three-
dimensional miniature of a Song chair. During this period, use
of chairs became prevalent; earlier, people generally sat on daises.
The miniature chair thus represents a new trend or fashion.

The surface decoration of *qingbai* also embodied the familiar and the new. Early wares made in the eleventh century were generally decorated with freely carved designs of flowers or birds, showing strong influences from both Yue and Ding wares. By the twelfth century, the carved decoration had become denser and more complex (see pl. 4.1). At about the same time, molded decoration was also introduced, from Ding porcelain. Though the low plasticity of clay based on porcelain stone did not easily take distinct imprints from the mold, the Jingdezhen potters adhered to this technique, apparently for its high production rate. When carefully done, molding in porcelain stone–based clay produced designs with layered depth and rounded edges, looking as if they were just growing out of the background (see pl. 6.2). The sense of growth and the tactile quality of such molded designs are quite wonderful and refreshing, in sharp contrast to the clear delineation of carved decoration.

Porcelain stone–based clay also has a natural advantage in forming sculptural elements. Typical examples include animals such as those on the shoulder of the mortuary jar (pl. 4.3). In the late thirteenth century, beaded appliqué and openwork also became popular, giving objects a greatly textured surface and sophisticated look (see chap. 2, fig. 1). In addition to all these decorations that altered surface texture, *qingbai* porcelain occasionally utilized color. Buddhist figures of the thirteenth century sometimes had unglazed areas, which were painted after firing.[6] The mortuary jar in plate 4.3 was likely such a case, though its unglazed area does not show any trace of colors. Another way was to add brown spots to the glaze, which would then bond permanently to the surface during firing (see pl. 6.4).

Archaeological fieldwork reveals that *qingbai* porcelain was invented no later than the second half of the tenth century. The earliest datable *qingbai* is a five-foliate-rimmed bowl excavated from a tomb in Jiangxi province, dated to A.D. 986.[7] For several reasons, Jingdezhen in Jiangxi province is considered the most likely site for its invention.[8] Though porcelain stone was widely available in southern China—its deposits stretch from Zhejiang province in the east to Yunnan province in the west—Jingdezhen enjoyed the best-grade porcelain stone in abundance. Jingdezhen's earlier experience in producing white porcelain during the Five Dynasties period (907–960) is certainly another favorable factor. Moreover, Jingdezhen was blessed with rich resources of wood to fuel

the kilns and was strategically located for water transport, ensuring easy distribution of its products. Not surprisingly, the richest remains of *qingbai* porcelain have been found in Jingdezhen today. So for all practical purposes, Jingdezhen was the most important home of *qingbai* porcelain.

There were also a good many *qingbai* kilns in the southern provinces of Jiangxi, Fujian, Guangdong, Guangxi, Zhejiang, Anhui, Hubei, and Hunan; together with Jingdezhen kilns, they formed the largest kiln group of the Song dynasty period.[9] Their products were similar in material and technique, yet their quality varied. Wares from Jingdezhen were indisputably the best. Products also varied, as different kilns catered to their own particular markets. Generally speaking, the Jingdezhen kilns supplied both domestic and foreign markets, while kilns along the seacoast, particularly those in Fujian and Guangdong, focused mainly on export wares.

From the outset, *qingbai* was produced in rich variety. Daily utensils included various dishes and bowls, pitchers, headrests, incense burners, and cosmetic boxes to satisfy household needs, while mortuary jars and religious sculptures such as figures of bodhisattvas served the souls and deities of the other world. Such diversified production enabled *qingbai* to compete successfully with other ceramic types and capture an increasingly large share of both domestic and international markets. The twelfth and thirteenth centuries saw the most productive period of *qingbai* porcelain. In Jingdezhen alone, Jiang Qi recorded that more than three hundred kilns engaged in industrial-scale production.[10] And archaeological findings have shown that buyers of *qingbai* came from all over China, as far as Inner Mongolia in the north, Jilin in the northeast, Sichuan to the southwest, and regions in southern China. In Lin'an (today's Hangzhou), the capital city of the Southern Song, shops specialized in *qingbai*.[11] Its success eventually caught the attention of the Southern Song court, which favored its jadelike quality.[12] International markets expanded to encompass a vast area that included Korea, Japan, Southeast Asia, the Middle East, and Egypt.

The primacy of *qingbai* did not last forever; in the late thirteenth century, its popularity started to decline. The causes could be multiple, but two seem to be crucial. At this time, Jingdezhen potters had exhausted the deposits of well-weathered porcelain stone lying near the earth's surface. Material quarried from deeper layers, of different chemical

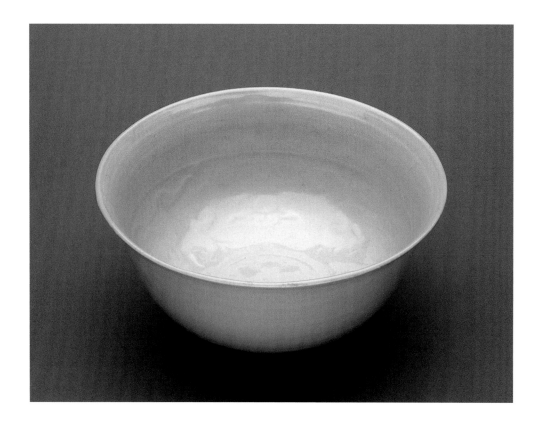

Bowl

Chinese, Yuan dynasty (1279–1368)
Jingdezhen *luanbai* ware, porcelain with
molded decoration
Diam. 6⅝ in. (16.8 cm)
Gift of Charles H. McClintick, 88.125

A roundel of a flower head circled by
four floral scrolls is lightly molded in the
well of this bowl. It has a slightly everted
rim and is covered with *luanbai* glaze
except for the footring, which indicates
it was fired by the traditional method,
upright. *Luanbai* wares thus embodied
a turning-away from the inverted firing
that had been practiced since the late
twelfth century.

composition, resulted in pots that warped or collapsed
during firing, and objects could no longer be made as thin
as desired.

This was also the time of the Mongol conquest of China,
which resulted in a dramatic change in taste. All areas of cul-
tural convention were affected, including painting and liter-
ary composition.[13] In ceramics, Jingdezhen, ever catering to
market need, began instead to produce the so-called *luanbai*
porcelain. This new type of porcelain was truly a product of
the time, for it lasted as briefly as the Yuan dynasty (1279–
1368). Flashy though it was, *luanbai* occupies a significantly
bright moment in the history of Chinese ceramics.

Luanbai Porcelain

This new porcelain developed in Jingdezhen demonstrates
important differences from its predecessor. While the *qingbai*
glaze is watery and transparent, tinged with light blue, the
luanbai glaze has an appearance like that of a goose egg;
luanbai means 'eggshell-white.' The glaze is opaque white,
creamy and matte, tinged with light gray, and *luanbai* wares
are often thick and heavy, both in body and in glaze (pl. 4.4).
The differences clearly express two distinct tastes: the quin-

tessential Southern Song preference for the exquisite and
light, and the Yuan desire for the rich and heavy.

In all likelihood, the new taste was deliberately initi-
ated and sponsored by the court of the Yuan dynasty. This
assertion can be corroborated by several events. In 1279,
the Mongols from the northern steppes conquered China,
establishing the new Yuan regime. Like their Chinese pre-
decessors, the Yuan emperors appreciated the enormous
importance of the ceramics trade as a source of revenue and
adopted a similar, even more ardent enthusiasm for ceramics
production. As early as 1278, a year before they captured
the Southern Song capital, the Mongol forces set up a special
agency in Jingdezhen, the Fuliang Porcelain Bureau (Fu-
liang ciju), to manage porcelain production.[14] Although the
actual workings of this agency remain unclear—whether it
was an official workshop to produce porcelain objects for
court use only, or was charged with supervising the porcelain
business in the whole Jingdezhen area—the agency repre-
sented direct involvement of the imperial court in Jing-
dezhen's porcelain production for the first time in its history.

Among extant *luanbai* wares are quite a few objects
inscribed with the Chinese characters *shu* and *fu*. A good

example is the bowl in the Jinglexuan Collection (pl. 4.5). Its interior wall is decorated with a lotus scroll, amid which the two opposed characters face each other. This inscription marks these objects as a special subgroup of *luanbai* porcelain. *Shufu* stands for Shumi yuan, the Privy Council of the Yuan government in charge of military affairs, which held immense power in the conqueror's regime. Wares bearing the *shufu* mark were therefore special commissions by this government body and were undoubtedly produced under the supervision of the Fuliang Porcelain Bureau. They were also among the highest-quality products from Jingdezhen and expressed the new taste at its best. Perhaps it is not too far-fetched to speculate further that *luanbai* porcelain was invented by the Fuliang Porcelain Bureau.

Much fewer in number but no less important are objects inscribed with the characters *taixi,* an abbreviation for Taixi zongyin yuan, a court palace where portraits of deceased emperors and empresses were installed to receive offerings. One superb *taixi* dish now appropriately resides in the Palace Museum, Beijing, once the Yuan capital.[15] It is richly decorated with molded designs of a five-clawed dragon chasing a pearl in the well, and with a lotus scroll, the Eight Precious Things of Buddhism, and the *taixi* mark around the wall. Obviously, *taixi* wares were utensils employed for sacrificial rituals conducted in that palace. Besides the *taixi* mark, the five-clawed dragon was crucial, for it was a symbol reserved for the emperor, in accordance with Yuan regulations.[16] The five-clawed dragon also appeared on *luanbai* wares lacking any mark, which indicates that the court commissions for *luanbai* wares were broad and large.

Aside from its historical significance, *luanbai* porcelain also embodied a breakthrough in technology. The unique *luanbai* glaze was achieved by deliberately decreasing the amount of calcium oxide, in the form of ash, added to the glaze. It served as a flux to lower the glaze's melting point so that it could fuse with the body during firing. Transparent glaze, like the *qingbai* glaze, usually required 10 percent or more calcium oxide; to achieve the opaque *luanbai* glaze, only 5 percent or so was used. As a result, many quartz particles remain undissolved and suspended in the glaze, thus creating its opacity. Also contributing to this effect were the minute gas bubbles retained in the thick layers of glaze and

PL. 4.5

Angular bowl

Chinese, Yuan dynasty (1279–1368)
Jingdezhen *shufu* ware, porcelain with molded decoration and *shufu* characters
Diam. 4⅝ in. (11.8 cm)
Loan from the Jinglexuan Collection

Bowls with angular, stepped profiles are the commonest forms of *luanbai* wares. The everted rim and sharp angular profile indicate their metalware origins, as does the molded decoration.

the crystals that formed during cooling. Together they make the opaque *luanbai* glaze creamy and matte.[17]

The lower calcium content induced a higher flux temperature for the *luanbai* glaze and consequently required a stronger clay body to withstand the heat. From the late thirteenth century, porcelain stone alone no longer sufficed, owing to its deficient alumina content. To overcome this problem, a new material, kaolin, was deliberately added. Rich in alumina and clay, kaolin increased both the strength and the plasticity of the porcelain body, lowered the warping rate, and successfully accommodated higher firing temperatures to produce harder porcelain. It saved Jingdezhen from its supply crisis and also made *luanbai* porcelain possible. Moreover, objects made of the compound clay (porcelain stone and kaolin) could again be fired in an upright position, as the body was strong and capable of undergoing high firing without warping.[18]

The emergence of *luanbai* porcelain in around the 1320s, in the mid-Yuan period, is substantiated by archaeological fieldwork in Jingdezhen. This information accords with the record in *The Official History of the Yuan Dynasty* (Yuan shi); a chapter on court sacrifices states that in 1321, new types of sacrificial wares different from existing types began to be made in Jiangzhe xingsheng, the area to which Jingdezhen also belonged.[19] With its leadership in porcelain production and the Fuliang Porcelain Bureau well into operation, Jingdezhen surely participated in the project, and the new ware it contributed was probably none other than *luanbai*. As to the reason why the Yuan court wanted this particular white color, with its rich and heavy tone, it is tempting to connect it to the customary belief that the Mongols adored the color white, and to the possible original use of *luanbai* wares as sacrificial utensils.

Finally, though *luanbai* began as an official ware, this did not exclude its use by the common people. On the contrary, the court's strong liking for *luanbai* porcelain must have helped to stir up a desire for this new product, and the trade-minded Mongols evidently encouraged its consumption, particularly as export goods to foreign lands. The shipwreck found off the Sinan coast of Korea has provided a telling example.[20] Datable to 1323, the time when *luanbai* had just been developed, the ship already carried a good many *luanbai* wares in its cargo. *Luanbai,* like *qingbai,* became another popular export ware.

Soon after the Mongols' departure, however, the Chinese discarded *luanbai,* which spoke loudly in a Mongolian voice, and reverted to their native interest in light, translucent porcelain. But it was *qingbai* no more; it was a purer, better porcelain based on the same two-ingredient body material and technology as *luanbai*. In a way, *luanbai* just took on a new appearance.

—J.C.

5

TALE OF A REVOLUTION: THE BRILLIANCE OF BLUE-AND-WHITE PORCELAIN

During the first half of the fourteenth century, when China was under Mongol rule, an artistic and economic revolution took place at Jingdezhen, the center of porcelain production in south-central China. Suddenly, brilliantly painted designs in cobalt blue transformed porcelain production forever. Outnumbering the pale blue and soft white monochrome porcelains so popular in China in earlier centuries, famed blue-and-white rapidly took hold and was, from the outset, in high demand in foreign markets. The translucent, white porcelain body provided a perfect ground for striking painted designs of deep cobalt blue. This stunning contrast had universal appeal. Blue-and-white ware dominated ceramics trade throughout the world until the eighteenth century, when European potters discovered how to produce a true porcelain body.

THE CONTEXT FOR BLUE-AND-WHITE

The fourteenth century marks a significant aesthetic redirection because ever afterward, the art of ornament, especially painting, figured prominently in porcelain production.[1] Several factors stimulated this remarkable change.

First, Mongol rule (Yuan dynasty, 1279–1368) incorporated China into a vast empire that stretched westward to the Black Sea, from Russia to the Pacific, facilitating travel, trade, and the exchange of ideas. In contrast to the Song dynasty (960–1279), when scholar-officials were privileged, the Yuan dynasty favored influential foreigners who traded and resided in China, particularly Arabs and Persians. Chinese scholar-officials preferred subtle, understated monochromes, but Middle Eastern markets avidly sought bold, brilliantly painted porcelains. The Mongol rulers' desire for increased revenues from exports such as ceramics, the Chinese monopoly of porcelain technology, and the presence of wealthy foreign merchants all gave impetus to the sudden

appearance and rapid development of Chinese blue-and-white porcelain.

Chinese ceramics history has precedents for painting on ceramic surfaces. As far back as the Six Dynasties period (220–589), Chinese potters periodically experimented with the use of color on a stoneware body. Stonewares, especially Changsha ware of the Tang dynasty (618–906) and Cizhou ware of the Song dynasty (960–1279), are celebrated for their painting in or under the glaze.

Precedents also exist for painting on a porcelain body. In 1975, archaeological excavations of the Tang city of Yangzhou revealed an intriguing forerunner of later blue-and-white. In the ninth and tenth centuries, or late Tang period, Chinese potters working at the Gongxian kilns in North China experimented by painting with imported cobalt on a high-fired, white porcelain body. Middle Eastern markets, familiar with the rich blues, most likely provided the cobalt and inspired the innovation, but for reasons unknown, the use of cobalt blue did not take hold in the Tang dynasty and suddenly disappeared. Despite this and other periodic experiments, there seems to be no direct connection between earlier use of cobalt and Jingdezhen blue-and-white of the fourteenth century. Unless more conclusive material comes to light, it seems that fourteenth-century blue-and-white was a sudden new discovery rather than part of a long and continuous development.[2]

In the fourteenth century, as in the late Tang period, Chinese potters used imported cobalt pigment. The Middle East already knew what splendid blues could be achieved by using cobalt as a colorant in glass and as a pigment to paint colorful underglaze designs on low-fired, tin-glazed ceramics.[3] Yet the Middle East produced only a low-grade ceramic body. Thus the idea of using Persian cobalt to decorate Chinese porcelain—hard, durable, and pure white—held great

PL. 5.1

Dish

Chinese, Yuan dynasty, 14th century
Jingdezhen ware, porcelain painted in underglaze cobalt blue
Diam. 18½ in. (47 cm)
Purchased in memory of Elizabeth M. Fuller with funds from the
Elizabeth M. Fuller Memorial Fund and the Edwin and Catherine M.
Davis Foundation, 76.7

With the Middle Eastern market in mind, fourteenth-century
Jingdezhen potters used clay molds to produce these large plates.
Their massive size and form suited Middle Eastern and Indian
eating customs, by which guests dined communally from such
dishes. Molds made possible the mass production of dishes of
uniform size and design. This plate masterfully integrates the
two decorative techniques of molding and painting.

Curiously, all the peonies in the well are solid white against
a background of dense blue lines, except for one capricious de-
tail where the painter playfully outlined the sepal of a flower.[4]

economic and artistic promise that was quickly realized. Foreign markets, and foreigners in China residing at southern ports such as Quanzhou, at the Mongol capital of Dadu (today's Beijing), or at Jingdezhen itself, played a significant role in stimulating the production of blue-and-white porcelain in China. In fact, foreigners outnumbered Chinese in the Imperial Bureau of Manufactures (Jiangzuo yuan), the government agency that had jurisdiction over porcelain, textiles, and other luxuries.[5]

Foreign and Domestic Markets

To what extent did foreign markets impact style and form? Muslim patrons' aesthetic preferences for rich, densely patterned surfaces and large forms strongly influenced many fourteenth-century blue-and-white porcelains. Two magnificent large blue-and-white dishes (pls. 5.1, 1.6) display ornamental schemes that were appreciated in the Middle East.

The dish in the Jinglexuan Collection (see pl. 1.6), reserved in white against a dark blue ground, features a star-shaped medallion. The mathematical multiplication of this motif, so precisely spaced and so beautifully painted, and the enrichment of the entire surface, suggesting *horror vacui,* is startlingly new in Chinese ceramics. The Seattle plate (pl. 5.1), which combines molding and painting, features at its center a lush garden with preening peacocks and sinuous plants, a scene reminiscent of Persian miniatures and textiles.[6] This cross-cultural interaction between the great artistic traditions of China and the Middle East during the Mongol era not only resulted in the flourishing of blue-and-white but also shaped ceramics traditions throughout the world.[7]

Although foreign markets were primary, and in the fourteenth century, the bulk of blue-and-white ware was exported, it was also made for the domestic Chinese market, where it received mixed reactions. The early-Ming connoisseur's manual *Gegu yaolun,* dated 1388, praises monochrome Raozhou or Jingdezhen porcelain, and then notes, "the blue-and-white (*qinghua*) and the multi-colored (*wuse*) specimens are vulgar in taste."[8] To Chinese connoisseurs who appreciated subtle Song monochromes, blue-and-white appeared garish and alien.

Nevertheless, evidence suggests that a significant amount of blue-and-white was made for the domestic market even in the Yuan period. The famed pair of monumental blue-and-white vases (fig. 1) in the collection of the Percival David Foundation collection, London, bear inscriptions dated 1351, which state that they were commissioned for a local temple and thus were intended for domestic consumption.[9] Blue-and-white porcelains of more modest scale, like the superbly molded and painted stem cup (pl. 5.2), were also produced for the Chinese, either for drinking wine or for ceremonial uses, to adorn domestic altars and shrines.[10]

Early Ming Porcelain for the Imperial Court

In 1352, the Mongols lost control of Jingdezhen, and in 1368, the Yuan dynasty fell, marking the end of Mongol rule and heralding the restoration of Chinese rule and the Ming dynasty (1368–1644). While the fifteenth century would mark a peak in porcelain production, the second half of the fourteenth century was a time of recovery from the destruction, disruption of production, and diminished patronage that had accompanied dynastic change. Private trade was severely

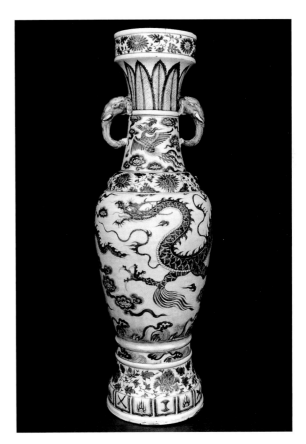

FIG. 1. This vase, dated 1351, and its identical mate provide a vocabulary of blue-and-white ornament in the middle of the 14th century. London, Percival David Foundation of Chinese Art.

curtailed, thus posing difficulties for the exporting of porcelain and the importing of Persian cobalt.[11]

Although dates in local records differ, evidence suggests that in 1369, just one year after the founding of the Ming (Bright) dynasty, the Hongwu emperor (1368–1398) established official porcelain kilns at Zhushan (Pearl Hill), in Jingdezhen, to provide porcelain ordered and used exclusively by the imperial court. In 1278, the Mongols had set up in Jingdezhen the Fuliang Porcelain Bureau, part of the Imperial Bureau of Manufactures, which supervised the production of porcelain for the imperial court. In the Ming dynasty, however, this relationship between the imperial court and the Jingdezhen porcelain industry intensified and became more firmly structured.[12]

Keen to establish the legitimacy of his rule, the Hongwu emperor issued directives concerning rites, ceremonies, and sacrifices to Heaven and to ancestors. Complying with rules established in high antiquity that sacrificial vessels be made of clay or gourds, he rejected gold, silver, and bronze for ceremonial use. He ordered that all sacrificial vessels be made of porcelain; the precise types of porcelain vessels to be used in rites and ceremonies were clearly prescribed.[13]

The early Ming potters working at Jingdezhen produced a significant quantity of porcelain painted in underglaze copper red, including this fine *kendi,* a water vessel popular in Southeast Asia (pl. 5.3). Late fourteenth-century porcelain decorated in underglaze copper red outnumbered wares with underglaze cobalt blue. The shift to copper-red pigment for underglaze painting appears to have been motivated by multiple factors, including the desire of the first Ming emperor to break with the immediate past and assert the Chinese character of the new dynasty. Other factors are the auspicious associations of the color red and the fact that the emperor's family name, Zhu, signifies 'red.' The shortage of imported cobalt at a time of prohibitions on foreign trade may also have encouraged the use of more readily available copper. A combination of these factors may well explain the new prominence of copper red in the Hongwu reign.[14]

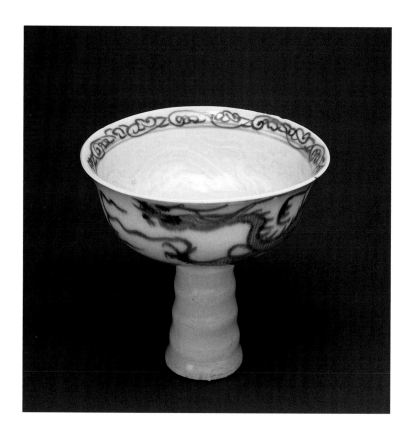

PL. 5.2

Stem cup

Chinese, Yuan dynasty, c. 1330–50
Jingdezhen ware, porcelain painted in underglaze cobalt blue with molded decoration
H. 4 in. (10.2 cm)
Loan from the Jinglexuan Collection

This vessel has two four-clawed dragons molded on the interior of the cup; a single three-clawed dragon chasing a flaming pearl, painted in underglaze blue, encircles the exterior. *The Official History of the Yuan Dynasty* (Yuan shi) documents the 1336 prohibition against the use of five-clawed dragons, which were reserved exclusively for the emperor.[15] Thus, with the exception of *shufu* (official) wares made for court use, Yuan porcelain is ornamented with three- and four-clawed dragons.[16] Not only the masterful combination of molding and painting but also the rapid, cursive brushwork of the exterior dragon distinguishes this superb stem cup.[17]

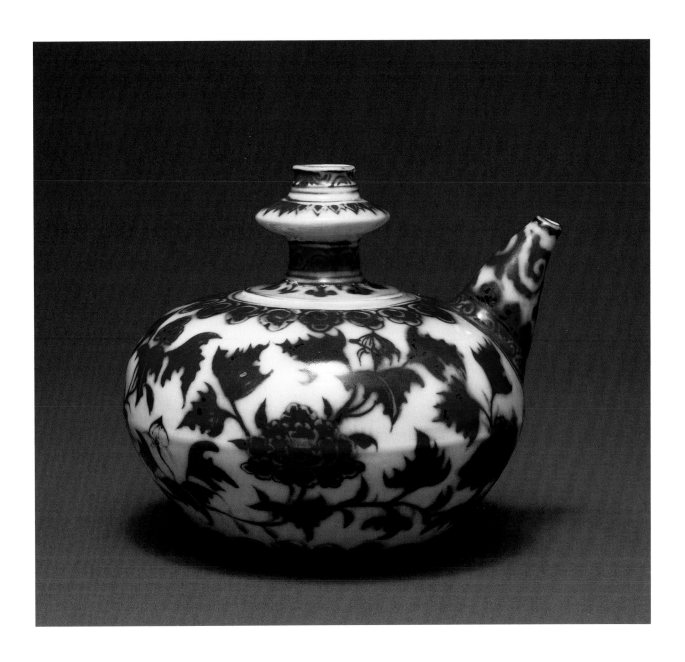

PL. 5.3

Kendi

Chinese, Ming dynasty, Hongwu period (1368–1398)
Jingdezhen ware, porcelain painted in underglaze copper red
H. 6½ in. (16.5 cm)
Loan from the Jinglexuan Collection

Only three metallic oxides—iron, cobalt, and copper—can with-stand the high temperatures at which porcelain is fired. Iron was rarely used on porcelain, presumably because it produces a brown color that dulls on a bright white surface and has limited appeal. Cobalt and copper fire to brilliant blue and deep red, respectively. These pigments are painted directly on the formed but unfired white porcelain body and covered with a transparent glaze; the piece is then fired once to high temperatures, often significantly higher than 1250°C. Cobalt is relatively predictable, and the viscosity of Jingdezhen glazes enabled good control. But underglaze copper red in a reduction firing tends to diffuse and turn gray. Thus the intense warm red of this *kendi* is rare and highly prized. One major advance of Hongwu's reign was the first systematic production of underglaze-red and monochrome-red porcelain, an achievement that would be taken to even greater heights in the first half of the fifteenth century.[18]

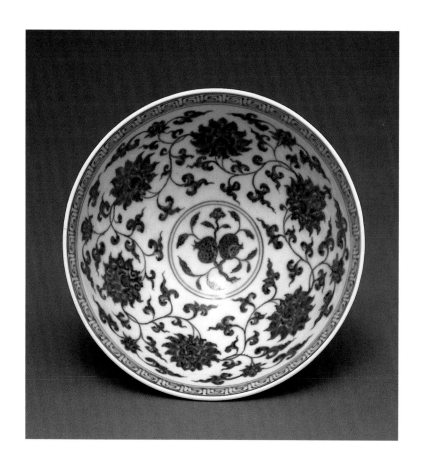

Reign marks, which bear the name of the emperor during whose rule an object was made, first appear on Chinese porcelain in the early fifteenth century and denote an elevated status for ceramics.[19] This bowl with sweeping lotus scrolls on its interior and double rows of lotus petals on the exterior has an imperial reign mark, *da Ming Xuande nianzhi* (made in the years of Xuande of the great Ming), painted in underglaze blue on its base. The much-admired court calligrapher Shen Du (1357–1434) appears to have established the style of early fifteenth-century imperial reign marks, reflecting the high status of these imperial wares and the close connection between the imperial court and the official kilns at Jingdezhen at that time.[20]

The Classic Age of Blue-and-White

In accord with the reestablishment of Chinese rule and the increasing importance of the domestic market, underglaze-painted porcelain of the late fourteenth and early fifteenth centuries came increasingly to reflect Chinese aesthetic preferences. Instead of the multiple bands of dense ornamentation prominent in the mid-fourteenth century and so popular in the Middle East, now imperial symbols, such as the dragon and the phoenix, and floral subjects occupy a broad, open field (pl. 5.4). The generous use of the white porcelain ground, masterful control of pigments, precision of the painting, and harmony of design and form distinguish porcelain of the fifteenth century, the classic age of Chinese blue-and-white.

Porcelain attained excellence in the early fifteenth century. The reigns of the Yongle (1403–1424) and Xuande (1426–1435) emperors were peaceful and prosperous; porcelain technology, materials, and process continued to improve; and in addition to foreign markets, imperial patronage was constant and substantial. These early Ming emperors demanded high quality, and the character, taste, and interests of each emperor had direct impact on porcelain production.

One of the most famous imperial projects of the period was the porcelain Buddhist pagoda known as Bao'ensi (fig. 2), which ranked as one of the seven wonders of the medieval world. Begun in 1412 and completed in 1419, it was built by the Yongle emperor at Jubaoshan, on the outskirts of Nanjing, to honor his deceased parents. (It endured until 1854.) Bao'ensi was faced with white porcelain bricks produced in Jingdezhen.[21] This project, as well as the imperial court's sizable orders for monochrome-white porcelain vessels for use in Buddhist and Confucian rituals and as gifts to foreign dignitaries, placed a high demand on Jingdezhen, one that would only increase in succeeding reigns. In 1393, the imperial order for porcelain numbered 10,000 pieces; however, by 1433, the eighth year of the Xuande emperor's reign, 443,500 pieces of porcelain were produced for the imperial court.[22]

The Yongle emperor, a patron of Buddhism, had favored monochrome-white ware, known as "sweet white ware."[23] The Xuande emperor favored blue-and-white and monochrome red. Xuande, a celebrated statesman, painter, poet, and art patron, oversaw the rebirth of the Imperial Painting Academy.[24] The academic tradition of court painting stimulated artistic excellence; the imperial design office commissioned professional artists to create drawings to be used in the decoration of imperial wares. In imperial porcelain, as in the painting style of the imperial court, the personal preference of the emperor prevailed.[25] Thus, during the Xuande emperor's reign, blue-and-white porcelain was officially accepted as an imperial ware, complete with official reign mark of four or six characters (pls. 5.4, 5.5).

Early fifteenth-century blue-and-white, and specifically porcelain produced during the Xuande reign, is distinguished by a sense of order, perfect balance, and spaciousness. The imported cobalt produced a glaze with softness and depth, combining deep blue and small spots of black. For example, the lotus blossoms painted inside the bowl (pl. 5.4) in underglaze blue have soft edges, with the white of the porcelain,

FIG. 2. Bao'ensi. After *Haiguan baogao* (Customs Report), 19th century. Reproduced in *Jinling da Bao'ensi da zhi* (Record of the Bao'ensi Pagoda at Jinling), 1937.

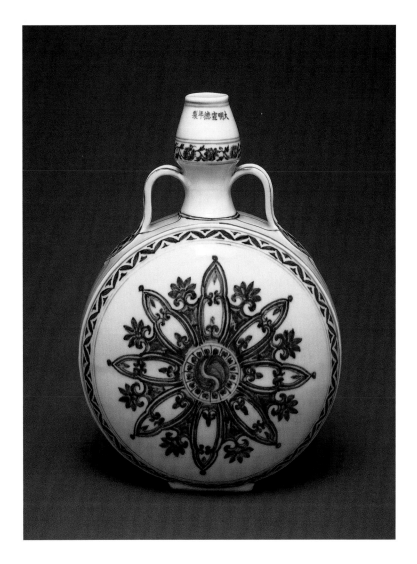

PL. 5.5

Flask

Chinese, Ming dynasty, Xuande reign mark and period (1426–1435)
Jingdezhen ware, porcelain painted in underglaze cobalt blue
H. 11½ in (29.2 cm)
Eugene Fuller Memorial Collection, 48.167

This flask is evidence of a continuing dialogue between the Middle Eastern and Chinese aesthetic traditions. In the early fifteenth century, the volume of overseas trade was significant, and Arabs were prominent in China, acting as interpreters for diplomats and traders as well as overseeing observatories.

Not only the form of this flask but also the interlaced floral medallion is Islamic in origin. In addition to the imperial reign mark just below the lip, the slight blue tint of the transparent glaze and dark "heaped and piled" cobalt bespeak the Xuande period.

not graded wash, defining the interior petals. And the imported cobalt precipitates through the glaze, creating dark spots, a celebrated effect known as "heaped and piled." In later centuries, potters often emulated early Ming blue-and-white, trying to re-create this effect. The mastery of execution and the superb integration of form and design distinguish early fifteenth-century blue-and-white.

Innovation and Changing Styles

In the years 1435 to 1465, from Xuande's death to the beginning of the Chenghua emperor's reign, imperial porcelains with reign marks were rarely made. A rapid succession of three ineffectual emperors, factional wars within the palace, and civil war resulted in a period of instability often referred to as the Interregnum. Just as in the seventeenth century, the absence of strong imperial patronage liberated Jingdezhen potters to explore new directions.

Popular in this turbulent era were freely painted figurative scenes in simple landscape settings, such as the two conversing scholars, framed by clouds, depicted on the handsome *meiping* (prunus vase; pl. 5.6). These figures have interesting parallels in contemporary Ming professional painting, although the painting on ceramics is more summary and less detailed than two-dimensional counterparts.[26] A sense of freedom, a desire to break away from strict imperial dictates, pervades mid-fifteenth-century porcelain. In 1465, however, political stability was restored when the Chenghua emperor assumed the throne and imperial taste was reimposed.

The reign of the Chenghua emperor (1465–1487) is known for the refinement of its porcelain. Though the emperor restored stability, he surrounded himself not with high-minded officials, but rather with concubines and servant-eunuchs whose families benefited substantially, setting a dangerous precedent for his successors.[27] Members of the imperial court, especially powerful eunuchs, increasingly controlled the porcelain industry and thereby achieved personal gain.

In 1468, the imperial kilns at Jingdezhen began work for the new emperor and his court, producing porcelain that Chinese connoisseurs rank highly, even above those of the early fifteenth century.[28] In later centuries, Chenghua imperial porcelain was the most widely acclaimed, the most expensive, and not surprisingly, the most frequently copied, including the imperial reign mark.

Throughout the Chenghua reign, the official kilns were held to exacting standards, and all but the best porcelain was discarded. The style of painting, especially on porcelain produced during the latter half of Chenghua's reign, is highly refined, different in character from Xuande imperial porcelain. Xuande imperial blue-and-white is robust and strong, the cobalt blue "heaped and piled" (see pls. 5.4, 5.5), whereas Chenghua imperial blue-and-white is light and delicate, the designs first outlined in underglaze blue and then filled in with graded washes ranging from medium to light blue (pl. 5.7).

A significant change is also evident in the choice and refinement of materials. The porcelain body is whiter, the glaze smoother and glossier. In addition, for the first time, the pigment includes the less intense blue of native cobalt, which creates a light feeling of "soft elegance," to borrow the words of archaeologist and ceramics expert Liu Xinyuan.[29] Whether the emperor was personally responsible for this artful change, or whether it was due to the influence of Wan Guifei, the powerful concubine who dominated the imperial court throughout the Chenghua reign, is matter of debate among Chinese ceramics specialists. Whoever set the standards, control was rigorous, and flawed pieces, produced for imperial court use but not selected, were pierced, smashed, and buried, not resold as in later times.[30] The quantity of discarded shards suggests that while huge amounts of porcelain were produced, only a small percentage was deemed suitable for imperial use.

One of the most celebrated artistic achievements of Chenghua's reign was the perfecting of a painting technique well suited to the imperial aesthetic. The process of *doucai,* 'interlocked' or 'joined' colors, consists of first outlining the design in cobalt blue, then glazing and firing. The cobalt outlines are filled in over the glaze with polychrome enamels, and the piece is fired a second time at a lower temperature (pl. 5.8). One credible theory suggests that the inspiration for *doucai* came from cloisonné, the technique of enameling on bronze, in which copper wires outline areas that are filled in with enamel colors.[31] Excavations at Jingdezhen have demonstrated that the *doucai* technique originated in the Xuande reign but attained the height of its refinement during the Chenghua period in the late fifteenth century.

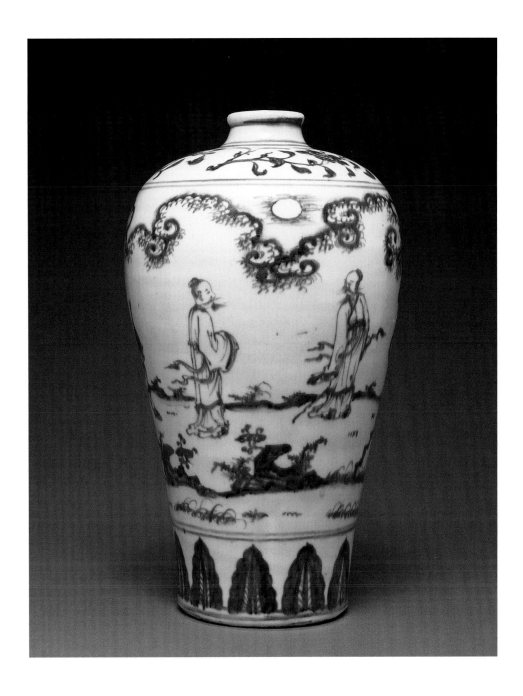

PL. 5.6

Vase

Chinese, Ming dynasty, 1436–64
Jingdezhen ware, porcelain painted in underglaze cobalt blue
H. 13¼ in. (33.7 cm)
Margaret E. Fuller Purchase Fund, 69.80

Typical of mid-fifteenth-century porcelain, this handsome *meiping* (prunus vase) has a fresh painting style with whimsical curling clouds setting off pictorial elements, such as the two scholars with flying sashes engaged in animated conversation

and, on the opposite side, a monumental pine tree. While the vase can be placed securely in the mid-fifteenth century, more precise dating is difficult because it lacks an imperial reign mark.[32]

Mid-fifteenth-century Ming blue-and-white exhibits spontaneity and charm. By contrast, the imperial wares that preceded and followed it may be closer to technical perfection, but they obey rigid rules and follow set patterns. Imperial patronage guaranteed excellence but also dictated style.

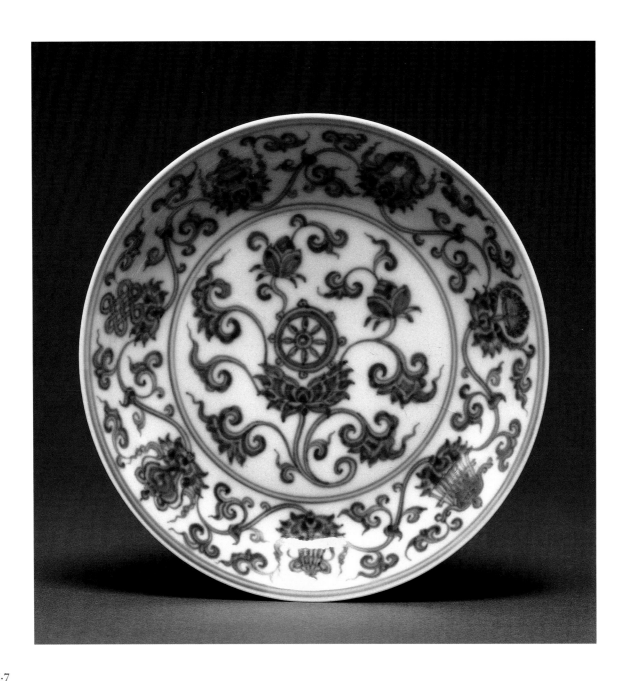

PL. 5.7

Dish

Chinese, Ming dynasty, Chenghua reign mark and period, 1481–87
Jingdezhen ware, porcelain painted in underglaze cobalt blue
Diam. 7½ in. (19 cm)
Eugene Fuller Memorial Collection, 51.85

A superb example of late fifteenth-century blue-and-white, this dish features the eight auspicious emblems derived from esoteric Tibetan Buddhism. In the center, fanciful lotus buds and tendrils gracefully surround a lotus holding the Wheel of the Law, while the remaining seven emblems—conch shell, canopy, umbrella, flower, fish, vase, and endless knot—linked by tendrils, embellish the well and the exterior of the dish. The perfection of Chenghua porcelain is evident in the thin white body, the smooth glaze, and the clarity and control of the graded blue washes.[33]

In the later years of his life, the Chenghua emperor, increasingly preoccupied with Buddhism, dressed in Buddhist robes for the performance of religious ceremonies. A large group of Chenghua porcelain with Buddhist symbols and Sanskrit and Tibetan inscriptions was found near the imperial Ming kilns.[34]

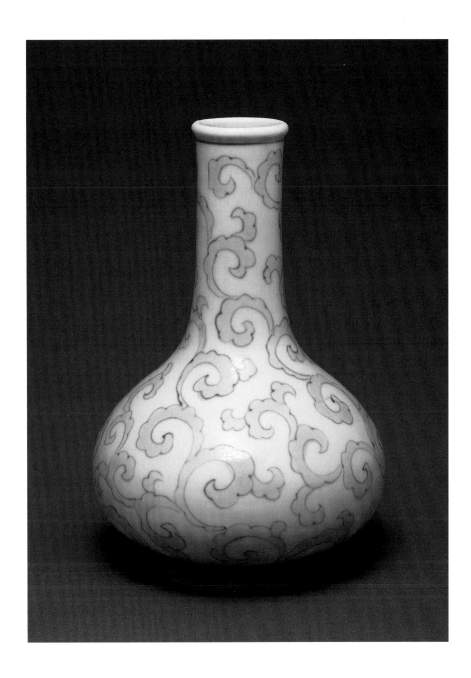

PL. 5.8

Vase

Chinese, attrib. Ming dynasty, Chenghua reign mark
and period, 1481–87
Jingdezhen ware, porcelain painted in *doucai* style
H. 7¼ in. (18.4 cm)
Eugene Fuller Memorial Collection, 51.89

Chenghua porcelain has long been the focus of collectors and connoisseurs. Late sixteenth-century texts record that it was valued more highly than Xuande wares. The substantial amount of silver—hundreds of thousands of taels for a single piece of Chenghua porcelain—made it well worth the effort to copy or even to create new types of "Chenghua" porcelain in later centuries. Is this tall-necked *doucai* vase a product of the imperial kilns of the late fifteenth century? Or is it a later porcelain intended to fool the unknowing and fetch a healthy price on the market? The fact that shards with this distinctive pattern have not yet been found in Chenghua strata at Zhushan, Jingdezhen, is curious. The fascinating connoisseurship problem surrounding this and related porcelain, all bearing Chenghua reign marks, remains the subject of lively debate.[35]

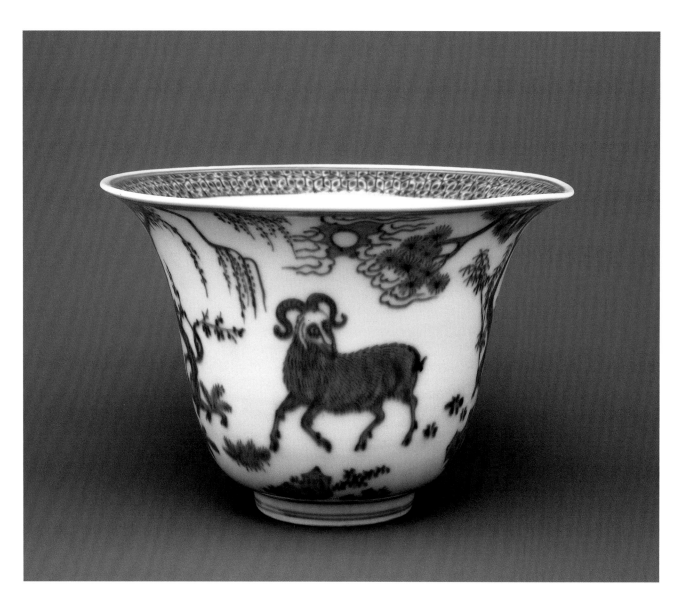

PL. 5.9

Bowl

Chinese, Ming dynasty, Jiajing reign mark and period (1522–1566)
Jingdezhen ware, porcelain painted in underglaze cobalt blue
Diam. 6⅜ in. (16.2 cm)
Eugene Fuller Memorial Collection, 48.163

New directions in sixteenth-century porcelain included a grow-ing interest in designs conveying auspicious messages, especially during Jiajing's reign, as the emperor was an ardent Daoist. The three goats and three suns, and the Three Friends of the Cold Season, painted in vibrant blue on the exterior of this bowl, carry a message of renewal appropriate to the beginning of the new year. The three suns and three goats, which are homophones (*yang*), form a rebus referring to a phrase from the *I Ching* (The

Book of Changes): "The first month of the year is the Tai Gua (Trigram of Tai) after which the three suns rise." Winter ends and spring arrives, *yin* is on the wane and *yang* is on the rise, thus heralding the rebirth of nature.[36] The Three Friends of the Cold Season, announcing the coming of spring, reinforce this auspicious message.[37] This bowl, with its attractive bell shape and brilliant purplish-blue decoration, embodies the strength and charm of finer sixteenth-century porcelain. This intense hue suggests the use of imported cobalt, "Mohammedan blue," brought into China via Turfan. During the Jiajing reign, foreign cobalt was often mixed with small quantities of native cobalt (*shizi*) to prevent the blue from running.

Demand and Supply at Jingdezhen

The sixteenth century witnessed both dynastic decline and the growth of a vibrant market economy. Eunuchs held undue power, weak emperors occupied the throne, and court extravagances as well as the maintenance of a large military force depleted the treasury, forcing higher taxes and hardship on the common people. At the same time, however, major social and economic changes were also taking hold. Porcelain and silk were traded abroad for silver, cities and towns burgeoned, trade and consumerism flourished, and the new Single Whip tax enabled people such as porcelain specialists to make an annual cash payment to the government in lieu of yearly periods of required service or corvée labor.[38] This change in taxation enabled highly skilled craftsmen to hire out on a permanent basis. These and other rapid developments impacted the porcelain industry, specifically the official kilns.

The extravagances of the court, particularly the emperors' and eunuchs' love of personal luxury, stimulated large orders for the official kilns at Jingdezhen. It proved impossible, however, to maintain the exacting standards of fifteenth-century imperial porcelains, particularly those produced during the Xuande and Chenghua reigns, when the emperors appear to have taken personal interest in the porcelain industry. To produce the finest-quality porcelain required unlimited time and expense, and the discarding of a large percentage of flawed, inferior products. For the sixteenth-century superintendents of the kilns, whether eunuchs or subprefects, cost control was a serious concern, as they were responsible for providing funding and supplying manpower because the imperial treasury was depleted.

In the sixteenth century, the court placed huge quantitative demands on Jingdezhen. For example, during the forty-four years of the Jiajing emperor's reign (1522–1566), more than 600,000 porcelains were made at Jingdezhen for use by the court.[39] To keep up with the insatiable demand, some imperial porcelain was contracted out to privately owned or commercial kilns, which were able to produce larger quantities in each kiln firing and at lower prices than were the government kilns.[40] Sixteenth-century porcelains —a good example is the handsome blue-and-white bowl (pl. 5.9) with a Jiajing imperial reign mark—often feature rebuses, auspicious symbols, and the plants known as the

Three Friends of the Cold Season (pine, blossoming plum, and bamboo), ubiquitous motifs in late Ming popular culture.

The imperial tradition of Ming blue-and-white porcelain continued well into the reign of the Wanli emperor (1573–1619). Unrest occurred at Jingdezhen in the early seventeenth century; overworked potters set fire to the official kilns to protest corrupt, greedy eunuchs. Nevertheless, official and contracted private kilns were prolific, filling imperial orders for massive quantities of porcelain, both blue-and-white and colorful polychrome overglaze enamels dominated by lively designs of writhing dragons and soaring, long-tailed phoenixes, symbols of emperor and empress (pls. 5.10, 5.11). In contrast to the generous use of white space and lucid, controlled designs of fifteenth-century blue-and-white, the porcelain of the sixteenth century evolved into exuberant overall patterning that has its own charm.

Dynastic Decline and New Markets

The use of inferior clay, glaze, and pigment as well as the hurried spontaneity of the painters reflects the decline in Ming imperial patronage and consequently in the quality of late Ming imperial blue-and-white porcelain. Perhaps as early as 1608, and certainly no later than 1620, the official government kilns were closed down.[41] Yet many private or commercial kilns at Jingdezhen, not burdened by imperial dictates and stimulated by healthy export and domestic markets, continued to satisfy the growing demand at home and abroad and to explore a broad range of new shapes, styles, and ornament. As socioeconomic changes transformed China and trade with Asia and Europe opened up, energy and vitality fueled the porcelain industry, heralding a new era of creativity and technical brilliance.

The revolution was complete, and the art of ornament was ever after integral to the art of porcelain in Europe and Asia. The story of blue-and-white was just beginning.

— M.G.G.

Brush rest and lobed box

Chinese, Ming dynasty, Wanli reign mark and period (1573–1619)
Jingdezhen ware, porcelain painted in underglaze cobalt blue
Brush rest: h. 4¼ in. (10.8 cm)
Box: h. 3 in. (7.6 cm)
Eugene Fuller Memorial Collection, 51.86, 51.87

In 1593, the imperial court ordered 500 brush rests in openwork with three dragons among mountains. The molded brush rest in the form of five intertwined five-clawed dragons atop mountain peaks would have offered a colorful and convenient resting spot for an ink-loaded brush.[42]

Less evident is the precise function of the lobed box, decorated with a design of phoenixes painted in deep Mohammedan blue. In the late Ming, such blue-and-white or polychrome porcelains were very popular enhancements for the desks of scholar-officials or eunuchs at the imperial court.

Vase

Chinese, Ming dynasty, Wanli reign mark and period (1573–1619)
Jingdezhen ware, porcelain painted in underglaze cobalt blue
H. 22½ in. (57.2 cm)
Eugene Fuller Memorial Collection, 54.120

In the late Ming period, potters also created a wide range of novel shapes evoking ancient forms and ornament. This vase is based on an ancient bronze wine vessel, or *zun,* of the late Shang to early Zhou period (12th–10th century B.C.), but its lower half, unlike its bronze prototype, is elongated. The leonine animal heads with bovine horns also allude to the *zun.* This archaistic vase is formed of slabs of porcelain luted together before being painted, glazed, and fired. The ubiquitous Wanli-period design features opposed five-clawed dragons set against floral sprays in molded relief, which was then painted.[43]

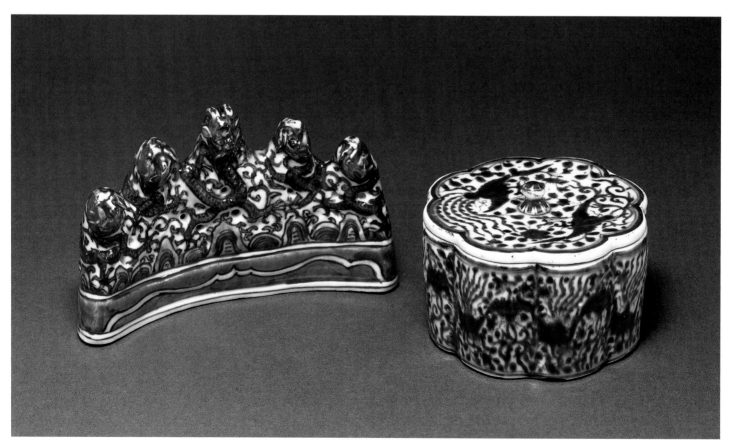

PL. 5.10

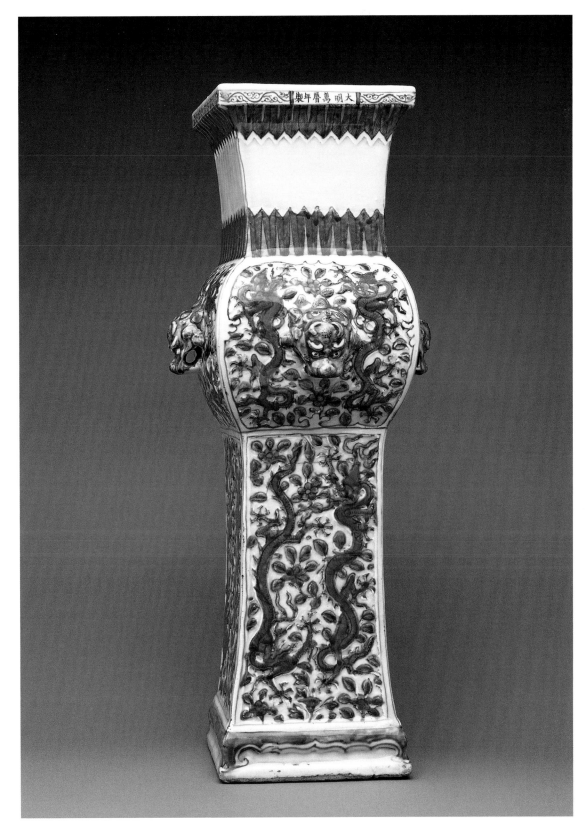

PL. 5.II

Early Porcelain Trade

6

BRIGHT DAWN OF THE PORCELAIN TRADE: WHITE AND QINGBAI

The romance of trade began with the desire to possess things made only in other lands—over the mountains, across the waters, all for exotic legendary treasures. International trade between the East and the West made one such story, properly dramatic with perilous trials—camel caravans and desert sand, ships and tempestuous seas. Chinese silk was the first such desire. By the late second century B.C., this fabric had linked the world's three great lands: China in the east, Parthian Iran in the middle, and Italy in the Mediterranean, a distance of more than 7000 kilometers. This trade route, the Silk Road, was traveled for a thousand years. It consisted of a vast network of trading centers where hosts of varied goods from different regions were exchanged. Diverse cultural ideas and artistic styles traveled along with these goods. Many of these trading centers consequently became prosperous cities and leading centers of culture, art, and scholarship. Capital cities of the ninth century, such as Chang'an of Tang China, Baghdad of the Abbasid Islamic empire, and Constantinople of the Byzantine Empire, are but a few outstanding examples.

From Land Roads to Sea Routes
During the ninth century, however, the Silk Road began to yield to maritime routes that already existed by the first century B.C. but which had never been able to challenge the dominance of the land route.[1] This major shift occurred partly because of the great loss of Tang power resulting from a bloody civil war, and China's consequent inability to safeguard the land route through Central Asia's regions. In addition, maritime trade had become more economical as knowledge of navigation accumulated through the ages, and improved seafaring ships attained far greater speed and capacity than any kind of land transport. Via the sea routes, Chinese goods were destined for Korea and Japan,

the archipelagoes in Southeast Asia, India, the Persian Gulf, the Red Sea areas of west Asia, and as far as Egypt in Africa.

Earlier in the seventh century, the Tang court had established the first Shipo si (Office of Maritime Trade) in Guangzhou near the southern border of China.[2] This office continued to operate throughout the Tang period (618–906), and its main responsibility was to procure foreign aromatics, spices, and gems that were fashionable in the luxurious lifestyle of Tang elite society. When the Song dynasty was founded in the late tenth century, the Office of Maritime Trade was greatly expanded and extended to three additional port cities along the coastline, Ningbo and Hangzhou in Zhejiang province and Quanzhou in Fujian province.

The reason for such expansion was the growing scope of trade and the importance of tax revenues collected from trading activities to finance the Song court. In addition to its traditional responsibility of securing supplies of precious goods for the imperial household, the Office of Maritime Trade in the Song dynasty administered licensing, customs duties, tributaries, taxing and sales, and even managed ritual ceremonies deemed conducive to trade as well as hospitality to attract more foreign traders.[3]

The Song regulations were subsequently improved and better enforced by the Mongols, who were most enthusiastic in encouraging trade. The Office of Maritime Trade eventually had jurisdiction over seven ports. The eager participation of the Song and Yuan governments stimulated and ensured the great expansion and prosperity of China's maritime trade from the tenth to the fourteenth century. Under their auspices, the trading network was expanded to include a good many regions. Contemporary records such as *Zhufan zhi* (Record of Various Barbarians) of 1225, by Zhao Rushi, mention about fifty-eight countries or regions of which fifteen

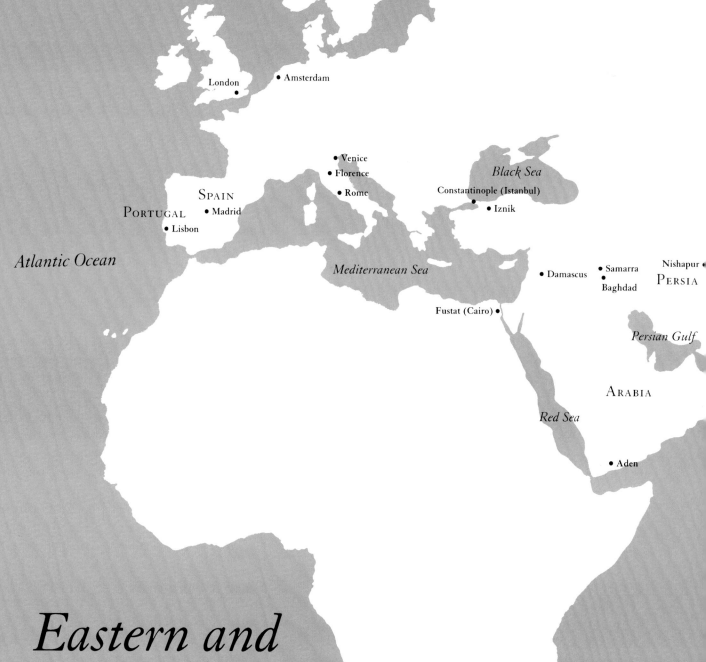

London
Amsterdam

Venice
Florence
Rome
Black Sea
Constantinople (Istanbul)
Iznik

SPAIN
PORTUGAL
Madrid
Lisbon

Atlantic Ocean

Mediterranean Sea

Damascus
Samarra
Baghdad
Nishapur
PERSIA

Fustat (Cairo)

Persian Gulf

ARABIA

Red Sea

Aden

Eastern and Western Trading Sites

Cape of Good Hope

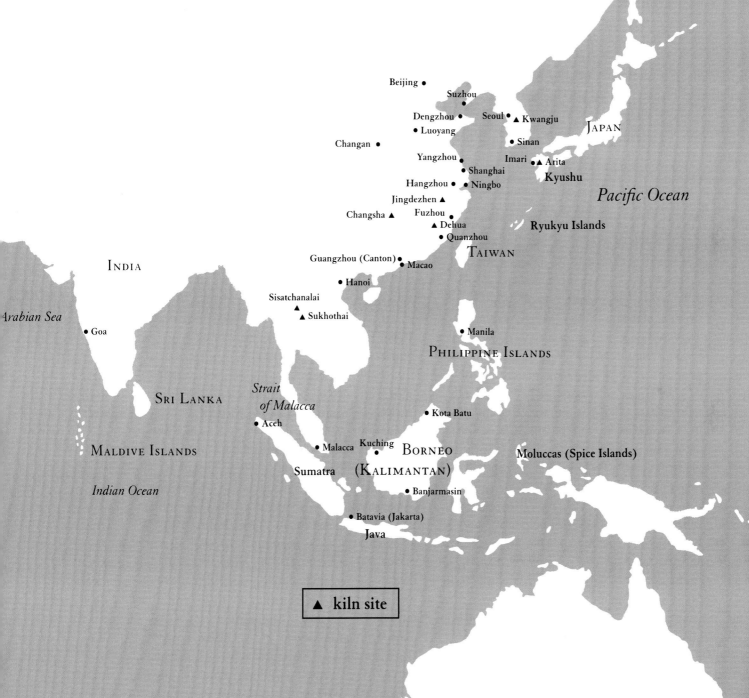

Beijing ●

Suzhou ●

Dengzhou ● Seoul ● ▲ Kwangju JAPAN

● Luoyang Sinan ●

Changan ●

Yangzhou ● Imari ● ▲ Arita

Shanghai ● Kyushu

Hangzhou ● ● Ningbo *Pacific Ocean*

Jingdezhen ▲

Changsha ▲ Fuzhou ● *Ryukyu Islands*

▲ Dehua

● Quanzhou

Guangzhou (Canton) ● TAIWAN

● Macao

INDIA ● Hanoi

Arabian Sea Sisatchanalai ▲

▲ Sukhothai

● Goa ● Manila

PHILIPPINE ISLANDS

SRI LANKA *Strait of Malacca*

● Aceh

MALDIVE ISLANDS ● Kota Batu

Indian Ocean ● Malacca Kuching BORNEO

● Moluccas (Spice Islands)

Sumatra (KALIMANTAN)

● Banjarmasin

● Batavia (Jakarta)

Java

▲ kiln site

had traded with Song China in porcelain and stoneware. The number increased to ninety-nine, with forty-four countries importing Yuan Chinese ceramics in *Daoyi zhilue* (A Brief Description of Island Foreigners) of 1349, by Wang Dayuan. Trading volume thus dramatically increased, as did the percentage of trade taxation in the imperial revenues. By the early Southern Song, in the mid-twelfth century, trade taxation reached more than 15 percent of the total national taxation, doubling the percentage in early Northern Song. A study of national taxation in the year 1289 reveals that trade taxation accounted for more than one-sixth of the national revenues of the Yuan government.[4]

China's International Ceramics Trade

The story of ceramics trade unfolded largely along the maritime routes. Coinciding with the major shift to maritime trade in the ninth century was the rapid increase of ceramics exports, undoubtedly made possible by the much greater capacity provided by sea shipping. Very soon, ceramics leaped into position as one of the most favored Chinese goods in international trade, second only to silk. Like silk, the art and technology of Chinese high-fired stoneware and porcelain had been a mystery to foreign lands for many centuries. Sought as a treasure, Chinese ceramics were eagerly imported by foreign partners and exerted considerable influence on the lifestyles and cultures of the countries they entered. They became a measure of wealth and status in these societies, as is seen in Southeast Asia even to the present.[5] As for the Chinese, they were not only enthusiastic about meeting such foreign desires, they also bartered ceramics with silk and other goods to settle import debts, as required by the Song and Yuan governments in their repeated efforts to stem the worsening outflow of the copper cash that had become an international hard currency.[6] For the Mongol rulers in particular, the ceramics trade was an excellent example of exchanging useless (cheaper) materials for useful (precious) things.[7] Their partners doubtless thought the same, only in reverse.

The long, exciting story of ceramics trade can be divided into two broad periods. The first began in about the ninth century and ended in the sixteenth century. The second period (see chaps. 9, 16), from the sixteenth to the eighteenth century, saw the Europeans and various East India companies start to take over the trade that traditionally had been an Asian business controlled by Chinese, Southeast Asian, and

Arab peoples.[8] Aside from various stonewares, three types of porcelains mainly formed the ceramics trade of the first period: white wares, *qingbai* wares, and blue-and-white wares. They came upon the scene in succession. The first porcelains to arrive in foreign lands were Xing and Ding white wares or ware types of the Tang and early Song dynasties. *Qingbai* wares entered in the eleventh century and quickly became a major variety during the Song and Yuan dynasties, for kilns that produced these wares were all located in the southern and coastal regions, where transportation to major ports was easier and faster. In today's political geography, about twenty countries, or more than thirty regions along the sea routes, have excavated sites with Chinese white and *qingbai* wares.[9] Blue-and-white wares emerged in the first half of the fourteenth century. And once they appeared, they dominated the ceramics trade.

In general, the Chinese traditionally divided the maritime trade into two main routes. One is the East Seas route to Korea and Japan. And the other, longer and more complex, is the South Seas route that includes all lands of Southeast Asia and beyond.

The East Seas Route

The story of trade between China and Korea could go back as far as the Chinese Warring States period (475–221 B.C.), when Korea's contact with the Chinese Yan state bordering the Korean peninsula was recorded.[10] Regular and closer contacts increased after 108 B.C., when the Han empire of China established the Lelang Commandery, the principal of four, in northern Korea, which was to become the base of the Koguryŏ kingdom about 400 years later. The presence of these commanderies imposed a Chinese influence, bringing Korea into a pan-Chinese cultural sphere and disseminating Chinese ideas, technology, and material culture.[11] China exported its greatest variety of goods to Korea, often accompanied by the technology that produced them. Sericulture was introduced first into Korea in the third century, while the technology of high-fired stoneware was also first mastered outside China by Korean potters in the Three Kingdoms period (57 B.C.–A.D. 668). As in many foreign lands, Chinese ceramics were desirable and fashionable commodities, and thus inevitably became models and inspiration for local copies and imitations. Many types of Chinese ceramics exported to Korea influenced local products. Comparisons could be drawn

between the Korean lead-glazed earthenware of the Unified Silla period (668–935) and the Tang polychrome *sancai* earthenware; between the famed Korean celadon of the Koryŏ dynasty (918–1392) and its earlier Chinese prototype, the green-glazed Yue stoneware of the ninth century; and later, between Korean blue-and-white porcelain of the fifteenth century and Chinese blue-and-white of the early Ming dynasty (1368–1644). Archaeological finds show that kilns producing early types of celadon and porcelain in the ninth to tenth centuries were densely scattered in the southwest tip and along the western coast of the Korean peninsula, where maritime trade with China was most active.[12] The Koreans particularly mastered skills of celadon and white porcelain. During the Chinese Southern Song period (1127–1279), Koryŏ celadon was of such high quality that it was held in great esteem and eagerly imported by the Chinese.[13]

Journeys to Korea and Japan

The main Chinese ports for maritime trade with both Korea and Japan were Yangzhou and Ningbo (the latter was called Mingzhou in the Tang and Song periods, Qinyuan in the Yuan dynasty). Chinese silk, ceramics, books, and Southeast Asian aromatics imported by China were exchanged for Korean silver, herbal medicines, linen, nuts, and more. A Tang shipwreck found outside the port of Ningbo contained several hundred Yue and Changsha green-glazed wares, matching similar wares unearthed on the Korean peninsula. Ding porcelain and Cizhou stoneware of northern China and *qingbai* porcelain and Longquan celadon of southern China comprised the main body of Song and Yuan export ceramics.[14] White and *qingbai* wares have been the most numerous so far among archaeological finds within the Korean peninsula. From another shipwreck found in the sea off Sinan, in Korea's South Cholla province, more than 6400 Chinese ceramic objects were salvaged, of which the majority were Longquan celadon wares and *qingbai* wares.[15] Datable to 1323, this Chinese ship was probably stopping over on the Korean shore before reaching its destination in Japan. A Jingdezhen *qingbai* vase identical to one in the Jinglexuan Collection (pl. 6.1) is among the group.[16] It is a familiar shape known in Korean as *maebyong,* after the Chinese name *meiping,* and many were produced by the Koreans themselves, revealing their passionate love for it.[17] Most notable are those Koryŏ white porcelain and celadon *maebyong* vases of the twelfth and thirteenth

PL. 6.1

Vase

Chinese, Yuan dynasty, c. 1325
Jingdezhen *qingbai* ware, porcelain with light bluish-toned glaze and carved decoration
H. 12½ in. (31.8 cm)
Loan from the Jinglexuan Collection

The *meiping,* or prunus vase, was popular in China during the Song dynasty and was made in a wide variety of ceramic types, including Ding porcelain (see chap. 3, fig. 2) and Cizhou stoneware as well as *qingbai* porcelain. Typically the vase was formed of several seamlessly luted parts that present a gentle, smooth profile. It was actually used as a wine container. Identical vases have been unearthed from a tomb dated to 1325 in Wannian county, Jiangxi province.

Bright Dawn of the Porcelain Trade: White and Qingbai 75

centuries that feature a high shoulder, flaring foot, and the unique Korean underglaze inlaid decoration.

Contact between China and Japan could be traced to the Western Han period (206 B.C.–A.D. 8).[18] For a long time, Japan was largely under the cultural influence of Korea. Direct contact with China was firmly established in the fifth century, and it flourished in the Tang dynasty, when almost every aspect of Tang culture—statecraft, architecture, art and music, literature, and lifestyle—became models for the Japanese court and society to emulate. Large official embassies, including groups of students and merchants, were regularly dispatched to China. They brought back not only new ideas for a new era, but also all sorts of fine things to suit the new taste.

This kind of wholesale learning mission came to an end in the ninth century, but trade further expanded between the two countries in the following Song dynasty period and included a huge quantity of ceramics. A license issued in 1105 by the Mingzhou Office of Maritime Trade to the Chinese merchant Li Chong indicates that a single trade ship could carry as many as 9000 ceramic bowls and dishes to Japan.[19] Silk and ceramics remained the two staple export goods, along with aromatics, books, tea, and Chinese copper cash, which for a period was used as currency in Japan. In return, Japanese gold, sulfur, wood, lacquerware, swords, and fans were much welcomed in China.

Archaeological finds in Japan show that Chinese trade ceramics were similar in variety to those sent to Korea. Early export ceramics of the Tang period were mostly *sancai* earthenware, Yue and Changsha green-glazed wares, and Xing and Ding white porcelain wares. Most ceramic finds in Japan date from the Song period, evidence that by the end of the eleventh century, white and *qingbai* porcelains as well as Longquan celadon were the main types of export wares to Japan. Large quantities of them have been found in more than forty counties across Kyushu, Honshu, and Shikoku islands.[20] While most export wares were the same types as those used in China, such as *meiping* (prunus vases), certain others, the sutra container, for example, were exceptional and peculiar to Japanese interests. These sutra containers, lidded and cylindrical in form, were often made to order in white or *qingbai* porcelain for the Japanese trade; in Japan, they were considered suitable utensils for storing Buddhist sutras for burials, presumably because the color evoked the sense of purity.[21]

A few hundred sutra containers have been excavated from sutra mounds and pagoda basements in various places in Japan. With them were also found *qingbai* jarlets and small *qingbai* lidded boxes similar to the one in the Seattle collection (pl. 6.2). So far, several hundred such boxes have been found in Japan, dating mostly from the late eleventh to the early thirteenth century. In China, these boxes were used to hold aromatics and other powders, but in Japan, the fact that they were entombed with Buddhist sutras indicates a special religious significance. Judging by the porcelain materials and molded decorations, many porcelain boxes exported to Japan seem to have been made in kilns along the coastline in Fujian and Guangdong provinces rather than Jingdezhen, revealing the important role these two provinces played in Chinese ceramics trade. These ceramics and other commodities were shipped to Japan mainly from Ningbo, in Zhejiang province.

THE SOUTH SEAS ROUTE

'The South Seas route' is a vague Chinese term that includes all foreign lands in the South China Sea and beyond. By the tenth century, Guangzhou and Jiaozhou (the Hanoi area in northern Vietnam) were the two centers of Chinese overseas trade. Various Chinese goods, including porcelains, were exchanged there with Arab and Persian merchants, who not only traded for their own regions but also acted as major intermediaries between China and countries farther west. With the Chinese, they bartered Western goods such as Roman glass, Indian cotton cloth, gems, and aromatics of both India and Southeast Asia's islands. Through these trades, Chinese porcelain was brought to major cities in the Middle East. Samarra, in Iraq, was the capital city of the Abbasid dynasty (750–1258) from 836 to 863, and Nishapur was the capital of Iran's Tahirid dynasty (820–872) and Saffarid dynasty (867–903).[22] Shards of Tang white porcelain have been unearthed from both sites; some, jade-*bi*-shaped bases of fine clay, reveal their origins in Xing and Ding kilns (pl. 6.3). They are among the earliest Chinese trade ceramics.

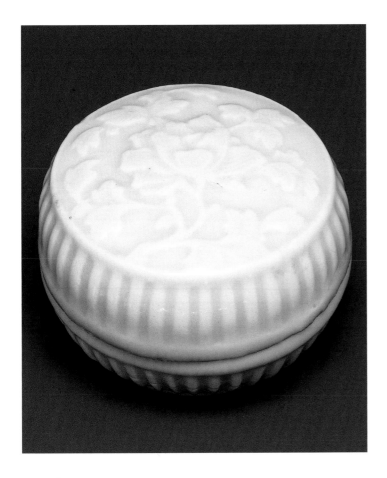

Shards

Chinese, Tang dynasty, 9th century
Xing and Ding ware types, porcelain excavated from Nishapur, Iran
(left; above), and Samarra, Iraq (below)
L. 3¼ in. (8.3 cm); l. 2¾ in. (7 cm); l. 2⅜ in. (6 cm)
The Metropolitan Museum of Art, Rogers Fund, 1922 and 1940

PL. 6.2
Lidded box

Chinese, Southern Song dynasty (1127–1279)
Jingdezhen *qingbai* ware, porcelain with light bluish-toned glaze
and molded decoration
Diam. 2½ in. (6.4 cm)
Thomas D. Stimson Memorial Collection, 45.78

During the Song period, small porcelain boxes of this kind met
a myriad of fashionable needs, such as storing aromatics, pow-
ders, drugs, and pigments. Made by almost every kiln, they ex-
hibit a great variety of form and decoration. In the Jingdezhen
area, numerous family workshops specialized in producing
boxes, many of which were stamped at the base with their fam-
ily names.

Journeys in Southeast Asia

In the eleventh century, direct Chinese participation in the
South Seas trade dramatically increased. Instead of the previ-
ous concentration on trading at Chinese port cities, Chinese
junks, with a standard capacity of 120 tons and now guided
by compass, sailed easily back and forth in the South Seas.
Setting out from Guangzhou or Quanzhou, they traveled
southward along the coastline to modern Vietnam, Cam-
bodia, Thailand, Malaysia, and Indonesia. After passing
through the Strait of Malacca and across the Indian Ocean,
they came to Sri Lanka and India. Then, by sailing north
along the west coast of the Indian subcontinent, they could
reach Pakistan and the Persian Gulf regions farther west; or
by crossing the Arabian Sea in another direction, they could
arrive at Aden, in Yemen, and then proceed north to Syria
and Egypt or south to Muqdisho, in Somalia.[23] Although both
Chinese junks and Arab dhows were by that time capable of
completing the whole journey, and occasionally might have
done so, such a voyage would take about two years because
of the need to wait for seasonal monsoon winds. It was more

feasible and economical to terminate each journey in one of several transfer stations. India and Sri Lanka, the island of Sumatra in Indonesia, and the southern area of the Malay Peninsula provided many such key positions for trade and ship provisioning. In this way, Chinese junks could stop on the east coasts of India and Sri Lanka or even along the Strait of Malacca, trading their cargoes and then heading back home. On the return voyage, the junks continued to sail eastward to ports such as Banjarmasin, Kuching, and Brunei in the Kalimantan Islands, and then farther northeast to the Philippines. Direct trading was also explored in areas like the Philippines, where distances were short. From the northern tip of Sumatra toward the east, the Chinese thus assumed the dominant position in trade with Muslim merchants from the west as well as in interisland trade among the Southeast Asian archipelagoes.

Trade goods were many, and transactions were complicated and followed a set order. The Chinese would first exchange Chinese goods with Arabs or Indians for luxuries and Indian cotton cloth, and then resell them, together with more Chinese goods, to the Southeast Asian islanders for aromatics and spices; sometimes the order was reversed. Not until the sixteenth century did this Chinese dominance falter, largely because of Portuguese penetration of the area, particularly their seizure of Malacca in 1511, and the Chinese government's discouragement of trade. The Chinese position continued to weaken as subsequent centuries saw the forceful participation in Southeast Asian trade of the various European East India companies.

Profit, importing of foreign goods, and projection of imperial supremacy were the incentives behind the expansive Chinese maritime trade in Southeast Asia. Ever stronger demands in the Song and Yuan periods for aromatics, spices, and medicinal drugs were now sufficiently satisfied by frequent trade traffic that exported the most desirable Chinese goods, particularly ceramics, in substantial quantities to the area. Enormous amounts of Chinese ceramic remains have been found in numerous coastal sites among Southeast Asia's islands, particularly in three regions: the east coast of Sumatra, the west coast of the Malay Peninsula, and the west and north coasts of Brunei, corresponding to what was recorded in the contemporary Chinese texts mentioned earlier.

Porcelain of white and *qingbai* types and green-glazed stoneware appear to have been the principal trade ceramics of the twelfth and thirteenth centuries. In addition, a small number of Changsha green-glazed wares from the late Tang were also found, indicating that the Chinese–Southeast Asian trade had begun in the ninth century as well.[24] These trade ceramics were largely of southern origin, produced in Zhejiang, Fujian, Guangdong, and Jiangxi provinces. Their form and decoration were much the same as those consumed in the Chinese domestic market. Common shapes included bowls, jars, and small incense boxes. Three exceptions, however, seem to have been made expressly for the Southeast Asian markets. One is the *kendi;* excavated finds in the area have proved them to be the largest group in existence. Another is a number of large plates, bowls, and ewers, popular in the Muslim communities of the Middle East. The third consists of small jars, cups, and figurines peculiar to the Philippines and Indonesia. These trade ceramics were highly valued by the locals and used as treasures in important rituals.

The *kendi* was a versatile utensil employed for various religious rituals as well as important secular occasions. The large wares must have been used to substitute for woven bamboo wares, shells, or even leaves as food containers in communal dining.[25] Miniature wares, on the other hand, apparently were endowed with special religious efficacy, for they were used mostly for burial with the deceased in the Philippines and Indonesia. So far, they remain a category of trade ceramics found almost exclusively in Southeast Asia.

The majority of these porcelain miniatures are *qingbai* and blue-and-white wares. A small incense burner and two small vases in the Jinglexuan Collection are such examples, making up a miniature altar set in their original context (pl. 6.4). Finds in the Philippines include a full array of such iron-spotted *qingbai* miniatures and their unspotted counterparts.[26] Rather surprising, however, are the similar sets, bound for Japan, found in the famous Sinan shipwreck off the coast of Korea.[27] This connection helps date those found in the Philippines to the early fourteenth century, but it leaves behind an open question of the reasons for this curious mixing of trade goods normally intended for Japanese and Southeast Asian markets, respectively.

From the west coast of India to the east coast of East Africa, archaeological investigation and excavation have revealed more than seventy ancient sites that conducted ceramics trade with China.[28] The findings of similar Tang

PL. 6.4

Small altar set

Chinese, Yuan dynasty (1279–1368)
Jingdezhen *qingbai* ware, porcelain with light bluish-toned glaze
and iron-brown spot decoration
center: incense burner, h. 3½ in. (8.9 cm)
left, right: vases, h. 5⅝ in. (14.3 cm)
Loan from the Jinglexuan Collection

Each of these miniature objects was assembled by luting together
a few parts. The object was then coated with *qingbai* glaze with
freely daubed spots of iron oxide that would produce brown col-
ors. These miniatures, peculiar to the Southeast Asian regions
and used as burial goods, were made in China exclusively for
export and did not appear in Chinese domestic markets.

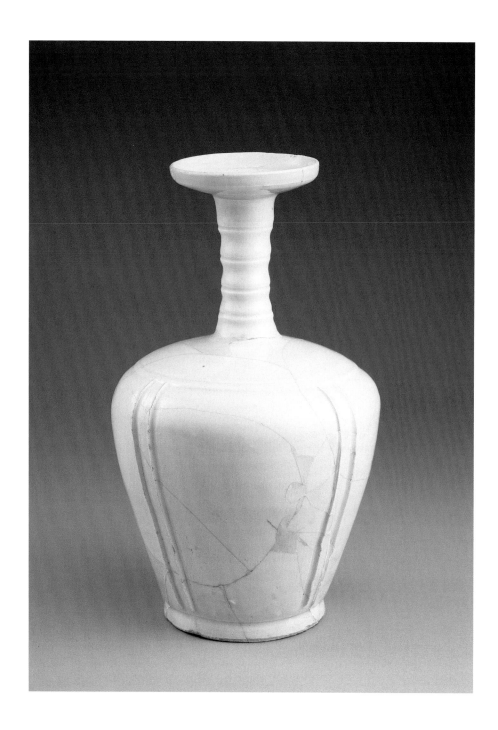

PL. 6.5

Bottle

Chinese, Liao dynasty, late 10th century
Ding ware type, porcelain excavated from Fustat, Egypt
H. 10 in. (25.4 cm)
The Art Museum, Princeton University, gift of the American Research
Center in Egypt through the courtesy of the Department of Antiquities
of the United Arab Republic

The bottle was discovered in an undisturbed sanitation pit in 1965.[29] Its tall, narrow, bamboolike neck is topped with a dish-shaped mouth, a Liao characteristic, and four pairs of vertical ribs around the body. The flaring foot has a flat, slightly recessed bottom.

porcelain shards of utensil bases in Sri Lanka, in Iraq and Iran, and in Fustat (old Cairo), Egypt, confirm that an extensive western-oriented trade route already existed in the earliest stage of ceramics trade in the ninth century.[30] Fine porcelains of the tenth century and later continued to flourish in the markets of these western regions.

A Journey to Fustat

A porcelain bottle found in Fustat has turned out to be a particularly interesting example (pl. 6.5). Besides its fine quality of material and technique, it compares closely in shape (except for the spout) with a white ewer excavated from the tomb of a Khitan lady in China's Liaoning province.[31] The tomb is datable to the early Liao dynasty (907–1125) in the second half of the tenth century. Clearly the Fustat piece is a Liao product, but it is less clear how it reached Egypt. One possibility is via the Silk Road, then under Liao control. The maritime route is plausible as well, for the Liao kilns producing this type of white ware were not far from the Liao port of Suzhou (today's Dalian), which faced the Song port of Dengzhou across the narrow Strait of Bohai. In the early Song, the court frequently issued edicts to forbid overseas trade with Liao in Dengzhou.[32] The circumstance indicates that private trade at this time was undoubtedly robust at least until the mid-eleventh century.

Once this Liao bottle reached Dengzhou, it could have entered the well-established Song maritime route. Probably reshipped in Quanzhou, the major port for South Seas trade, it was then finally ready for its incredibly distant destination—Fustat, Egypt's political and economic center since 642. Today, ceramic remains in Fustat are abundant. Of its 600,000 to 700,000 shards, Chinese ones account for more than 20 percent, the largest group. These shards are material evidence of the great prosperity of Fustat and also attest Fustat's commercial and cultural connections with China.[33] Moreover, they prove that Chinese ceramics were a source of inspiration for local Egyptian potters.

Similar phenomena can also be observed in other Islamic ceramics centers in Iraq, Syria, and Iran. Almost every type of Chinese ware exported to these regions was enthusiastically imitated, including *sancai* earthenware, white and *qingbai* porcelains, green-glazed stoneware, and blue-and-white. This tradition was carried on by Islamic potters until the eighteenth century. One of their early ambitions was to re-create the fascinating whiteness of Chinese porcelain's body and glaze, but the attempts were unfruitful; they lacked the right kind of clay. As an alternative, Islamic potters invented an opaque white glaze to cover their dark-colored earthenware, and apparently also to obtain a better background for painted decoration, because rarely did the Islamic potters in Iraq during the Abbasid period copy the undecorated, Chinese monochrome-white porcelain. Rather, they were inclined to paint decorative designs in single or multiple colors or in lusters of metallic iridescence over the white glaze.[34] Something similar occurred later in Europe, where tin-glazed earthenware was also inspired by Chinese porcelain whose whiteness intrigued the Europeans as an ideal surface for polychrome paintings.

—J.C.

THE LOOK OF PORCELAIN: EARLY ATTEMPTS

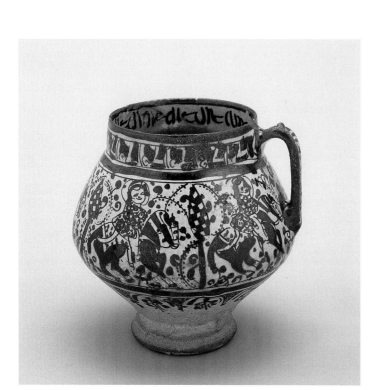

PL. 7.1

Jug

Persian, late 12th century

Earthenware with white slip and luster decoration

H. 5⅛ in. (13 cm)

Eugene Fuller Memorial Collection, 50.93

Checkerboard-styled cypress trees are a characteristic decoration on lusterware works from Persia. Here they create a fantastic landscape for the round-faced figures on galloping horses who race around the central panel.[1] This shimmering luster decoration, with its use of metals, was perfected in Mesopotamia, the cradle of the ancient art of alchemy. The quest to turn base metals into gold would later play a role in the European search for a porcelain formula (see chap. 2).

Because the secret of producing white, translucent porcelain was carefully guarded in China, porcelain inspired imitation in countries where it was a rare, imported treasure. Having discovered neither the clay formula nor the high-fire techniques necessary to make true porcelain, early Islamic potters of ninth-century Mesopotamia and Persia perfected a white, opaque glaze. They added tin oxide to a clear lead glaze, which gave their thick-walled, buff-colored pottery a white surface suitable for painted decoration.

Tin-Glazed Wares and Lusterware

Islamic armies marched west in the eighth century, conquering most of Spain; gradually Islamic potters carried the art of tin glazing and luster decoration across northern Africa into that region. Hispano-Moresque ware is a tin-glazed earthenware produced in Andalusian Spain as early as the thirteenth century; similar wares were produced in Valencia after the art of tin glazing moved north on the Iberian Peninsula. Tin glazing was the first major innovation assimilated into the ceramics tradition of the West since the fall of the Roman Empire.[2]

As the knowledge of tin glazing spread through Europe, similar wares approximating the look of porcelain were produced. Trade extended the tradition into Italy, where it became known as maiolica. Along with the technology of tin-glazed earthenware, the art of decorating the white ground with a glimmering luster decoration traveled from Mesopotamia and Persia where it was developed (pl. 7.1), to Spain (pl. 7.2), and to Italy (pl. 7.3). These ceramic wares embody two of the great passions of medieval and Renaissance Europe: they look white, like Chinese porcelain, and their painted decoration has a metallic sheen that casts the glimmer of gold.

PL. 7.2

Hispano-Moresque dish

Spanish, Manises, c. 1500–1535
Tin-glazed earthenware with luster decoration
Diam. 14⅜ in. (36.5 cm)
Eugene Fuller Memorial Collection, 46.36

This dish represents the end of the great Spanish luster tradition of the mid-thirteenth through fifteenth centuries.[3] Its molded, spiral gadrooning around the broad rim imitates Renaissance metal repoussé work, but the dish derives many of its decorative motifs from Islam—seen here in the six-spoked wheel designs in *encaje,* an interlocking lacy pattern, and in *florecillas,* or little flowers, which all originate in Islamic design. The thistlelike plant that appears on every fourth gadroon may derive from a cypress motif, which also appears on the Persian jug (see pl. 7.1).[4]

Lusterware was highly revered, its production a guarded art form. A hole punched into the dish before it was glazed may indicate that it was made to hang on the wall and was prized primarily for display. But this was also a time when eating utensils were rare, and people often ate with their hands. The dish probably held a ewer of scented water with which diners washed their hands at table between courses. The wear in the raised center was likely caused by the ewer being placed on and then removed from the dish. We have not been able to identify the abraded coat of arms in the center shield, which appears to depict a running rabbit.

Luster decoration was one of the finest techniques developed by Islamic potters, first in Mesopotamia and later in Egypt, Persia, Spain, and Italy. A complicated formulation composed primarily of silver and copper oxides, the pigment was applied over the glazed and fired ware and given another, cooler reduction firing in a muffle kiln. In this oxygen-poor environment, the metallic oxides adhered to the surface and then were burnished or polished to create a lustrous effect.

With the westward advancement of Islam, the tin-glazed tradition moved into Moorish Spain. Metallic luster decoration gave the illusion of glimmering precious metal to the white-glazed earthenware of Spain and inspired the term 'golden ware.'

It is uncertain how the knowledge for producing tin-glazed earthenware first arrived in Italy—possibly it crossed east from Spain. Hispano-Moresque lusterwares exported through the isle of Majorca to Italy were called maiolica. Later the name was applied to Italian tin-glazed wares of the Renaissance. It may derive from the name Majorca, but it could also have evolved from the Spanish name for luster, *obra de málequa.*[5] Potteries producing metallic luster glazes were established in Italy at both Deruta and Gubbio by 1500.

PL. 7.3

Plate

Italian, Deruta, c. 1520–25
Maiolica, tin-glazed earthenware with cobalt-blue and
luster decoration
Diam. 16⅝ in. (42.2 cm)
Eugene Fuller Memorial Collection, 47.79

The decorative elements of this plate feature the characteristic
straw-yellow, iridescent luster of Deruta, Italy. They combine
Islamic motifs with an iconic Christian scene. The border re-
tains overlapping scale patterns and other geometric designs
from the Islamic tradition, creating a strong rhythm with the
symmetrical European acanthus scroll and abstract vegetal mo-
tifs. In the well of the plate, a scene of Saint Francis (1181–1226)
is painted in a pictorial style made familiar by the humanistic
spirit of the Renaissance.

Depictions of Saint Francis of Assisi, the early thirteenth-
century founder of the Franciscan order, were popular through-
out the Renaissance. The theme of Saint Francis Receiving the
Stigmata, the wounds of the crucified Christ, is symbolized by
fine blue lines connecting the kneeling saint and the figure on
the cross. Saint Francis was one of the most popular subjects on
Deruta *piatti da pompa,* or large display plates, and it is thought
that they were sold to the more affluent pilgrims visiting nearby
Assisi.

Istoriato Wares

Along the base of a double-handled jar (pl. 7.4), the artist
informs us that the source for his energetic, vividly painted
scene is Exodus 17. It depicts Moses in the desert after he
struck a rock designated by God, in response to the angry
Israelites' question: "Why have you brought us out of Egypt
with our children and our herds to let us all die of thirst?"
Water miraculously gushes from the rock, and thirsty Israel-
ites rush to fill their water jars. This narrative style of deco-
ration, known as *istoriato* (literally, storied), treats tin-glazed
earthenware as a canvas—a ground for finely painted histori-
cal, biblical, mythological, and genre scenes that bring real-
ism and perspective to ceramic art.

The glaze that produced the all-important white surface
on which these narrative scenes were painted contains par-
ticles of suspended tin oxide that reflect light and give the
surface its white, opaque appearance. The creation of intri-
cately decorated maiolica wares began with the firing of
brown pottery, either wheel-thrown or molded, to a hard but
porous biscuit state. Dipping the wares in tin glaze prepared
them for painting, a delicate operation that involved apply-
ing wet pigments to the dry, matte surface. There was no
margin for error, as the color immediately seeped into the
unfired white glaze. A clear glaze was applied over the tin
glaze and colored decoration before the ware was fired a
second time at about 950–1000°C.[6] By the sixteenth century,
the palette for *istoriato* wares incorporated earlier pigments
of copper green, purple-brown manganese, a newly devel-
oped cobalt blue, yellow from antimony oxide, iron red, and
orange (antimony and iron). If luster was applied, the ware
was given a third, low-temperature firing.

Istoriato wares were considered important works of art
in their own time and continue to be respected as one of
Renaissance Italy's finest artistic achievements. The Renais-
sance was a time when the creation of luxurious works such
as painting, sculpture, architecture, and the decorative arts
promoted an ever increasing number of artists into higher
social standing, though potters and painters who fashioned
and decorated ceramics generally did not sign their work.
The Seattle jar is one of few examples that bears an inscrip-
tion: VRBINI/ALFONSVS.PA/TANAZZIVS/FECIT. Alfonso
Patanazzi was one of four brothers producing *istoriato* ware
in the *bottega,* or workshop, of the Patanazzi family.[7] Their
work dates from around 1575 through 1625. Among the arts,

istoriato-style maiolica earthenware received the highest esteem of patrons.[8] "The making of earthen pots . . . will not diminish the greatness and worth [of princes]," wrote Cipriano Piccolpasso in his treatise on the art of pottery, *I tre libri dell'arte del vasaio* (The Three Books of the Potter's Art, 1557).[9]

The Seattle jar combines *istoriato* with another specialty of Urbino, the painting of popular Renaissance motifs known as grotesques, stylized animal and human forms entwined in scrolled and leafy designs. Inspired by ancient Roman designs reinterpreted by the artists of the Renaissance, the grotesque painting on the reverse side of this jar features exotic winged creatures carrying baskets of flowers upon their heads, putti (infant boys) riding on dolphins, and buxom female figures with wings for arms and legs made of leaves. The bearer of the coat of arms painted in the oval at the center of the grotesque motifs has not yet been identified.

Were splendid maiolica wares created for display on sideboards and hung on walls as a manifestation of wealth, or did they serve as functional tableware and vessels? Because they rarely show scratch marks on their rather soft surfaces —not even on plates, where one would most expect to see marks made by knives, the commonest eating utensil of the period—they were probably used only for special occasions. The inclusion of a wide variety of practical shapes in maiolica services, some not particularly suited to narrative decoration, supports the speculation that these valuable services were employed for occasional, functional use and not just for display.[10]

Several theories exist concerning the use of the Seattle jar. Maiolica vessels served as containers for medicaments in pharmacies of the day. The word DIAMVSCO, inscribed in a scrolling ribbon above the coat of arms on this jar, may relate to *diamoschum,* or 'made from musk.'[11] This jar's great size and the extraordinary value of musk (a substance secreted by an abdominal gland of male musk deer and used in perfume as a scent and fixative) make it an unlikely container for musk. The scene of Moses and the Israelites, with a similarly shaped jar painted in the foreground, may denote its use as a water jar. But because the serpentine handles would not have borne the weight of the volume of water a jar of this size would hold, it was probably created for decorative display.

—J.E.

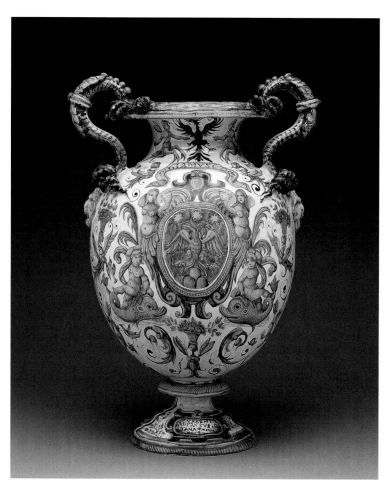

Reverse of double-handled jar, PL. 7.4

PL. 7.4

Double-handled jar

Italian, Urbino, c. 1600–1610
Painted by Alfonso Patanazzi
Maiolica, tin-glazed earthenware with polychrome decoration
H. 24½ in. (62.2 cm)
Eugene Fuller Memorial Collection, 48.33

8

THE CHINESE TRADEMARK:
BLUE-AND-WHITE AND ITS INFLUENCE ON ASIAN WARES

Another episode of China's ceramics trade transpired in the fourteenth through sixteenth centuries. It involved the primary type of trade porcelain, blue-and-white, which became by any definition China's signature porcelain. From its first appearance on the international market in the mid-Yuan period, around 1325, to the 1700s, blue-and-white ware dominated ceramics and answered many people's needs, practical and aesthetic. And wherever it turned up, the advanced technology it embodied exerted significant impact on local ceramics industries.

In China, the mid-Yuan period continued to witness prosperity in both official and private business. Vigorous trade with Southeast Asia far eclipsed the volume of ceramics traded there during the Song. This commerce returned handsome revenues to the Yuan treasury and helped fuel the Mongols' powerful war machine.

In the late fourteenth and early fifteenth centuries, the Ming dynasty emperors (1368–1644), having ejected the Mongols and reestablished Chinese rule, were eager to restore the much-tarnished image of Chinese imperial supremacy. They revived and institutionalized the so-called tributary system, whereby official representatives of foreign "barbarian" countries came to trade in the name of paying tribute or demonstrating allegiance. To encourage such visits as well as to show its magnanimity and power, the Ming government regularly overcompensated for these tribute goods. Tribute brought by foreign ships was not only tax free but was also repaid with gifts of much higher market value. Financial interest was sacrificed more often than not, and private trade was even prohibited at one point during the first reign of the Ming dynasty. When private ships were allowed to resume their visits, those accompanying the tribute ships were also given tax-free treatment. In an earnest effort to invite and solidify tributary relations with foreign countries, the Yongle emperor (r. 1403–1424) sent grand imperial envoys and expeditions to the lands of Southeast and western Asia, and as far as the east coast of Africa. The ability to dispatch the world's largest fleet—consisting of more than 60 ships with at least 27,000 personnel aboard them—must have been highly gratifying to the Chinese. Surely the sight of this naval force must have impressed their "barbarian" contemporaries as well. While such official voyages served primarily political purposes, they also furthered and expanded trade.

The impact of Chinese imperial activities on Southeast Asian countries was significant. Chinese patronage and the local governments' allegiance to Ming China gave rise to many new trading ports, which replaced previously flourishing ports in other regions.[1] These newly developed ports, such as Malacca on the Malay Peninsula and Kota Batu in Brunei, quickly became major trading centers in the fifteenth century. Malacca even used a system like the Chinese Shipo si (Office of Maritime Trade) in administering its transfer-trade business and rapidly established itself as the most desirable terminus for merchants from both the East and the West.[2]

Because the tributary trade with China was arbitrarily created by the Ming government to be hugely profitable to foreign parties, tribute ships came in flocks. In this way, the Ming emperors satisfied their vanities, while foreigners acquired abundant profits. The Ryukyus (now Okinawa prefecture, Japan), for example, after establishing diplomatic relations with China in 1372, received gifts that included a new seaworthy ship every year when they went to China with their tributes.[3] However, the Ming practice of identifying

overseas trade with foreign diplomacy was obviously contradictory to normal economic principles. In reality, it inevitably opened loopholes for many visiting ships that were private all but in name, and deficit trading was bound to be a burden on the Ming treasury.

The Ming government eventually had to take the trade deficit seriously. As a consequence, the Ryukyu traders, from around the mid-fifteenth century on, received no more free new ships and were required to pay for their own ships' repairs.[4] The Ming government was finally forced to introduce "tribute permits" to control and limit the swarms of foreign tribute ships arriving in Chinese ports. Ryukyu was granted one visit every two years; Vietnam's Champa kingdom (in central Vietnam) and Korea one every three years; and Japan only one every ten years.[5] This stringent policy apparently overcorrected the problem and, as a result, aggravated previously inconsequential disturbances by pirates along the Chinese seaboard. They became a dire menace, especially those from Japan.

This chain of events took a vicious turn, for in order to stamp out piracy, the Ming government terminated all overseas trade and closed China's coast. This ill-fated decision, carried out in 1523, only led to worse piracy and forced legitimate private trade into clandestine operations, which soon formed powerful syndicates that, ironically, were managed by local Chinese government officials along with shipping lords.[6] On the other hand, the absence of legitimate Chinese participation in trade created an invaluable opportunity for the Portuguese, with their superior navigational skills, to take over the lion's share of trade as they shuttled between East and West.

By the end of the sixteenth century, when the Ming government lifted the ban on overseas trade, the syndicates and the Portuguese had already come to share dominance in trade with Japan and Southeast Asia. In short, while Chinese overseas trade in the fifteenth century was characterized by grandiose imperial patronage, trade in the sixteenth century was very much in the hands of industrious smugglers and Portuguese sailors. They continued to supply the world with fine Chinese ceramics, particularly the beautiful blue-and-white wares that became the most popular and highly valued ware.

Blue-and-white porcelain became possible with the importation of bright cobalt pigments from the Middle East.

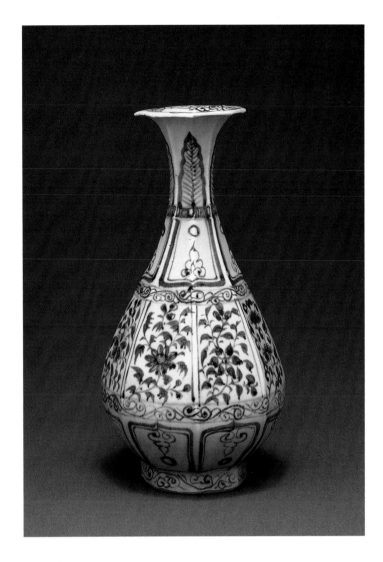

PL. 8.1

Vase

Chinese, Yuan dynasty (1279–1368)
Jingdezhen ware, porcelain with eight-faceted body and underglaze-blue decoration
H. 9¼ in. (23.5 cm)
Loan from the Jinglexuan Collection

This vase represents a typical Yuan style in decoration, densely painted from rim to footring with four main design registers alternating with five border patterns. Within each main register, self-contained panels conform to the octagonal form of the vase. The regularity for which Islamic art is famous is clearly evident here, coupled with Chinese motifs and the sense of swift, freehand painting that had also been conventional in China.

Although China had previously experimented with cobalt, the results did not grip the Chinese imagination. Blue-and-white's success in the Yuan period owed to its being first and foremost an export ware catering to Muslim consumers, who cherished this Chinese product with its brilliant blue paintings of Islamic designs on luminous white porcelain. Yuan blue-and-white from Jingdezhen was therefore characterized by its Islamic taste expressed in rich and dense decoration (pl. 8.1).

The Jingdezhen potters also developed a great variety of shapes and other decoration to suit the specific needs of different markets. The Muslims used massive dishes, usually about 40 centimeters in diameter, and bowls for communal dining. Southeast Asia required miniature altarpieces and vessels—round or cuboid jars, double-gourd ewers, and jarlets in the form of starfruit (pl. 8.2).

The quality and high value of Chinese blue-and-white imports led naturally to attempts by local ceramics workshops to reproduce them. Archaeological finds indicate that imitation occurred in Vietnam in the late fourteenth century, almost immediately after the first appearance of Chinese blue-and-white. In Thailand and Korea, it happened a few decades later; in Japan, over two centuries later. As for the Middle East, Islamic metalwork's shapes and patterns first influenced Yuan and early Ming blue-and-white wares. Once developed and transformed into Chinese designs, however, they in turn served as models to inspire Muslim potters. Imitation of Chinese blue-and-white wares was a common custom in the Muslim world from the fourteenth to the eighteenth century. In Fustat, potters copied Chinese blue-and-white wares almost as soon as they arrived in Egypt.[7] And interestingly, in Ottoman blue-and-white pottery of the early sixteenth century, we see many counterparts to Chinese originals (see pls. 8.7, 8.8). These products may not have served the high end of local markets. They reflected, however, the responses of local potters to the technical challenges of Chinese blue-and-white. Their form and decoration illustrate the fascinating process of assimilation of foreign elements, while still retaining and expressing the interests of local people. The following examples offer simply a glance at such stylistic interactions.

Vietnam

It is clear that Seattle's Vietnamese blue-and-white vase was Chinese-inspired in form and decoration (pl. 8.3), particularly when compared to the Yuan vase in the Jinglexuan Collection (see pl. 8.1). Slightly lobed to echo the eight facets of the Yuan bottle, it displays a strikingly similar layout of decoration from the mouth rim to the footring. The alternate, stylized wave and orchid panels in the main register are a distinctive Vietnamese feature. The simplified plantain leaves on the neck and lotus panels in the lower body were adapted from typical Yuan motifs, but their free, almost abstract, approach adds an interesting sense of liveliness and rusticity.[8]

Though its chemical properties are not entirely clear, Vietnamese blue-and-white, judging by appearance, is likely a stoneware, or possibly earthenware, when fired around 1000°C. Kaolin in the glaze increased clarity, and white slip was sometimes applied to create a whiter background for underglaze-blue painting. The earliest Vietnamese blue-and-white is datable to the late fourteenth century, and production peaked in the fifteenth and sixteenth centuries.[9] The cobalt used in Vietnam, a blackish blue generally linked to coarser wares, was probably imported from Yunnan in southern China, while the bright, clear blue seen on finer wares most likely came from the Middle East.

A large, elegant bottle in the Topkapi Saray Museum bears around its shoulder an important inscription, indicating it was made in 1450, in the modern Nam Thanh district of Hai Hung province, east of Hanoi. Archaeological excavations in Hai Hung province have revealed fourteen old kiln complexes that all appear to have made blue-and-white wares.[10] A shard painted with wave and orchid motifs similar to those on the Seattle bottle was found at the Lang Ngoi kiln complex in the same area.[11] The finds at the Chu Dau kiln complex are mostly of higher quality. The range of its products, in comparison with archaeological finds outside Vietnam, suggests that the Chu Dau kiln was a prime source of Vietnamese export wares to Southeast Asia,[12] particularly Indonesia, as attested by richer finds unearthed in Sulawesi and Java islands. The reduction of Chinese trade in this region in the fifteenth and sixteenth centuries coincided with the flourishing Vietnamese blue-and-white trade.

Incentive may also have come from the rulers of the Le dynasty (1418–1527), who enthusiastically embraced the

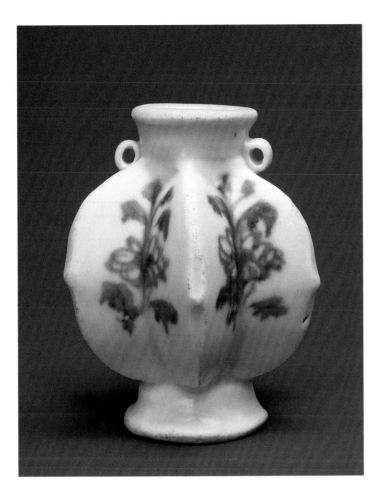

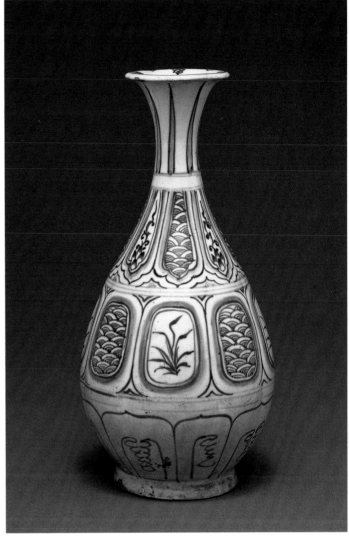

PL. 8.2

Jarlet

Chinese, Yuan dynasty (1279–1368)
Jingdezhen ware, porcelain with underglaze-blue decoration
H. 3⅛ in. (8 cm)
Loan from the Jinglexuan Collection

With their unique tropical presence, starfruit-shaped jarlets
have been excavated in the Philippines in both *qingbai* and blue-
and-white styles.[13] Small in scale, they nevertheless manifest the
same high quality in form and decoration.

PL. 8.3

Vase

Vietnamese, northern kilns in Hai Hung province, 15th century
Stoneware with underglaze-blue decoration
H. 10 in. (25.4 cm)
Eugene Fuller Memorial Collection, 57.75

This vase, typical of Vietnamese blue-and-white in the
fifteenth century, exhibits unmistakable Chinese influence
yet is endowed with Vietnamese taste.

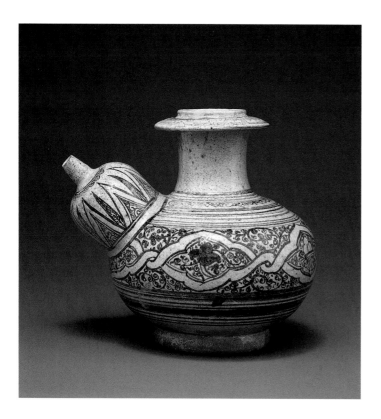

PL. 8.4
Kendi

Thai, 15th–16th century
Sisatchanalai ware, stoneware with underglaze-iron black decoration
H. 8¾ in. (22.2 cm)
Gift of Gloria Gunn Prince, 92.82.82

The decorative elements of this *kendi*—floral scroll on the body, pointed leaves on the mammiform spout—are reminiscent of both Chinese and Vietnamese styles, but they are incorporated in such a way that the overall design, drawn in well-controlled strokes, becomes an organic unity.[14]

Chinese influence, brought in by the brief Chinese occupation of 1407–27. Cherished as family heirlooms or employed to decorate palace walls, Vietnamese blue-and-white wares made great contributions to the material cultures of the Southeast Asian countries. They competed with and supplemented, to a certain extent, Chinese blue-and-white porcelain in the Southeast Asian market for about three centuries. Only in the seventeenth century did they begin to lose their competence in the market, and so gradually disappeared—a time that, again, coincided with China's resumption of dominance in the ceramics trade, with its trademark blue-and-white porcelain.

Thailand

Thai underglaze-iron painted stonewares were influenced by both Chinese and Vietnamese ceramics. The history of its production and trade was similar to that of the Vietnamese blue-and-white and was closely tied to Thailand's participation in the international ceramics market. It emerged in the Southeast Asian trade market in the second half of the fourteenth century and disappeared in about the mid-sixteenth century, when production ceased, possibly because of the Burmese conquest in 1569.[15] The main center of Thai ceramics production was concentrated in central Thailand with its two most famous kiln groups, Sisatchanalai (Sawankhalok) and, to the south of it, Sukhothai. The Seattle *kendi* (pl. 8.4) is a lovely example of the typically fine Sisatchanalai ware. The thick clay body, fired to a brick red, is neatly formed to impart a feeling of composure. A fine white slip covers the dark body to provide a better surface for the black painting, on which a coat of transparent, green-toned glaze is thinly applied. Though the motifs are stylized floral and geometrical patterns, they were painted with vigor, resulting in a lively design full of vitality.

Korea

Under the auspices of the Chosŏn emperors, fine blue-and-white porcelains were produced. Korean potters started to make porcelain at the end of the fourteenth century. The earliest Korean blue-and-white wares are datable to the mid-fifteenth century, and they are modeled on Chinese prototypes of the early Ming period (fig. 1). High-quality wares like the one shown here were made in the royal kilns in Kwangju in Kyonggi province, close to Seoul. The pigment,

Middle Eastern cobalt reimported from China, was assigned only to skillful painters dispatched from the court. Decoration with this imported cobalt shows a characteristic "heaped and piled" effect similar to early Ming blue-and-white pieces, owing to the rich iron content of the cobalt ore. Native cobalt was discovered in the second half of the fifteenth century but was not in common use until the seventeenth century onward.

The bamboo and the plum motifs on this jar were popular in both Ming China and Chosŏn Korea. Bamboo is a symbol of resilience and flexibility, and its hollow stem implies modesty and the capacity to learn and absorb. The delicate plum blossom, first to bloom at the start of spring, evokes courage, purity, and uniqueness. This jar's grandiose scale and richness of detail are unusual for Korean blue-and-white; rather they reflect Chinese taste reminiscent of Ming jars made in the Hongwu reign (1368–1398).

Though they supported production of blue-and-white, the Chosŏn rulers advocated an austere taste and generally preferred undecorated white porcelain wares. White porcelain constituted most of Korean porcelain production from the beginning of the dynasty, in 1392, up to the mid-seventeenth century, and blue-and-white production was limited.[16] Practically speaking, imported cobalt was also in limited supply. Superb blue-and-white ceramics were therefore a rare sight. Like blue-and-white wares imported from China, they were treasured and used by the Chosŏn emperors in royal etiquette together with white wares.[17] It would not be surprising if such a jar were also used as a Korean tribute for presentation to the Chinese court.

The Chinese influence on Korean blue-and-white began to wane around the second half of the seventeenth century, when Korean production of blue-and-white porcelain increased after the fifty-year turmoil of Japanese invasions. By the eighteenth century, innovative forms dramatically increased, as did the variety of decoration. Underglaze painted porcelains in cobalt blue, iron brown, and copper red often demonstrate fresh designs emphasizing original shapes and spontaneous brushwork. They were imbued with a distinctive harmony, vitality, and subtlety. The Seattle bottle, painted in blue with rock and peonies wrapping around the body, is such an example of a typical late-period Korean style (pl. 8.5).

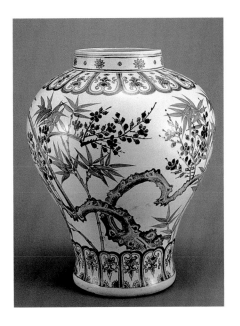

FIG. 1. Korean jar, mid-15th century. Porcelain with underglaze-cobalt decoration of plum and bamboo, h. 16⅛ in. (41 cm). Yongin, Korea, Ho-Am Art Museum.

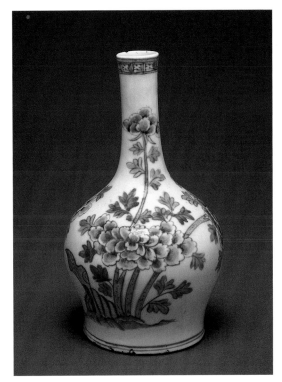

PL. 8.5

Bottle
Korean, Chosŏn dynasty, c. 1800–1850
Porcelain with underglaze-blue decoration
H. 8 in. (20.3 cm)
Gift of Frank S. Bayley III in memory of Dorothy Stimson Bullitt, 82.127

The Chinese Trademark: Blue-and-White and Its Influence on Asian Wares 93

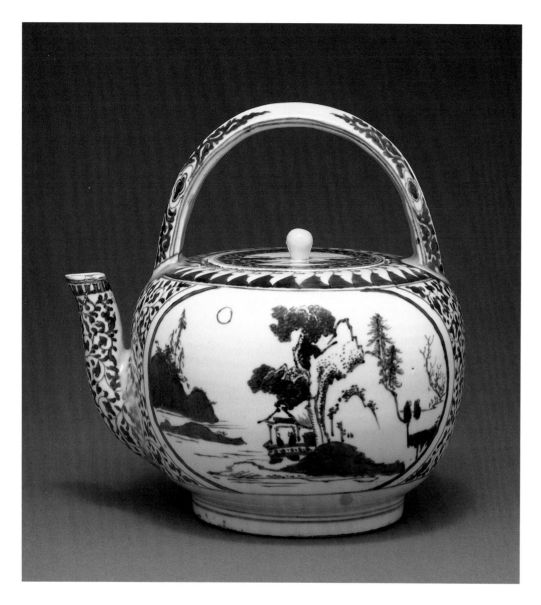

PL. 8.6

Ewer

Japanese, Edo period, c. 1640–50
Shoki Imari ware, porcelain with
underglaze-blue decoration
H. 8⅞ in. (22.5 cm)
Eugene Fuller Memorial Collection, 70.11

The landscapes in the oval panels, one
on each side of this ewer, recall the
Chinese style in both brushwork and
motifs. Such paintings were meant
to evoke an ideal natural atmosphere
rather than representing a real scene.
Retreating to nature or reposing in
a pavilion in natural surroundings, as
depicted here, was a typical ideal of the
Chinese literati.

Japan

The start of Japanese porcelain production was greatly facili-
tated by the expertise of Korean potters, who came to Japan
most likely as captives of Toyotomi Hideyoshi's (1537–1598)
army at the end of the sixteenth century. They helped dis-
cover the porcelain stone in Izumiyama in Arita, Kyushu
island. They were responsible for introducing the climbing
kiln (*noborigama*) capable of temperatures to around 1300°C,
and also potters' crafts including the underglaze-iron paint-
ing technique. About the same time, responding to the Ming
Wanli emperor's tolerance of overseas trade, Chinese blue-
and-white porcelains were quickly regaining dominance in
the ceramics market. The growing demand for and interest

in Chinese blue-and-white ware spurred Japan's production. The first Japanese blue-and-white porcelain was made in around 1620 at the Arita kilns in Saga (Hizen) prefecture, where glazed stoneware had been made using methods similar to those of Korea. It is therefore natural to find that early Japanese blue-and-white porcelain wares bear both Korean and Chinese potting features and underglaze painting styles. Some even imitated the Chinese character *fu* or Ming imperial marks at the base.[18] Japanese scholars call these early blue-and-white pieces, dating roughly to the first half of the seventeenth century, *shoki* Imari wares, literally, the earliest wares from Imari, the port city a short distance northwest of Arita.

Typical *shoki* Imari features a thick body, a clear glaze with bluish tinge, and sketchy underglaze-blue decoration. The cobalt blue was imported; its bright or dark tones indicate its different origins, generally from the Middle East or China. The bail-handled ewer in the Seattle collection is a fine example of *shoki* Imari (pl. 8.6). It is datable to the second half of the seventeenth century, as the influence of the Chinese blue-and-white of the so-called Transitional period (c. 1620–1683) is plainly visible.[19] On the other hand, its large size is reminiscent of similarly shaped Chinese ewers of the late sixteenth century, which in fact had the same mouth diameter but were slightly taller.[20]

Shoki Imari ware was warmly embraced by Japanese scholars and fit nicely into the environment advocated by the Japanese tea ceremony of the time. In this context, and judging by its large size, the Seattle ewer is very likely to have been used as a freshwater jar (*mizusashi*) in the tea ceremony. The ewer also gives a sense of the novelty and vigor much favored at that time.

The popular demand for blue-and-white greatly advanced the porcelain industry in Arita, which also gained additional though unintentional assistance from Jingdezhen around the middle of the century, when porcelain production was halted by the disturbances caused by the dynastic change from Ming to Qing. The Arita porcelain industry boomed to such a scale that between 1650 and the mid 1700s, it was able to supply Japanese, Southeast Asian, and European ceramics markets all at the same time.[21] By the late seventeenth century, a new style of Japanese blue-and-white porcelain, *ai* (indigo) *kakiemon,* emerged with distinctive Japanese characteristics (fig. 2); the few remaining traces of Chinese blue-and-white nearly

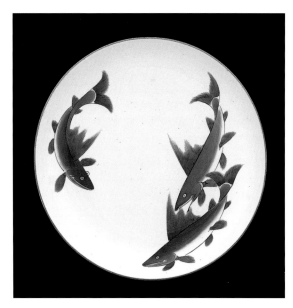

FIG. 2. Japanese plate, *ai kakiemon* type, before 1711. Porcelain with underglaze-blue and iron-brown decoration. Seattle Art Museum.

disappeared. Such Japanese blue-and-white porcelain tended to emphasize the delicacy of the painting and the refinement of the white body. Motifs were often composed in asymmetrical designs balanced masterfully by the plain, unpainted spaces. Short brush strokes used on the earlier blue-and-white porcelain were largely replaced by outlines and filled-in washes that were to a great extent responsible for the tranquillity and refined taste of the painting. Japanese blue-and-white porcelain of this tradition remained, together with overglaze enameled wares, the essence of Japanese porcelain production in the following centuries.

The Middle East

Leading ceramics centers in the Muslim world attempted to reproduce almost every type of Chinese ceramics that arrived in their lands. In terms of porcelain, Tang white wares were imitated in Fustat during the ninth and tenth centuries, while Song white and *qingbai* wares were prototypes preferred by Iranian potters in the twelfth century, the Seljuk period (1038–1194).[22] Although Abbasid potters in Iraq rarely made monochrome-white wares, their renowned lusterwares and painted polychrome wares, like those from other Islamic pottery centers, reflected Chinese influences in the use of opaque white glaze.

The use of cobalt blue was, however, a Muslim preference

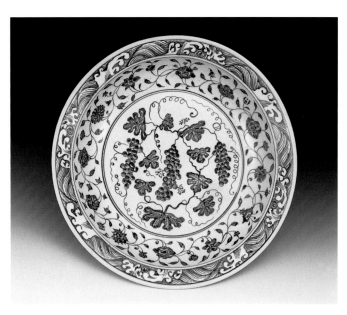

FIG. 3. Chinese Jingdezhen plate, 1426–35. Porcelain with underglaze-blue decoration. Shanghai Museum.

in the Middle East. Among the early Islamic painted wares, cobalt blue appears to be the most important metal oxide used for decoration. Abbasid potters in the ninth century produced what is, so far, the earliest cobalt-blue painting over opaque white glaze. The style then spread throughout the Muslim world, as attested by abundant archaeological finds not only in Samarra, where they formed a distinguished group, but also in Iran, Syria, and Egypt.[23] Seljuk blue-decorated wares were actually underglaze blue painted on a white slip and then covered with a transparent glaze. The Seljuk potters of Iran were thus responsible for the invention of underglaze cobalt blue in the Muslim world.[24] In China, a few shards excavated at the Tang city of Yangzhou bear underglaze-blue decoration with a style and motifs that closely resemble those on Abbasid blue-painted wares, an unmistakable influence of Islamic ceramics. But since the technique of underglaze painting was not yet known in the Abbasid period, the Tang underglaze blue apparently reflects the native tradition of underglaze decoration developed and commonly used in the Changsha kilns in Hunan province. Underglaze blue itself, however, was not widely used in Tang China, and it seemingly soon disappeared until the first half of the fourteenth century, when the demand of the Muslim regions for blue-and-white porcelain raised it from oblivion into

the limelight and to a great extent conditioned its shape and decoration.

The ensuing centuries saw an ingenious transformation of Islamic features and their blending with native Chinese conventions in the decorative repertoire of Chinese blue-and-white. A major change occurred in the early fifteenth century. The massive, robust forms of the Yuan style, and sometimes their geometrically oriented decoration and dense layout, persisted, but pictures of delicate floral sprays and traditional Chinese motifs, such as the bird-and-flower theme, often became main subjects and were set against a spacious background (fig. 3).

Turkey and Iran

The renowned Ottoman blue-and-white wares of the early sixteenth century imitated Ming blue-and-white of the fifteenth century. A large plate made in Iznik, Turkey, for example, resembles a Chinese original in the Shanghai Museum collection in shape and decoration (pl. 8.7). But actual prototypes most likely were provided by the collection of early Ming Chinese blue-and-white in the Topkapi Palace in Istanbul, which was assembled from war booty taken by the Turks in Iran, Syria, and Egypt during the Ottoman conquests of the 1520s. Many other blue-and-white plates of the same grape-vine subject, like this one in The Metropolitan Museum of Art (pl. 8.7), bear additional turquoise, green, or red colors that enhance the blue tones (pl. 8.8).[25]

Iranian potters also imitated imported Chinese blue-and-white porcelain during the Safavid period (1502–1722). Production of imitations particularly flourished in the mid-seventeenth century, when supplies from China were temporarily suspended because of China's internal political turmoil. A notable group of such wares are those modeled after the style of the so-called Kraak ware, the late Ming blue-and-white porcelain exported from China (see pls. 8.9, 9.2), while many others of the seventeenth and eighteenth centuries often feature Chinese-inspired designs with a distinctive Persian taste.

—J.C.

PL. 8.7

Plate

Turkish, Ottoman period, c. 1525
Iznik ware, pottery with underglaze-blue and
turquoise decoration
Diam. 15⅛ in. (38.4 cm)
The Metropolitan Museum of Art, Harris Brisbane
Dick Fund

Though closely imitating the Chinese prototype,
this plate also reveals some interesting differences
in the relationship of the vessel shape to the layout
of its decoration. In Chinese prototypes, when the
cavetto of a plate is continuous (see fig. 3), a con-
tinuous floral scroll would usually decorate it.
Correspondingly, the rim of the plate would also
be circular. When the cavetto is lobed, say, in
twelve brackets, twelve single units of floral spray
would appear, one in each bracket, and the rim
of the plate would be accordingly lobed. The
painted, double-line border marking the central
well would also correspond to the profile of the
cavetto and rim. There was thus a clear correla-
tion between the shape of the vessel and the
layout of motifs. Such meticulous adherence to
geometrical precision was seemingly a result of
the influence of Islamic art, but ironically, it was
lost or disregarded when the Iznik potters copied
Chinese prototypes.

The rim of this Iznik plate is foliated in nine
brackets, but the border of the central well is a
double-outlined circle. The cavetto is continuous
but decorated with ten individual floral sprays.

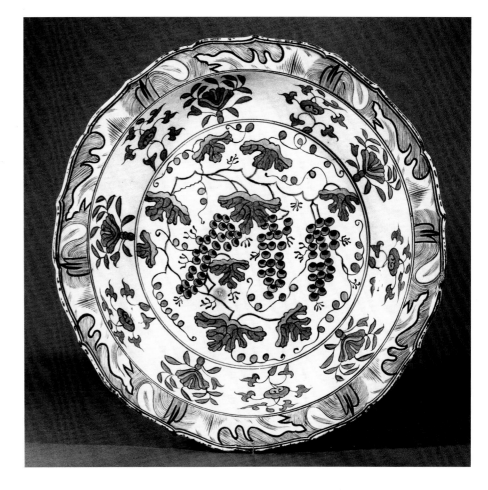

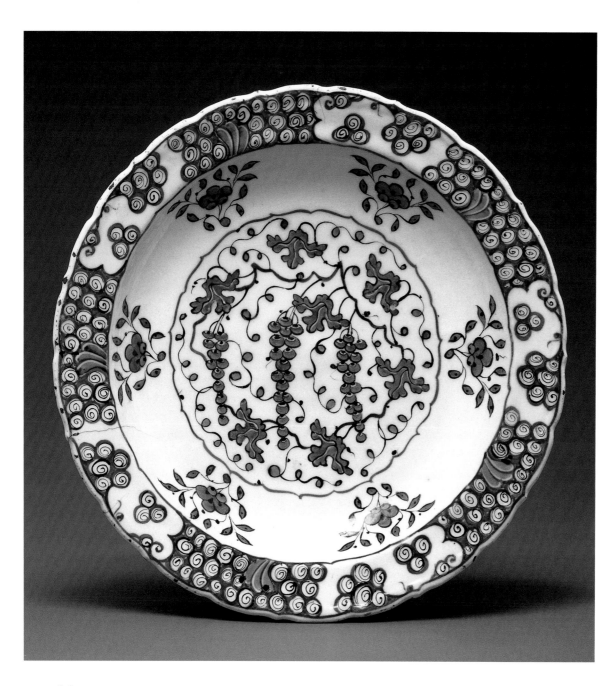

PL. 8.8

Plate

Probably Syrian (Damascus), Ottoman period, late 16th century
Pottery with underglaze-blue, black, and sage-green decoration
Diam. 12 in. (30.5 cm)
Eugene Fuller Memorial Collection, 57.17

Motifs are outlined in black and filled with blue and sage-green hues. The exterior is decorated with five florets alternating with six grass pattterns. The design of this plate, in terms of its form, motifs, and palette, appears more reminiscent of that of the Iznik plate (see pl. 8.7) than of Chinese Ming prototypes.

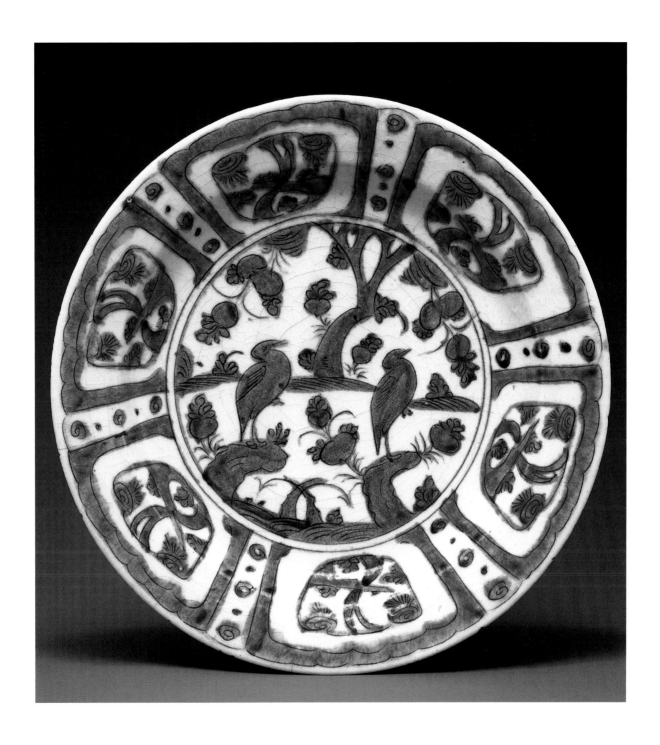

PL. 8.9

Plate

Iranian, Safavid period, 17th century
Pottery with underglaze-blue decoration
Diam. 13⅞ in. (35.2 cm)
Eugene Fuller Memorial Collection, 48.146

Previously known as the Kubachi ware type, named for the town of Kubachi, in today's Daghestan in northwestern Iran, Kubachi wares were, however, likely made in the nearby city of Tabriz. The cracks in the thin glaze are one conspicuous feature of this group, which also has underglaze polychrome decoration. A blue-and-white plate with a similar central bird-and-flower motif is in the Arthur M. Sackler Gallery, Washington, D.C.

Early East-West Trade

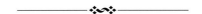

The Crusades, a succession of wars fought by European Christians between the years 1095 and c. 1291 to reclaim the Holy Land from the Muslims, had lasting effects on European civilization. As isolated European crusaders traveled east from their feudal homelands, they were exposed to new philosophies, innovations in science and technology, and new customs and lifestyles. Crusading knights returned to their own lands accustomed to flavorful spiced foods that contrasted sharply with the bland fare at home, and to garments of luxurious materials, such as damask and silk, instead of coarsely woven wool and linen. The aroma and taste of pepper, nutmeg, cinnamon, cloves, and saffron from the distant lands of the Moluccas (Spice Islands) and India evoked a sense of Paradise for medieval Europeans. Spices became a symbol of prestige; they served as gifts of state, were bequeathed from one family generation to the next, and had great value in trade. Pepper, for example, could on occasion substitute for gold.[1]

Throughout these wars, Europe's contact with the Muslim countries along the eastern coast of the Mediterranean that controlled East-West trade also created new markets and stimulated commerce, particularly for the Italian merchant fleets of Genoa, Pisa, and Venice. The established merchant fleets of Italy, active in the Asian spice trade since the eleventh century, provided the transportation that made the Crusades possible. In an ironic twist of cross-cultural history, it was early astronomical and nautical knowledge gleaned by novice Italian sailors from seafaring Arabs that over time enabled a European fleet to deliver crusaders to the door of the Islamic world.

As the Crusades fostered trade and encouraged Europeans to organize and investigate beyond their medieval boundaries, the resulting ventures stimulated research in navigation and improvement of ship designs. Capitalizing on this newly gained knowledge of the seas and distant lands, the Portuguese made forays south in the Atlantic from about 1419, seeking gold along the west coast of Africa and attempting to round the Cape of Good Hope. Their goals were to bypass trade duties and taxes levied by Muslim middlemen on goods traveling through Middle Eastern lands and to discover a direct sea route to sources of Asia's rare and unusual commodities.[2]

Queen Isabella of Spain banked on a westerly route to the Spice Islands. Following Christopher Columbus's exploratory voyage, Pope Alexander VI (1431–1503) audaciously proclaimed a line of demarcation dividing the non-Christian world in half from pole to pole, passing 100 leagues to the west of the Cape Verde Islands (located 300 miles off the coast of Senegal, West Africa). The Papal Bull claimed all lands to the west, the entire "New World," for Spain. Portugal gained lands to the east including Africa and India. The Treaty of Tordesillas (1494) moved the line west, offering Portugal the opportunity to settle Brazil and capitalize on an important Atlantic Ocean current that catapulted them, after decades of exploration down the coast of Africa, around the Cape of Good Hope. Sailing west, the Spanish successfully established the "Manila galleon" trade in the late 1560s; it was founded on their access to the silver from the Americas, especially that of Peru, which was a valued trade commodity in the East. Their return route from the Philippines through Mexico assured a steady flow of spices, Chinese silks, and porcelain into Europe.

Portuguese and Spanish expeditions, circumnavigating the globe to the east and the west, ultimately brought European control of the lucrative East-West trade that had been dominated by Muslim merchants since the earliest days of the Silk Road. Asian trade, via commerce between ports to the east of the Cape of Good Hope, had been active for

centuries, but it was an expanding world economy fueled by the Western desire for spices, medicaments, silks, and porcelain that brought about the greatest change. Maritime exploration by the Portuguese and Spanish, then by the Dutch and English, formed the beginnings of a global network that would become the information highway of its time, opening avenues for the exchange of ideas and beliefs as well as goods.

Vasco da Gama's voyage from Lisbon to India and back between 1497 and 1499 inaugurated the Cape of Good Hope route, which gave Portugal control of the Eastern trade. Various porcelains he had received in India, along with jewels, rare fabrics, and amber, were given or sold to the Portuguese king, Manuel I.[3] In an effort to bypass the established trading ports of India and deal directly with China, the Portuguese arrived at Guangzhou (Canton) in 1517. They were at first denied access, but through arduous negotiations, the Portuguese became the first Europeans to trade directly with the "Terra dos Chins" (Land of the Chinamen).

The Portuguese quickly learned about China's Confucian hierarchy of social rank, which accorded scholars the highest status and merchants and traders the lowest. To conduct business, Westerners had to pose as an official trade mission rather than appear as merchants; the Portuguese established a tenuous arrangement based on the Chinese system of accepting foreign "tributes" in exchange for Chinese "gifts." Tempting fate, the Portuguese bargained for different terms. Relations worsened, culminating in a formal ban on Portuguese trading in all Chinese ports. A spirited period of illegal activity ensued as Chinese junks loaded with contraband arrived at the Portuguese-controlled port of Malacca. After 1533, the Portuguese made regular unofficial visits to Chinese ports.

Because Portugal did not have natural resources or other commodities desired in Eastern markets, the fleet acquired goods to trade along the way. Gaspar da Cruz, a Dominican missionary, documented the illegal but prosperous trade in the *Treatise on Chinese Matters,* detailing the Portuguese sale of products acquired at various African, Middle Eastern, and Asian ports of call. They exchanged pepper, sandalwood, aloes, incense, ivory, and amber for silk, porcelain, rhubarb (known for its healing properties), china root (a remedy for complaints 'that have their origin in cold,' such as gout and shivers), and camphor sold by the Chinese merchants.[4] By 1557, normal relations were reestablished between the two

countries, and the Portuguese were allowed to settle and locate a trading post on the Chinese mainland at Macao. Throughout the sixteenth century, the easterly sea routes to Asia were the domain of the Portuguese. They controlled the route around the Cape of Good Hope and other strategic pinch-points determined by currents and necessary stopovers for water and food along the lengthy maritime passages to the Far East.

The Dutch East India Company

Portugal's trade monopoly with the East, threatened only by the Spanish doing business out of the Philippines late in the sixteenth century, began to erode toward the end of that century. It was difficult to maintain a grip on such a far-flung empire. Eager to seize control of Portugal's lucrative colonies, both the Dutch and English began rounding the Cape of Good Hope and confronting the Portuguese in Asian waters. With good business acumen and ship-building skills, the Dutch soon gained prominence. A new era of East-West trade began in the seventeenth century as maritime and mercantile activities coalesced in the hands of the Dutch.

Perhaps presaging things to come, the Dutch had acted as brokers for the Portuguese spice trade operating from the Moluccas during the previous century of Portuguese domination. In 1595, Philip II of Spain placed an embargo on Dutch trading in all Portuguese ports, so the Dutch set out to establish direct trade in Asia. This enterprise involved pursuing their long-standing interest in the spice trade but also included pirating from their former partners, the Portuguese. They brought the cargoes of two Portuguese carracks, large sailing vessels, captured at sea, to the Netherlands for auction. Surprisingly, blue-and-white porcelain of the late Ming dynasty, more than spices and silks, generated sensational interest at the public sales of the contents of the *São Tiago* in 1602 and the *Santa Catarina* in 1604. Both James I of England and Henry IV of France acquired blue-and-white porcelain in the 1604 sale.[5] The Dutch called the Chinese blue-and-white ware *kraakporselein* (porcelain from a carrack). The word *kraak* soon became a Dutch synonym for Chinese porcelain and is the term by which it is known today.

The Porcelain Trade

The European fascination for Chinese porcelain had grown during the period of Portuguese trade when the treasured

ware became more readily available, although it was mostly restricted to an elite Portuguese clientele and nobility in other European countries. Costly porcelain began to flood into Europe when the Dutch entered the Eastern trade and catered to the captivated European market. Porcelain was one of the high-priority commodities handled by the newly formed Dutch East India Company (Vereenigde Oostindische Compagnie—V.O.C.) founded in 1602.[6] From T. Volker's 1954 study of existing V.O.C. bills of lading, an estimated 3 million porcelain objects were shipped into Europe between 1604 and 1657. More recent research reveals that not all porcelain shipments were registered, especially those consignments handled by private traders, private merchants, or V.O.C. employees, such as the ship's captain and officers, who also shipped on company vessels. The cargo of the V.O.C. *Witte Leeuw,* which sank in the southern Atlantic in 1613 and was salvaged in 1976, contained a large quantity of porcelain not even mentioned in the bill of lading.[7] Judging by the evidence, vast quantities of porcelain, especially blue-and-white, streamed into Europe during the seventeenth century. Kraak ware inspired a tremendous European craze for porcelain.

Porcelain in Painting

Dutch ports teemed with rare and coveted commodities during the seventeenth century, as Amsterdam assumed the mantle of trade and became the European center for commerce and banking. It was the clearinghouse for the steady flow of both Asian goods and European products into and out of European markets. Chinese porcelain coming into the Netherlands during this period was so highly valued that it often appeared in the most extravagant type of Dutch still-life painting, the banquet scene.

In the banquet painting by Abraham van Beyeren (pl. 9.1), a Kraak porcelain bowl takes central focus with a rare nautilus shell, also from an exotic distant place. Found only in deep waters of the South Pacific and Indian Oceans, these rare shells, which in themselves had no value, were treated as precious oddities and given lavish gilt mounts by wealthy collectors. The blue-and-white bowl and mounted nautilus shell share a precarious placement on the table amid a rich array of food, Venetian-style glass goblets, a German *Römer* (wineglass), and Dutch silver. This feast for the eye also, for our purposes, serves to document the wealth of goods circu-

lating through Dutch ports and society during the peak of Dutch power. This opulent display of luxury is balanced by temporal symbols—an open pocket watch, rotting fruit, and the unsettling view of tipped and unbalanced precious objects, alluding to the transient nature of time and pleasures taken from earthly goods. Keeping the "visual extravagance . . . within the bounds of propriety," carefully balancing opulence with a sober message, was a necessity for the conservative Calvinist sensibilities of the Dutch.[8]

The blue-and-white Kraak bowl in van Beyeren's still life dates between 1600 and 1643–46—from the time the Dutch first arrived with large shipments of Kraak ware in the Netherlands to the time of the Hatcher cargo, which consisted of approximately 25,000 Kraak wares and other Chinese porcelains. This cargo was salvaged in 1983 from a Chinese junk that foundered in the South China Sea sometime between 1643 and 1646. Dishes with peach motifs, and dotted pendant decoration similar to that of the bowl in the painting, were also part of this spectacular find.[9]

An earlier date, within the range for this bowl, is indicated by studies of shape and style of decoration undertaken by Maura Rinaldi.[10] Kraak porcelains of the 1640s were more thickly potted than earlier Kraak wares, and the cobalt color had changed from a deep, shaded blue seen in the painting to a lighter, more violet-toned blue. Nevertheless, shapes and decoration of Kraak ware changed remarkably little over the bowl's possibly forty-year span.

Kraak porcelain traditionally has been dated to the reign of the Wanli emperor (1573–1619), with some later wares of similar appearance included in this category.[11] The largest quantity of Kraak porcelain was produced during Wanli's time, but earlier forerunners with Daoist symbols were produced near the end of the Jiajing emperor's reign (1522–1566), and its production continued after Wanli's death in 1620. The presence of Kraak porcelain in the Hatcher cargo proved that it was produced in quantity until after 1640 and was not restricted to the Wanli period.

Decoration on Kraak Porcelain

Kraak porcelain was first produced as late Ming export ware. It was greatly admired in the West for its fine white paste and vibrant decoration in underglaze cobalt blue. Animals such as deer and birds, figures in a landscape, vases filled with flowers, and occasionally Chinese symbols are the central

PL. 9.1
Abraham van Beyeren (Dutch,
1620/1–1690)
Banquet Still Life, c. 1653–55,
signed at left edge of table,
AVB f
Oil on canvas
42⅛ × 45½ in. (107 × 115.6 cm)
Samuel H. Kress Collection,
61.146

decoration of the broad dishes and wide bowls of the most common type of Kraak ware. Wide, flaring panels filled with Daoist, Buddhist, or other auspicious symbols alternating with sprays of fruits or flowers are a distinguishing feature around the plates' wide rims or covering the bowls' interiors and exteriors.

Years of interaction between the Chinese porcelain industry and Islamic potters generated a flow of innovative ceramic shapes and motifs between the two cultures. The format for compartmentalized border panels on Kraak ware (pl. 9.2) originates from the same Islamic banded and patterned-border design of metalwork and ceramic ware that influenced some Hispano-Moresque ware and early tin-glazed Italian works (see pl. 7.3). Within the Islamic format of repeating panels around Seattle's Kraak dish (pl. 9.2), we find Chinese symbols: Daoist emblems and the auspicious Eight Precious Things, denoting good fortune. The four large plants that resemble sunflowers, but with clefts in their fruitlike centers, developed from an earlier and simpler peach motif. The peach, represented on many Kraak wares, is a Daoist symbol meaning 'long life.' The large-veined artemisia leaf, a protection from illness, is often depicted on Kraak porcelain and is found here in one of the large border panels. A distinguishing trait of Kraak ware, seen on this large dish, is the chipping around the rim edges. The Japanese referred to this loss of glaze as 'insect bites,' as though the edge were moth-eaten.

PL. 9.2

Dish

Chinese, Ming dynasty, c. 1610–20
Jingdezhen Kraak porcelain with underglaze-blue decoration
Diam. 20¼ in. (51.5 cm)
Bequest of Joan Louise Applegate Dice, 91.40

A long, weary-eyed, but aggressive dragon curls through styl-ized clouds and flames in the center of the dish. Only about a dozen known dishes bear this motif.[12] The dragon, symbol of the emperor, is rare on Kraak ware. This dish was produced during the declining years of the Wanli reign, as the Ming were increas-ingly besieged by northern Manchu invaders and the court was viewed as weak and corrupt. At this time, the symbol of the dragon may not have been held in such high esteem. The skill-ful painting and its deep, beautifully shaded blue color make this dish a particularly fine example of Kraak porcelain.[13]

Porcelain Trade with Japan

True porcelain was first produced in Japan early in the seventeenth century on the island of Kyushu. Relatively simple in form and decoration, early Japanese wares catered to the local domestic market and developed into a new export item in southern China and Southeast Asia. Fine Chinese porcelain continued to come into Japan until the period of 1633–39, when a series of edicts expelled foreigners from Japanese soil and forbade Japanese maritime trade. Dutch and Chinese traders and some Southeast Asian nations were allowed to bring ships into Nagasaki Harbor on a more limited, fixed schedule. The importing of Chinese wares waned, bolstering the fledgling Japanese porcelain industry and preparing it for the great demand for Japanese porcelain that was to come.

Disruption of Chinese porcelain production at the kilns in Jingdezhen was occurring by 1620 and continued throughout the overthrow of the Ming dynasty in 1644 by the conquering Manchus from the north until the solidification of the Manchu Qing dynasty by 1680. During this period of dynastic transition, the supply of Chinese porcelain exported to Europe dwindled; in 1656, four homebound East Indiamen, ships of the Dutch East India Company, left their great trade center of Batavia on the island of Java with no porcelain on board.[14] Porcelain trade with China continued in such a weak and sporadic fashion that the Dutch East India Company turned to the Japanese porcelain industry to fulfill the pressing consumer demand in Europe. From 1641 until the Japanese policy of *sakoku* (closed country) was lifted in 1854, the Dutch were the only Europeans with direct access to Japan.[15]

PL. 9.3

VOC plate

Japanese, c. 1660–80
Hard-paste porcelain, Imari ware, export type (*fuyō-de*)
Diam. 15⅜ in. (38.9 cm)
Floyd A. Naramore Memorial Purchase Fund, 75.78

At the heart of this plate is the monogram VOC, for Vereenigde Oostindische Compagnie, the Dutch East India Company. Such plates may have been ordered for company use both at the Eastern headquarters in Batavia and at the offices in Holland, but this assumption has never been documented.[16] Two phoenixes, a flowering camellia, and pomegranates swirl about the monogram. Bamboo plants alternate with peonies as the primary motifs in the panel decoration around the rim of the plate.

This type of Japanese export ware was known as *fuyō-de* (hibiscus-type) because of the petal-like panels that radiate from the central motif.[17] The immediate source for this style of compartmentalized border decoration on Japanese export ware was Kraak porcelain.

PL. 9.4

Garniture of five vases

Dutch, Delft, The Metal Pot factory, c. 1710
The central baluster vase is signed by Lambertus van Eenhoorn
(d. 1721)
Delftware, tin-glazed earthenware
Baluster vase and cover: h. 19¾ in. (50.2 cm)
Beaker-shaped vases: h. 17 in. (43.2 cm)
Gourd-shaped vases: h. 16¾ in. (42.5 cm)
Margaret E. Fuller Purchase Fund, 54.81.1–5

The Dutch called a garniture of large vases a *kaststel.* Designed
for display atop a *kast,* a type of high cupboard, or on a chimney-
piece, the concept for these impressive vases was inspired by
Chinese Ming altar vases collected by the Dutch. The enterpris-
ing Dutch potteries, capitalizing on the dearth of blue-and-
white porcelain from war-riddled China during the transition
from the Ming to the Qing dynasty, created a market for Delft-
ware garnitures in sets of three, five, or seven matching vases
that would continue into the next century.[18]

PL. 9.5

Kast

Dutch, c. 1640–50
Rosewood, ebony, and oak
H. 7 ft. 4 in. (223.5 cm)
Margaret E. Fuller Purchase Fund, 91.64

The homes of prosperous Dutch burghers, the great merchants
of Europe in the seventeenth century, prominently featured
kasten on which Chinese porcelain, Delftware, metalwork, or
glassware was proudly displayed. These cabinets also served as
storage for valuable household items such as dinner services,
silverware, and linens.

Delftware

Following years of strife with their overlord, Philip II of Spain (r. 1556–1598), the increasingly Calvinist Dutch declared their independence from Roman Catholic Spain in 1581 but were recognized as the fully independent United Provinces of the Netherlands only in 1648. Throughout these years, the industrious Dutch became increasingly purposeful and prosperous as they developed their role as the "Carryers of the World," as Daniel Defoe called them. Maritime trade in their golden age, the second half of the seventeenth century, ensured the economic prosperity of the country. It also introduced Dutch potters to the wonders of Chinese porcelain.

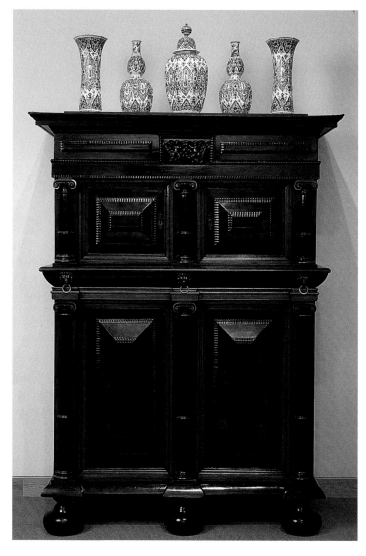

PL. 9.5

The development of a tin-glazed earthenware industry in the Netherlands during the seventeenth century was stimulated by the arrival of Italian ceramics artisans and by the enormous impact of the China trade as the East-West trade passed from the Portuguese to the Dutch. As the taste for maiolica ware declined in Italy, artisans moved north into the Low Countries, bringing the technique for tin-glazed earthenware to the Dutch ceramics industry. Their arrival coincided with large shipments of Chinese blue-and-white porcelain entering Dutch ports at the beginning of the seventeenth century. In Italy, richly colored decoration on tin-glazed earthenware was favored, but at the Dutch potteries, blue-and-white tin-glazed earthenware quickly became fashionable.

Production of tin-glazed earthenwares centered in the town of Delft, where a revitalized ceramics industry coincided with a decline in the Dutch beer-brewing business. As Dutch prosperity increased during the second half of the seventeenth century, Delft's high-quality beer was overshadowed by the fashion for drinking spirits, especially the gin produced in the nearby town of Schiedam, and by increased competition from French wines. Plagued by excise taxes, the brewers made the plausible claim in 1674 that 75 percent of the retail price of beer went to state coffers. In addition to high taxes and changes in taste, the shortage of unpolluted water, essential for the brewing of beer but less critical for the distillation of spirits, forced brewers out of business.[19] Abandoned brick breweries became ideal establishments for potters, who were also concerned about fire. Many potteries kept the names of the former brew houses, such as De Metalien Pot (The Metal Pot) or De Greiksche A (The Greek A). Because tin-glazed earthenware attempted to emulate porcelain, the Dutch referred to their wares as Hollants Porceleyn. Although it was produced in other Dutch cities as well, all tin-glazed earthenware made in Holland is popularly known as Delftware, for its early and largest center of production.

A dense but lively decoration in cobalt blue, seen on Seattle's garniture of vases (pls. 9.4, 9.5), reveals a confluence of Asian influences on European design. During the period of this garniture, the kilns at Jingdezhen, rebuilt in 1683, were active once more in the porcelain trade. Under the rule of the nonisolationist Kangxi emperor, Qing dynasty porcelain arrived in Europe and influenced the Delft potters.

Centrally placed medallions, a popular decorative device on Qing ware of the period, march around the middle of each Seattle vase. Their shapes come from Chinese vases and jars of the Ming and Qing dynasties, which were entering the European market in the seventeenth and early eighteenth centuries. But the overall dense, textural patterns on the garniture evoke another exotic Asian decorative style and rare commodity, the famous shawls of Kashmir, India. Lambertus van Eenhoorn, the decorator of the Seattle vases, was known for his distinctive 'Kashmir' motifs on Delftware.[20]

A love for blue-and-white ceramics inspired by the Chinese and Japanese wares pouring into Europe throughout the seventeenth century, and the European wares that emulated them, has remained a part of Western culture to this day. In the seventeenth century, blue-and-white porcelain and the Islamic and European tin-glazed wares that mimicked it filled entire rooms in palaces. It remained popular throughout the eighteenth century, both as Chinese export ware and in myriads of underglaze-blue patterns on European porcelain. Blue-and-white porcelain in the late nineteenth century filled Claude Monet's dining room at Giverny in spectacular contrast to the lemon-yellow cupboards and walls. While a student at Oxford, Oscar Wilde (1854–1900) proclaimed, "We spend our days looking for the secret of life. Well, the secret of life is art. . . . I find it harder and harder to live up to my blue china." This statement caused an incredible stir. From the pulpit of Saint Mary's Oxford, its vicar, Dean Burgon, berated Wilde: "When a man says not in polished banter, but in sober earnestness, that he finds it difficult to live up to the level of his blue china, there has crept into these cloistered shades a form of heathenism which it is our bounden duty to fight against and to crush out, if possible."[21] Never mind the vicar—the legacy of Chinese blue-and-white porcelain lives on in its countless variety, especially in the English Blue Willow pattern. Dating from the early nineteenth century, it continues to be one of the most popular patterns of all time.

Coffee, Tea, and Chocolate

Three exotic and costly beverages were introduced throughout Europe during the early seventeenth century as Europeans pursued their passion for traveling in search of things foreign, curious, and rare. Each entered in an aura of exclusiveness and mystery.

Chocolate was the first to arrive. Spanish explorers attempting to reach the Spice Islands via a westerly route rather than around the Cape of Good Hope returned from Mesoamerica, the New World, in the early 1500s with a hearty, bitter, cold drink made by the Aztec people from the paste of crushed cacao beans and water. The Spanish court controlled the importation and consumption of chocolate, soon taken as a hot drink, and maintained its monopoly until early in the next century, when chocolate was introduced through royal marriage and trade to the rest of Europe. Tea arrived next, brought in small quantities from China in the sixteenth century by Portuguese and Dutch sailors. A vessel of the Dutch East India Company carried the first commercial shipment of tea to Amsterdam in 1610. The last of the exotic drinks to arrive in Europe was coffee. Native to Ethiopia, the plant and its culture spread to Arabia, arriving in Europe in the early seventeenth century at the termini of the Middle Eastern trade routes—the ports of Venice, Marseilles, London, and Amsterdam.

All three beverages were highly lauded for their medicinal qualities: coffee as an elixir of life, tea as a miracle cure and remedy for gout, and chocolate to ease stomach ailments. All three became beverages to be served on special social occasions; by the eighteenth century, they were consumed daily.[22]

When coffee, tea, and chocolate entered Europe, no serving vessels were specifically associated with their use. European earthenware and metal jugs, tankards, and mugs used for ale and wine, the principal beverages of previous centuries, were not suitable for sipping these hot, costly beverages brewed in very small quantities. Porcelain soon filled this void as the China trade rapidly developed in the seventeenth century. Wealthy Europeans were introduced to thinly potted, translucent-bodied, and lusciously glazed porcelain, a perfect material for small, delicate, and heat-resistant accessories for brewing and serving these exotic beverages. Asian porcelains in Europe had earlier been rare and highly prized objects of wonder. Now, the availability of porcelain, coupled with modish rituals for serving and partaking of the new beverages, made porcelain serviceable. By the end of the seventeenth century, coffee, tea, and chocolate were fashionable throughout Europe, and they gave rise in part to the so-called Age of Porcelain.

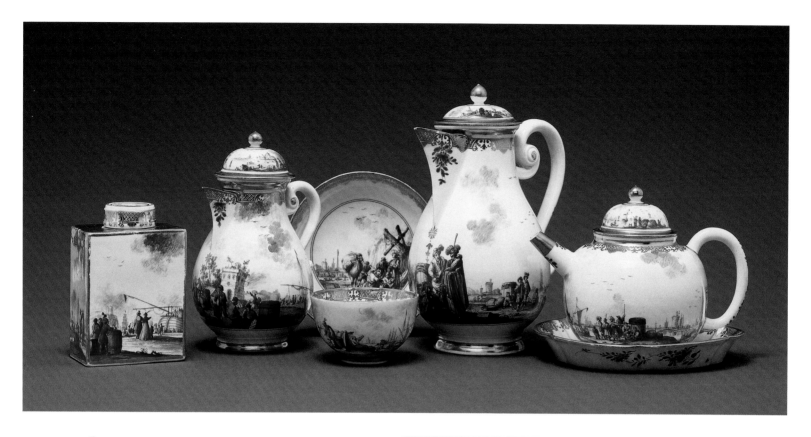

PL. 9.6

Selections from a tea and coffee service

German, Meissen factory, c. 1725–30
Hard-paste porcelain with monochrome iron-red enamel and gilding
Marks: crossed swords in blue; gilder's mark, 99
from left:
Tea caddy: h. 4¼ in. (10.8 cm)
Hot water jug: h. 6½ in. (16.5 cm)
Saucer: diam. 5 in. (12.7 cm)
Tea bowl: diam. 3⅛ in. (8.3 cm)
Coffeepot: h. 8¼ in. (21 cm)
Teapot: h. 5 in. (12.7 cm)
Teapot stand: diam. 6⅛ in. (16 cm)
Gift of Mr. and Mrs. Robert S. Nichols, 91.101

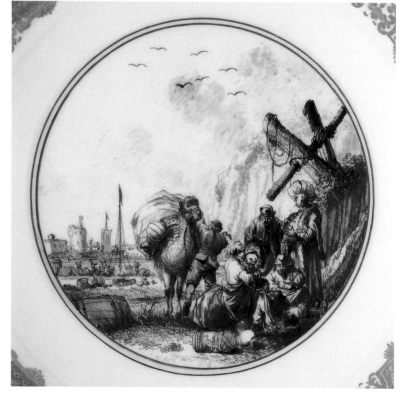

Detail of saucer

Harbor Scenes on Porcelain Tea and Coffee Services

Coffee and tea wares were a major part of the production of Meissen, the first hard-paste porcelain manufactory in Europe. Coffee was the favored drink in Germany, but following the fashions of the French court, German nobility also drank tea. By the time the Germans began to drink tea in earnest during the second quarter of the eighteenth century, the Meissen manufactory was well established; many tea and coffee services of this period were produced in porcelain instead of silver. The costly wares were greatly coveted and would also have been used, along with tea, by the very wealthy.

Bustling harbor activities—docks loaded with barrels and bales of cloth—associated with trade in the seventeenth and eighteenth centuries are featured in the painted scenes on these services. European merchants and townspeople interact with exotic Middle Eastern and Asian-style figures, dressed in silk robes and wondrous plumed turbans or Chinese-style hats, to represent the distant countries in which the beverages originated. Harbor or port scenes, popular on coffee and tea porcelain wares produced at Meissen in the 1720s and 1730s, derived from contemporary engravings that had their origins in landscape and marine painting of the seventeenth century.

Seattle's service (pl. 9.6), painted *en camaïeu* (several tones of the same color) in rare iron red, came into the collection attributed to the first great painter of the Meissen factory, Johann Gregor Höroldt (1696–1775). He was known for his talent as a landscape and figural painter and for his innovative work with enamel colors. His arrival at the Meissen factory in 1720 (a year after the death of its founder, Johann Friedrich Böttger) established a new artistic direction for Meissen. Höroldt's innovative pictorial motifs and his development of brilliant new colors quickly eclipsed the artistic quality and rather dull, impermanent colors that had plagued porcelain decoration in Böttger's time.

In 1721, Höroldt hired his first assistant, Johann Georg Heintze (b. 1706), who with another protégé, Christian Friedrich Herold (1700–1779), became proficient in the harbor scene genre introduced by Höroldt.[23] As a result of difficulties in distinguishing between the work of the master and his student, this service has also been attributed to Herold. The matter is complicated by the fact that individual artists were not allowed to sign their works out of courtesy to the royal patronage of Augustus the Strong and his son, Augustus III, and as a symbol of factory solidarity. A few autograph wares exist, but they reside in the porcelain collection housed in the Zwinger in Dresden, or in other distant collections, making direct comparisons difficult.

These beautifully painted scenes offer the marvelous detail, such as the intricate rigging of a ship, and the sure hand of a master that is evident in Höroldt's signed work. The facial features of the figures on the Seattle service are, like Höroldt's famous faces, defined and individualized. Yet clustered groups of two or three rather plump figures and tower ruins sprouting foliage and grasses in the background are characteristic of Christian Friedrich Herold's scenes.[24] In addition to harbor scenes, this service features another of Herold's hallmarks, a winter scene with thatch-roofed huts and ice-skaters painted on the teapot stand. In Höroldt's favor is the outstanding quality of painting on this iron-red service when compared with the colorful scenes on Seattle's other service, attributed to the student, Herold.

In the polychrome service (pl. 9.7), attributed to Herold, plump figures with round faces wear exotic clothing of the East as well as ordinary Western dress. They stand in groups of two or three at quayside, surrounded by crated trade items near masted ships. Herold's colored enameled scenes fill a low-horizon landscape under soaring skies full of glowing, violet-blue and peach-colored clouds. A small box signed by Herold in the porcelain collection in Dresden exhibits enameled elements like those on the Seattle tea and coffee service.[25] The harbor and winter scenes on the Seattle coffeepot and teapot are reserved in purple luster and gilt cartouches.[26]

—J. E.

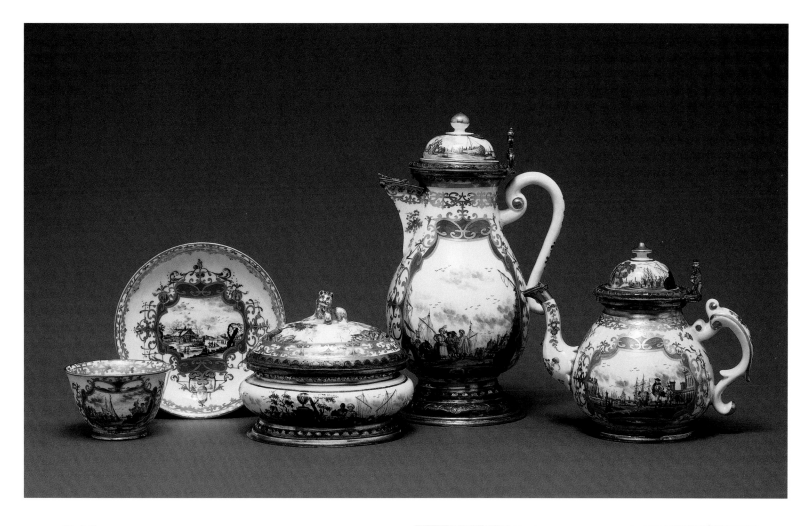

PL. 9.7

Selections from a tea and coffee service

German, Meissen factory, c. 1730–35
Hard-paste porcelain with polychrome enamel and gilding
Painted in the style of Christian Friedrich Herold
Marks, porcelain: crossed swords in underglaze blue; gilder's
mark, 76
Silver-gilt mounts: mark of Augsburg, Germany; maker's
mark, P.S. (J. P. Schuch, d. 1745)
from left:
Tea bowl: diam. 3 in. (7.6 cm)
Saucer: diam. 4⅞ in. (12.4 cm)
Sugar box: h. 3¾ in. (9.5 cm)
Coffeepot: h. 8⅜ in. (21.3 cm)
Teapot: h. 5 in. (12.7 cm)
Gift of Mr. and Mrs. Robert S. Nichols, 91.102

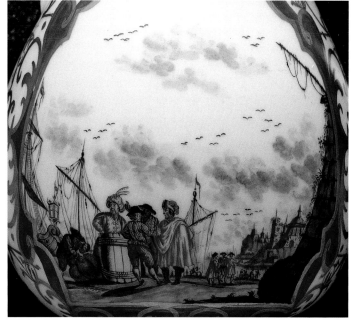

Detail of coffeepot

Imperial Patronage
and
Princely Enterprises

CHINA: FROM COMMERCIAL MARKETPLACE TO IMPERIAL PALACE

In China, periods of political instability and economic uncertainty often correspond to times of significant artistic innovation and change.[1] Under the Mongols in the fourteenth century, blue-and-white porcelain was produced on a large scale for the first time. The seventeenth century saw not only the demise of the Ming dynasty (1368–1644), as the Manchus, a seminomadic tribe from China's northeast, conquered China and established the Qing dynasty (1644–1912), but also the revitalization of the porcelain industry by the shifting of patronage and the opening of new markets.

Related socioeconomic factors at work in China during the late sixteenth and early seventeenth centuries stimulated new markets for Jingdezhen porcelain, thus compensating for the cessation of imperial patronage by 1620.[2] One significant factor was the opening of trade with Asia and Europe.

From 1567 onward, China relaxed its overseas trade restrictions with all countries except Japan, which enabled the exchange of goods such as porcelain and silk for silver coinage. Dutch and English ships carried huge quantities of porcelain to Europe. For example, between 1602 and 1682, the Dutch East India Company transported more than 16 million Chinese ceramics to Europe.[5] The influx of silver encouraged rapid growth in the material prosperity of the merchant and literati classes. Thus the first thirty years of the seventeenth century were prosperous, especially in southern China, and the demand for porcelain was high in both foreign and domestic markets.[6] Though not affordable by ordinary people, contemporary porcelain was not highly valued in late Ming China; earlier porcelain and stonewares were considered collectible, but porcelain vases and dishes of the day were

PL. 10.1

Set of five dishes

Chinese, Ming dynasty, Tianqi reign (1621–1627)
Kosometsuke, porcelain painted in underglaze cobalt blue
Diam. 5¾ in. (14.6 cm)
Loan from the Asian Art Museum of San Francisco,
The Avery Brundage Collection
Gift of Effie B. Allison

Produced in sets of five, an unheard-of number to the Chinese, but the number desired by the Japanese for teaware, these *mukozuke* dishes, made to hold delicacies, were placed on a lacquer tray.[3] They display the whimsy and freedom of the late-Ming porcelain painter. The tiger and pine tree motif engagingly varies from one dish to the next, the tiger appearing more like a large cat than a ferocious beast. *Kosometsuke* was produced for the Japanese market primarily during the Tianqi reign.[4]

simply an integral part of a well-to-do household, as they are today.[7]

How did these new foreign and domestic markets impact style? After the death of the Wanli emperor and the lifting of trade prohibitions with Japan in 1620, Japanese markets made known their needs and aesthetic preferences. One large category of Chinese porcelain of the early seventeenth century, produced for Japan during the Tianqi period (1621–1627), is referred to as *kosometsuke* or "old blue-and-white."[8] Generally roughly potted and freely painted, in Japan these wares served as daily tableware and for the tea ceremony. The asymmetrical designs, unusual shapes, and charming, often amusing, underglaze-blue motifs, such as the comical tigers on a set of small plates (pl. 10.1), were a purposeful response by Chinese potters to Japanese taste in tea accoutrements. In contrast to the perfection of Chinese imperial wares, *kosometsuke* dishes celebrate imperfection, the suggestion of the individuality of the potter, and rustic simplicity.[9]

New Themes: Landscape and Narrative

'Transitional porcelain' is a term that describes ware produced between 1620, when the Wanli emperor died, and 1683, the year in which the Qing dynasty reestablished governmental supervision at Jingdezhen. Transitional porcelain, formerly little studied because of its nonimperial status, is compelling because, in addition to new foreign markets, it reflects the tastes and interests of the moneyed Chinese elite —merchants and literati. During those years, the kilns, both official and commercial, no longer routinely reproduced a set of overused traditional design elements. Freed from governmental control, the Jingdezhen porcelain industry explored exciting new directions, most notably landscape and narrative subjects.[10]

Landscape, formerly a subordinate motif in ceramic decoration, suddenly filled the expansive surfaces of tall, cylindrical forms, as seen in Seattle's superb vase, a rare example of a complex landscape brilliantly painted in polychrome (pl. 10.2). This emergence of landscape as a primary motif on seventeenth-century porcelain reflects the responsiveness of the porcelain industry to newly expanded markets, especially the literati.[11] In times of political uncertainty and dynastic change, the natural world was perceived as eternal and unchanging in contrast to the ephemerality of human life and

institutions. Despite the establishment of a non-Chinese dynasty, the landscape was inalterably a part of China and Chineseness. Among the landscape conventions shared by painting and porcelain in the seventeenth century are contorted rocks and overhanging rock cliffs, prominent intertwined foreground trees and patterned foliage, and a strong sense of spatial depth created by diagonal receding waterways, layered rocks in parallel brush strokes, and distant peaks of wash.

The seventeenth century, a tumultuous period in which the Chinese Ming dynasty was overthrown by the Manchu Qing dynasty, was an age in which restless landscape imagery dominated Chinese painting. Early in the century, the great master Dong Qichang (1555–1636) rethought, revitalized, and redirected the art of landscape painting (fig. 1), and many literati painters followed his lead, each developing a distinctive mode of personal expression.[12] Given their fondness for landscape painting, the literati elite, who were poets and painters, and the upwardly mobile merchants, who emulated literati lifestyles, provided a ready market for porcelain decorated with landscapes.

The evolution of landscape styles on porcelain and by what means new developments in landscape painting were transmitted to those who drew the designs for porcelain produced at Jingdezhen needs further investigation. Two modes of transmission have been identified. The first are the paintings owned, and in some cases painted, by members of the literati class, scholar-officials who held posts in Jiangxi province and were painters themselves, for example, Mi Wanzhong (1570–1628). Their work and paintings in their collections are possible sources of inspiration. Comparisons reveal shared approaches to form and composition.[13] Yet they differ: whereas painters on paper and silk created individual, self-expressive styles, the anonymous porcelain painters, like woodblock artists, tended to follow the stylistic trends of their time.

A more concrete and obvious source of transmission of style and subject are woodblock illustrations, which, having markedly improved in quality by late Ming times, enjoyed heightened popularity and were widely disseminated in the sixteenth and seventeenth centuries. Sinuous, horizontal clouds and distant peaks are among the conventions linking woodblock-printed landscapes to landscape paintings on

Cylindrical vase

Chinese, Qing dynasty, Shunzhi reign (1644–1661)[14]
Jingdezhen ware, porcelain painted in underglaze cobalt blue and
polychrome enamels
H. 18½ in. (46 cm)
Eugene Fuller Memorial Collection, 72.75

Curiously, polychrome decoration is comparatively rare on
seventeenth-century Transitional porcelain, and this tall vase
is a particularly fine example because of the high quality of
its painting and potting.[15]

The landscape composition, adeptly wrapped around the
circular form and unified by cloud formations, is consistent
with works by late-Ming to early-Qing painters such as Dong
Qichang (see fig. 1). The dynamic, often turbulent landscapes
so expressive of seventeenth-century painters' inner worlds reso-
nated in landscapes painted by porcelain specialists on three-
dimensional surfaces.[16]

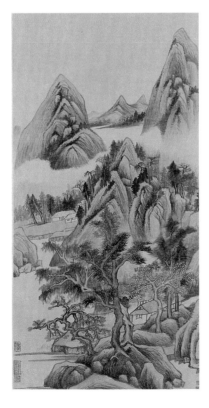

FIG. 1. Dong Qichang
(1555–1636), *Reminiscence of
Jian River* (c. 1620). Hanging
scroll, detail, ink and color
on paper. Loan from the Yale
University Art Gallery, gift of
Leonard C. Hanna, Jr., B.A.
1913, Mrs. Paul Moore, and
Anonymous Oriental Purchase
Fund.

Reverse of vase,
PL. 10.3

PL. 10.3

Cylindrical vase

Chinese, Ming dynasty, Chongzhen reign (1628–1644)[17]
Jingdezhen ware, porcelain painted in underglaze cobalt blue
H. 17¾ in. (45.1 cm)
Anonymous loan

Superbly painted in brilliant blue, the scenes depict three well-known characters in *The Romance of the Three Kingdoms* by Luo Guanzhong (c. 1330–c. 1400), which narrates the unsuccessful exploits of a brotherhood sworn to reestablish the Han dynasty after its fall in the third century.[18] Figuring prominently on the vase is Lord Guan, an exemplar of martial skill and moral rectitude, identifiable by his celebrated sword, Blue Dragon. The other scene features Lord Guan's constant companions, his son Guan Ping and Zhou Zhuang, who holds the reins of Lord Guan's legendary horse, Red Hare. When this vase was produced, Manchus and warlords were constantly challenging Ming rule; heroes like Lord Guan, however, were in short supply.

porcelain. During the Ming dynasty, woodblock printing became more specialized as artists, not carvers, created compositions that were increasingly elegant and refined.[19]

Not only geographical proximity but also commercial networks linked the centers of woodblock printing in Anhui and Fujian provinces with Jingdezhen. For example, the Huizhou merchant guilds in Anhui province were involved both in woodblock printing and in the distribution and sale of Jingdezhen porcelain. The influence of woodblock prints on porcelain production is well established, especially in the choice of scene or subject matter and stylistic conventions, such as small hooked lines for grass or diagonals to create deep spatial recession.[20]

As the domestic market for porcelain and woodblock prints expanded dramatically among the affluent, not only landscape but also narrative themes deeply embedded in Chinese culture provided a rich source of subject matter for porcelain decoration (pls. 10.3, 10.4). Scenes from historical novels enjoyed a high degree of popularity and often can be read as political commentary.

A good example is *The Romance of the Three Kingdoms* (San'guo yanyi), a fourteenth-century historical novel based on events that took place in the third century, just after the fall of the great Han dynasty. The novel, along with related dramas and oral tales, revolves around themes of conflicting loyalties, resistance to foreign rule, and futile efforts to piece back together a failed dynasty once celebrated for its enlightened governance. In the last years of the Ming dynasty, these themes resonated. No doubt the issue of loyalty to a failing dynasty confronted many. *The Romance of the Three Kingdoms* was among the first historical tales to be issued in a woodblock-illustrated edition in the fourteenth century.[21]

Just like popular figures in woodblock illustrations, the main characters of a story painted on porcelain, such as Lord Guan with his imposing sword (pl. 10.3), were immediately recognizable to a Chinese audience. Understandably, the depiction of familiar characters from beloved tales, historical or fictional, had strong appeal and enhanced the attraction of contemporary porcelain, which not only enlivened and beautified interiors but also reflected relevant, indeed pressing, issues of the day.[22]

At least two technical improvements account for the high caliber of late Ming blue-and-white porcelain. Good-quality kaolin from Mount Gaoling was now available to private kilns for use in preparing body and glaze. Furthermore, the cobalt from Zhejiang, used for underglaze-blue pigment, attained a new level of brilliance and depth after the Wanli period, because ore was refined by smelting instead of the earlier, less effective technique of washing.[23] The beauty of the painting was further enhanced by the reintroduction of subtle gradations of wash, ranging from very pale tones to a deep luminous blue. At the outset of the Qing dynasty, potters built on these technical refinements and continued the lively styles of late Ming Transitional porcelain.

By 1644, decades of incompetent rule, delegation of power to corrupt eunuchs, overspent coffers, unpaid soldiers, and natural disasters had severely weakened the Ming dynasty. In that year, the rebel Li Zicheng captured Beijing, but shortly thereafter, he was supplanted by the Manchus, who established the Qing dynasty (1644–1912). As the Manchus consolidated their rule over South China during the Rebellion of the Three Feudatories, in 1674, Jingdezhen was pillaged and burned. The destruction caused a brief pause in porcelain production; by 1683, however, the kilns were rebuilt, and in that same year, Zang Yingxuan, the first imperially appointed Qing dynasty supervisor of the imperial kilns, arrived in Jingdezhen. From 1683 until 1756 and the death of Tang Ying, the last great supervisor of the imperial kilns, Jingdezhen porcelain production experienced its last peak period, reaching a level of technical perfection unattained in earlier times.

With the reestablishment of imperial control in the second half of the seventeenth century, themes with any hint of political resonance that could be interpreted as unflattering to the new rulers disappeared, and apolitical tales, most notably *The West Chamber* (Xi xiang ji), increased in popularity. A tale of passionate consummated love between a young, struggling scholar and an aristocratic beauty, *The West Chamber* was considered inappropriate to perform, or even to be seen reading, in polite Confucian society,[24] yet the slightly erotic and risqué nature of this drama undoubtedly added to its entertainment value and appeal as a subject for porcelain decoration (pl. 10.4). This engaging romance was the most enduring source for narrative scenes on porcelain, first appearing on fourteenth-century blue-and-white, increasing in popularity as the seventeenth century progressed, and carrying over into early eighteenth-century porcelain.[25]

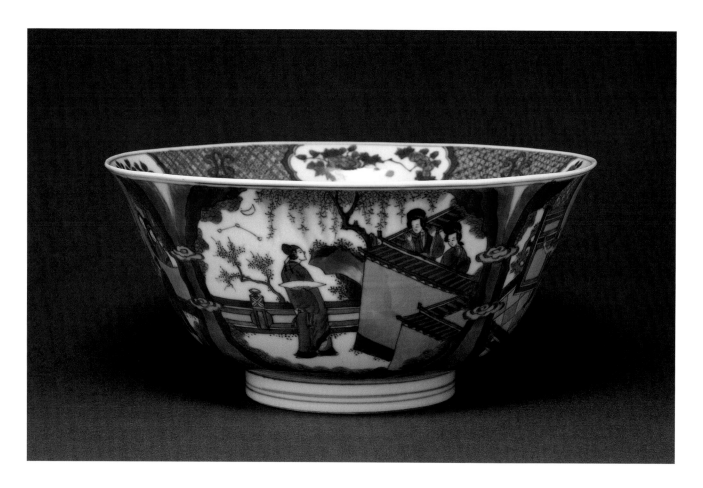

FIG. 2. *Burning Incense and Worshiping the Moon* (Qiangjiao lianyin), from Ming edition of *The West Chamber* (Xi xiang ji). Reproduced in *First Series of Old Editions of Theatrical Musicals* (Guben xiqu congkan chuji), Zhang Zhendao, ed.

PL. 10.4

Bowl

Chinese, Qing dynasty, Kangxi period, c. 1700[26]
Jingdezhen ware, porcelain painted in underglaze cobalt blue
Diam. 8¼ in. (21 cm)
Gift of Mrs. John C. Atwood, Jr., 70.42

The fourteenth-century drama *The West Chamber* tells of a poor scholar, Zhang Sheng, seen here holding a fan, who falls passionately in love with Oriole, an aristocratic beauty. In this night scene, from behind a high wall and accompanied by her clever maid, Crimson, Oriole smiles at scholar Zhang, her hands raised in delight. Shining above them are constellations thought to determine the lovers' fate. The scene appears to represent the two lovers by moonlight in the secrecy of the monastery garden. The narrative continues around the exterior of the bowl with three more scenes from the story: a ceremony at the monastery in memory of Oriole's late father; scholar Zhang handing a letter to monk Huiming; and General Du Que breaking the seige of the monastery.

In the Seattle bowl on *The West Chamber* theme, the spatial divide of the wall and the placement of figures are similar to earlier woodblock-printed illustrations of the same scene (fig. 2). Such prints are integral to the visual culture of seventeenth-century China. General compositional similarity suggests the importance of prints as a source for narrative scenes painted on porcelain.

In the center of the bowl (detail) is a rebus. Five boys fight for a helmet (*kui*), a homophone for another character that means first place in the civil service examinations.[27] This is yet another example of how porcelain decoration often had meaningful associations for those for whose delectation it was made.

Landscape, too, retained its popularity well into the Kangxi period, further exploring stylistic trends begun in late Ming–early Qing Transitional wares. On a large, handsome vase in the Seattle collection, controlled gradations of blue accented by the white of the porcelain body depict a magnificent landscape setting populated by scholars at leisure (pl. 10.5). This vase is among the folk or nonimperial wares that represent the best of Kangxi blue-and-white. These stunning blue-and-white landscapes have a painterly brilliance that captured the attention of Europeans as well as the Chinese.

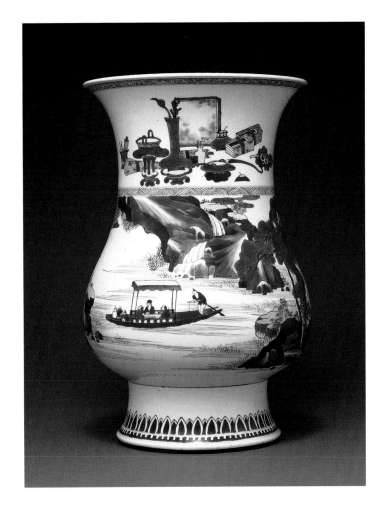

Detail showing rebus of five boys, PL. 10.4

PL. 10.5

Vase

Chinese, Qing dynasty, Kangxi period, 1700–1715[28]
Jingdezhen ware, porcelain painted in underglaze cobalt blue
H. 13½ in. (34.3 cm)
Eugene Fuller Memorial Collection, 33.1183

Monumental rocks and waterfalls encircle the vase, serving as spatial divides for scenes of scholars enjoying the beauties of nature as they relax and drink wine on a leisurely boat trip on the river.[29]

The upper register features the "hundred antiquities," an arrangement of bronze and ceramic vessels, books and paintings, and a *ruyi* scepter in front of a table screen. In keeping with the conservative intellectual climate of early Qing, this theme underscored the Manchu rulers' appreciation of Chinese antiquity and Chinese learning, promoting the legitimacy of the Qing dynasty.[30] Like early Qing calligraphy, which sought inspiration in high antiquity, this porcelain form is based on a *zun,* an ancient bronze wine-vessel type.

Imperial Porcelain: Qing Monochrome Wares

Nowhere is the technical finesse of Qing imperial porcelain more evident than in the striking array of monochromes produced for both ceremonial and daily household use by members of the imperial court. Without doubt, these single-color glazes, so demanding in their composition and firing, represent the greatest achievement in porcelain production during the Qing period. Using copper as a colorant in the glaze, Jingdezhen potters created the deep brilliant red of oxblood glazes (pl. 10.6) and the soft blush of peachbloom (pl. 10.7). Cobalt produced a wide range of tones from deep midnight blues (pl. 10.8) to pale luminous hues (pl. 10.9). And iron, the most ubiquitous glaze-coloring agent throughout Chinese ceramics history, at the hand of the porcelain master matured into light green (pl. 10.10), buttery or lemon yellows (pl. 10.11), speckled tea dust (pls. 10.12, 10.13), as well as café au lait, iron-rust, coral reds, and pinks—an unprecedented range of colors and visual effects.[31]

Glaze technology is a fascinating subject that preoccupies ceramics specialists (potters, scientists, and historians) who seek to reconstruct the composition and preparation of body and glaze, firing temperature, and kiln atmosphere required to achieve a particular color or effect. Among the most elusive and fascinating are the copper-red monochrome glazes, which are extremely difficult to control.[32] Porcelains with copper-red glazes were fired in wood-burning kilns primarily in a reduction (low oxygen) atmosphere. This vivid deep red was achieved by a concentration of only 0.1–0.5 percent by weight of colloidal copper, not by human blood or gems, as some tall tales suggest.[33]

Copper is second only to iron in frequency of use as a colorant in Chinese glazes.[34] Among the most technically sophisticated glazes involving copper is peachbloom, which is associated with the imperial kilns in the first two decades of the eighteenth century or late Kangxi period. The soft, variegated pink is achieved by sandwiching metallic copper, not copper oxide, between layers of clear glaze and firing it under both reduction and oxidation.[35] Where the copper migrates through the top layer of glaze, it oxidizes green. On the Seattle water pot (pl. 10.7), three dragon roundels incised into the porcelain are accented with a spattering of fine moss-green spots.[36]

From the fourteenth century on, the Chinese used cobalt oxide pigment to paint directly on porcelain. When it was covered with a clear glaze, the result was dazzling blue-and-white porcelain. Even earlier, in the Tang dynasty (618–906), cobalt was suspended in low-fired lead glaze to create a deep blue.

The term 'celadon' derives from the name of the shepherd Celadon, a character in the seventeenth-century French play *Astrée,* based on a novel by Honoré d'Urfé (1568–1625). The gray-green of Celadon's costume became the most fashionable color of the time. In the nineteenth century, the term 'celadon' was used to describe high-fired green-blue ceramic wares and glazes colored by a small percentage of iron oxide and fired primarily in a reducing atmosphere, and to identify ceramics with such a glaze. Subsequently the term was applied to a wide range of green glazes.

The technical brilliance of the eighteenth-century Jingdezhen potter is shown to advantage in unusual glazes, such as tea dust (*chaye mo*). The speckled effect was created by underfiring the iron oxide glaze. Precedents for this type of glaze are found in Tang and early Song stonewares of North China.[37] Tea dust was among the glazes revived and perfected under the leadership of the master potter Tang Ying, who was also supervisor of the imperial kilns.

PL. 10.6

Vase

Chinese, Qing dynasty, Kangxi period, 1700–1715
Jingdezhen ware, porcelain with copper-red glaze
H. 17¾ in. (45 cm)
Eugene Fuller Memorial Collection, 50.59

One name for these rich deep reds of the Kangxi period is Lang ware (*langyao*) because Lang Tingji, who from 1705 to 1712 was governor of Jiangxi province, where Jingdezhen is located, was charged by imperial decree with reinventing Ming copper-red monochrome glazes. Oxblood (*sang de boeuf*) is another name for this glaze. Where the glaze is thin on the mouth rim and base of this vase, no color remains except a pale crackled green. Where the glaze is thick and saturated with copper, it turns toward a black hue. Subtle variations of vibrant deep red enliven the entire surface of the vase. The flowing glaze stops suddenly just above the foot, an effect requiring consummate control, and one which later potters were unable to re-create.

PL. 10.6

PL. 10.7

Beehive water pot

Chinese, Kangxi reign mark and period (1662–1722)
Jingdezhen ware, porcelain with peachbloom glaze
H. 3⅜ in. (8.5 cm)
Eugene Fuller Memorial Collection, 53.23

Peachbloom glaze is limited primarily to eight prescribed
shapes, all made to grace a scholar's desk.[38] The shape of this
water pot, which was used to pour water onto an inkstone
to facilitate the grinding of ink, is known in Chinese as
"[Li] Taibo's wine jar" (*Taibo zun*), a reference to the Tang
poet Li Bai, who loved to drink and who is often portrayed
leaning on a pot of wine (see pl. 12.39).[39]

PL. 10.8

left:

Bowl

Chinese, Qing dynasty, Yongzheng reign mark and period (1723–1735)
Jingdezhen ware, porcelain with pale cobalt-blue glaze
Diam. 4⅝ in. (11.9 cm)
Gift of John C. Atwood, Jr., 70.38.1

right:

Two bowls

Chinese, Qing dynasty, Kangxi reign mark and period (1662–1722)
Jingdezhen ware, porcelain with dark cobalt-blue glaze
Diam. 4⅞ in. (12.3 cm)
Eugene Fuller Memorial Collection, 37.72.1–2

Porcelain glazed in monochrome blue was produced in the fourteenth century and thereafter and attained new heights in the late seventeenth and early eighteenth centuries, when blue glazes ranged from rich, deep purplish blues to a pale, ethereal sky blue. These bowls bear imperial marks, and each is one of a pair.

PL. 10.9

Dish

Chinese, Qing dynasty, Qianlong reign mark and period (1736–1795)
Jingdezhen ware, porcelain with pale cobalt-blue glaze
H. 1½ in. (3.8 cm)
Eugene Fuller Memorial Collection, 35.239

Archaism came into vogue in the early Qing period, reaching a peak during the Qianlong reign. Potters looked for inspiration to bronze and ceramic forms of the distant past. This footed dish resonates with the past, echoing the search for the antique feeling of highly refined imperial stonewares of the Song dynasty.[40] Though different in color and composition from Song antecedents, the soft blue glaze of the dish, colored by light concentrations of cobalt, reinforces the allusion to earlier courtly monochromes.

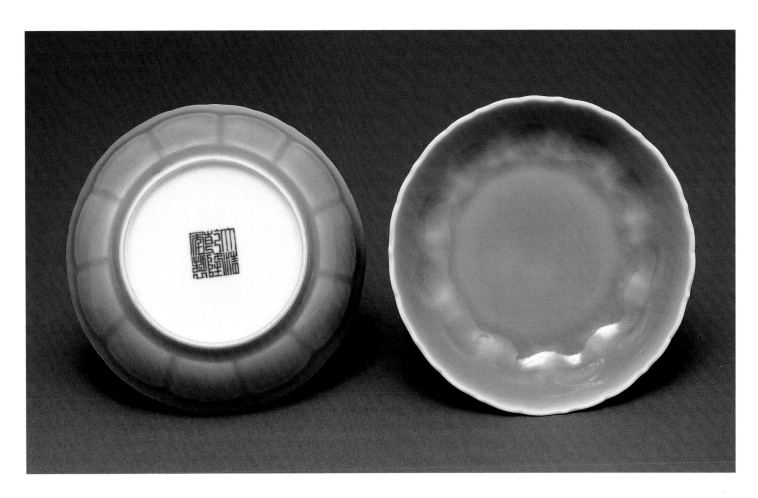

PL. 10.10

Pair of dishes

Chinese, Qing dynasty, Qianlong reign mark and period (1736–1795)
Jingdezhen ware, porcelain with celadon-green glaze
Diam. 4⅝ in. (11.8 cm)
Eugene Fuller Memorial Collection, 44.118.1–2

Celadon glazes appear on the earliest Chinese high-fired wares
and were used continually in later centuries; their color and
smoothness are akin to jade.[41] In the Qing dynasty, celadon
glazes on a white porcelain body created soft, luminous greens
and blues. In the molded and incised petal designs of these ele-
gant small dishes, the glaze darkens, creating a subtle interplay
of light and dark.

PL. 10.11

Pair of bowls

Chinese, Qing dynasty, Yongzheng reign mark and period (1723–1735)
Jingdezhen ware, porcelain with iron-yellow glaze
Diam. 4 in. (10.2 cm)
Gift of Mrs. John C. Atwood, Jr., 70.37.1–2

This exquisite pair of bowls is of the type designated for use at
the imperial court by a concubine of the first rank—white inte-
rior and yellow exterior. To create imperial yellow, the porcelain
body and clear glaze were fired first to a high temperature. Once
the piece had cooled, a yellow enamel glaze of silica, lead, and
iron oxide was applied on top of the clear glaze and fired at a
lower temperature.

PL. 10.12

Vase

Chinese, Qing dynasty, Yongzheng reign mark and period (1723–1735)
Jingdezhen ware, porcelain with tea-dust glaze
H. 11⅝ in. (29.5 cm)
Gift of Mrs. Floyd C. Shank, 65.60

This well-proportioned *meiping* (prunus vase), with its broad
shoulders and high-gloss, spinach-green glaze, bears an impe-
rial Yongzheng reign mark written in seal script on the glazed
base. Referred to in Qing dynasty texts as "imperial kiln official
glaze," tea dust appears to have been reserved for use at the
imperial court.[42]

PL. 10.12

PL. 10.13

Gourd-shaped flask with two handles

Chinese, Qing dynasty, Qianlong reign mark and
period (1736–1795)
Jingdezhen ware, porcelain with tea-dust glaze
H. 18½ in. (47 cm)
Eugene Fuller Memorial Collection, 37.109

Tea-dust glaze contains 6 to 10 percent iron
oxide by weight. Tea-dust monochromes were
reduction-fired gradually to high temperatures
of 1200–1300°C, then slowly cooled, resulting
in the olive-green cast of this glaze. Like many
late Qing imperial porcelains, the large scale
of this flask enhanced its presence and attrac-
tiveness as decoration. A piece of paper affixed
to the base documents its sale in 1882 as part of
the Hamilton Palace collection (see chap. 2).

Some of the exquisite imperial monochromes were desig-
nated specifically for use in state ceremonies, such as sacrifices
to Heaven and Earth, which were central to the life of the
imperial court, as they established the legitimacy of the dy-
nasty and sustained harmony within the empire. A symbol-
ism rooted in antiquity determined the color appropriate
to each occasion and ceremonial place: blue for the Altar of
Heaven, yellow for the Altar of Earth, red for the Altar of
the Sun, and white (or pale blue) for the Altar of the Moon.
In addition to ritual vessels of porcelain, the emperor's

robes accorded with these specified colors on ceremonial
occasions.[43]

Just as state ceremonies, overseen by the Court of Imperial
Sacrifices, were carried out according to minutely detailed
rules, daily court life was also precisely regulated. The num-
ber and color of porcelain for household use was assigned
according to rank. Generally speaking, the higher the rank,
the more yellow, since yellow was the imperial color and was
prohibited for common people. For example, *Regulations of
the Palace of the Qing Dynasty* specifies yellow for the empress,

empress dowager, and by omission the emperor; yellow outside and white inside for a concubine of the first rank (see pl. 10.11), and yellow with green dragons for second- and third-rank concubines.[44] This textual source confirms that official wares, produced at Jingdezhen and bearing the imperial reign marks, were ordered by the Court of Imperial Entertainments and intended for court use according to precise rules and regulations.[45] The emperor also bestowed imperial porcelain, including monochromes, as gifts on special occasions.

While texts describe the regulated and often hierarchical use of some types of imperial porcelains, the specific function (or functions) of most porcelain is impossible to determine. Use also changed over time. For example, an elegant polychrome bowl might be an eating utensil at the time it was produced, then several generations later, it might be raised to the status of prized antique and placed on an ornate stand.[46]

Imperial Porcelain: Polychrome Enamels

At Jingdezhen, the first half of the Qing dynasty was an era of experimentation and brilliance not only in the realm of monochrome glazes but also in polychrome enamels. Low-fired enamels are finely ground pigments or colorants suspended or dissolved in a silica compound rich in lead oxide to lower its melting point.[47] First used on porcelain in the first half of the fifteenth century, colorful enamels painted on top of a transparent glaze were often combined with cobalt blue painted under the glaze in *doucai,* or "interlocking colors," style. In the sixteenth century, colorful overglaze enameled porcelain was produced in great abundance along with blue-and-white, to satisfy the Jiajing and Wanli courts' insatiable demands. In the seventeenth century during the late Ming–early Qing Transitional period, however, it was made in far smaller quantities (see pl. 10.2).

In the reign of the Kangxi emperor (1662–1722), *famille verte* (green family) enamels reached their apogee.[48] The name, coined by the nineteenth-century collector Albert Jacquemart, derives from the dominant shades of green that distinguish this palette with its watercolor-like, translucent colors plus opaque red and black.[49] The Kangxi *famille verte* dish (pl. 10.14) has a design of pomegranates and tangerines painted in washes of dark and light green, light turquoise, yellow, and aubergine on a prefired body. Characteristic of

Qing potters' love of combining multiple decorative techniques in one piece, a design of sinuous imperial dragons, totally unrelated to the fruit, was incised into the porcelain body before firing; it is visible beneath the painted decoration only upon close examination. Or a sumptuous combination of contrasting colors could be achieved by surrounding underglaze-blue floral motifs with an overglaze enamel ground of deep yellow (pl. 10.15). Such complex decorative techniques, which required repeated firings, attest to the sophisticated taste of imperial patrons and the technical accomplishment of early Qing porcelain specialists at Jingdezhen.

Influenced by the technologies of European glass and enamels on metal, Chinese porcelain specialists creatively expanded the palette of colors, opacity, and tonal range of overglaze enamels used for porcelain decoration.[50] The newly introduced enamels of the *famille rose* palette—arsenic white, gold ruby-red, and lead-tin yellow—differed in composition and preparation from their European counterparts. First introduced at Jingdezhen around 1720, *famille rose* enamels were widely employed a decade later and, by 1750, had completely replaced the *famille verte* palette.

Why did the new palette become predominant so rapidly? What impact did technological innovation—the introduction of these new pigments—have on style? Answers are suggested by a comparison of the *famille verte* dish with fruit design (pl. 10.14) and the handsome, large dish decorated with flowering plum, camellia, and lichen elegantly painted in *famille rose* enamels (pl. 10.16). Whereas the painter of the *famille verte* plate employs black line and stippling to give depth and texture to the flat green leaves and translucent fruit, the *famille rose* painter uses the new opaque white to achieve delicate gradations of color. Plum blossoms, for example, are exquisitely rendered in opaque white enhanced by pale shades of pink and green. The camellia leaves twist and turn in space, changing subtly from pale yellow to light green to deep blue-green. The exquisite composition and fine detailing of this monumental dish and the diminutive cup with tree peony and dragonfly (see pl. 10.17) display the painterly effects of *famille rose,* effects not possible with earlier polychrome enamels.[51] These two pieces and the medallion bowl (see pl. 10.18) bear the mark of the Yongzheng emperor (r. 1723–1735), during whose reign *famille rose* porcelain reached its peak.

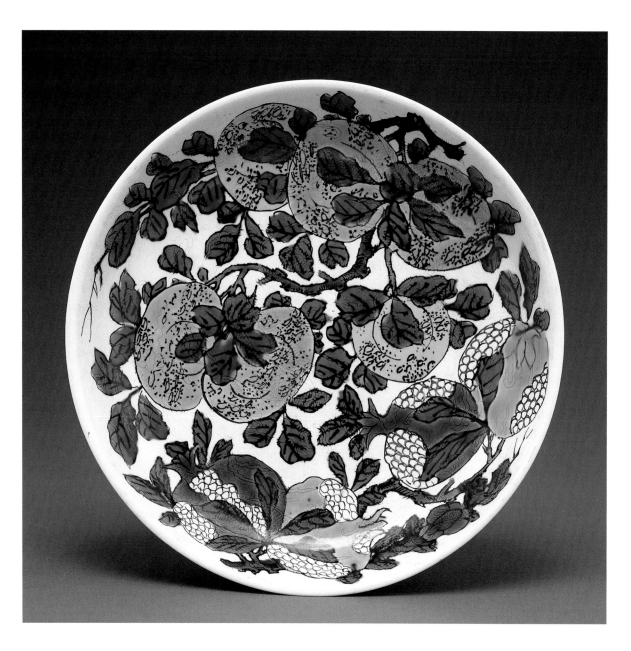

PL. 10.14

Dish

Chinese, Qing dynasty, Kangxi reign mark and period, 1680–88[52]
Jingdezhen ware, porcelain incised and painted in enamels
Diam. 9¾ in. (24.8 cm)
Eugene Fuller Memorial Collection, 56.166

Su sancai (plain three colors) represents one type of *famille verte*. After being formed, while still in a leather-hard state, the porcelain body was incised on the interior and exterior with a design of two lively dragons chasing a flaming pearl. It was then fired. *Famille verte* enamels, minus iron red, were then applied on the prefired biscuit body to paint heavily laden branches of tangerine and pomegranate, a potent symbol of the wish for many offspring. Black lines and stippling detail the design, enhancing the vivid colored washes, and a covering of clear glaze heightens the design. A Kangxi reign mark is written in underglaze blue within a double circle on the base.

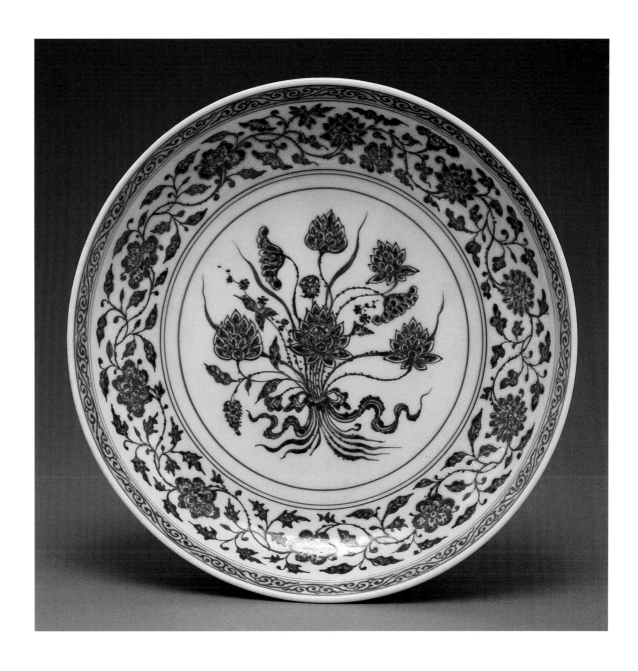

PL. 10.15

Dish

Chinese, Qing dynasty, Yongzheng reign mark and period
(1723–1735)
Jingdezhen ware, porcelain painted in underglaze cobalt blue
and overglaze yellow enamel
Diam. 10⅞ in. (27.7 cm)
Eugene Fuller Memorial Collection, 36.60

Qing dynasty porcelains often evoke the past, especially highly
esteemed blue-and-white wares of the fifteenth century. The
basic design scheme of this dish—a narrow band of classic scroll
at the rim, flower scroll in the well, and at the center, a bouquet
of lotus and other water plants, all painted in rich underglaze
blue—derives from classic early Ming blue-and-white. The im-
perial yellow ground, which creates a striking contrast with the
deep blue, also echoes imperial porcelain of the fifteenth and
early sixteenth centuries.[53] This dish, while referencing the past
and paying homage to tradition, has a sumptuous beauty akin
to an embroidered imperial silk robe.[54]

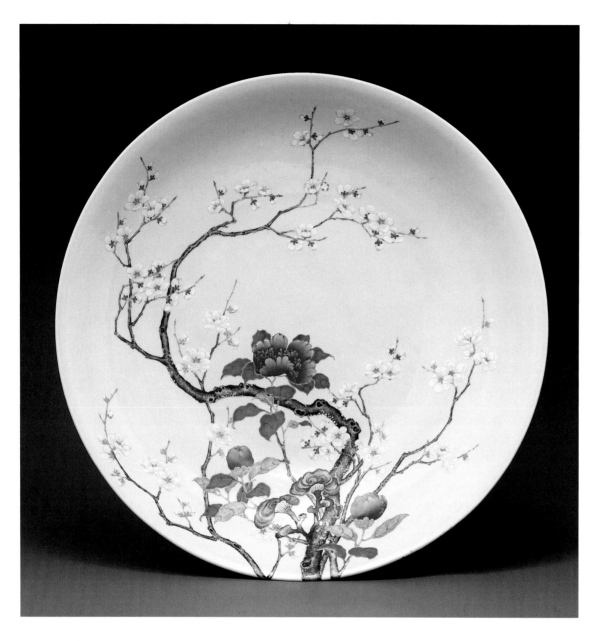

PL. 10.16

Dish

Chinese, Qing dynasty, Yongzheng reign mark and period (1723–1735)
Jingdezhen ware, porcelain painted in overglaze *famille rose* enamels
Diam. 19¾ in. (50.2 cm)
Loan from the Collection of Henry and Ruth Trubner

A refined courtly aesthetic characterized by bright color, love of fine detail, and desire for technical perfection pervades the arts of the Qing dynasty palace. This exceptional dish embodies the courtly aesthetic, its monumental scale reflecting its imperial origins. The stately branches of blossoming plum, extending over the edge, use to advantage the plate's spacious circular ground. The understatement of the delicate plum blossoms, softly toned in white on white, complements the rich, saturated orange-red of the camellia. The combination of camellia and blossoming plum symbolizes the first month of the year and the passage from winter to spring.

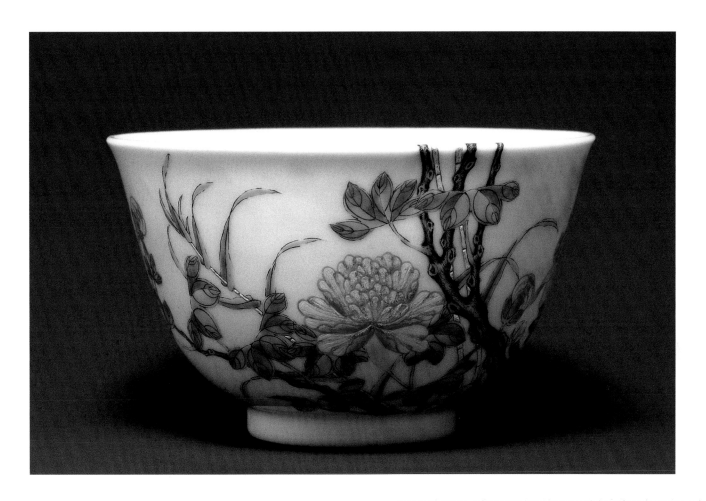

PL. 10.17

Cup

Chinese, Qing dynasty, Yongzheng reign mark and period (1723–1735)
Jingdezhen ware, porcelain painted in *famille rose* enamels
Diam. 3½ in. (8.9 cm)
Gift of Mrs. John C. Atwood, Jr., 70.49

In addition to the dragon and the phoenix, symbols of the emperor and empress respectively, floral motifs were a favored subject of imperial art, regardless of medium: they appeared on textiles, lacquer, cloisonné, painting, and porcelain. Not only striking colors and sensuality gave flowers their appeal, their auspicious meanings also embodied the emperor's beneficence.

The tree peony, or *mudan* (*Paeonia suffruticosa*), known as the king of flowers, has been associated with kingship ever since the Tang dynasty (618–906), when a craze for peonies swept the palace.[55] As the flower of wealth and rank, it also expresses the wish for prosperity and, in addition, signifies spring. To drink from this elegantly painted porcelain cup and discover the dragonfly in the interior must have been a delight.

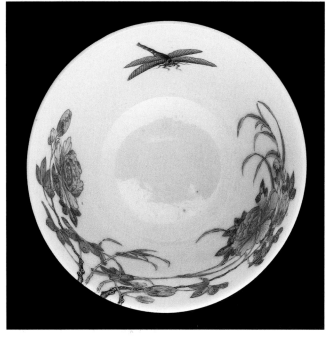

Interior of cup

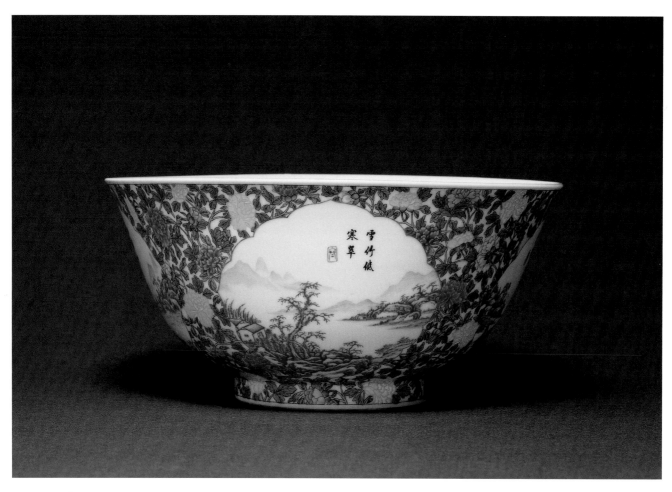

PL. 10.18

Bowl

Chinese, Qing dynasty, Yongzheng reign mark and period (1723–1735)
Jingdezhen ware, porcelain painted in *famille rose* enamels
Diam. 6¼ in. (15.9 cm)
Eugene Fuller Memorial Collection, 33.55

As is characteristic of Yongzheng porcelain, this bowl's interior is plain white, while the exterior is richly painted.[56] Landscapes of the four seasons appear in reserve medallions. Akin to a monochrome ink painting, the landscapes bear a short poetic inscription; however, the seal is not the name of the maker, but rather a standard character specifying the season. This scene is winter (*dong*); the poem reads: "Bending low, the snow-covered bamboo still glints a cool emerald-jade green."[57] While the magenta landscapes accord with painting styles popular at the Qing court, the porcelain painter enhances the landscape medallions by placing them against a colorful millefleur ground, most prominently, interlaced herbaceous peonies.[58] The overglaze-blue imperial reign mark on the base suggests that the decoration of this bowl was done in the enameling workshop within the imperial palace in Beijing.

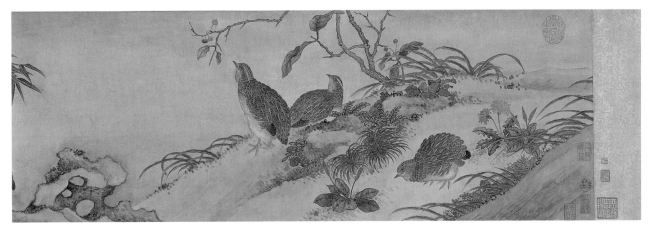

FIG. 3. Xu Yang, *Everlasting Contentment*, 1773. Section of handscroll, ink and color on paper. Loan from the Yale University Art Gallery. The Banker's Trust Company Foundation and the Karen Y. Wang Funds.

At the eighteenth-century Qing imperial court, the arts of painting and porcelain were more closely allied than ever before, owing to the technical advance of *famille rose* enamels, which enabled porcelain painters to achieve effects comparable to, though different from, their scroll-painter counterparts. The Yongzheng and Qianlong emperors' intense interest in the arts was no less central to artistic cross-fertilization and the evolution of a unified style at court. Scroll painters were inspired by elegant porcelain design, and porcelain artists, especially those working within the imperial palace, were conversant with court painting. By imperial command, painters best known for scrolls and albums periodically worked on porcelain in the enameling workshop.[59] Thus, strong imperial patronage stimulated a fascinating courtly alliance between painting (fig. 3) and porcelain, celebrating refined design, brilliant color, and exquisite detail—hallmarks of Chinese imperial art regardless of medium or era.

Palace records dating to the Yongzheng reign document the fact that the enamels used to decorate these and other porcelains were produced in the imperial glass factory, one of twenty-eight imperial workshops located within the palace precincts in Beijing. Enamels were then sent to Jingdezhen. While the majority of Qing imperial porcelain was decorated at Jingdezhen, some white, undecorated porcelain vessels were also shipped from Jingdezhen to the imperial palace, where they were painted in the enameling workshops and fired in a muffle kiln (pl. 10.18). Standards were high and controls tight, as imperial orders specified the precise quantities of each vessel type and design. Only the most daring of porcelain specialists, like Tang Ying, supervisor of the official kilns, dared innovate, risking imperial displeasure.[60]

One of the most intriguing aspects of Qing porcelain production is the influence of Europe. No doubt European enameled metalwork in the Limoges style appealed to the Kangxi emperor and his successors, inspiring the Chinese to create new enamels that enabled them to achieve comparable naturalistic effects. For example, the shading so admired in European painting and enameling was now possible with opaque white. Just as chinoiserie became a vogue in Europe, so, too, did a fascination with Europe and things European capture the imagination of the Chinese imperial court, a fascination fueled by the presence of learned Jesuits, including the Italian painter Giuseppe Castiglione.[61]

In China, both imperial patronage and commercial markets sustained the porcelain industry. If commercial markets at home and abroad encouraged innovation and diversity of style, imperial patronage guaranteed high standards and elegant, if conservative, design. How did Chinese imperial patronage of the porcelain industry compare to that of European royalty who vied with one another for supremacy in porcelain production? As the eighteenth century progressed, the vitality of the Qing court and the imperial porcelain kilns of China began to wane.[62] Yet the porcelain industry in Europe was just entering its heyday.

—M.G.G.

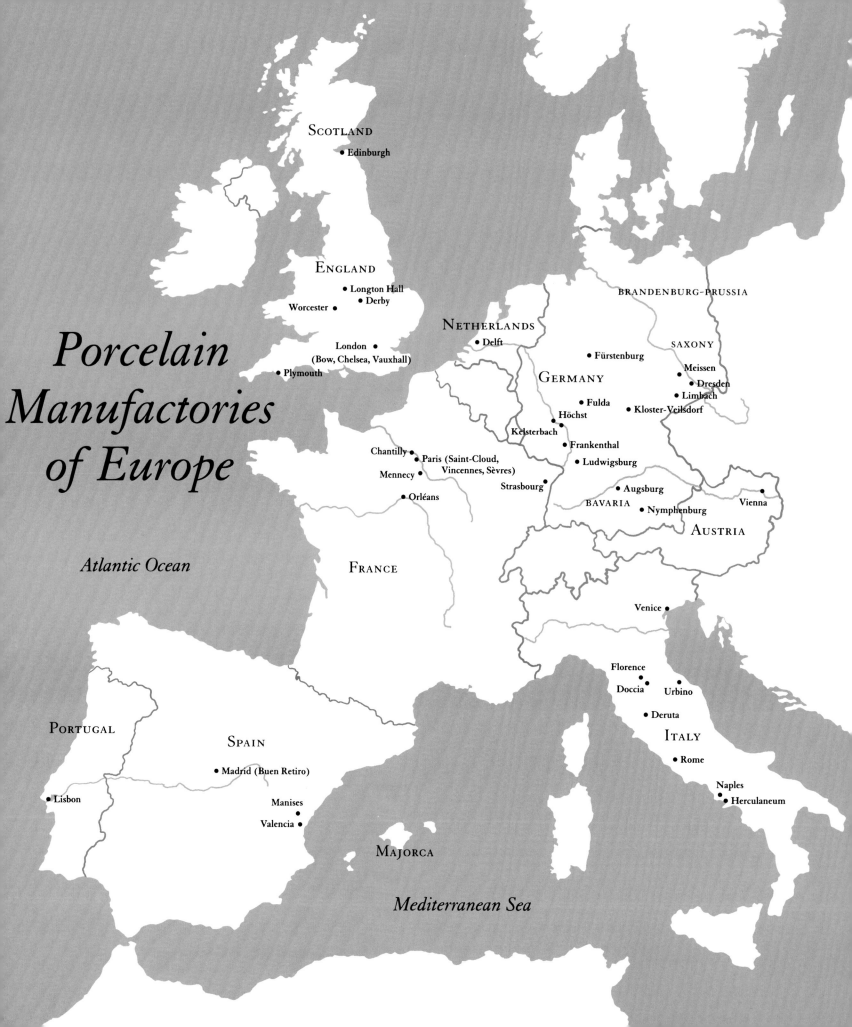

Porcelain Manufactories of Europe

SCOTLAND
• Edinburgh

ENGLAND
• Longton Hall
• Derby
Worcester •
NETHERLANDS
• Delft
BRANDENBURG-PRUSSIA
SAXONY
London
(Bow, Chelsea, Vauxhall)
• Fürstenburg
GERMANY
• Meissen
• Dresden
• Limbach
• Plymouth
• Fulda
• Höchst
• Kloster-Veilsdorf
Kelsterbach •
Chantilly
• Paris (Saint-Cloud,
 Vincennes, Sèvres)
• Frankenthal
Mennecy •
• Ludwigsburg
• Orléans
Strasbourg •
• Augsburg
BAVARIA
• Nymphenburg
• Vienna
FRANCE
AUSTRIA

Atlantic Ocean

Venice •

Florence
Doccia •
• Urbino
• Deruta

PORTUGAL
SPAIN
ITALY
• Rome
• Madrid (Buen Retiro)
Naples •
• Herculaneum
• Lisbon
Manises •
Valencia •
MAJORCA

Mediterranean Sea

II

EUROPEAN PRINCELY COLLECTIONS, ENTERPRISES,
AND DYNASTIC MARRIAGES

During the fourteenth and fifteenth centuries, Chinese ceramics were so rare in Europe that, today, only three documented works are known from before 1500. The earliest is the Fonthill porcelain vase dating from about 1300 (see chap. 2, fig. 1). Nearly two centuries later, the Katzeneln-bogen bowl is listed in the 1483 inventory of the German Landgrave of Hessen-Kassel. A celadon bowl mounted in Europe in silver-gilt, it is described as a gilded goblet with cover made from *Erde von Indien* (Indian earth), an early instance of Europeans equating the terms 'Indian' and 'Asian.'[1] Made from a high-fired stoneware clay body very close in composition and firing requirements to porcelain, it dates from the late fourteenth or early fifteenth century and probably came from Longquan.

The third piece is a Longquan celadon dish included in a group of porcelains presented by Sultan Qā'it Bāy of Egypt to Lorenzo de' Medici in 1487. We also know that the last two pieces resided in special princely repositories for treasures.

PRINCELY COLLECTIONS

Porcelain was so valued that it was placed in select collections housed in special rooms. In France and Italy, such rooms—*études, cabinets,* and *studioli*—were included in the living quarters of the nobility. The desire to purposefully collect objects, such as illuminated manuscripts, or precious gold, silver, and enameled metalwork, for personal pleasure or to share with one's family and friends became evident around the turn of the fifteenth century. In sixteenth-century Germany, objets d'art, rare curiosities from distant lands and seas, and scientific instruments were placed in a room called *Kunst- und Wunderkammer* (cabinet of art and curiosities). In earlier times, the *Schatzkammer* was the family treasury

for jewels, gold bullion, and documents. As it became fashionable to acquire objects and paintings for the sake of purposely forming collections of art, the *Schatzkammer* often served as a repository for art as well; the terms *Kunstkammer* and *Schatzkammer* are often used synonymously.

In 1572, a few years before his innovative work with the soft-paste porcelain known as Medici porcelain, Francesco de' Medici added a second floor to the Uffizi palace in Florence. Built as ducal offices by Giorgio Vasari (1511–1574) for Cosimo de' Medici, the Uffizi would now house the collection of the Medici grand dukes. At the heart of the newly added *galleria* was an octagonal room, the *tribuna,* which replaced the former *studiolo* of the Medici.

The gallery become a repository for mystical natural treasures as well as man-made works of art. Precious gems, a horn thought to have come from a unicorn, an iron nail (half of which had reputedly been turned to gold by alchemy), cloaks of parrot feathers from the Americas, and parade armor shared the space with paintings by Raphael, Michelangelo, and Dürer. Breaking with European beliefs that mysteries of the natural world were best left to God, the questing, humanist ideas of the Renaissance embraced mystical wonders and human achievements. This spirit guided the search for a universal knowledge and the encyclopedic collections that formed in its wake.

Porcelain in Sixteenth-Century Collections

The numbers of porcelain objects included in princely collections swelled as trade developed in the sixteenth century. On his first voyage to India, Vasco da Gama returned with porcelain for King Manuel I (r. 1495–1521), which triggered future orders. In the royal Santos Palace in Lisbon, the

pyramidal ceiling of the "porcelain room" was later embellished with 261 plates, mainly blue-and-white, acquired at various times throughout the century and into the early seventeenth century.[2] In 1570, Queen Caterina (b. 1507), wife of King João III, added more porcelain, ivory fans, Chinese paintings, furniture of black wood (probably lacquered), and Indian crystals and coverlets to her already famous collection. In Lisbon, the Portuguese also sold some porcelain to other European nations, primarily wares imported by the Dutch. In 1580, there were six shops selling porcelain in Lisbon's Rua Nova dos Mercadores.

Porcelain's status as an esteemed princely gift or possession endured even as its accessibility increased. Early records more often reveal small repositories of treasured porcelain items rather than large holdings. Three porcelains arrived in 1509 at Southampton for the newly crowned Henry VIII of England. A Wanli period blue-and-white bowl with silver-gilt mounts in the collection at Burghley House in England is reputed to have been a gift from Queen Elizabeth I (1533–1603) to a godchild. In contrast, the Italian Medici inventories of 1553 had grown to some 400 wares, including 59 celadons and 298 pieces of blue-and-white.

Porcelain in Seventeenth-Century Collections

In the seventeenth century, control of the porcelain trade shifted as Portuguese and Spanish maritime superiority yielded to the Dutch. Both Portugal and Spain concentrated on inter-Asian trade, and they shipped only enough porcelain to meet the demand at home. Under the new leaders in East-West trade, an abundance of porcelain flowed into the Netherlands and was dispersed throughout Europe. In the seventeenth century, porcelain for display and to grace the table became the emblems of high social status, surpassing the previous criterion of using spices in the preparation of food or passing them around the table as a tasty treat during the dessert course.[3] New dining rituals and an increasing trend toward integrating porcelain into interior design, partially inspired by colorfully decorated Japanese porcelain arriving in Europe after the mid 1660s, heightened the fervor for porcelain and the phenomenon known as Chinamania.

Porcelain Rooms

In palaces and homes of the aristocracy and the rising merchant class made wealthy by trade, porcelain rooms were opulent, delightful showplaces. Vases of all sizes, plates, cups and saucers, and figures might cover the walls from floor to

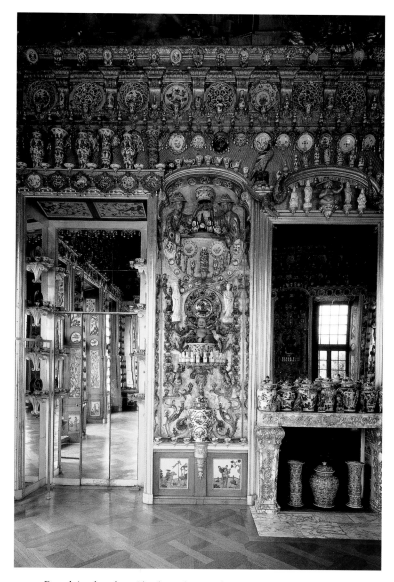

FIG. 1. Porcelain chamber. Charlottenburg Palace, Berlin. Stiftung Preussische Schlösser und Gärten Berlin-Brandenburg Bildarchiv. One of the most famous European porcelain rooms was created early in the 18th century in the Charlottenburg Palace. Built by the Elector of Brandenburg Frederick III (1657–1713) for his wife, Sophie Charlotte, it exhibited their Chinese and Japanese porcelain collection in an orchestrated array of color and form. The room and collection have been skillfully rebuilt since World War II.

ceiling. Placed upon grand fireplace surrounds, on cornices above doorways, and on specially designed wall brackets, porcelain glimmered in mirrored plate glass or created an exotic addition to Asian lacquered wall panels.

Rooms brimming with porcelain became the fashion in palaces from England to Russia. Even though the idea of the porcelain room never really caught on in France, French technology and tastes of the nobility informed the passion for interior ornamentation. Improved French mirror-glass technology made it possible to cover greater expanses of walls, as at Versailles, and the growing desire for things exotic resulted in porcelain's being incorporated in interior design. Royal marriages, especially unions with the Netherlands' House of Orange, encouraged and spread European Chinamania.

The Princess of Orange, Louise Henriette (1627–1667), took her Chinese porcelain with her when she departed The Hague to marry the Elector of Brandenburg-Prussia in 1646. It became the start of a collection of Chinese and Japanese wares that eventually filled four rooms in the Orangenburg Palace near Berlin. Her husband wrote of her obsession with porcelain: "My wife says she is frightened that if there were a fire, the servants would remove the furniture, etc., whereas she is more concerned about the porcelain."[4] When the English queen Mary II (1662–1694) and her Dutch husband King William III of Orange (1650–1702) bought in 1689 the house that would become Kensington Palace, Mary moved in with her porcelain and Delftware. An inventory taken 15 months after her death describes 11 rooms housing 780 porcelains.

The culmination of the porcelain room was the porcelain palace, an installation conceived by Augustus the Strong, Elector of Saxony and King of Poland. His collection of Asian art was crowded into the basement of a small Dresden palace, called the Hollandisches Palais in recognition of the country still in control of the Eastern trade. It was later rebuilt and renamed the Japanisches Palais as Augustus continued to add to his collection of more than 20,000 porcelains, including the largest group of Japanese porcelain outside Japan. Unfortunately, plans for more than 30 rooms and viewing galleries to exhibit not only the Asian collection but also true porcelain from the first European factory at Meissen were left uncompleted following the death of the visionary ruler in 1733.

PRINCELY ENTERPRISES AND DYNASTIC MARRIAGES OF THE EIGHTEENTH CENTURY

In the eighteenth century, respected Chinese and Japanese porcelain wares continued to arrive in bulk in Europe, primarily under the aegis of the expanding English East India Company. But the greatest porcelain story of this time was the advent of the production of true porcelain in Saxony and its radiating impact. The onset of Europe's Age of Porcelain began as kings, electors, princes, and counts eyed the revolutionary success in Meissen and then demanded their own porcelain factories. Inevitably, the secret of the so-called white gold produced at Meissen eventually leaked, and other enterprises lacking the formula for hard paste and the resources to produce it developed improved methods for producing soft-paste, or artificial, porcelain. During the eighteenth century, the flourish of European porcelain factories began as workers defected from the Meissen factory, was further encouraged by the perception that patronage of a porcelain factory enhanced prestige, and was activated through the inspiration and influence of dynastic marriages.

Meissen's closely guarded secret for producing and firing hard-paste porcelain first filtered out as a few disenfranchised workers, disgruntled with prisonlike living conditions, professional rivalries, and low pay, fled or were lured away. With the assistance of Meissen's kiln master, Samuel Stöltzel (1685–1737), who was bribed to leave the factory, a second European hard-paste porcelain factory was up and running in 1719. Founded in Vienna by a war commissioner of Austria, Claudius du Paquier (d. 1751), and a few financial backers, this factory was always underfunded. The Habsburg emperor Charles VI, having embraced the mercantile policy supported by Louis XIV of France and Augustus the Strong of Saxony, took interest in the local enterprise, but unlike Augustus, he offered no financial support. Du Paquier's twenty-five-year imperial patent to produce porcelain expired in 1744. On behalf of Empress Maria Theresa, the state assumed management of the Vienna factory, bringing its first period to an end. The rather scarce porcelain produced during that time is known as Du Paquier porcelain (pls. 11.1, 11.2).

PL. 11.1

Tureen

Vienna, Du Paquier factory, c. 1725–30
Hard-paste porcelain with enamel colors and gilding
H. including monkey finial 7¾ in. (19.7 cm), l. 14 in. (35.5 cm)
Gift of Martha and Henry Isaacson, 69.171

Atop this tureen sits a strange, forlorn-looking monkey. The ethos of depicting apes or monkeys in art started as an early medieval symbol of heresy or paganism and later became a parody of mankind.

In the seventeenth and eighteenth centuries, monkeys were often a satirical symbol of human follies and vanities. *Singeries,* monkeys portraying humans, became popular in the visual language of the mid-eighteenth century. The Meissen factory produced an entire monkey band of figures playing musical instruments.

Rather than a lampoon, the monkey on the Seattle tureen represents the allure of the exotic, just as its Kakiemon-style floral decoration and palette evoke far-off Japan. The *mozaik* ground pattern of the tureen is a variation on the familiar diaper pattern in the baroque style of the previous century. This tureen is from one of the earliest known services produced by the Du Paquier factory. It is popularly known as the Prince Rohan service, a later designation.[5]

Detail showing American Indian

PL. 11.2

Sugar bowl

Vienna, Du Paquier factory, c. 1725
Decorated, probably in Breslau (present-day Wrocław, Poland),
by Ignaz Preissler, c. 1725–30
Hard-paste porcelain with black enamel and engraving
H. 3½ in. (8.9 cm)
Gift of Martha and Henry Isaacson, 69.173

The black monochrome *Schwarzlot* decoration on the covered sugar bowl combines motifs of leaf and strapwork (*Laub und Bandelwerk*) characteristic of baroque style. It incorporates fanciful Asian-style figures, a celebrated decorative element during the first half of the eighteenth century.

The painting is attributed to Ignaz Preissler (1676–1741), one of a number of independent painters who worked at home or in small private studios. These *Hausmaler* decorated porcelain in the tradition of enamel decorators working on metal, glass, and tin-glazed earthenware from the mid-seventeenth century on.

Preissler painted sophisticated enamel decoration on both glass and porcelain. On this bowl, another exotic individual joins the Asian-style figures—a stately American Indian is intricately wheel-engraved inside the sugar bowl (see detail).[6]

Meissen, a Noble Tableware

A glorious medley of the arts resonated throughout Saxony during the final years of Augustus the Strong's life and reign. The success of the Meissen porcelain factory, the addition to the royal *Kunstkammer* of dazzling objets d'art, splendid court festivals held in the baroque arena and pavilions of the Zwinger palace, and a flowering of all the arts, including the music of Johann Sebastian Bach (1685–1750), were part of the extravaganza. In a letter, the King of Prussia wrote of his visit to the Saxon court in 1728: "The magnificence here is so great that I believe it could not have been greater at the court of Louis XIV, and although I have only been here two days, I can truly say that I have never seen the likes of it."

Elaborately decorated Meissen services of this time began to fulfill Johann Böttger's promise to Augustus that he would create porcelain services comparable to those of silver. Still too precious for actual use, they probably held a place of honor as ornamental display on buffets, functioning in the baroque silver tradition of the previous century, or as center-pieces on tables set with dishes of silver or silver-gilt. They may occasionally have been used for special state dinners, but little wear is evident (pl. 11.3). By the late 1730s to early 1740s, porcelain began to replace silver services on grand banquet tables (pl. 11.4).[7] Augustus the Strong died in 1733, and his legacy of Meissen porcelain remained a revered royal acquisition. Three Meissen plates in Seattle's collection represent different aspects of noble tablewares: the continuation of royal Saxon commissions to the Meissen factory for court use, the importance of Meissen porcelain to royalty abroad, and the decorating of porcelain as a noble endeavor.

Plate

German, Meissen factory, c. 1730–34
Hard-paste porcelain with enamel colors and gilding
Marks: crossed swords in underglaze blue and Japanese Palace inventory number, engraved N=147/W
Diam. 8⅞ in. (22.5 cm)
Gift of Martha and Henry Isaacson, 69.201

The decoration on this service combines the armorial shield of the Elector of Saxony and King of Poland with Japanese Kakiemon-style flowers and bound sheaves of grain; Augustus the Strong probably ordered it. Another possibility is that it was a commissioned service commemorating the coronation of Augustus III in Kraków on January 17, 1734. The service was delivered from the Dresden porcelain warehouse in 1734, so it was not available at the time of the coronation in Poland. Though popularly known as the Krönungsservice (coronation service), this is a nineteenth-century designation. An exact date for this service has not been determined.[8] Almost the entire service is marked with a Japanese Palace inventory number, which denotes that it is part of the royal collection. (These numbers are also known as Johanneum numbers, an association with a nineteenth-century repository of the royal collection.) The Chinese, Japanese, and Meissen porcelain in the collection of Augustus the Strong was first inventoried in 1721; pieces were added until 1727. The inventory of 1770 notes that this table service bears the coat of arms of the King of Poland and Elector of Saxony but does not refer to the coronation of Augustus III. The center of the coat of arms includes the crossed-swords emblem of the Electorate of Saxony. In 1723, these swords were designated as the mark of the Meissen factory.

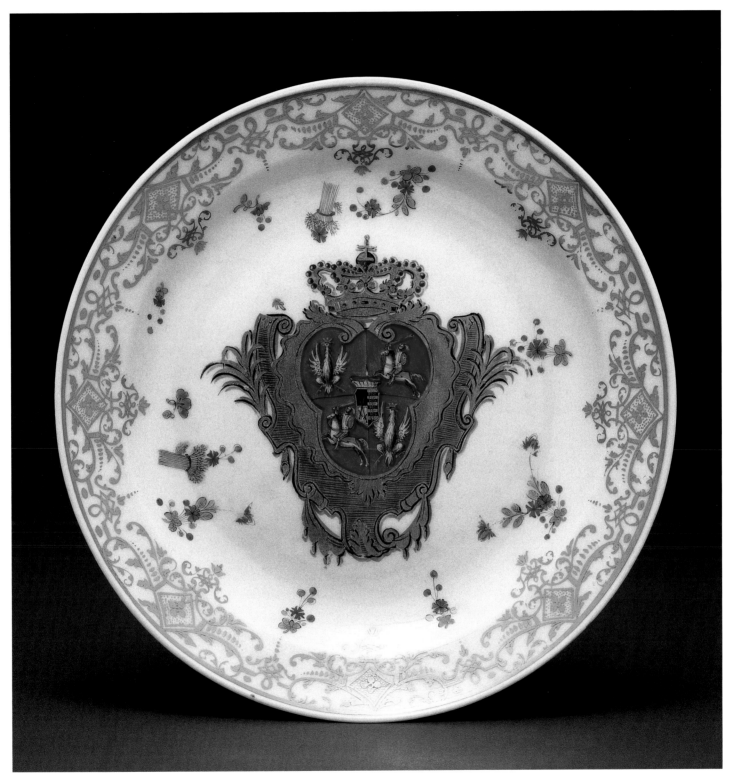

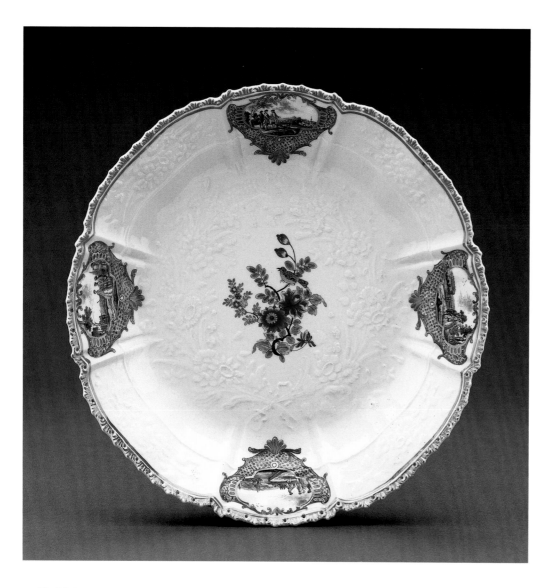

PL. 11.4

Plate

German, Meissen factory, c. 1741–43
Hard-paste porcelain with enamel colors and gilding
Marks: crossed swords in underglaze blue and impressed 20
Diam. 11¾ in. (30 cm)
Gift of Martha and Henry Isaacson, 69.184

The design of this dish, a molded floral form with pierced rim, is attributed to Johann Friedrich Eberlein (1695–1749), who mentions this service in a work report of 1741.[9] At this time, Meissen painters continued to combine Asian-style flowers (*indianische Blumen*) with European scenes, such as the miniature landscapes and harbor scenes in the four cartouches on the border of this plate. They were beginning, however, to replace Asian flowers with European floral decoration.

By the 1740s, Meissen table services were in great demand among the European aristocracy. This plate is from a service delivered between 1741 and 1743 to Tsarina Elizabeth I Petrovna (r. 1741–1761). Elizabeth gained an appreciation for the arts of Western Europe from her father, Peter the Great, who had embraced Western European culture when he established his capital in Saint Petersburg in the early eighteenth century. Elizabeth became a collector of Meissen porcelain. Around 1744, she established her own imperial factory with the assistance of Conrad Hunger, an early defector from the Meissen factory. One of the band of traveling workers who purported to know the secret of making porcelain, Hunger had been in Vienna, Venice, and Stockholm before coming to Saint Petersburg.

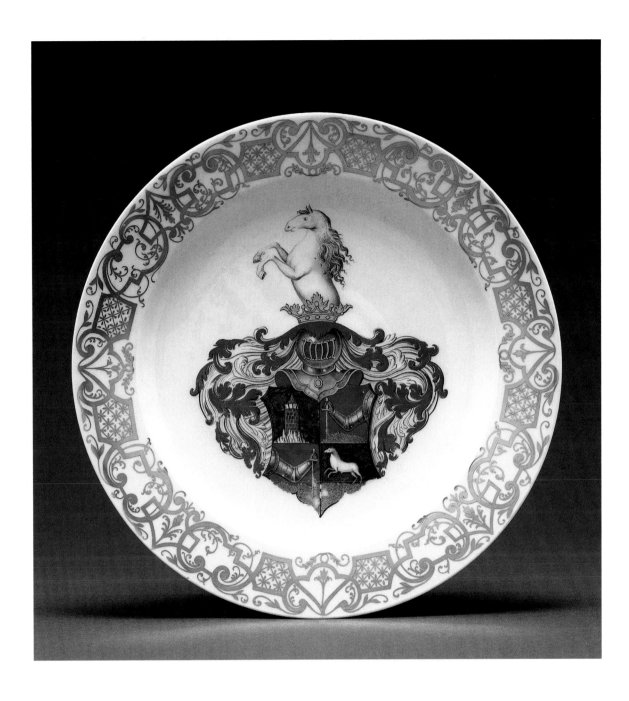

PL. 11.5

Plate

German, Meissen factory, 1735–40
Decorated outside the factory in 1748 by Carl Ferdinand
von Wolfsburg (1692–1764)
Signed: peint par Charles Ferdinand de Wolfsbourg â Breslau
l'an 1748
Hard-paste porcelain decorated with enamel colors
Mark: crossed swords in underglaze blue
Diam. 8¾ in. (22.2 cm)
Gift of Martha and Henry Isaacson, 69.202

This plate bears the coat of arms of the Benada family,
Bohemian-Silesian merchants who were elevated to the nobil-
ity in 1706. The aristocrat Carl von Wolfsburg painted it. Also
known for his miniature portraits, von Wolfsburg turned his
hand to porcelain painting as a refined pastime. Works deco-
rated by him are very rare.[10]

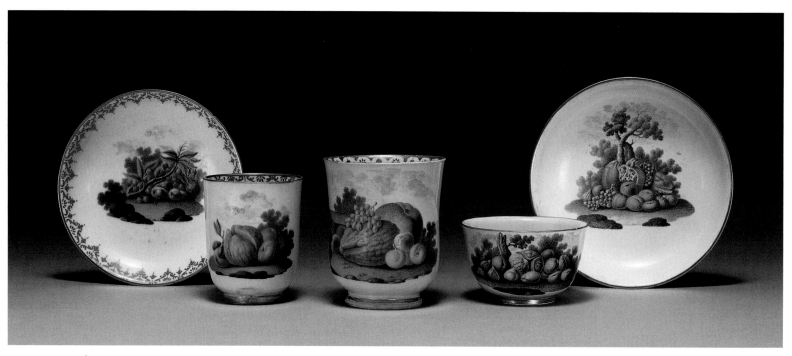

PL. 11.6

DYNASTIC MARRIAGES

A desire to compete with the Meissen factory was also inspired by dynastic marriages of three princesses of Saxony, granddaughters of Augustus the Strong, with European royalty. Each of these women either contributed to the establishment of a royal factory in her new homeland or, if a factory was already under way, provided additional impetus to its development.

Princess Maria Amalia Christina married Charles, King of Naples and the Two Sicilies, in 1738. Their marriage united the royal houses of old rivals, the Bourbon King Louis XIV of France and Augustus the Strong, through a great-grandson and granddaughter, respectively. A Naples porcelain factory was founded on the grounds of the couple's royal palace at Capodimonte in 1743.

Princess Maria Josepha married the Dauphin of France in 1747. It didn't take her long to stoke the competitive fire between the Meissen factory and the budding French factory at Vincennes. As a gift, she sent to her father, Augustus III of Saxony, a magnificent giant bouquet of about 480 Vincennes porcelain flowers in a white vase, flanked with allegorical figures of the arts, all mounted on a gilded base. Her accompanying note stated, "Vincennes already surpasses Meissen."

Also in 1747, the third granddaughter, Maria Anna Sophia, and her new husband, the Elector of Bavaria Maximilian III Joseph (1727–1777), began to establish a porcelain factory at their hunting lodge, Neudeck in der Au. After many failed attempts, it produced a satisfactory porcelain in 1754, and in 1758, the decision was made to move the factory to the grounds of the Nymphenburg palace in Munich.

Capodimonte and Buen Retiro

The soft-paste porcelain of Capodimonte is composed of fine white clay and glass frit, rather than the porcelain stone of Meissen's hard paste. It is also fired at a lower temperature. The porcelain of Capodimonte soon became prized for its highly translucent, milky white body and lustrous glaze.

The patron of the Capodimonte factory held the titles of Charles IV, King of Naples, and Charles VII, King of the Two Sicilies, concurrently until he left Italy for Spain, where in 1759 he was crowned Charles III, King of Spain.[11] He was so fond of his Capodimonte porcelain that he moved the factory (workers, equipment, and 9500 pounds of porcelain paste) to a new site at the Buen Retiro Palace in Madrid.

PL. 11.6

Coffee cup and saucer, chocolate cup, c. 1750
Tea bowl and saucer, c. 1755

Italian, Capodimonte factory
Soft-paste porcelain with enamel colors and gilding
Marks: fleur-de-lis in underglaze blue; on tea bowl, an illegible mark
in underglaze blue
from left:
Saucer: diam. 5⅛ in. (13 cm)
Coffee cup : h. 3⅛ in. (8 cm)
Chocolate cup: h. 3½ in. (9 cm)
Tea bowl: h. 2 in. (5.1 cm)
Saucer: diam. 5⅜ in. (13.7 cm)
Dorothy Condon Falknor Collection of European Ceramics,
87.142.62, .63, .49

The lush still-life subjects of fruit on these wares pay homage
to the rich agricultural valleys near Naples, where the Capo-
dimonte factory was founded. They are painted in the style
made popular by Giovanni Caselli (1698–1752). Princess Maria
Amalia arrived for her wedding in Naples with a dowry that in-
cluded no fewer than seventeen Meissen porcelain table services.
The founding of a porcelain factory became a goal of the royal
couple in addition to their patronage of other aspects of the
decorative arts. Charles also founded an academy of design and
a tapestry factory. Porcelain, after hunting, became his passion.

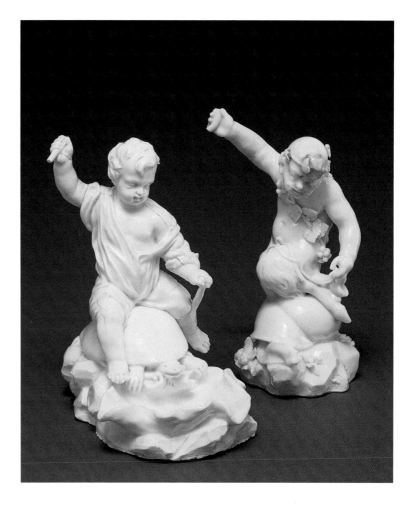

PL. 11.7

Figure of a boy (putto) and figure of a young satyr

Italian, Capodimonte factory, c. 1744–45
Models by Giuseppe Gricci (1700–1770)
Soft-paste porcelain
left: boy, h. 6¾ in. (17.2 cm)
right: satyr, h. 6½ in. (16.5 cm)
Dorothy Condon Falknor Collection of European Ceramics,
87.142.51, .41

These figures date from the early years of the factory's produc-
tion and reveal some of the struggles that occurred in dealing
with the new medium. The firing cracks in the boy riding a tor-
toise, burned discoloration from firing, and the unglazed spot
and green discoloration on the head and face of the satyr riding
a giant snail give evidence of challenges in production.[12]

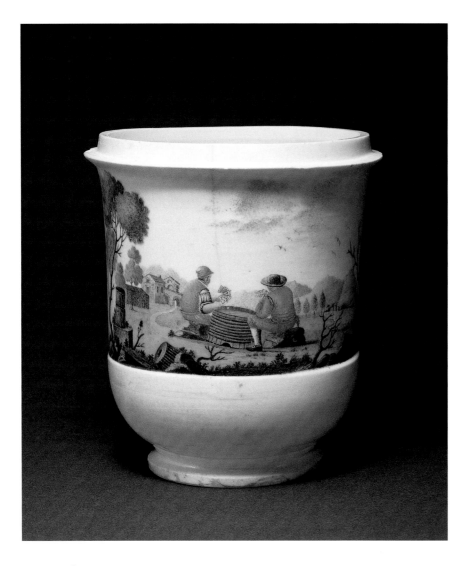

PL. 11.8

Vase

Italian, Capodimonte factory, c. 1750–57
Soft-paste porcelain with enamel colors
Mark: fleur-de-lis in underglaze blue
H. 6¼ in. (16 cm)
Dorothy Condon Falknor Collection of European Ceramics, 87.142.43

This vase probably once had a cover. A bit large for a tobacco jar, it can best be imagined as an ornamental vase upon a mantel or shelf.[13] The broad, smooth surface provides a perfect body and contrast to the landscape scene featuring large figures in the foreground. They are painted in a stippled manner (sfumato) characteristic of Capodimonte, creating a hazy atmospheric setting perfect for a lazy summer afternoon's card game.

PL. 11.9

Plate

Probably Spanish, Buen Retiro factory, c. 1760–65
Soft-paste porcelain with enamel colors and gilding
Mark: fleur-de-lis in underglaze blue
Diam. 15⅞ in. (40.3 cm)
Dorothy Condon Falknor Collection of European Ceramics, 87.142.84

It is difficult to distinguish late Capodimonte ware from early Buen Retiro, but the floral design on this plate relates to similar painted motifs on panels in the Aranjuez porcelain room in the Buen Retiro Palace.[14] This room, one of the earliest commissions undertaken at the new site, takes the concept of a porcelain room a step beyond just decorating the walls with porcelain wares. Like the earlier grand porcelain room at Capodimonte, the Aranjuez room's walls and ceiling are lined with thick porcelain plaques that fit together like puzzle pieces.

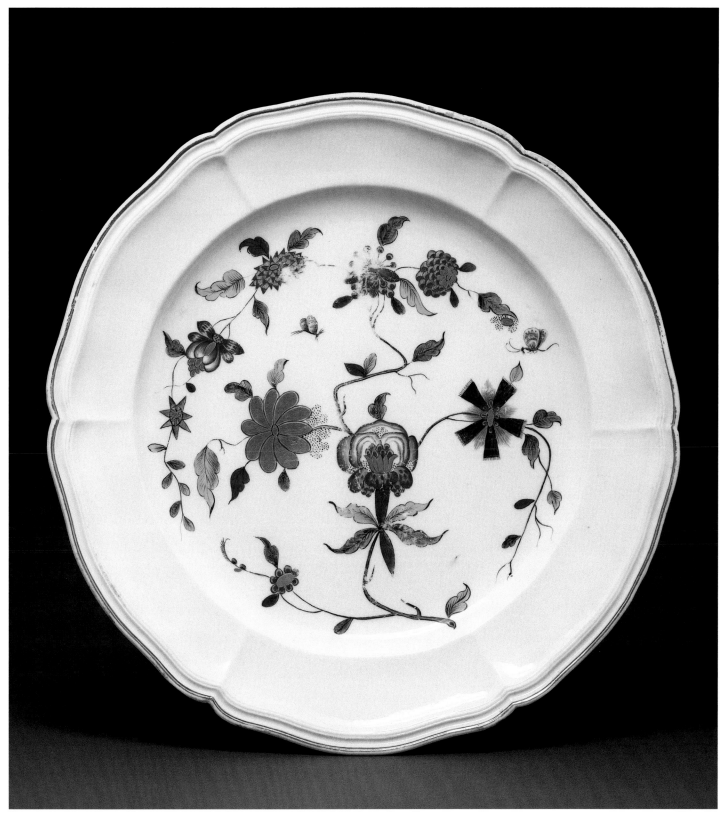

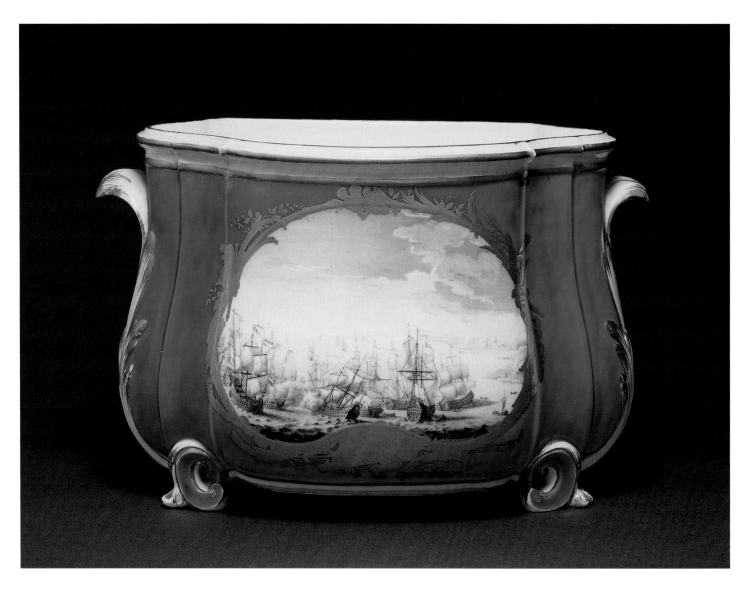

PL. 11.10

Flower vase (*cuvette à fleurs Courteille*)

French, Vincennes factory, 1755/56
Trophy scene on reverse painted by Louis-Denis Armand *l'aîné*
(active 1745–83)
Marine scene unattributed
Soft-paste porcelain with enamel colors and gilding
Marks: interlaced L's, the date letter C, crescent mark for Armand *l'aîné*
H. 7¾ in. (19.7 cm), w. 12¼ in. (31 cm)
Purchased with funds from the Guendolen Carkeek Plestcheeff
Endowment for the Decorative Arts, 99.8

The Seattle *cuvette à fleurs Courteille*[15] belonged to Madame de Pompadour. It was the centerpiece of a five-piece garniture of vases displayed at Saint-Ouen, one of her residences.[16] Decorated with a vibrant *bleu céleste* ground color, it features a motif that is extremely rare on Vincennes porcelain, a marine scene. While Louis reigned, France was frequently at war, but scenes commemorating military and naval battles were a minor part of the repertoire of paintings on French porcelain. The factory sales register records only six items with *bleu céleste* and marine decoration sold before 1757.[17]

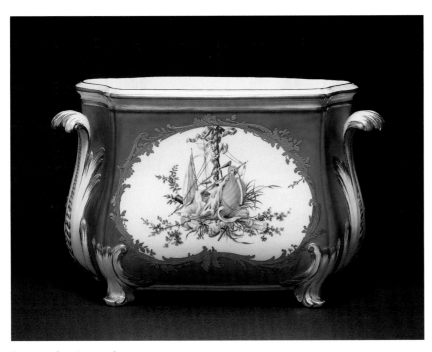

Reverse, showing trophy scene, PL. 11.10

Vincennes and Sèvres

In 1745, two years before Princess Maria Josepha married the son of King Louis XV, the French king had granted a royal privilege to the soft-paste porcelain manufactory in Vincennes. Valid for twenty years, the privilege awarded Vincennes the exclusive right in France to manufacture Meissen-style painted and gilt-ornamented porcelain depicting human figures. A great rivalry ignited between the two royal factories of Saxony and France.

The year 1745 proved auspicious for the financially struggling operation in Vincennes. That same year, a young woman, Madame d'Etiolles, was officially installed as the king's mistress. Granted the title Marquise de Pompadour, this charming, bright, and ambitious woman established herself as the chief patroness of the arts and became one of the most influential persons in Louis's court. Lauded as one of the great love matches of the time, Louis XV and Madame de Pompadour also shared a passion for porcelain. She became the powerful sponsor of the Vincennes manufactory.

Soon after installing Madame de Pompadour as his mistress in 1745, Louis went to war, leading his troops in the campaign in Flanders. In 1747, Louis XV and Augustus III became allied through the marriage of their son and daughter. Although Louis had opposed Augustus's succession to the Polish throne in 1733, they later were allies in the Seven Years' War (1756–63).

The years around 1755 and 1756 brought French victories at sea, memorialized on Vincennes porcelain. The scene on the Seattle *cuvette* (pl. 11.10) depicts a yet unidentified battle between the Dutch and French fleets. Another French naval victory is recorded on two *vases hollandais,* also decorated in *bleu céleste* and marine scenes.[18] They commemorate an early triumph for the French navy and ground troops in the Seven Years' War. In April 1756, the French wrested most of the island of Minorca and Port Mahon from the British, and by June, they controlled the entire island. Soon after the victory, Madame de Pompadour held a celebration party at one of her residences, L'Ermitage. In his memoirs, the Duc de Luynes described on July 20, 1756, the joyous gathering, the grand fireworks, and the small gifts presented to the guests—the men received decorative ribbons *à la Mahon* for their swords.

Associating the marine scenes on the *vases hollandais* with this celebrated event, the painter at the royal factory inscribed the words 'de Mahon' in part of the decoration. These vases, which would have flanked the Seattle *cuvette,* were part of Madame de Pompadour's garniture of vases. They would have been splendidly reflected standing on a mantelpiece backed by mirrors. In the reflection, the viewer could admire

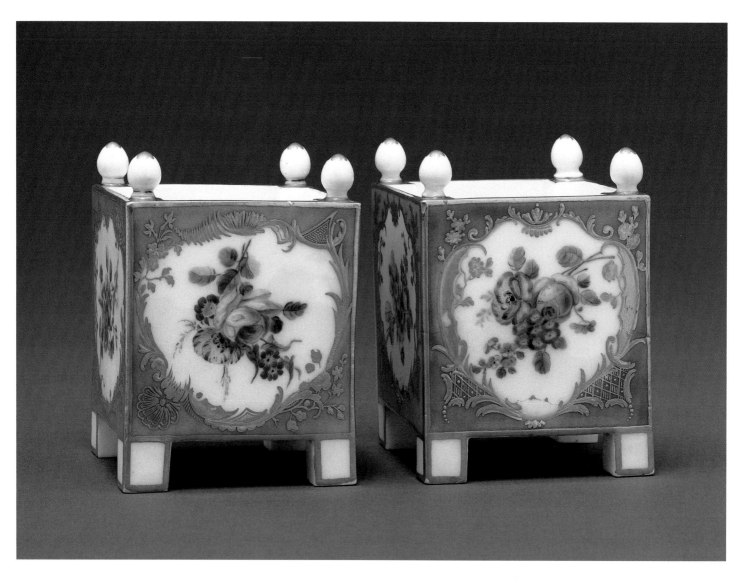

PL. II.11

Pair of miniature orange tubs

French, Vincennes or early Sèvres factory, 1756/57
Painted by Pierre-Antoine Méreaud (Méreaud *l'aîné,* active 1754–91)
Soft-paste porcelain with enamel colors and gilding
Marks: one pot with interlaced L's enclosing the date letter D, and
painter's mark; the other with an incised 8
H. 3⅝ in. (9.3 cm)
Purchased with funds from the estate of Mary Arrington Small and
the Decorative Arts Council, 85.215.1–2

Vincennes and Sèvres became known for their beautiful white porcelain of the highest quality. *Caisses carrées* (square boxes), sometimes called *caisses à fleurs,* were produced in three sizes; this pair is the smallest. They were made to contain flowering plants (there are holes in the bottom for drainage) and probably sat on small trays arrayed along the grand banquet tables of the period.

intricately painted assemblages of idealized trophies of war: the hulls of warships and various weapons draped in strands of pearls and ribbons.[19]

Madame de Pompadour was so enthralled with the Vincennes porcelain factory that when it required larger quarters, she encouraged its relocation close to her new château at Bellevue. In 1756, the factory moved to a new site at Sèvres; wares produced after the move are known as Sèvres porcelain. In 1759, Louis XV, who had been a shareholder in the enterprise, became the sole proprietor of the manufactory. Sèvres became very important during the Seven Years' War, when Saxony was occupied by Frederick the Great of Prussia. Because of the war, the Meissen factory, which had dominated porcelain manufacture since its founding, was in great disarray. Sèvres, stepping into the breach, led the fashions and the market in ceramics throughout Europe until the last decades of the century.

Nymphenburg

The Meissen factory managed to control the manufacture of hard-paste or true porcelain in Europe for forty years. The exception to their monopoly was the Du Paquier factory's limited production, in Vienna. It was from Vienna that workers knowledgeable in the production and decoration of porcelain began to disperse throughout Germany in the late 1740s. One of the factories to benefit from the influx of skilled artists was the one in Neudeck-Nymphenburg.

Unsuccessful experiments to produce porcelain had been undertaken in Bavaria since about 1729. From these early years until 1747, when Princess Maria Anna Sophia married the Elector of Bavaria, the court in Munich bought heavily from Meissen. As a granddaughter of Augustus the Strong, she was extremely interested in collecting and manufacturing porcelain; she offered her support to the new Bavarian enterprise at Neudeck-Nymphenburg.

The most important appointment to the Nymphenburg factory was that of the sculptor Franz Anton Bustelli. He began work on November 3, 1754, and was immediately ranked as chief modeler. The pipe bowl in the Seattle collection (pl. 11.12), with its grotesque face, displays the skilled, playful modeling for which Bustelli became famous. Franz Anton Bustelli and Johann Joachim Kändler of Meissen are considered the greatest porcelain modelers of eighteenth-century Europe.

—J.E.

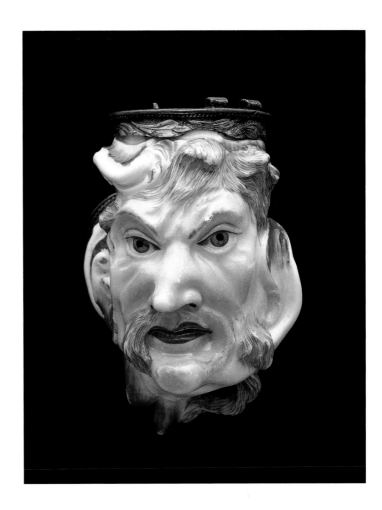

PL. 11.12

Pipe bowl

German, Nymphenburg factory, c. 1755–60
Model by Franz Anton Bustelli (employed by the factory 1754–63)
Hard-paste porcelain with enamel colors and metal mounts
Unmarked
L. 2⅜ in. (6 cm)
Dorothy Condon Falknor Collection of European Ceramics, 87.142.40

West Meets East

12

Asian and European Porcelain: Reflections

———————— ❖❖❖ ————————

A Passion for Things Chinese

As trade increased in the seventeenth century, more Europeans became enthralled with visions of Cathay, as the Celestial Empire was now popularly known. A cult of orientalism developed, based on what were considered exemplary elements of Chinese government, religion, and culture. Cathay was hailed as having the best and longest-established government. Confucian philosophy was its official religion, but it was benevolently tolerant of other beliefs. Cathay was the home of wisdom, virtue, and good faith. Gentlemen debated the ethical axioms of Confucianism as guidelines for the proper management of society. In another instance of cross-cultural exchange, these precepts were introduced into Europe by returning Jesuits who had taken Christianity to China.

Europeans pondered their relationship with China, a land cast as paradise and bathed in a glow of idyllic wonder, though not everyone was easily convinced. In a series of letters dealing with various Chinese questions, Frederick the Great of Prussia queried Voltaire about his utopian view of Cathay. When asked how European rulers should react to the exemplary standards credited to the Chinese, Voltaire responded, "Admire and blush, but above all imitate."[1] Despite criticism, the devotees presented banquets and royal fetes graced by courtiers dressed in 'Mandarin'-style silk robes and curious hats. Voltaire's play *Orphelin de la Chine,* adapted from a Chinese original, became popular on the London stage in 1759 as *The Orphan of China.* Stage settings for ballets and interiors of residences gloried in *décor à des chinois.*

Architectural extravaganzas exhibiting a distinctly Asian character began to rise on European soil. Always delighted to associate himself with mighty empires, Louis XIV of France collected Chinese art and built a Chinese-inspired, jewel-like pleasure house for a favored mistress. Covered in blue-and-white tin-glazed earthenware tiles, it was nevertheless called *Trianon de porcelaine,* in honor of the material it aspired to resemble. In addition to his Japanese Palace, Augustus the Strong of Saxony built a magnificent residence, an *indianisches Lustschloss* (1720–32) in Pillnitz. It features a sloping, pagoda-inspired roof and a decorative frieze of Asian-style figures. Following this trend, pagoda-like pavilions became the height of fashion on the grounds of castles, châteaus, and stately homes throughout Europe. An Elector of Bavaria built the Pagodenburg (c. 1722) in the park of his summer palace at Nymphenburg. The *maison chinoise,* built for François Racine de Monville, joined other exotic pavilions—a temple of Pan and a pyramid-shaped icehouse—on his property, Désert de Retz, in the 1770s. They were designed to entice the French king away from the nearby bridle trails of Versailles, in hopes he would honor the estate with a royal visit. In London, the House of Confucius in Kew Garden (c. 1745) and William Chamber's great pagoda at Kew (completed in 1762) created a fashionable atmosphere. Various lattice-adorned fishing houses and bridges, as well as grander buildings, were created in the so-called Chinese taste.

Rooms in these residences (*cabinet chinois* in France, *chinesisches Zimmer* in Germany) were appointed with lacquer wall panels and furniture as well as intricately decorated textiles, tapestries, wallpaper, and, of course, porcelain, which mingled Asian-style flower motifs and fanciful scenes with exotic birds, dragons, and insects. In England, where styles dictated by Chinese taste reached a peak in the 1750s, a kaleidoscope of Asian patterns was still evident, and the use of the term 'Indian' continued to be applied to the various imports from East Asia. During this period, the fascinating English woman of letters Lady Mary Wortley Montagu (1689–1762) decorated her dressing room "like the Temple of an Indian god . . . the very curtains are Chinese pictures on

gauze, and the chairs, the Indian fan-sticks with cushions of Japan satin painted."[2] Lady Mary's interest in things foreign extended beyond the realm of art and fashion. While living in Turkey from 1716 to 1718 as the wife of the English ambassador, she learned of the use of cowpox as an inoculation against smallpox. Upon her return to England, she helped introduce the practice of inoculation against the disease in Europe. Lady Mary's taste and actions embody the cross-cultural exchange of philosophies, medical practices, social values, and art that are also reflected in European porcelain, which imitated or was closely inspired by Asian wares.

Of many Asian wares, the fine Chinese and Japanese porcelains that comprised the main body of export ceramics shipped to Europe via various European East India companies became Europe's primary models for imitation. Aside

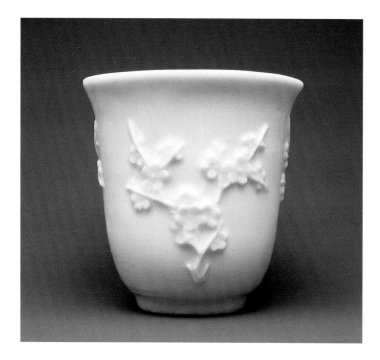

from the pervasive blue-and-white, such wares were largely of two types: Chinese *dehua* porcelain (*blanc de chine*) and Chinese or Japanese polychrome overglaze-painted porcelain.

Dehua Ware

The history of ceramics production at Dehua, in Fujian province in southeastern China, began in the early twelfth century. The town did not distinguish itself, however, until the Ming dynasty (1368–1644), when a new type of porcelain was created there that could legitimately be called *dehua* for its uniqueness. This new ware was made from local porcelain stone that contained an extremely low level of iron oxide but a high level of potassium oxide, which gives the porcelain an exceptional degree of translucence and an oily, jade-like appearance.[3] The resultant soft whiteness became the trademark and unique advantage of these wares, most of which therefore received no additional painted decoration. Only occasionally were underglaze blue or overglaze enamels used.

Another distinguishing feature of *dehua* is its sculptural quality. Vessels routinely were decorated with carved, molded, or appliquéd designs, the best of which imparts a subtle, spacious, painterly effect rarely seen on other types of porcelain. Plum blossoms were a popular motif (pl. 12.1). On this beaker, they were molded and then applied to the surface but appear to be softly emerging from the background. With the fine-grained body and unctuous glaze, the appliqué creates a visual effect close to that of jade carvings. Fascination with sculptural quality also led the potters of Dehua to create shapes unique to other materials, such as book scrolls, antique bronzes, and cups of rhinoceros horn (pl. 12.2). Rhinoceros horn was held to possess special power to nurture health as well as the mind. Drinking cups were therefore made of them and commonly decorated with auspicious motifs, typically on the subject of longevity—pine and crane, plum, and deer. Such cups were naturally costly, and thus often copied in *dehua*.

From the late Ming period, figural sculptures, mainly Buddhist and Daoist deities, became an outstanding product and specialty of *dehua*. They were often modeled with expressive forms and particular details to present individual identities. The figure of the bodhisattva Guanyin in the Seattle collection is an elegant example of the fine artistry of *dehua* sculpture (pl. 12.3). It also represents a typical

PL. 12.3

Figure of Guanyin

Chinese, Qing dynasty, 18th–19th century
Dehua ware, porcelain modeled with a female figure sitting on a tall, reticulated *taihu* rock
H. 19 in. (48.3 cm)
Eugene Fuller Memorial Collection, 43.42

Guanyin is the Chinese name for Avalokitesvara, the lord of tender glances. He is a bodhisattva, a compassionate being who has attained enlightenment but chooses to remain in the world to help others. During the tenth century in China, Guanyin began to assume the female form.

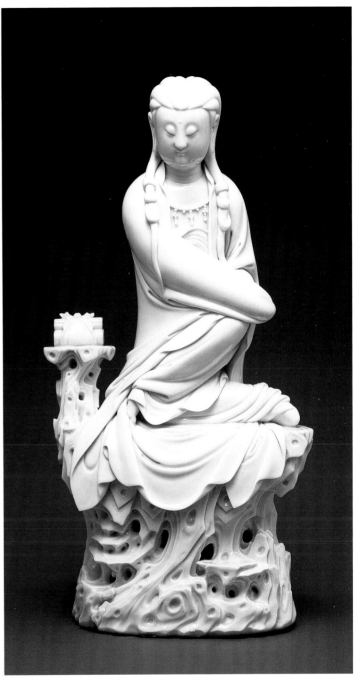

PL. 12.3

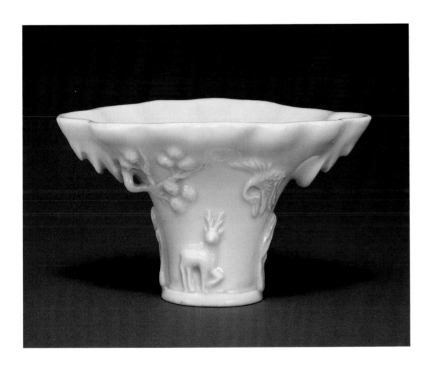

PL. 12.2

Cup

Chinese, Qing dynasty, late 17th century
Dehua ware, porcelain in the form of a rhinoceros horn with carved and appliqué decoration
H. 3 in. (7.6 cm)
Eugene Fuller Memorial Collection, 33.681

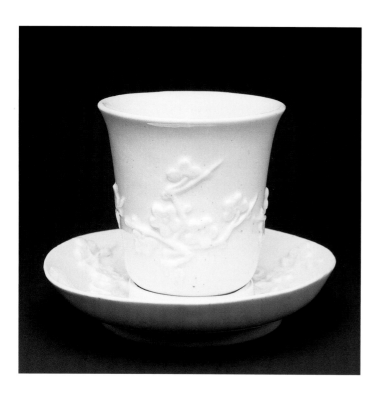

The tall beaker shape is based on the Chinese original (see pl. 12.1), but the *trembleuse* saucer is a European design; it is fitted with a circular gallery to secure the beaker in hands that "trembled" with age or illness.

eighteenth-century style, marked with whiter but less creamy color in body and glaze, and richer and more intricate details in such formal elements as drapery and the *taihu* rock. The figure's considerable size attests to the potting and firing skills of the Dehua potters.

From the outset of ceramics production at Dehua, the majority of its wares appear to have been made for export, for a great deal of them have been found outside China, in Japan, Southeast Asia, and Europe, which traded with China via maritime routes (see chaps. 6–9). Around the seventeenth century, the characteristic *dehua* porcelain was known in Europe by the French name *blanc de chine* (white of China). Even those relatively coarse wares produced exclusively for export were reckoned a superior kind of porcelain.[4] *Dehua* ware was greatly admired, collected, and imitated by the Europeans in the eighteenth century.

Blanc de Chine in Europe

Traditional lore, rather than evidence, links a small Chinese porcelain jar housed in the treasury of San Marco in Venice to Marco Polo, but the jar is early white ware that could date from the late thirteenth century.[5] It belongs to a group of white porcelain that originated at the ceramics center of Dehua. In Europe, *blanc de chine* inspired Western potters to create their own versions.

In its earliest years of production, Meissen produced *blanc de chine*–style wares, but the soft-paste porcelain factories in France and England during their early years produced the finest European porcelain in Dehua's white style. These wares are termed 'soft paste' because they receive a relatively low firing of up to 1150°C. Handling them is one of the great joys of porcelain study and collecting. They have a solid, well-defined feel, but also a rich, warm lushness.

When the first English porcelain of the Chelsea and Bow factories was developed in the mid 1740s, it lacked the essential ingredients of Chinese hard-paste porcelain, kaolin and porcelain stone. But the Chelsea *blanc de chine*–style wares, made from a formula that combined quartz and a fine clay, vitrified by glass frit and lime, beautifully exhibit the ability to produce another type of white-bodied translucent porcelain. These wares have a glowingly rich quality, though some of the definition of the modeled and applied prunus decoration in hard-paste *dehua* ware is lost in the soft-paste porcelain and glaze of Chelsea.

The Merchants of London

Soft-paste porcelain production in England was under way by 1745, thirty-five years after production of hard-paste porcelain commenced at Meissen, Germany. The English nobility never embraced the idea of establishing porcelain factories for prestige. Porcelain in England was developed by artisans and merchants in private commercial businesses as an important part of the trade in luxury goods. Britain's late entry into the business of European porcelain was due partly to the lack of direct patronage that had characterized porcelain production on the Continent. Another factor was Britain's new role in world trade. The British East India Company dominated the Eastern porcelain trade throughout the eighteenth century. The quantities of Chinese export porcelain arriving in Britain aboard company and private traders' ships made it less urgent for the British to create their own.

The first two porcelain factories in England began with experiments in producing a porcelain formula in 1744, in Bow, East London (the factory was established in 1747), and in 1745 with a factory located in the village of Chelsea. These new factories competed with foreign imports from both Asia and the Meissen factory. About eight years after beginning operation, Nicholas Sprimont, director of the Chelsea factory, wrote an appeal to the House of Commons for protection from the competition of "Dresden China" that London china dealers were importing and selling without paying customs duty.[6]

Early French Blanc de Chine

When in 1701, Count Ehrenfried von Tschirnhaus, who was instrumental in establishing a hard-paste porcelain factory in Saxony (see chap. 2), visited the soft-paste porcelain factory at Saint-Cloud near Paris, he purchased various examples of their production. Unimpressed with their porcelain's stability, he described how the wares shattered easily because of the large quantity of salts in their composition.[7] The factory produced a soft-paste porcelain in the early 1690s, but its earliest identified wares date from around 1700 to 1710.

A French porcelain factory was established in 1730 on a site purchased by Louis-Henri, Duc de Bourbon, Prince de Condé (1692–1740), near his château at Chantilly. When he fell out of court favor, he was exiled to his estate and had time to pursue his many interests. A great eccentric, he believed that in his next life, he would be reincarnated as a

PL. 12.5

Glass cooler

French, Saint-Cloud factory, c. 1730–40
Soft-paste porcelain with molded decoration
Unmarked
H. 5 in. (12.7 cm)
Blanche M. Harnan Ceramic Collection, Gift of the Seattle Ceramic Society, Unit II, 65.135

Saint-Cloud built a profitable business that specialized in the production of *blanc de chine*–style wares. Sprigs of prunus blossoms were a common decoration at Saint-Cloud. In the Seattle glass cooler (*seau à verre*), decorative traditions of East and West meet.[8] The influence of *dehua* wares is seen in the pierced rock (*rocher percé*) with chrysanthemum decoration on porcelain that has been glazed but left in the white. The shape, the bold, reed-like gadrooning, and the grotesque heads forming small handles derive from European metalwork.

Pitcher (or cream boat) and stand

French, Chantilly factory, 1740–45
Soft-paste porcelain with tin glaze
Unmarked
Stand: l. with stem 5¼ in. (13.4 cm)
Pitcher: l. from spout to beginning of handle 3 in. (7.6 cm);
h. 2 in. (5.1 cm)
Dorothy Condon Falknor Collection of European Ceramics, 87.142.13

The early Chantilly wares were imitations or close adaptations
of porcelain from Asia. By the time Seattle's little pitcher and
stand[10] were made, the Asian-inspired styles of the factory were
giving way to European influences.[11] The overlapping acanthus-
leaf molding of the cup and the strawberry-leaf molding of the
stand, purely European adaptations, remain in the manner of
blanc de chine.

horse. Among his odder enthusiasms, he maintained a pala-
tial stable with a fully equipped veterinary hospital, to assure
himself of adequate accommodations upon his return.

The duke avidly collected Asian textiles, lacquer, and por-
celain. His death inventory of 1740 listed about 1700 porce-
lain and stoneware objects, some of which he had inherited
from earlier Condé and other family collections.[9] He took a
keen interest in the production of the new factory at Chan-
tilly, which reflected different design influences from his
extensive porcelain collection.

PL. 12.7

Cups

British A-marked wares, c. 1745
Soft-paste porcelain with enamel colors
Mark: incised A on the quail-pattern cup (the other two are
unmarked)
left to right: h. 2⅜ in. (6 cm), 2⅝ in. (6.6 cm), 2⅜ in. (6 cm)
Dorothy Condon Falknor Collection of European Ceramics,
87.142.127–129

These rare coffee cups portray three types of Asian-inspired
decoration on European porcelain of the eighteenth century.
The white cup with relief-molded prunus decoration represents
blanc de chine. The other two cups exemplify types of poly-
chrome overglaze painting done in Asia and imitated in Europe.
The cup with enameled black panels alternating with flowers is
in the *famille noire* style inspired by Chinese porcelain decorated
with a black ground color, which was produced during the reign
of the Kangxi emperor (1662–1722). The Japanese Kakiemon-
style quail pattern, with its characteristic palette, is the design
source for the center cup. S-shaped handles on two of the cups
originated in European silver forms.

A-Marked Ware: Researching an Enigma

Intriguing mysteries constantly emerge in the world of porcelain study. The concept of the classification 'A-marked porcelain' was promoted by the presentation of a single teapot to the English Ceramic Circle in 1937. Since that time, only thirty-four additional A-marked wares have been added.[12] The search for a home, both factory and country of origin, for the beautifully potted coffee cups with their sophisticated decoration remains unresolved.

Earlier scholars researching these mystery wares occupied two schools of thought concerning their origin. One group looked to continental Europe, particularly Italy; the other staunchly favored a British attribution. Even though all examples of A-marked porcelain had been found in England (some later were found in Scotland as well), the porcelain body composition was unlike any known to have been made in Britain in the eighteenth century. Its extreme translucence and the cold grayish color evidenced by some of the wares (others are creamy in color) related it more closely to the contemporary hard-paste porcelain of Northern Italy. Those visual characteristics, plus early spectrographic analyses, seemed to support an Italian provenance.[13]

Nevertheless, through the years, voices in favor of a British attribution gained momentum. Sources for the figural scenes on A-marked wares—one depicts a cricket match—relate to prints popular in Britain in the mid-eighteenth century. Some of the tea wares are painted with scenes after engravings by Hubert-François Gravelot (1669–1773), from *Songs in the Opera of Flora,* the same popular play that triggered the name for the pattern Hob in the Well (see pl. 12.24). These factors, and the characteristic porcelain shapes, including lion-shaped finials peculiar to England atop two teapots in the group, all lend credence to a factory probably near London, or possibly Edinburgh, as the source for this porcelain.[14]

The most recent analytical research on the A-marked wares was undertaken in 1996 by Dr. Ian C. Freestone of the British Museum's Department of Scientific Research.[15] The results reveal a similar compositional relationship between A-marked porcelain and English Limehouse and Pomona wares made from clay-rich pastes, in contrast to the typical glassy pastes produced in England at the time. However, both the Limehouse and Pomona formulas used ball clay, which is formed when kaolin is transported away from its source by streams and rivers, picking up minerals and organic matter as it travels. The clay used in the A-marked wares is a relatively pure kaolin, or china clay. It is found near the feldspathic parent rock from which it erodes.

The component of kaolin in A-marked porcelain introduces an intriguing source for this group. The A-marked porcelain formula corresponds to the type of ware described in the "first Bow patent" granted in December of 1744 to the merchant Edward Heylyn (1695–1765) and the Irish-born portrait painter Thomas Frye (1710–1762). The specifics of the patent, enrolled in April of 1745, describe their clay: "The material is an earth, the produce of the Chirokee nation in America, called by the natives *unaker.*"[16]

It has long been known that a 20-ton load of clay transported from the Carolinas to London in 1743–44 was related to early porcelain research conducted by Frye and Heylyn.[17] The wares made from this clay have never been identified. Could they be the A-marked porcelains? The composition of the porcelain paste and low concentration of lead in their glaze fit the description of the first Bow patent.[18] One category of the A-marked group includes skillfully enameled tea wares with scenes after engravings. These intricately painted wares are termed 'high style'—the Seattle cups are included in the other 'stock pattern' category of A-marked produced wares.[19] The painting on the high-style wares is unquestionably the work of a very talented artist. As a successful painter and mezzotint engraver, Thomas Frye is decidedly a candidate for this enameled decoration.[20]

Questions abound. Twenty tons of clay produces a considerable number of porcelains. If the clay from the Carolinas was used in the production of A-marked porcelain, where are the other wares? Was the production not profitable? Were the firing temperatures too high and difficult to control? Research and discussion of the A-marked group will continue as new scientific analyses are undertaken and the Scottish question is further explored.

KAKIEMON STYLE

Japanese porcelain was first produced in the early seventeenth century on the southern Japanese island of Kyushu. Korean potters, traveling in the wake of Japanese armies returning from failed invasions of Korea near the end of the sixteenth century, founded kilns in the Hizen district, an established center for ceramics manufacture in southern Kyushu. Under their direction, the first Japanese porcelain was produced in the Karatsu stoneware kilns.

Japanese porcelain entered the arena of world trade during the 1640s. With the fall of the Ming dynasty in China and the waning supply of Chinese export porcelain from kilns disrupted by war, Dutch and English traders sought new sources of porcelain. Japanese wares helped fill the growing void. To meet demands dictated by porcelain-hungry Europeans accustomed to Chinese wares, Japanese potters and decorators expanded their repertoire of sparsely decorated Korean-inspired ware by adding Chinese shapes and more elaborate motifs. The Dutch orders of 1659, which took two years to complete, included enameled wares. Polychrome overglaze-painted decoration soon became a focus of Japanese production.

One of the most celebrated styles of enameled porcelain is associated with the Kakiemon, by tradition a family of enamelers. By 1688, they had established their palette of colors and were decorating porcelain from a kiln now known as the Kakiemon kiln.[21] *Nigoshide* (milky white), a fine white porcelain body, developed into the characteristic ware of the kiln. Large areas often remain undecorated to show off the whiteness of the porcelain and to serve as a background for the painted design.

Kakiemon motifs are painted in a distinctive palette of soft enamels whose colors include turquoise, blue, yellow, and orange-red. Sparsely painted pictorial subjects such as the quail (pl. 12.8), and other flower and bird patterns particularly favored by Kakiemon potters, became distinctive features themselves. Figural subjects, such as Hob in the Well (see pl. 12.24), are rare. The style of Kakiemon was widely imitated at other contemporary kilns in Arita. These similar products are generally referred to by the term 'Kakiemon type.'

Kakiemon-type wares made in Arita and shipped from the port of Imari, beginning in the 1670s and 1680s and continuing into the early eighteenth century, had enormous

Headrest

Japanese, Edo period, mid–late 17th century
Arita ware, Kakiemon type, porcelain painted with overglaze enamels
H. 5¾ in. (14.5 cm)
Gift of Martha and Henry Isaacson, 76.100

The headrest was constructed from slabs of clay and painted on all sides, including the base (usually left unpainted), with a palette characteristic of the early-period Kakiemon style. The design includes typical motifs—chrysanthemum, quail, orchid, and stylized wavy grass against a spacious background. The quail and chrysanthemum form a pun in Chinese, meaning "live in peace," a symbolic connotation not likely lost on the Japanese, who had kept a close cultural connection with China since the eighth century. (A Chinese quail painting is shown in chapter 10, figure 3.) This subject had several variations: sometimes the quail would pair with millet, or with the plum tree.

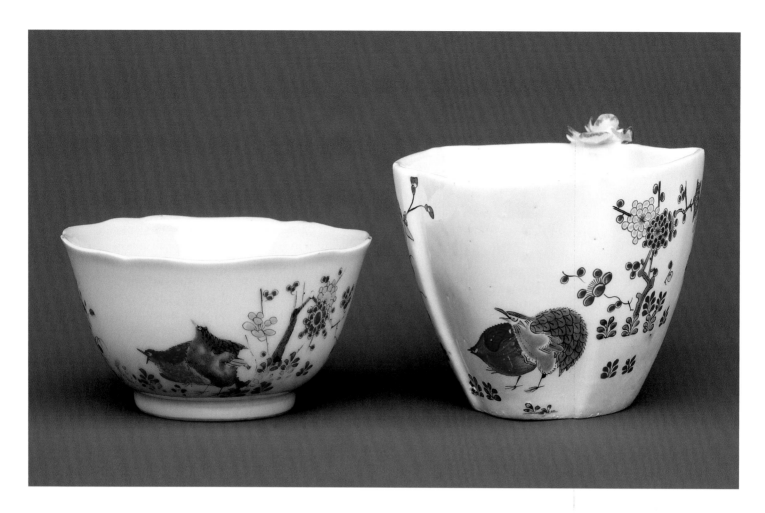

PL. 12.9

left:

Tea bowl

Chinese, Qing dynasty, 18th century
Porcelain decorated in Holland in Kakiemon style, mid-18th century
Unmarked
H. 3 in. (7.6 cm)
Gift of Martha and Henry Isaacson, 76.113

right:

Pitcher (cream boat)

French, Chantilly factory, c. 1735
Soft-paste porcelain with enameled decoration
Mark: hunting horn in red
L. without handle 3¼ in. (8.3 cm)
Gift of Mrs. George W. Stoddard in honor of the museum's
50th year, 84.97

impact on the development of porcelain forms and decoration in the West. Using a palette of rich iron red, green, and brown, with restrained gilded highlights, porcelain painters at European factories such as Meissen and Chantilly copied patterns directly from the Japanese originals.

A threefold cultural interaction in the realm of porcelain is evident in a tea bowl in the Seattle collection (pl. 12.9): an eggshell-thin Chinese ware decorated with a Japanese motif by a European artist. Because of the Delftware tradition, the art of enameling ceramics was well established in the Netherlands by the last quarter of the seventeenth century, when Dutch enamelers had access to Asian porcelain coming through Dutch ports. The practice of independent Dutch artists decorating Asian porcelain imported in the white, or adding enameled motifs to imported blue-and-white wares, continued into the eighteenth century.

A peculiarity of Dutch enameled ware is the distinctive grayish-green color used by Dutch decorators, which subsequently has popped off the porcelain, especially where it was thickly applied. This anomaly appears in the tea bowl (pl. 12.9) in the accent color on the tailfeathers of the blue quail, and in comparable works on which blue quail lack their wings.[22] This may occur when the glaze and the clay body shrink differentially in firing.

Japanese porcelain with Kakiemon decoration was the most costly and desirable porcelain arriving from Asia when the Chantilly factory began to create porcelain in this fashionable mode. Kakiemon wares, a favored portion of Louis-Henri de Bourbon's porcelain collection, offered a primary spark of inspiration to the early Chantilly production. The enamel colors of Chantilly are more transparent than those on the Japanese headrest (see pl. 12.8), and though the painters at the French factory were influenced by the design, no one would mistake the plump birds on the French pitcher (the bird in the rear resembles a blowfish with legs) for a Japanese version of the quail pattern. The peachlike form of the pitcher also derives from a Japanese original.

Chantilly, Kakiemon, and the French Trade

Porcelain became part of the Duc de Bourbon's collection through inheritance, but as a major shareholder in the French East India Company (Compagnie des Indes), he undoubtedly had opportunities to acquire Asian imports through the firm and, after 1719, from private traders as well. In that year, a revamped French East India Company, which had earlier tried to establish trade through western ports in India, joined the practice of other European trading companies and opened the profitable inter-Asian trade between Asian ports to private traders. Voyages from 1723 to 1728 were conducted by the French East India Company; those from 1733 to 1744 were primarily the business of private traders with some investment from the company.[23]

Although not nearly as large as the East India companies of the Netherlands and England, the great maritime nations of the seventeenth and eighteenth centuries, the French company was able to establish respectable operations in Canton and Manila. French traders of this period followed the formula of the time: they acquired porcelain, gold, lacquer, and tea in Canton; silver from the Americas via the Spanish in Manila; and spices, timber, rice, horses, and elephants from the Spice Islands and other Southeast Asian ports of call.[24] Some of this merchandise was off-loaded on the homeward journey in the Middle Eastern markets of Arabia, the Turkish Ottoman Empire, and Persia. In exchange, the French acquired silver, delicacies such as coffee and dried fruits, carpets, and Arabian horses for the home market.[25]

After a long and distinguished career in foreign trade, Pierre Blancard, a former navigator and member of l'Académie de Marseilles and of the Société académique des sciences de Paris, published his manual for conducting business in the East in 1806.[26] He described how immense quantities of porcelain for trade were brought from China's interior and distributed to stores in Canton. The stores dealt with foreign traders. French East India Company lists of the second quarter of the eighteenth century record blue-and-white, *famille verte,* Yong-Cheng (the most distinguished, produced during the reign of Yongzheng, 1723–1735), and *famille rose* porcelain.[27]

"Trade with Japan is little known; the English disdained it after having tried it; the French never attempted it," Blancard wrote in his manual.[28] Nevertheless, Japanese porcelain was available to the French through the ports of

PL. 12.10

Plate

Japanese, Edo period, 17th–18th century
Arita ware, Kakiemon type, porcelain painted with overglaze enamels
Diam. 7½ in. (19.1 cm)
Eugene Fuller Memorial Collection, 56.123.1

PL. 12.11
Dish

French, Chantilly factory,
c. 1735
Soft-paste porcelain with
enamel colors
Unmarked
Diam. 5 in. (12.7 cm)
Dorothy Condon Falknor
Collection of European
Ceramics, 87.142.21

Canton and Manila. In 1735, the French crown awarded the factory at Chantilly permission to manufacture porcelain in the Japanese style. Artists at the factory had access to the Bourbon collection of Kakiemon wares, which included "old Japanese" and contemporary examples.[29] Certainly, the patterns depicted on Chantilly porcelain—the quail, the red and yellow squirrel, the banded hedge, and red dragon—were current on Kakiemon wares arriving in Europe into the eighteenth century.[30]

Floral Decoration
The foliated rim and sparse, asymmetrical floral motif in the Kakeimon palette translates from Japanese plates (pl. 12.10) to Chantilly products (pl. 12.11). European porcelain painters did not understand the bamboo fence motif on the originals; it is rendered as a simple X design on the French dish. The crane decoration is perhaps the only Kakiemon-style pattern done at Chantilly that was not also produced at Meissen in a very similar manner. In Europe, the birds in this pattern were often incorrectly referred to as storks or herons.[31]

PL. 12.12

Octagonal bowl

Japanese, Edo period, late 17th century
Arita ware, Kakiemon type, porcelain painted with overglaze enamels
Diam. 4¼ in. (10.8 cm)
Gift of Martha and Henry Isaacson, 76.97

This Japanese octagonal bowl displays the finest qualities of Kakiemon style, with its pure white body and floral sprays delicately painted on the eight facets. In form and decoration, this Japanese style translated into a Meissen cup and saucer in the Seattle collection (see pl. 12.13).

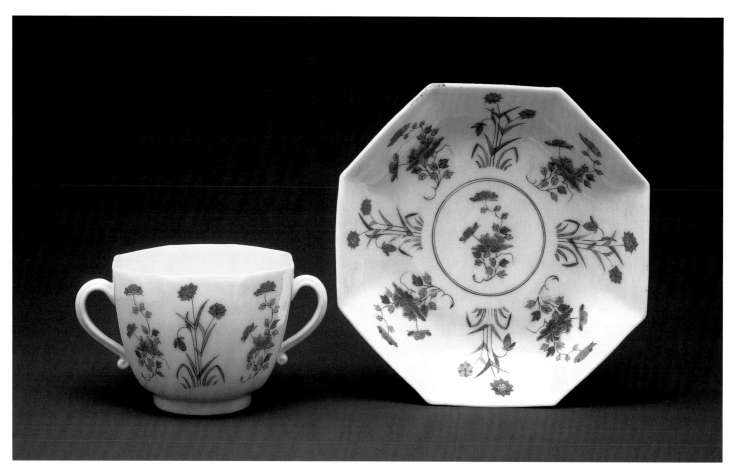

PL. 12.13

PL. 12.13

Double-handled cup and saucer

German, Meissen factory, 1729–31
Hard-paste porcelain with enamel colors
Marks: crossed swords in overglaze blue and Japanese Palace inventory number, cup and saucer engraved N=348/W
Cup: h. 2⅜ in. (6 cm)
Saucer: diam. 5⅝ in. (4.3 cm)
Gift of Martha and Henry Isaacson, 61.75

Meissen began copying Japanese Kakiemon wares in the mid 1720s when these wares were the height of fashion in Europe. Japanese originals from the Dresden royal collection were made available to the decorators at the factory. The most active period of Meissen production in the Kakiemon style was from 1729 to 1731. This cup and saucer, one of two in Seattle's collection, are marked with the factory's crossed swords in overglaze enamel rather than the standard underglaze blue.

As early as 1709, Asian porcelains from Augustus the Strong's collection served as inspiration for Meissen productions. But in 1731, spurious dealings concerning Meissen copies of Kakiemon originals ended with disgrace, imprisonment, and deportation for two men affiliated with the factory.[32]

In December of 1729, the French merchant Rodolph Lemaire (b. 1688) contracted with the king, Saxony's Finance Department, and the Manufactory Commission for the exclusive right to sell Meissen porcelain in France and the Netherlands. Secretly Lemaire negotiated with his sponsor, the manufactory commissioner Count Karl-Heinrich von Hoym (1694–1736), to produce copies of Japanese Kakiemon with the intention of selling these "reproductions" on the Parisian market. Lemaire selected more than 200 Asian porcelains from the king's Japanese Palace collection to copy, and in violation of factory policy, he was first able to obtain unmarked Meissen Kakiemon-style porcelain in 1729.[33] He also acquired Meissen Kakiemon-decorated wares bearing crossed-swords marks over the glaze, which could be ground off or removed by acid. These porcelains were then intended to be sold at a higher price as Japanese originals.

In March 1731, the scandal broke. Lemaire was deported, and Count von Hoym was imprisoned. Over 4500 porcelains ordered and produced during Lemaire's tenure were confiscated from von Hoym's residence and transferred to the Japanese Palace, where they became the property of the king. Seattle's cup and saucer, as well as the plate decorated with a tiger (see pl. 12.18), are marked with crossed swords over the glaze and the Japanese Palace inventory numbers wheel-engraved and colored in black. They received engraved numbers when they came into the king's possesion.[34] They were part of the clandestine von Hoym–Lemaire enterprise. As a result of this affair, by royal decree, the crossed-swords mark in underglaze blue became mandatory on all Meissen porcelain. Interestingly, a Japanese plate in Seattle's collection bears an inventory number signifying that it was once in the collection of the king (see pl. 12.19).

Phoenixes

The motif of phoenix amid floral sprays started to appear on both Kakiemon ware and Kakiemon-type Arita ware in the late seventeenth century, often accompanied by formalized brocadelike flower scrolls as seen on the shoulder and neck of this square bottle (pl. 12.14). The square form derives from the shape of Dutch gin bottles and was likely copied after bottles sent to Arita kilns by Dutch ships. The decoration, however, was painted by a Dutch artist in close imitation of a Kakiemon design showing a phoenix and hibiscus alternating with a crane in flight above chrysanthemums. The fabulous phoenix, considered to be the queen of all birds, was a popular motif in both Japan and China (see pls. 5.1, 5.10). The phoenix with hibiscus or peony symbolizes fame and splendor, while the paired crane and chrysanthemum express the wish for longevity. Such meanings might not have been known to the Dutch enameler, but the exotic picture and its beautiful colors must have fascinated him and his patrons.

Early European factories utilized Japanese octagonal and hexagonal shapes. In theory, if the ware slumped in the firing, it would be less noticeable than on a round shape. Warping is clearly evident in the hexagonal jar, which lacks its cover (pl. 12.15), but it was still deemed worthy of decoration.

Tall Japanese hexagonal jars with covers, decorated in Kakiemon style, were known in England in the late seventeenth century. Two famous jars of this form, dating from the years 1670–90, are in the Hampton Court Palace collection of the Queen of England. Japanese and European jars in this popular shape are all generally known as Hampton Court jars. Meissen made copies of these Kakiemon-style jars in the 1730s, but because Chelsea examples are so close in decoration to the Japanese originals, it is believed that they are second-generation rather than third-generation copies. Featured on the Seattle jar are long-tailed phoenixes.

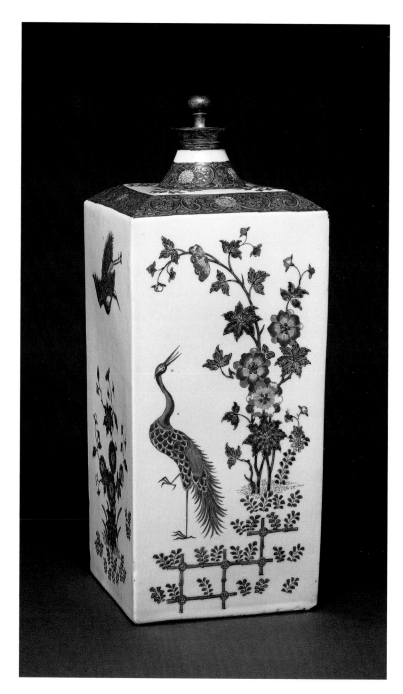

PL. 12.14

Square bottle

Japanese, Edo period, 18th century
Arita ware, porcelain decorated in Holland in Kakiemon style
H. 10¼ in. (26.1 cm)
Gift of Martha and Henry Isaacson, 76.99

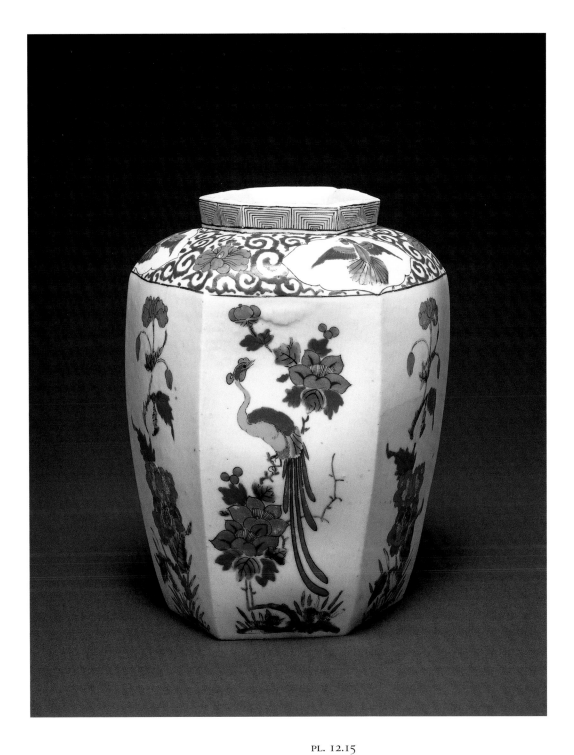

PL. 12.15

Hexagonal jar

English, Chelsea factory, c. 1753–55
Soft-paste porcelain with enamel colors and gilt
Mark: red anchor inside neck rim; cover missing
H. 8½ in (21.6 cm)
Gift of Martha and Henry Isaacson, 69.166

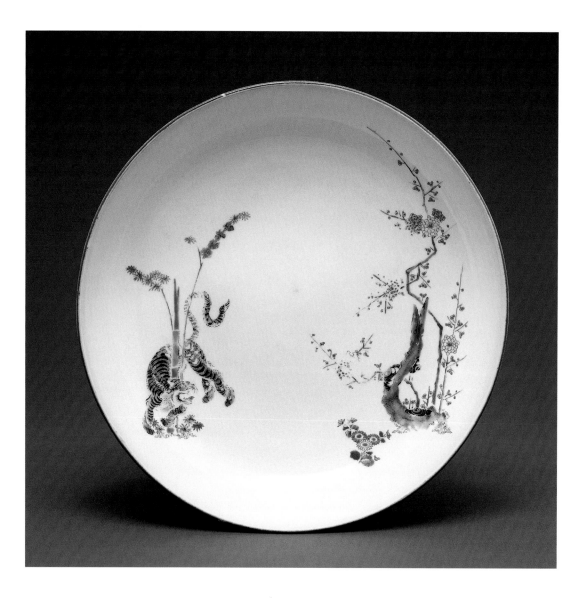

Tigers

Though the symbolism of tiger and bamboo connotes the weak (bamboo) submitting to the strong (tiger), these depictions of sinuous tigers present an engaging paradox: in curling around or approaching the bamboo, the tiger also adopts the flexibility that is one of the plant's chief virtues.

PL. 12.16

Plate

Japanese, Edo period, late 17th century
Arita ware, Kakiemon type, porcelain painted with overglaze enamels
Diam. 9¾ in. (24.8 cm)
Eugene Fuller Memorial Collection, 56.122

Like their Chinese counterparts, Japanese decorative motifs are usually emblems of auspicious meanings. The subject of tiger and bamboo was favored by Japanese potters and painters of the Kanōschool in the seventeenth and eighteenth centuries. It symbolizes safety, for legend has it that the only way for the tiger to escape from its enemy the elephant is to enter a bamboo grove.

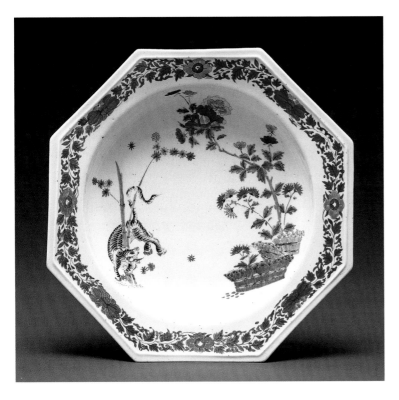

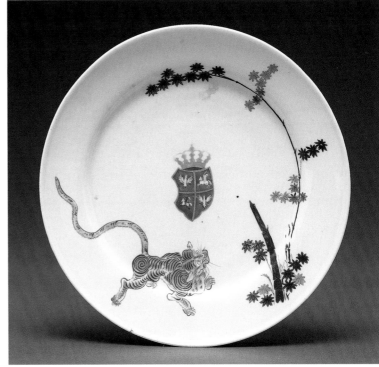

PL. 12.17

Plate

English, Chelsea factory, c. 1755
Soft-paste porcelain with enamel colors
Unmarked
Diam. 9¼ in. (23.5 cm)
Gift of Martha and Henry Isaacson, 69.164

This pattern was listed in a Chelsea factory sale of 1755, as
"wheatsheaf and tyger dishes." The tiger curling around bam-
boo on this plate is combined with another famous Kakiemon
pattern, the banded hedge motif (mistaken for stalks of wheat
by the English), rather than with the prunus tree that is depicted
on the Japanese plate in the Seattle collection (see pl. 12.16).

The fierce tiger curling around a stalk of bamboo on this
English plate derives from imported ware from Japan. Pro-
duced on this plate at the first porcelain factory in England, it
was one of the most popular Kakiemon designs. An earlier
adaptation on Meissen dinner services of the late 1720s and
1730s was recorded in the royal collection inventories as the
gelber Löwe (yellow lion). This motif actually represents a yel-
low tiger; such misidentifications of exotic animals were com-
mon through the eyes of eighteenth-century Europe.

PL. 12.18

Plate

German, Meissen factory, 1729–31
Hard-paste porcelain with enamel, gilt, and luster
Marks: crossed swords in overglaze blue and Japanese Palace
inventory number, N=72/W
Diam. 9⅛ in. (23.2 cm)
Gift of Martha and Henry Isaacson, 69.200

The wide-eyed, Kakiemon-style, red and gilt-striped tiger
with bamboo is a copy of a Kakiemon original and is from the
Lemaire orders.[35] Plates decorated with this pattern and marked
with the Japanese Palace inventory number 72 are listed in the
inventory of 1770. It is significant that the inventory does not
mention the royal arms of Poland, which were added to some of
these plates, including this one; they are a later addition.[36]

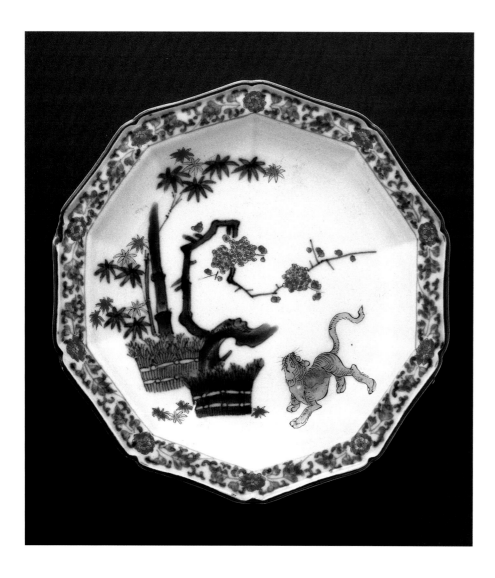

PL. 12.19
Plate

Japanese, Edo period, early 18th century
Arita ware, Kakiemon type, porcelain painted
with underglaze cobalt blue and overglaze
enamels
Marks: *kin* character in underglaze blue and
Japanese Palace inventory number, N=36-□
Diam. 5½ in. (14 cm)
Gift of Martha and Henry Isaacson, 76.98

In this Japanese depiction of a yellow
tiger, the banded hedge motif accompanies
the bamboo and prunus decoration. The
banded hedge appears here in the form of
an enclosure of grasses or reeds bound with
cloth bands and encircling the trunk of
each tree. Of the nineteen types of fences
and hedges defined during the mid-
fifteenth century in the Japanese rules
of gardening, the banded hedge was the
most respected.

The Banded Hedge

The enclosure forms one element of traditional Japanese
garden design. Fences, hedges, and other plantings may
symbolically encompass a whole universe in a limited space.
Within the strolling style of garden (*shūyū*), which leads
the viewer along a wandering path, high hedges create a
separation from the outside world, while lower ones, such
as the banded hedge, often signify a safe hiding place.

A teapot in the Seattle collection (pl. 12.21) illustrates a
medley of Kakiemon themes that became popular subjects
on European porcelain. The Japanese banded hedge pattern
and a phoenix in flight are joined by a prunus (flowering
plum) tree and bamboo. The prunus and bamboo represent
two of three elements in a traditional theme in Chinese

literature and art, Three Friends of the Cold Season. The
third element, the pine, was omitted by the Worcester
decorators.

The plum is the essence of purity. The bamboo represents
uprightness and, because it is pliable, strength in weakness.
The pine, evergreen even in the face of winter, stands for
steadfastness and courage against great odds.[37] As ancient
symbols, they coalesced in literature and art to support these
Confucian ideals. As part of Chinese literati culture, the
Three Friends of the Cold Season motif was introduced into
Japan, where it was assimilated into the vernacular language
of design. Chinese patterns became part of the Kakiemon
and Imari enameled porcelain traditions of the seventeenth
and eighteenth centuries.[38]

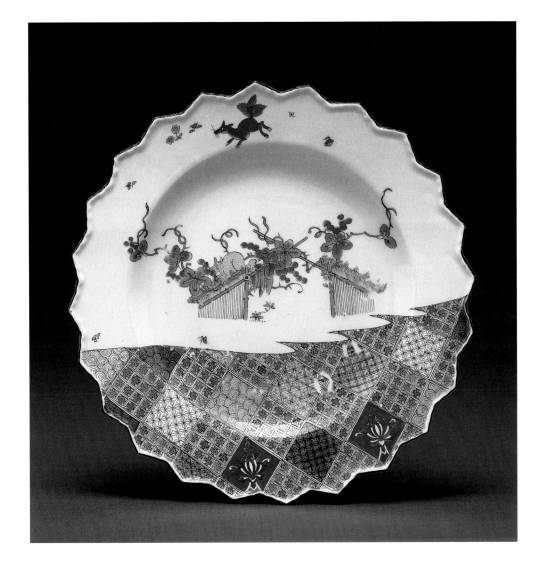

PL. 12.20

Plate

German, Meissen factory, c. 1740
Hard-paste porcelain with enamel colors
and gilt
Marks: crossed swords in underglaze blue
and impressed 20
Diam. 9½ in. (24.1 cm)
Dorothy Condon Falknor Collection of
European Ceramics, 87.142.106

The form and division of pattern on this plate is an adaptation of a late seventeenth-century Japanese double-leaf-shaped dish. A dish of this type was acquired for Augustus the Strong in Holland in 1723.[40] The upper half of the plate is painted with a sparse scene of a banded hedge in the Kakiemon palette. This scene is separated and quite distinct from the lower geometric design influenced by textiles.

Meissen, though inspired by Asian wares, wanted to look recognizably European. The rigidly painted banded hedge on this Meissen plate is more stylized than the bundled hedges depicted on Japanese prototypes. Here, it becomes a running fence contained by bamboo poles.

Confused by the furry animals represented in this pattern, Europeans called it the flying fox or flying dog pattern. Now that these creatures have been identified as a type of Asian squirrel, the pattern has the rather lackluster designation of 'red and yellow squirrel' pattern.

In the Chinese Transitional period (c. 1620–1683), the flowering plum occurs most often as a short tree with oversize blossoms.[39] English porcelain painters at the Bow and Worcester factories embraced this configuration. Seattle's Worcester teapot depicts a stubby, gnarled prunus tree with huge blossoms. These prunus flowers, composed of concentric circles of dots, are so stylized that they no longer attempt to resemble actual plum blossoms.

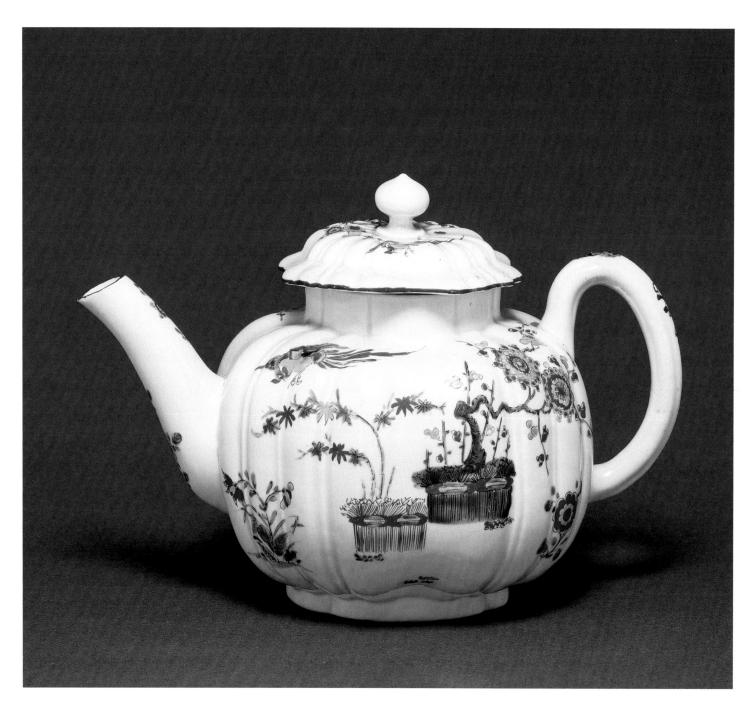

Teapot

English, Worcester factory, c. 1753–54

Soft-paste porcelain with enamel colors

Unmarked

H. 5½ in. (14 cm)

Kenneth and Priscilla Klepser Porcelain Collection, 94.103.5

A combination of Asian-influenced motifs is presented upon this teapot, which was shaped after a contemporary European silver form. A continuum in the East-West interchange of decorative designs in the seventeenth and eighteenth centuries, lobed melon shapes in Western silver were inspired by the red stoneware teapots of Yixing, the earliest Chinese teapots to arrive in Europe.

Rare Figures in Kakiemon Scenes

Figures are rare on Japanese Kakiemon export porcelain and on Kakiemon-style porcelain of Europe. When they appear, they are Chinese in character.

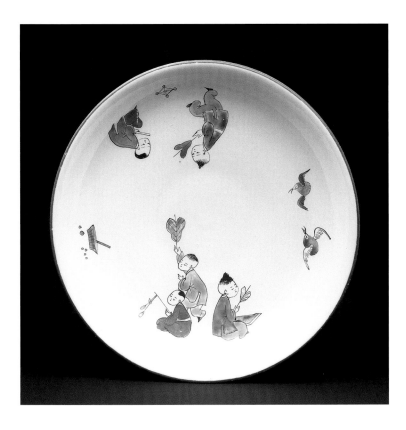

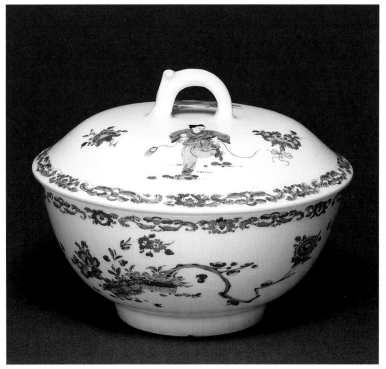

PL. 12.22

Plate

French, Chantilly factory, c. 1735
Soft-paste porcelain with enamel colors
Unmarked
Diam. 5¼ in. (13.3 cm)
Dorothy Condon Falknor Collection of European Ceramics, 87.142.15

The beautifully translucent, jewel-like enamel colors of the Chantilly factory are evident in this depiction of boys at play. In Japan, these figures were known as Chinese boys (*karako*).

PL. 12.23

Bowl

English, Bow factory, c. 1753
Soft-paste porcelain with underglaze blue and enamel colors
Marks: short painted line in red on bottom of bowl and inside lid
Diam. without cover 6 in. (15.3 cm)
Blanche M. Harnan Ceramic Collection, Gift of Seattle Ceramic Society, Unit I, 64.136

The Bow Porcelain Manufactory of New Canton was the official early name of the English factory that produced this bowl. It heralds the factory's goal to compete with and even undercut Asian imports. The Japanese banded hedge pattern, a prunus tree, a "Chinese boy" playing with a string to which an enormous flower is attached, and a mythical lion (*shishi*) make up the pastiche of Asian-inspired motifs on this bowl and cover. This is a rare Bow pattern.

This style of covered, strap-handled Japanese bowl was unusual at Bow. A Japanese bowl of this type was recorded in the porcelain collection of Augustus the Strong of Saxony in 1721, but the form never became fashionable either in Meissen porcelain, where it was produced with a twig handle, which inspired Bow, or in the many other European factories that were influenced by Asian and Meissen production.[41]

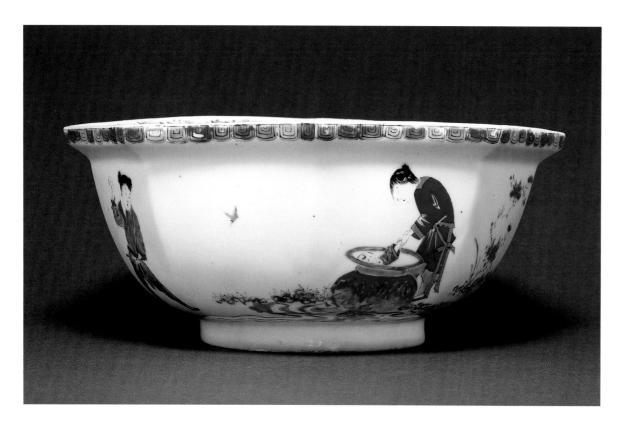

PL. 12.24

Bowl

English, Chelsea factory, c. 1755
Soft-paste porcelain with enamel colors
Unmarked
Diam. 9 in. (22.9 cm)
Gift of Martha and Henry Isaacson, 69.165

A boy emerging from a large ceramic jar is the central theme
of a popular Japanese Kakiemon scene copied at Meissen and
Chelsea.[42] The intermingling of East and West is visible in the
Japanese Kakiemon form, motif, and palette of this European
porcelain bowl, which illustrates a Chinese folktale commonly
known in the West by its English title, "Hob in the Well." The
Chinese story depicts a heroic act by the young Sima Guang
(1019–1086), who became a great Song dynasty scholar and
statesman. He is depicted on the left, casting stones at a water jar
in which a young boy has become stuck and is drowning. Once
the jar has been smashed, water gushes forth, and a friend assists
in the rescue. Pictorial representation of the story had already
appeared in Sima Guang's lifetime. Known to the Chinese as
"child smashing the urn," the subject has become a symbol of
quick wit and vision.

In Japan, the Chinese statesman of the story is called Shiba-
Onkō, and a treasured Chinese porcelain jar is also involved.

The seventeenth-century Japanese version takes on the dimen-
sion of parable. A young boy becomes lodged in the most prized
possession of a village. After numerous vain attempts to pull
him out, the youthful Shiba-Onkō is called upon to decide be-
tween the value of the revered porcelain vessel and human life.
His choice to break the pot foretells his humanity as a future
statesman.[43]

The name 'Hob in the Well' was given to this pattern at the
Chelsea factory. It comes from a one-act English comedy, *The
Country Wake,* published in 1696 and revised in 1711 as *Flora, or
Hob in the Well.* The plot of this popular farce had little to do
with the Chinese tale. The lead characters in the play are Flora,
a young heiress, and her suitor, Mr. Friendly. The young lovers'
plans to marry are thwarted by Sir Thomas Testy, Flora's uncle
and guardian. Hob enters the story as the fellow designated to
deliver to Flora Mr. Friendly's letter outlining the details for
their elopement. Hob, of course, is captured by the evil Sir
Thomas and thrown down a well. He is saved from drowning
(the only connection to the Chinese tale) by his parents. Flora,
who at the moment of escape shows some reluctance to flee with
her beloved, asks where they are going. Mr. Friendly replies,
"To a doctor that shall cure thee of all fears forever—to the par-
son, the parson, my dear angel." She goes.[44]

PL. 12.25

Plate

Japanese, Edo period, late 17th century
Arita ware, Kakiemon type, porcelain
painted with overglaze enamels
Diam. 7½ in. (19 cm)
Eugene Fuller Memorial Collection, 59.14

On this plate, the *taihu* rock, the
Three Friends of the Cold Season,
and two birds form a garden scene
composed in an asymmetrical, deli-
cate manner and painted in a soft
palette, both typical of the Kakiemon
style. The brown-glazed edge derives
from Chinese export wares of the
mid-seventeenth century; their rims
were often glazed this way to cover
the easily chipped edges. The over-
glaze blue enamel on the tree trunks
was, however, a Japanese innovation
introduced into China during the
late Kangxi period (1662–1722; see
pl. 12.27). Substituting for underglaze
blue, this blue enamel facilitated the
making of polychrome ware in one
firing, instead of the two needed for
underglaze colors.

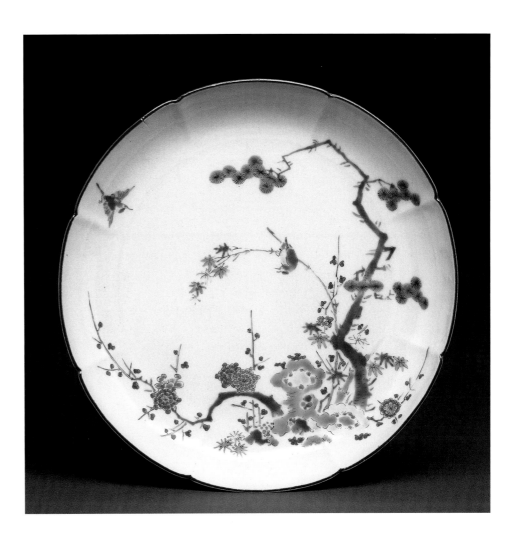

The Rock and Bird-and-Flower Motifs in Kakiemon Style

The bird-and-flower motif is an abiding theme in both Chi-
nese and Japanese painting and decorative art. It portrays a
natural environment but also may evoke symbolic connota-
tions; such motifs are associated with particular meanings.
The hollow rock painted in turquoise green on a Japanese
plate (pl. 12.25) represents the famous Chinese *taihu* rock,
which symbolizes firmness and long life. The pine, bamboo,
and plum, the Three Friends of the Cold Season, endure
winter's bitter cold when most other plants wither. Their
shared strength is therefore a powerful metaphor for stead-
fast friendship, particularly under difficult conditions. This
theme originated in China in the twelfth century and soon
entered artistic media. It was also introduced into Korean
(see chap. 8, fig. 1) and Japanese art works.

Europeans' fascination with the trendy Kakiemon style was manifested in their products. Almost every European porcelain factory produced close copies as well as imitations utilizing the Kakiemon palette and spacious composition. A good example of the latter is seen on a plate made in the Chelsea factory (pl. 12.26). Japanese-inspired form, pattern, and palette were introduced at Chelsea in 1750 to promote the factory's newly improved porcelain body. The result is a "taste entirely new," as advertised by the owner and director of the factory, Nicholas Sprimont.[45]

The motifs of rock and flower are fully exploited on a large Chinese plate (pl. 12.27). In elegantly painted details, the flowering plants and the *taihu* rocks comprise a fenced garden scene. The composition is spacious and slightly formalized, recalling the Kakiemon style. This *famille rose* palette differs from Kakiemon in that it consists of pink instead of orange-red, and in its white enamels. The diaper pattern with reserved panels bordering the rim is a very common decoration on Chinese export wares. It is not surprising to see it on a Meissen sugar bowl and stand (pl. 12.28).

PL. 12.26

PL. 12.26

Plate

English, Chelsea factory, c. 1754
Soft-paste porcelain with enamel colors
Mark: red anchor
Diam. 8½ in. (21.6 cm)
Gift of Dr. and Mrs. S. Allison Creighton, 95.103

PL. 12.27

Plate

Chinese, Qing dynasty, Kangxi period, c. 1722
Jingdezhen ware, porcelain painted with
overglaze enamels
Diam. 17⅛ in. (43.5 cm)
Eugene Fuller Memorial Collection, 35.267

PL. 12.27

PL. 12.28

Sugar bowl with stand

German, Meissen factory, c. 1730
Decorated in the style of Johann Ehrenfried Stadler (1701–1741)
Hard-paste porcelain with enamel colors and opal luster
Unmarked
Stand: diam. 7 in. (7.8 cm)
Bowl: h. 4⅝ in. (11.8 cm)
Gift of Martha and Henry Isaacson, 69.206

These pieces display an exuberant picture of a pheasant posing
on a stylized rock, and exotic Asian flowering plants such as
peonies, plum, and chrysanthemums, all unknown in Europe at
this time. The palette of these two pieces also appears to echo the
new Chinese fashion for pink.

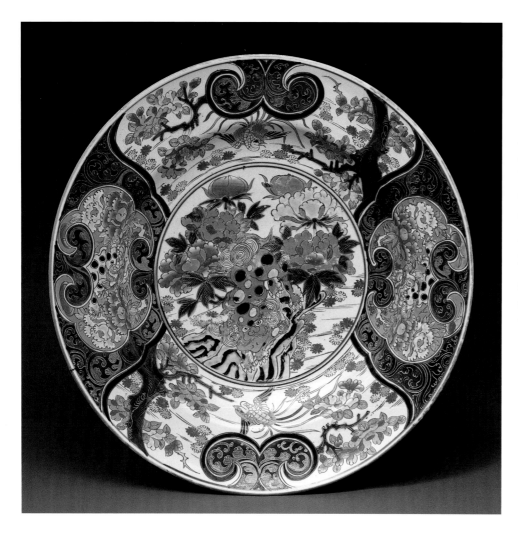

PL. 12.29

Plate

Japanese, late 17th century
Arita ware, Imari type, porcelain painted
with underglaze blue and overglaze enamels
Diam. 21¼ in. (54 cm)
Floyd A. Naramore Memorial Purchase
Fund and Eugene Fuller Memorial Collection, by exchange, 76.22

This Japanese plate presents a lion
(*shishi*), symbol of protective power, with
peonies in the central medallion and two
reserved cartouches on the rim. The
background scene of stylized small chrysanthemum florets floating in water is
a design common on Japanese lacquer
works.

IMARI WARE

Named after the seaport about 12 kilometers from Arita,
where Arita porcelain was shipped out, Imari style refers to a
type of decoration developed in Arita in the last two decades
of the seventeenth century. It is characterized by its palette of
underglaze cobalt blue and overglaze enamels of strong colors, such as iron red and gold. Imari designs usually show
auspicious symbols and stylized pictorial scenes (pl. 12.29).
The Imari-style wares, sometimes called *ko-imari* (old Imari),
were made for both export and Japanese domestic markets
throughout the eighteenth century. Like the Kakiemon palette, the Imari style was widely copied by European potters.
The Chinese also created porcelain in the Imari style, almost
exclusively for the export market.

 One type of Imari export porcelain featured underglaze-
blue decoration that left blank spaces for lavishly applied

overglaze patterns in enamel colors and gilt. The Seattle
plate (pl. 12.30) with characteristic iron-red, cobalt blue, and
gilded patterns was influenced by Japanese originals dating
from about 1720–40. This style of decoration is commonly
referred to as brocaded Imari because some of the radiating
panels resemble brocaded textiles. But it is probably the pattern listed in the Chelsea sales records in 1756 as "a rare [or
fine] old japan pattern blue and gold."

PL. 12.30

Plate

English, Chelsea factory, c. 1756
Soft-paste porcelain with underglaze blue, enamels, and gilt
Mark: anchor in underglaze blue
Diam. 9⅝ in. (24.5 cm)
Gift of Martha and Henry Isaacson, 69.167

Dragon: Lord of the East

The dragon is one of China's most complex symbols, and certainly one of the most popular decorative motifs (see pls. 5.2, 5.11; 9.2). Its image can be traced back to the third millennium B.C. A purely mythical creature, the dragon combines features of various animals—a horse's head, deer's horns, bull's eyes, snake's neck, fish's scales, and eagle's claws. The dragon has many subtypes and commands numerous legends and cosmological functions, one of which is the cardinal point east, as seen on the Song period mortuary jar (see pl. 4.3). The dragon controls the wind and the rain as it flies and swims; it is therefore a life-giving creature, for water is essential to sustain life and ensure a great harvest. The traditional annual dragon dance festival is a manifestation of this belief and involves prayer and celebration. In the dance, the dragon chases after a ball symbolizing the pearl it spits from its mouth—an auspicious sight heralding the coming of much-anticipated rain. A similar image is often featured in porcelain designs, as seen on the covered conical bowl and in openwork on the white bowl (pls. 12.32, 12.33). On imperial wares, the dragon is a symbol of the emperor himself, a convention established as early as the Han dynasty (206 B.C.– A.D. 220). On these two bowls, the dragon was formed with admirable artistry.

The dragon was also a popular motif on Japanese ceramics and was sometimes paired with the phoenix, after Chinese examples, to symbolize male and female in general and the emperor and empress in particular. The stylized dragon and phoenix pattern of the Meissen plate (pl. 12.34) is unmistakably a close copy of a Japanese prototype; so is the red and gold palette. These Meissen copies were often so successful that they are difficult to distinguish from the originals. On this plate, the delicate sprays and leaves painted near the whirling phoenixes seem to have been a Meissen addition— perhaps to identify the piece as a Meissen product, or simply to give an extra touch to the decoration.

Vase

English, Worcester factory, c. 1765
Soft-paste porcelain with enamel colors and gilt
Unmarked
H. 16 in. (40.7 cm)
Gift of Martha and Henry Isaacson, 81.9

The form of an ancient Chinese bronze beaker
inspired the modeler of this tall octagonal vase.
Even though it slumped in firing, it was considered
worthy of decoration. Japanese Kakiemon-style
dragons curl through flowering trees on panels that
alternate with prunus and chrysanthemums, but
Imari is the overall influence seen in this vase.
The motifs and gilt trelliswork completely fill the
space in a manner very unlike sparse Kakiemon
decoration.

PL. I2.32

Covered bowl

Chinese, Qing dynasty, Yongzheng reign mark and period (1723–1735)
Jingdezhen ware, porcelain with underglaze blue and overglaze enamels
Diam. 7⅝ in. (19.3 cm)
Gift of Mrs. John C. Atwood, Jr., 70.45

Known as *doucai* (joined colors) in Chinese for the combination of underglaze blue and overglaze enamels, the style was most renowned for wares made in the mid-fifteenth century and the early eighteenth century. These *doucai* wares share a similar elegance in designs that feature clean forms and exquisite painting.

PL. 12.33
Bowl

Chinese, Qing dynasty, Qianlong reign mark and period (1736–1795)
Jingdezhen ware, porcelain with reticulated decoration filled in with
transparent glaze
Diam. 5¼ in. (13.3 cm)
Eugene Fuller Memorial Collection, 35.252.2

The transparent, stencil-like rice-pattern formation was created
by piercing tiny holes directly into the dried, unfired body and
then dipping it in glaze until the holes were full. This labor-
intensive technique first appeared in Jingdezhen during the
Yuan period (1279–1368) on *qingbai* wares with simple patterns
composed of rice-grain shapes. Here, the thin wall and multi-
shaped holes embody a perfection of skill attained in the eigh-
teenth century.

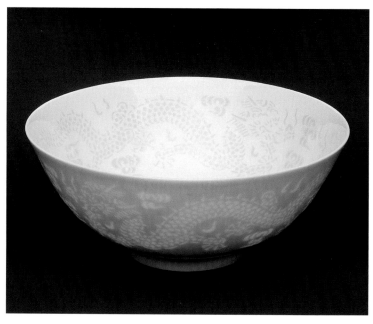

PL. 12.33

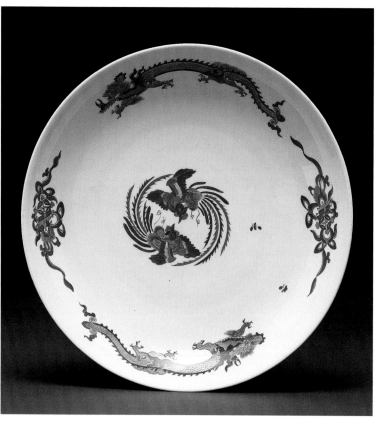

PL. 12.34

PL. 12.34
Plate

German, Meissen factory, c. 1734–39
Hard-paste porcelain with iron-red colors and gilt
Marks: crossed swords in underglaze blue and K. H. C. in purple
Diam. 11¾ in. (29.9 cm)
Gift of Martha and Henry Isaacson, 69.199

Produced as a table service for the royal household of Augustus
III in Dresden, this pattern was delivered in three different
installments between the years 1734 and 1739. The initials
K. H. C. indicate that this plate was in the royal storeroom or
pantry, the Königliche Hof-conditorei.

FAMILLE VERTE AND FAMILLE ROSE

Famille Verte

The primary style of Chinese overglaze porcelain during the Kangxi reign, prior to the emergence of *famille rose,* was a type of decoration centered around green enamels. Its name, *kangxi wucai* (five colors of the Kangxi period), indicated that it was related to the *wucai* style of the late Ming period. While the late Ming *wucai* consists of underglaze blue and overglaze primary colors, the typical *kangxi wucai* comprises only overglaze colors, including newly introduced overglaze blue and black. Like contemporary blue-and-white, whose blue hue has a range of shades, the *kangxi wucai* overglazes have many tones, notably a dominant green. The scheme exerted strong influence on the decoration of European porcelain. Many examples can be found in Meissen and Chelsea products of the early periods. Europe named this green color scheme *famille verte* later in the nineteenth century.

The palette of *famille verte* consists basically of green, yellow, iron red, aubergine, black, blue, and occasionally gold. Diluting with water or mixing colors produced more tones and colors. The style is ubiquitous on Kangxi over-glaze painted wares but is best represented by wares featuring figural motifs, such as warriors with weapons and horses (*daomaren,* pl. 12.35). Green permeates the plate. It is intriguing that it was applied not only as a color but sometimes as a form. Its various tones describe volume, as seen, for example, in the rocks in the foreground and background. Black, on the other hand, was used only for outlines and never for chiaroscuro to suggest volume, as in Western pictorial conventions. Black was also used for decoration but was often limited to the figure's hair and boots, as if to punctuate the color scheme. The motif of warriors with weapons and horses features characters or scenes from Chinese classical novels and dramas, though many depictions are so generic that they defy identification. Objects decorated with such pictures represent most of the best works of the *famille verte* style, combining masterful paintings and seasoned enamel-firing skills, as shown by the brilliant quality of this plate's enamels. The pervasive green even sparkles with a charming iridescence that resembles mother-of-pearl.

While one may wonder why green in particular was given a leading role, yet employed so artificially in decoration, it is certainly realistic for depicting a natural scene like the lotus pond in the Seattle plate (pl. 12.36). The green lotus leaves and reeds are alive with bursting vitality and freshness. The painting would look just like a color photograph, if one chose to overlook the green lotus blossom at far left and another odd-colored one at upper left. It is clear that even in such a seemingly realistic scene, the potter was more interested in the evergreen *famille verte* palette than in a faithful representation. This style undoubtedly inspired the plant painting seen on the beautiful Worcester vase (pl. 12.37). Sparsely composed and slightly formalized, with a touch of the Japanese Kakiemon style, the flowering plant was painted in a Chinese *famille verte* palette, but with far more delicate touches that impart a sense of tranquillity. The elongated profile of the vase and the long stems of the plant together

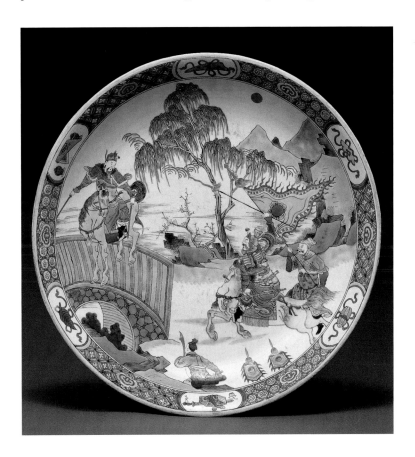

PL. 12.35

Plate

Chinese, Qing dynasty, Kangxi period (1662–1722)
Jingdezhen ware, porcelain painted with overglaze enamels
Diam. 13⅜ in. (34 cm)
Eugene Fuller Memorial Collection, 49.25

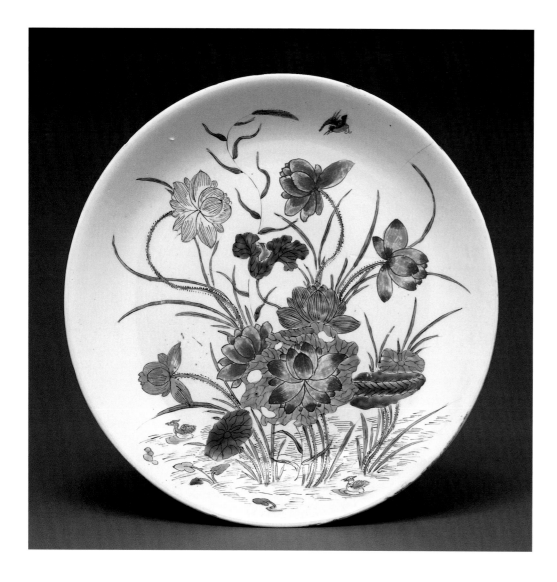

PL. 12.36

Plate

Chinese, Qing dynasty,
Kangxi period (1662–1722)
Jingdezhen ware, porcelain painted
with overglaze enamels
Diam. 13½ in. (34.3 cm)
Eugene Fuller Memorial
Collection, 44.113

create a sense of monumentality in this Worcester vase, which is in fact small in size.

Three-dimensional porcelain figures also claimed a share of this fashionable green style. Because of its color scheme, the Seattle reclining figure (pl. 12.39) seems to have been taken from the "warriors" plate (see pl. 12.35), except he is not a military general: he wears the crane badge on his back, indicating the first rank in the civil service. The figure represents the drunken and soundly sleeping Li Bai, the famous Tang poet, as he is portrayed in the poem "Eight Immortals in Wine" (Yinzhong baxian) by his contemporary, the poet Tu Fu. The enamels were painted directly on the prefired but unglazed porcelain body, which gives a slightly matte effect to the surface. The Chinese term for this style, *su sancai*,

means "plain three colors"—green, yellow, and brown (also see pl. 10.14). It often appeared on export porcelain figures, including those in the form of Westerners. Such specific Chinese colors as well as forms offered European potters unique characteristics to follow and incorporate in making their own Oriental-style pieces. An interesting practice is seen on a small French figure (pl. 12.38), which is modeled largely after a Chinese *dehua* figure of Maitreya. The French potter freely combined *dehua* form, *famille verte* palette, and stereotypical Asian facial features in this figure (though the face is not that of Maitreya). In so doing, he created a fantasized image in the visual idiom that was a basic characteristic of the European chinoiserie style, which is explored in the next chapter.

PL. 12.37

Vase

English, Worcester factory, c. 1752
Soft-paste porcelain with enamel colors
Unmarked
H. 7¾ in. (19.7 cm)
Kenneth and Priscilla Klepser Porcelain Collection, 94.103.1

The inverted baluster form of this vase comes from a Kangxi (1662–1722) original.[46] An article published in the *London Chronicle* in May 1763 presents a glowing, if somewhat biased, viewpoint on the merits of Worcester porcelain compared to Asian and other European wares:

> I myself have travelled into foreign parts, and have both
> seen and made trials of most of the different kinds of
> Porcelain that are manufactured at home and abroad,
> and am convinced thereby, that neither Dresden ware,
> though honoured by Royal Patronage, and in itself truly
> beautiful and elegant; nor that of Chantilly, which is so
> highly extolled and favoured in France, nor any other
> European Porcelain that I have anywhere seen, can com-
> pare with the Worcester in real and useful excellence . . .
> and the finer sort, which is enameled, so nearly resembles
> in every particular the finest Oriental pieces, whether of
> China or Japan.[47]

PL. 12.38

PL. 12.38

Figure

French, Saint-Cloud, c. 1735–45
Soft-paste porcelain with enamel colors
Unmarked
H. 2⅛ in. (5.4 cm)
Dorothy Condon Falknor Collection of European
Ceramics, 87.142.26

Saint-Cloud produced Chinese figures in stand-
ing, sitting, and reclining postures. This little
figure has an elongated shape and is the type that
was often mounted in silver or silver-gilt to create
a small box for snuff. In France, the fashion for
smoking tobacco was largely replaced during the
second half of the seventeenth century by the fad
of inhaling snuff. In the eighteenth century, the
taking of snuff became a social grace fashion-
able throughout Europe. The powdered, cured
tobacco leaves were mixed with various scents,
such as orange flowers or musk, to develop differ-
ent blends.

PL. 12.39

Figure of Li Bai

Chinese, Qing dynasty, Kangxi period (1662–1722)
Jingdezhen ware, porcelain with enamels on
biscuit
L. 6¼ in. (15.9 cm)
Eugene Fuller Memorial Collection, 45.16

PL. 12.40

Plate

English, Bow factory, c. 1755–58
Soft-paste porcelain with enamel colors
Unmarked
Diam. 8¾ in. (22.2 cm)
Gift of Dr. and Mrs. S. Allison Creighton,
95.105

Famille Rose

While the Bow plate (pl. 12.40) shows an overall design still reminiscent of Kakiemon style, the shaded pink enamels of its flowers, also seen on the Bow teapot (pl. 12.43), reflect a new taste and palette inspired by a different Chinese style such as that represented by the dish (pl. 12.42). The Europeans later named this new Chinese pink style *famille rose,* for the rose-pink color dominant in the decoration. The pink enamel uses colloidal gold as its colorant. It was introduced from Europe around 1720, likely via European enameled copper wares, such as enameled watches. To achieve the effect of color gradation, an opaque, lead arsenate–based white pigment was mixed with the enamels to lighten them, and sometimes it was also used as a color itself. This mixing greatly expanded the range of tones and produced a softened visual effect; the Chinese called it "powdered colors" (*fen cai*).

The imperial enameling workshop in the Forbidden City of Beijing was responsible for early experiments in enameling porcelain. Undecorated high-quality porcelain wares were sent from Jingdezhen to be painted in the imperial workshop. The best enamelers from Jingdezhen and Guangdong province in the south were summoned for this task. They were supervised by European Jesuits, who were at the time in charge of the enameling workshop. Sometimes the Kangxi emperor himself was involved in directing them. Many enamels were imported from Europe until 1728, when the workshop succeeded in making its own enamels.

Porcelain enameled in the imperial workshop has been called "enameling colors" (*falang cai*). Early examples of *falang cai* often have a fully covered, formalized design with a thick application of strong-colored enamels reminiscent of enameled metal wares produced in Europe and China

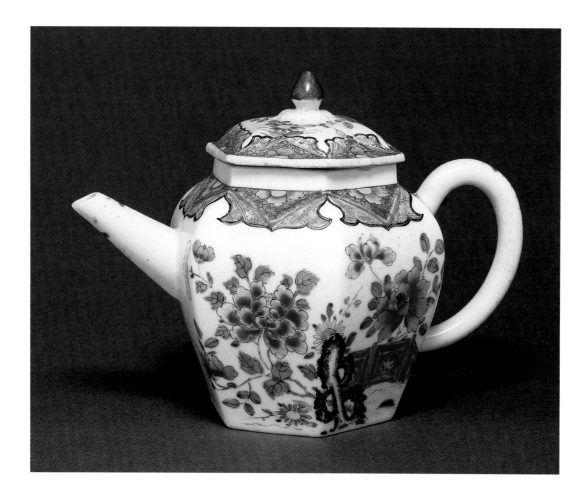

PL. 12.41

Teapot

English, Chelsea factory,
c. 1750–53
Soft-paste porcelain with
enamel colors
Unmarked
H. 4½ in. (11.4 cm)
Gift of Martha and Henry
Isaacson, 76.213

during the Ming dynasty. Enameled porcelains produced during the Yongzheng and early Qianlong reigns changed to feature a traditional Chinese painterly style and were often inscribed with one or two expressive lines of poetry (see pl. 10.18). Under the Qing emperors' auspices, the imperial workshop quickly mastered the technique of enameling porcelain, and its palette developed into more than twenty colors or tones.

Around the beginning of the Yongzheng reign, Jingdezhen was already making *famille rose* porcelains for the court (see pls. 10.16, 10.17) and at the same time was engaged in domestic and export markets (see pl. 12.27). The dish with rich diaperwork borders (pl. 12.42) is a solid example of Jingdezhen products for the commercial market. The blossoms and fruits in the center were first outlined, then filled in with opaque white pigment on which enamels were applied, then "washed away" with a wet brush to achieve satisfying tonal gradations. The body of this dish is delicately formed and

eggshell thin. Its exterior is painted a dark pink, as if to flaunt such a color indulgence. The four border patterns are minutely delineated; it is not uncommon to see up to seven elaborate borders circling around a central motif in this type of so-called ruby-back ware.[48]

The Chelsea hexagonal teapot (pl. 12.41) is connected with the Chinese dish (pl. 12.42) in its use of *famille rose* color schemes, design of rock and flower motifs, and similar turquoise diaper patterns seen on the lid and collar around the top of the teapot. The pink color became fashionable in Europe in the mid-eighteenth century. In France, it contributed to the spirit of the rococo style of Louis XV, as seen in the porcelains of Sèvres and the paintings of François Boucher.[49] From its inception, the pink color scheme became a paramount style in Chinese overglaze enameled porcelain of the Qing dynasty. Inevitably, *famille rose* porcelain formed the mainstream of Chinese export ware to Europe in the eighteenth and nineteenth centuries.

—J.E. AND J.C.

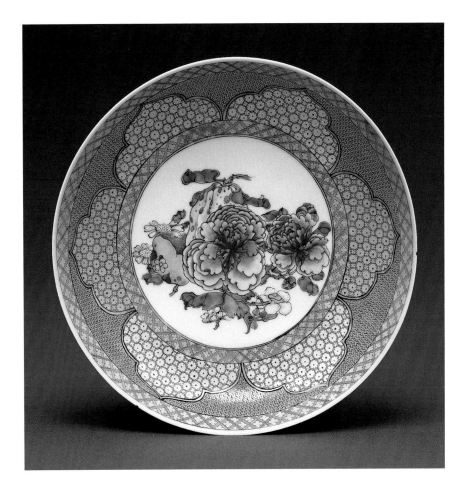

PL. 12.42

Dish

Chinese, Qing dynasty, c. 1723–35
Jingdezhen ware, porcelain painted with
overglaze enamels
Diam. 7¾ in. (19.7 cm)
Thomas D. Stimson Memorial Collection, 47.151

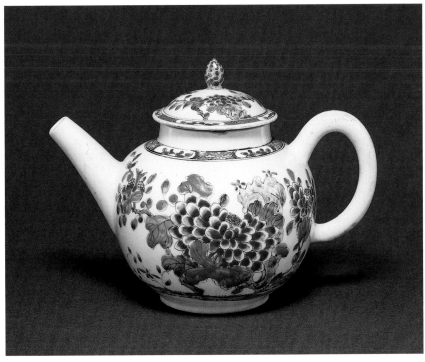

PL. 12.43

Teapot

English, Bow factory, c. 1755–58
Soft-paste porcelain with enamel colors
Unmarked
H. 5 in. (12.7 cm)
Gift of Dr. and Mrs. S. Allison Creighton, 95.98

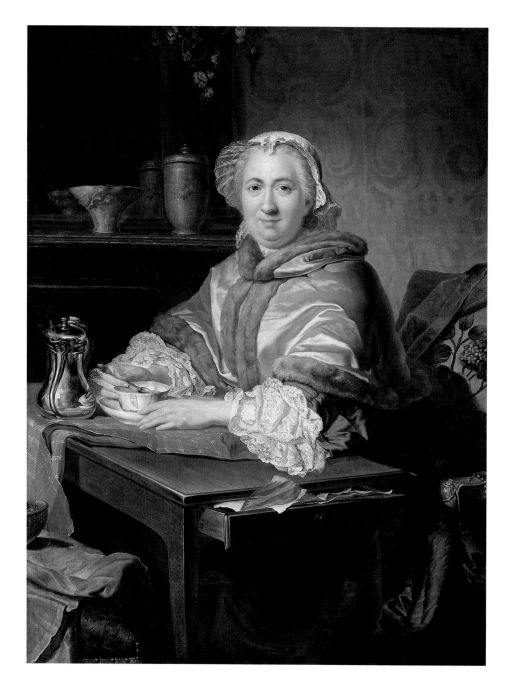

PL. 12.44
Jacques-André Joseph Aved (1702–1766)
Portrait of Madame Brion, Seated, Taking Tea, 1750
Oil on canvas
50⅝ × 38⅛ in. (128.6 × 96.8 cm)
Purchased with funds from the Frederick Pipes Estate Fund, General
Acquisitions, Mary Arrington Small Estate, and the Eugene Fuller
Memorial Collection, by exchange, 87.99

MADAME BRION AND HER PORCELAIN

Madame Brion was clearly proud of owning porcelain and
had it included in her portrait. On well-appointed mantel-
pieces like hers, the Chinese *blanc de chine* cup, in the form of
a rhinoceros horn (see pl. 12.2), was a standard accessory in
the eighteenth century. It is accompanied by a tall Kangxi
(1662–1722) covered jar of the type that served as models for
European tobacco jars. An early, very rare French Vincennes

tobacco jar (*pot à tabac*) in the Seattle collection derived from this form (pl. 12.45). At the top of the painting, flanking the mirror, is the lower portion of a wall-light or sconce (*bras de lumière*) composed of swirling lacquered (tole or japanned) foliage adorned with the famous porcelain flowers of Vincennes. Madame Brion shared her taste for lighting with royalty. The dauphine, the Saxony princess who sent her father Augustus III a huge bouquet of Vincennes porcelain flowers, decorated her room at Versailles with *bras de lumière*—a pair made of three branches in imitation of natural stems (probably lacquered) and covered with Vincennes flowers. The carefully represented, indentifiable porcelain in this painting make an odd conjunction with Madame Brion's bowl and saucer. They are too large to be Japanese or Chinese, and the design is not recognizable as Asian. It is the artist's rendition of Asian porcelain.

The atmosphere of the exotic East is also present in the popular flame-red cloth of imported Indian cotton shot with white or silver thread on Madame Brion's table. A more subtle Eastern influence is seen in the damask wall coverings of heavy fabric with shimmering, foliated designs in satin weave on a plain, woven ground. It is a type of European fabric with roots in the early tradition of richly woven Middle Eastern textiles associated with the far-off city of Damascus, from which it gets its name.

A curious aspect of this painting is the artist's title for it. We see Madame Brion seated at her provincial-style writing table, pausing from her correspondence or sewing to take refreshment. But she is drinking coffee, not tea. The silver vessel on the table is not a typical short, squat teapot with the spout placed low on the body, but a flat-bottomed style of French coffeepot known as a marabout. The swirling fluted decoration and the short pouring lip, suitable to the thick Turkish coffee favored by the French, are typical of its features.

In 1744, the French artist Aved painted a portrait of Louis XV that earned him the title *peintre du roi,* the king's painter. By 1750, he was well established in the circle of French artists that included Boucher, Madame de Pompadour's favorite painter, and Chardin. In that year, he presented his portrait of Madame Brion to the Salon.

—J.E.

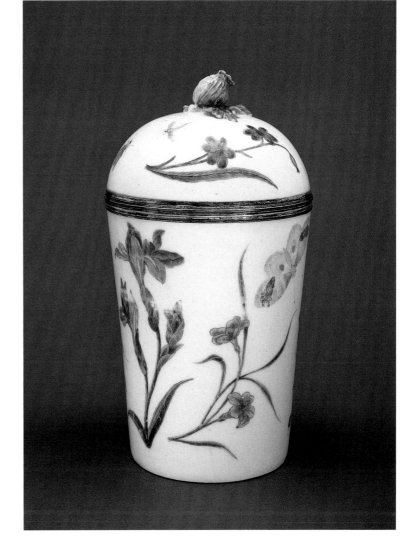

PL. 12.45

Tobacco jar

French, Vincennes factory, c. 1745–49
Soft-paste porcelain with enamel colors
Mark: unidentified painter's mark in blue on bottom of jar and inside rim of lid
H. 7⅞ in. (20 cm)
Dorothy Condon Falknor Collection of European Ceramics, 87.142.30

Although the shape of this tobacco jar (*pot à tabac*) is Asian, the influence of the German Meissen factory, often seen in early decoration on Vincennes porcelain, is evident in the Meissen-style flowers inspired by woodblock prints.[50]

13

CHINOISERIE

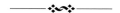

Chinoiseries evoke the allure of Asia. The term, unknown in the seventeenth and eighteenth centuries, is not used in any publication before 1840, and first appears in *Dictionnaire de l'Académie* in the 1880s.[1] Since that time, it has developed various connotations. For some, it encompasses the genre of European styles based on Asian design. A pagoda-style pavilion in an English garden, an Italian textile with phoenix pattern, German porcelain with Asian-style floral decoration, and a lacquered French table fit this definition. For others, 'chinoiserie' is a term that describes European decorative designs based on Asian figural and landscape scenes. Beginning in the seventeenth century, they were not exact copies but interpretations of the originals. The iconography of these motifs often was not understood; artists and patrons were interested in borrowing the style, not the content (see pl. 13.4).

Today, 'chinoiserie' is more commonly understood to be an eighteenth-century style that was a wholly European concept of exoticism. Innovative decorative motifs depicting imaginary and whimsical interpretations of life in Asia, they were inspired by a blend of factual accounts and fantasy. Chinoiseries typically present exotic figures clothed in flowing robes and elaborate headdresses, and situated in fanciful landscape settings. Whether these figures represent people of China, India, the Middle East, or Japan is often difficult to determine; they are a mélange of Asian and Middle Eastern peoples referring not to geographical boundaries so much as to a general concept of Asia. This is the chinoiserie we will explore.

Early compositions of fanciful Asian-style figures appeared in French designs produced by Antoine Watteau (1684–1721) soon after 1707[2] and developed influentially in the work of François Boucher (1703–1770) and Jean Pillement (1728–1808). Through engravings of their paintings and drawings, the style was dispersed throughout the arts of Europe. Chi-

noiserie themes reached their peak of popularity during the height of the rococo period, the second quarter of the eighteenth century. In the decorative arts, the idiom was adopted by tapestry weavers, wallpaper designers, cabinetmakers who produced lacquered (japanned) furniture, silversmiths, and painters of porcelain. The style remained in vogue on the Continent until after the middle of the century, when a revival in classical art began to take hold. In England, the fancy for chinoiserie lasted through the century, although it became more restrained with time.

Chinoiserie on Meissen Porcelain

Johann Gregor Höroldt (1696–1775) is credited with introducing the fanciful chinoiserie style at Meissen. In the early days of his career, Höroldt was known in Vienna for his work as an easel painter and for his fashionable chinoiserie murals. Recognizing a fertile new arena for his talents in the art of European porcelain, he joined the new porcelain manufactory of Du Paquier and served as an integral player in its hard-paste porcelain production, the first to compete with the monopoly of Meissen. At Du Paquier, he met Samuel Stöltzel, the renegade kiln master from Meissen who had helped establish the competitive factory in Vienna. Höroldt, the most talented porcelain painter of the Du Paquier factory, became Stöltzel's trump card in the ongoing game of porcelain intrigue.

A year after his defection from Meissen, Stöltzel once again became dissatisfied. Claudius du Paquier had failed to provide him promised compensation, so he plotted his return to Meissen. The talented young Höroldt, whom Stöltzel enticed away from the Du Paquier factory, arrived in Meissen alone in April 1720, bearing only a letter of introduction and some precious stolen enamel colors. Stöltzel, ill and filled with angst concerning the reception he would receive upon

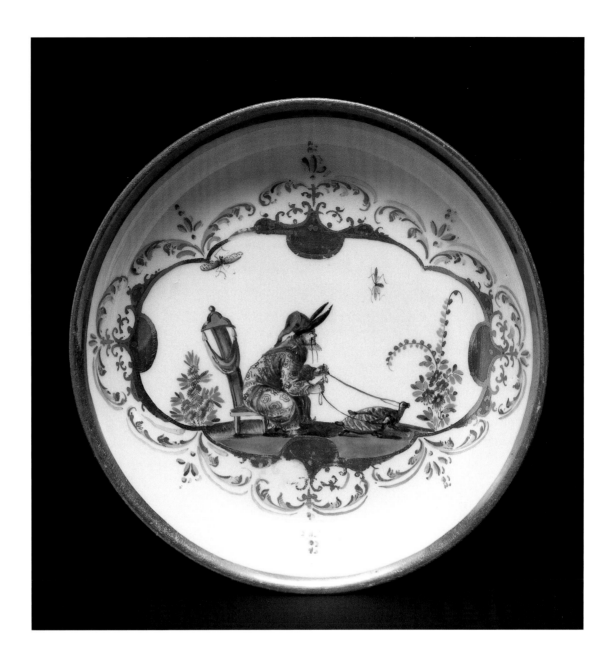

PL. 13.1

Saucer

German, Meissen factory, c. 1725
Böttger porcelain with enamel colors and gilding
Mark: gilder's mark, 23
Diam. 5 in. (12.7 cm)
Dorothy Condon Falknor Collection of European Ceramics, 87.142.101

This saucer is an excellent example of the fanciful, sometimes odd scenes depicted in chinoiserie. Here, an exotically robed gentleman in a feather-eared cap is attempting to drive a stationary chair harnessed to two tortoises. A huge mosquito flies overhead.

The saucer, which would have held a companion tea bowl, was produced during the early years of Höroldt's tenure. Because the works were rarely signed, attribution is difficult. The painting on it more closely resembles the work of Philipp Ernst Schindler (1695–1765), registered at the factory in 1725.[3]

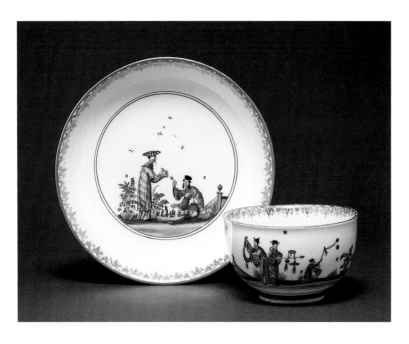

Tea bowl and saucer

German, Meissen factory, 1730s
Hard-paste porcelain with enamel colors and gilding
Marks: crossed swords in underglaze blue; gilders' marks,
tea bowl, 7, saucer, 4
Saucer: diam. 5¼ in. (13.3 cm)
Tea bowl: h. 2 in. (5.1 cm)
Gift of Dr. and Mrs. S. Allison Creighton, 95.95

This saucer illustrates two figures with a fretwork game board
on which Asian-gowned play pieces are placed. Several figures,
including one with an elaborate gong, appear on the tea bowl.

his return, had retreated to Freiberg, in southern Germany,
at the last minute to await developments. His talents as an
innovator in the field of porcelain production and in devel-
oping enamel colors for decoration assured his pardon,
however; he was soon back at work in the factory.

Augustus the Strong and the directors of Meissen were
greatly impressed with Höroldt's work. He moved up
through the ranks, from his initial position as decorator to
that of court painter in 1723 and the prestigious head of the
painting studio in 1731. In these years, he was most active
as a decorator of porcelain; in 1732, the context of his work
was specifically defined as supervisor of the painters, a largely
administrative role. Höroldt's greatest achievements were
the development of new enamel colors and his innovative
chinoiserie designs.

Porcelain decorators under Höroldt's direction, such as
Johann Ehrenfried Stadler (see pl. 13.3) and Adam Friedrich
von Löwenfinck (see pl. 13.4), were influenced by his vision.
Another source for porcelain designers was engravings of
chinoiseries that passed between Augsburg, a city famous for
its goldsmiths and engravers, and the Meissen factory. Augs-
burg *Hausmaler* who were decorating Meissen porcelain
outside of the factory created magical chinoiseries in gilded
silhouettes (see pls. 13.5, 13.6).

Many of the wares decorated in the chinoiserie style
were directly inspired by a large number of engravings and
sketches in the corpus of design work known today as the
Schulz Codex.[4] A good portion of the designs has been at-
tributed to Höroldt. These wonderfully intricate miniature
motifs are part of a European design tradition that had its
origin in marginal illustrations in illuminated manuscripts.

By the 1730s, when the Seattle tea bowl and saucer (pl.
13.2) were decorated, there was a generic quality to some
chinoiserie scenes produced by the Meissen factory. During
this period, Höroldt's role became more administrative, and
some of the creative spark from his time as an active designer
is gone. Nevertheless, the chinoiseries continued to feature
delightful renditions of people at leisure, either at play or in
ceremonial processions.

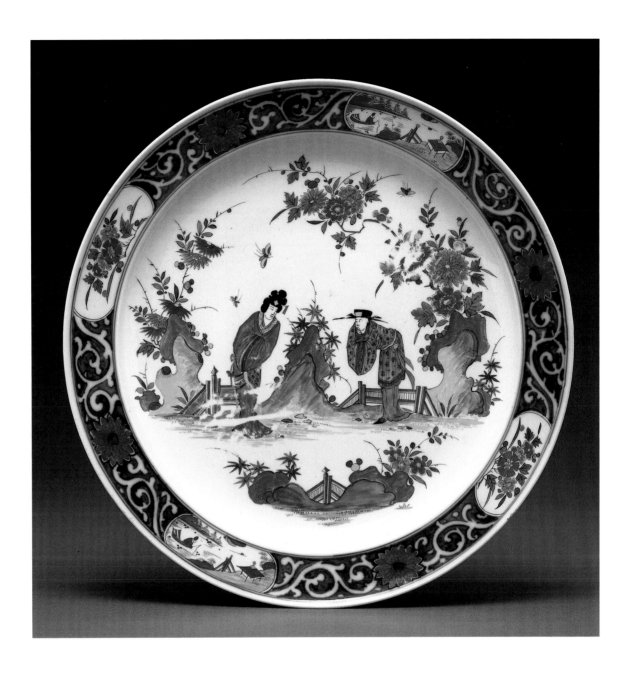

PL. 13.3

Plate

German, Meissen factory, c. 1725–30
Painting attributed to Johann Ehrenfried Stadler (1701–1741)
Hard-paste porcelain with underglaze blue, enamel colors, and luster
Unmarked
Diam. 12⅛ in. (30.8 cm)
Gift of Martha and Henry Isaacson, 69.203

Stadler, who worked at Meissen after 1723, painted a number of works based on a series of engravings, "Neiuwe geinventeerde Sineesen" (Newly Invented Chinoiseries), published by the Amsterdam printmaker Petrus Schenk the Younger between 1700 and 1705. They feature large chinoiserie figures, sometimes on horseback, among stylized rocks and overpowering flowering plants.[5] Painted decoration attributed to Stadler often incorporates an elaborate use of metallic luster, called mother-of-pearl (*Perlmutter*), a costly material containing gold.

PL. 13.4

Tankard

German, Meissen factory, c. 1735
Painting attributed to Adam Friedrich von Löwenfinck (1714–1754)
Hard-paste porcelain with enamel colors
Mark: crossed swords in underglaze blue
H. without lid 6 in. (15.3 cm)
Gift of Martha and Henry Isaacson, 58.100

The subject of this tankard is known in China as *fu lu shou,* meaning happiness, official position, and longevity. It is not likely that the porcelain painters at Meissen were familiar with the significance of this scene. It represents an importation of style, not meaning. With a few fanciful changes, such as head-gear and age of the figures, they made a faithful representation of the key elements in the Chinese story.[6] Happiness and prosperity (*fu*) are represented by the youthful figures. There are five boys in the scene, a symbolic number in China. The man wearing a red robe stands for officialdom (*lu*). Even though he has a skullcap instead of a Chinese official's cap, he represents the di-

vine official (*tian guan*) in his best ceremonial dress, holding a scroll. Unfurled, it would bear a saying such as "May the divine official bring good luck," an auspicious New Year message. Longevity (*shou*) is in the guise of the balding old man dressed in green. In a Chinese depiction, he would appear older, with graying hair and wrinkled face. The god of longevity is known to ride a deer and carry a staff; the two boys central to the scene present both of these attributes. This rare tankard is from a service made for an Englishman, the second Earl of Jersey.[7] For those who could afford them, Meissen services became de rigueur in the 1730s and 1740s.

Deep, rich, contrasting enamel colors, the use of black enamel, black outlining of the figures, and chinoiserie themes silhouetted against the stark white porcelain of Meissen are all characteristic of Adam Friedrich von Löwenfinck's work. A bold painter with his own distinctive style, he chafed under Höroldt's restrictive controls. In 1736, he left the factory to paint faience and become a founder of the German porcelain factory at Höchst.

PL. 13.5

Coffeepot

German, Meissen factory, Böttger porcelain,
c. 1720–25
Decoration attributed to the Seuter family workshop,
Augsburg, c. 1725–45
H. 8¼ in. (21 cm)
Gift of Martha and Henry Isaacson, 69.190

The porcelain is unmarked. The silver-gilt
mounts bear the mark for Elias Adam
(c. 1669–1745), in Augsburg.

Augsburg Decoration

The idealized scene of Asian-style figures admiring rare, exotic monkeys is produced in detailed, fine drypoint engraving on painted gold silhouettes. This distinctive style of gilt chinoiseries (*Goldchinesen*), using the materials and techniques of metalwork, was a specialty of Augsburg, Germany, a city long known for its outstanding goldsmiths and engravers. As early as 1711, the Meissen factory established a relationship with Augsburg goldsmiths such as Elias Adam, who mounted this teapot with metal fittings. During the 1720s, there was an active exchange between the cities: chinoiserie engravings from Augsburg were used at the factory, and Meissen porcelain was sent to Augsburg for decoration.[8] Light and airy gilt chinoiseries of the type seen on the Seattle coffeepot (pl. 13.5) were produced by the Seuter family in Augsburg.[9] Most chinoiseries in this style are attributed to Abraham Seuter (active 1725–47), one of two brothers who headed the family's workshop. They were *Hausmaler*, porcelain decorators who worked outside the factory.

By the time the Capodimonte factory opened at Naples in 1743, chinoiseries were used more as components for interior decoration, such as for walls or doors, than as motifs on porcelain. A fabulous chinoiserie room was designed and modeled in Capodimonte porcelain in 1757–59. Porcelain plaques with Far Eastern figures in relief covered the walls and floor of an entire room in the Portici Palace of the King and Queen of Naples. This room survives; it was moved to the palace at Capodimonte in 1865.

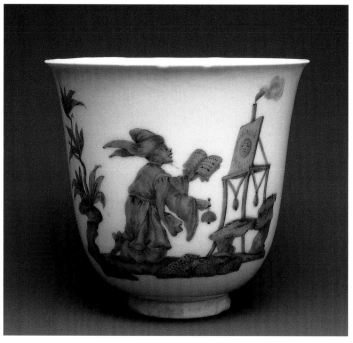

PL. 13.6

Tankard

German, Meissen factory, Böttger porcelain, c. 1720–25; pewter thumb-ball lid

Decoration attributed to the Auffenwerth family workshop, Augsburg, c. 1730–35

Unmarked

H. 9¼ in. (23.5 cm)

Gift of Martha and Henry Isaacson, 69.192

In this outlandish scene, a dragon and fantastic-appearing bird dive at figures gathering fruit from a tree. The fruit is probably intended for the privileged seated figure being shielded by a parasol. This heavy, intricately engraved chinoiserie decoration featuring bold fretwork patterns is identified with Johann Auffenwerth (d. 1728) and at least three of his daughters, who also decorated porcelain in Augsburg.[10]

PL. 13.7

Tea bowl

Italian, Capodimonte factory, c. 1747–50

Soft-paste porcelain with enamel color

Mark: fleur-de-lis in underglaze blue

H. 2¾ in. (7 cm)

Dorothy Condon Falknor Collection of European Ceramics, 87.142.48

This tea bowl decorated in apple-green enamel depicts a chinoiserie figure worshiping at an altar. The mighty influence of Meissen is seen in the early wares of the Capodimonte factory. Chinoiseries were not a major production for the factory, but when they do appear in its earliest years, they are most often in the silhouetted style of Meissen and Augsburg, usually in gold. This example in green is extremely rare.

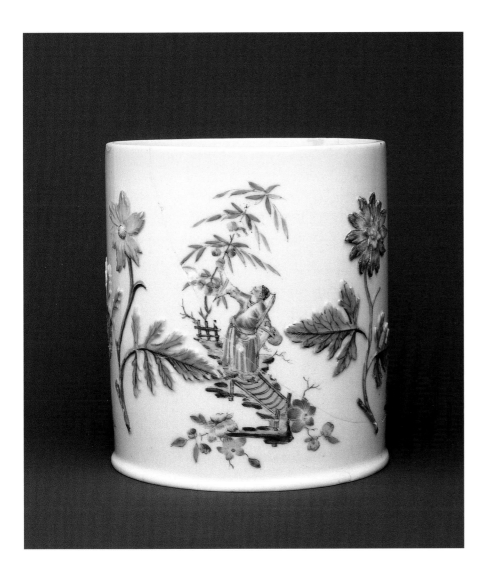

PL. 13.8

Tea caddy

Spanish, Buen Retiro factory, c. 1760–65
Soft-paste porcelain with enamel colors
Mark: fleur-de-lis in underglaze blue
H. 4½ in. (11.5 cm)
Dorothy Condon Falknor Collection of European Ceramics, 87.142.69

A Meissen connection is evident in this work—the large floral decoration in relief echoes Johann Böttger's style. The chinoiseries decorating this tea caddy are in the style of Jean Pillement (1719–1808). His whimsical, airy designs became fashionable in all areas of the decorative arts during the 1750s. Thirty-nine engravings of his chinoiseries, together with designs from other artists, were published in a book in late 1759 or early 1760. Its title, *The Ladies Amusement; or Whole Art of Japanning Made Easy,* is a misnomer. As a leading guide for the dispersion of ornamental design, it influenced all the arts, not only lacquered, or japanned, work produced in the drawing rooms of society women, as it implies. Pillement's vision of imaginary figures in dreamlike environments, such as this tea caddy's spiraling scene of a man climbing a ladder to pick fruit, can be seen in textiles, metalwork, ceramics, enamels, furniture, and carpets of the period.

Parts of porcelain wares occasionally are broken or lost, and knowledge of their original use can be lost over time. Did this porcelain jar have a lid and serve as a canister for tea leaves, a container for tobacco, or was it a drinking glass (*bicchiere*)? At least one chinoiserie example with a cover and early floral finial is known.[11] That the small vessel could be sealed, and bears a scene that evokes the far-off land of tea, seems to indicate that the Seattle jar, now lacking its cover, was probably a tea caddy.

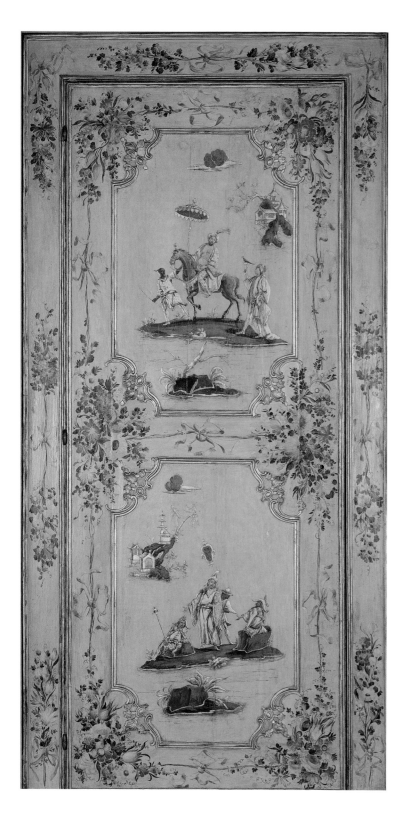

THE DOORS OF CA' REZZONICO

Eighteenth-century palaces along the Grand Canal, like the Ca' Rezzonico (now a municipal museum of decorative arts), featured rooms painted and furnished in the Chinese manner. Sparked by the accounts of early travelers' journeys to China, Italian interest in the East developed into a passion as the Venetian Republic built its wealth and power on trade with the Middle East, and later with China. In the eighteenth century, Italians embraced the European vogue for Asian styles and chinoiseries, decorating furniture, ceramics, metalwork, glass and textiles, and even entire rooms in "Chinese" taste. These rooms rarely remained intact, as changing styles prompted new decor. However, three yellow doors with chinoiserie scenes designed in relief to resemble Asian lacquer on both front and back are known to have still been in the palazzo at the beginning of this century.[12]

The upper panel of the door on loan to the Seattle Art Museum (pl. 13.9) presents a scene of a gentleman on horseback. Although he is dressed in the flowing robes and turban associated with the garb of a Middle Eastern pasha or an Indian mogul, his features are Caucasian, an example of exotic motifs that mixed Eastern costumes and accessories with European faces.

PL. 13.9

Door

Italian, Ca' Rezzonico, Venice, c. 1760
Possibly painted by Giandomenico Tiepolo (1727–1804)
Paint and gilding on wood
H. 109½ in. (278.3 cm)
Anonymous loan

To arrive at the Ca' Rezzonico on the Grand Canal for a late-night masked ball or revelry would have been a magical occasion in Venice in the mid-eighteenth century. Evening events at this patrician pleasure palace were bathed in candlelight, which illuminated wall murals and magnificent ceiling frescoes and flickered across furnishings painted in vivid blues, greens, and yellows, all highlighted with lavish gilding. This vibrantly decorated door, with its exotic Eastern imagery, would have caught the shimmering glow.

A porcelain figure in Seattle's collection (pl. 13.10), an example of "turquerie," signifies the influence of the Islamic world on Europeans at this time, especially the powerful Turkish Ottoman Empire.[13] This "Turkish" gentleman, with a crescent atop his turban, represented Asia in an eighteenth-century series of allegorical porcelain figures symbolizing the continents, or the four quarters of the globe. Africa, America, and Europe were included in this rather limited view of the world.

The lower door panel of the Ca' Rezzonico door is a model example of chinoiserie depicting European interpretations of life in China: exotic figures with Chinese-style silk garments, hats, and long mustaches, placed in make-believe settings of unusual plants and pagoda-style buildings. Seattle's figure from the Spanish Buen Retiro factory is a similar depiction in porcelain (pl. 13.11).

Today, only one of the three chinoiserie doors remains at the Ca' Rezzonico. The names of Giambattista Tiepolo (1696–1770) or his son Giandomenico (1727–1804), who were working on frescoes in the palace from 1757 to about 1760, have been suggested as the designers of the door.[14] A comparison of the chinoiseries on these doors with frescoes designed and painted by Giandomenico Tiepolo at the Villa Valmarana ai Nani, south of Vicenza, indicates that he may have also designed and painted the Ca' Rezzonico doors.

In 1757, the Tiepolos, father and son, were working in Villa Valmarana, where nearly 300 square meters of their frescoes cover the walls and ceilings. Giambattista's full-blooded heroic scenes from the epic poetry of Homer and Virgil fill the main villa. Executed in the classical pictorial tradition, they energetically sweep around the walls and swirl overhead in the atmospheric rococo style of the day. The figures include helmeted and crimson-cloaked gods and classically draped goddesses dramatically placed against golden, sun-drenched clouds and vibrant blue skies.

Giandomenico assisted his father in painting the mythological frescoes of the main villa. By the period of this commission, however, the thirty-year-old son was more than just his father's collaborator. In a departure from his father's style, Giandomenico painted six of the seven rooms of the villa's guesthouse in a hearty, down-to-earth manner. Probably supported by the preference of the patron, he chose vernacular rather than majestic subjects for the smaller, more informal spaces of the guesthouse.[15] Scenes of peasants eating or

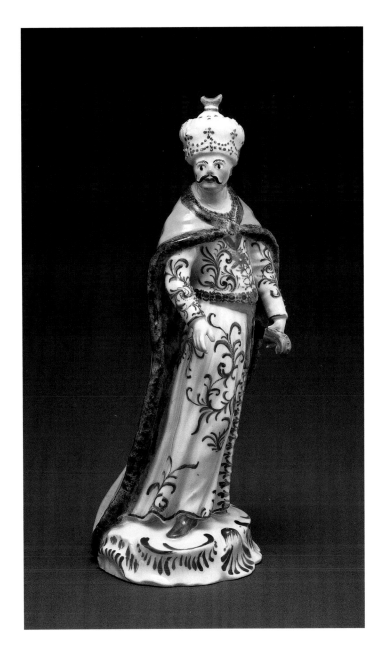

PL. 13.10

Figure

German, Limbach factory, c. 1775
Model by Caspar Jensel
Hard-paste porcelain with enamel colors and gilding
Unmarked
H. 7⅞ in. (20 cm)
Gift of Martha and Henry Isaacson, 76.126

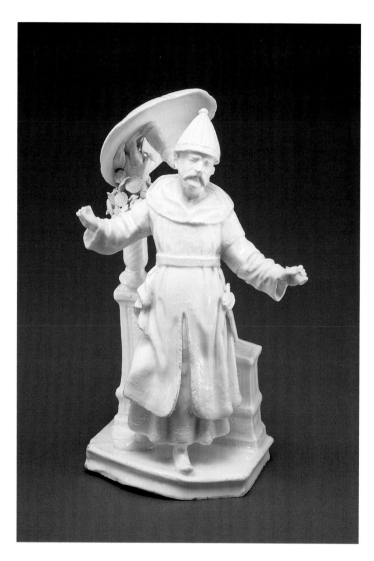

Figure

Spanish, Buen Retiro factory, c. 1760s

Soft-paste porcelain

Unmarked

H. to top of parasol 8 in. (20.3 cm)

Dorothy Condon Falknor Collection of European Ceramics, 87.142.75

strolling down a road, people at a carnival, a pair of lovers, and chinoiseries are all painted in a straightforward and literally grounded style. Wolfgang von Goethe (1749–1832) toured the Villa Valmarana in 1786; he distinguished the "sublime style" of the villa from the "natural style" of the guesthouse, stating a preference for the less opulent, more contemporary look in a letter recording his visit.[16]

The walls in the Chinese Room (Stanza Cinese) of Villa Valmarana are covered with Giandomenico's chinoiseries, a theme he explored in fresco, brush-and-ink drawings, and oil on canvas.[17] These have striking similarities with the paintings on the door from the Ca' Rezzonico. Giandomenico's inclination to paint flat, planar compositions is seen in both.[18] Silhouetted against stark backgrounds, slouching Chinese mandarins or figures sporting feathered turbans are central to scenes set upon expanses of earth, suspended in space (fig. 1). They are surrounded by retinues of attendants wearing their hair in queues or with winged hats, carrying parasols like the one on the door's upper panel and softly rounded heart-shaped fans or standards. Beneath

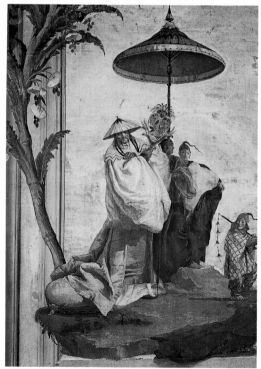

FIG. 1. *Mandarin's Promenade.* Fresco by Giandomenico Tiepolo (1727–1804). Villa Valmarana ai Nani, Vicenza, c. 1757. Foresteria, Stanza Cinese.

their Asian-style headgear and drooping mustaches, their faces are Western. Their postures, the rendering of facial features, and predominant use of browns and golds are consistent in the frescoes and the door, where Giandomenico's naturalistic style is evident in the nonchalantly seated pasha riding his horse.

The Villa Valmarana frescoes are ranked among Giambattista Tiepolo's most famous works. The guesthouse frescoes are considered Giandomenico's masterpiece. The Chinese Room especially had a major stylistic impact on decorative frescoes in Venice during the second half of the eighteenth century.[19]

The Tiepolos returned to Venice in the winter of 1757 and embarked on a great ceiling fresco of an allegorical wedding scene in the Ca' Rezzonico, the first work of a commission that they finished in about 1760. The following year, Charles III, of Capodimonte and Buen Retiro porcelain fame, called Giambattista to Madrid, where he would remain until the end his career.

The Ca' Rezzonico had at least one room done in "oriental" motifs.[20] Giandomenico, working in the late 1750s and early 1760s, would have been available to paint chinoiseries. There are close stylistic affinities between Giandomenico's frescoes and the remaining doors from the Ca' Rezzonico, but the doors lack a signature, and there is no documented lacquerwork by Giandomenico. Thus such an attribution must remain speculative, awaiting further research.

CHINOISERIE IN ENGLAND
Late Ming and Transitional wares (c. 1620–1683) of freely painted figures in landscapes, and their Japanese versions, inspired blue-and-white porcelain produced in Europe. Much Chinese porcelain dating between 1635 and 1700 featured the Chinese scholar pursuing numerous activities in nature. (For an earlier example, see plate 5.6.)[21] This subject was bound to appeal to Europeans in the throes of exploring the philosophical relationship of rational man in harmony with nature during the eighteenth century's Age of Enlightenment. In England, outdoor themes were especially popular, and people of leisure took to rusticating in beautifully landscaped gardens, public parks, and tea gardens.

— J. E.

PL. 13.12
Plate
English, Bow factory, c. 1755–60
Soft-paste porcelain with underglaze-blue decoration
Mark: 2 in underglaze blue
Diam. 13 in. (33 cm)
Gift of Garry L. White in memory of Walter H. Meyer, 92.167

The pattern on this plate was recorded in the Bow records as the 'image' or 'bordered image' pattern. Because this subject and even the name given to it were not understood, it became popularly known as the 'golfer and caddy.'

In fact, this scene presents a Chinese scholar carrying a staff and accompanied by an attendant entrusted with his musical instrument, a zither (*qin*), strolling through a topsy-turvy landscape. In the genre of Chinese scenes that inspired this popular Bow pattern, the base of the precipitous rocky cliff under which the figures pass would have been anchored at the ground line in the lower scene, with trees growing out and upright, or hanging straight down the cliff face because of their weight, in a more natural fashion.[22] At Bow, this portion of the motif is segregated, as if disconnected, and painted along the side of the plate.

PL. 13.13

Bowl

English, Chelsea factory, c. 1765
Soft-paste porcelain with enamel ground color and gilding
Mark: gold anchor
Diam. 6¾ in. (17.2 cm)
Gift of Martha and Henry Isaacson, 76.236

In the early years of the Chelsea factory, the influence of Asian and Meissen porcelain was strong. During the period of the Seven Years' War that devastated Saxony (1756–63), the influence of the Royal French Manufactory at Sèvres began to replace that of Meissen in European porcelain. This stunning chinoiserie scene of a musician is produced in the richly burnished, impasto gilding style of the French factory upon a deep blue ground, known at Chelsea as mazarine blue. Perfected in France, this ground color, listed in sales records as blue lapis (*bleu lapis*) is probably what the factory stock-lists called "Helot blue," for

its inventor Jean Hellot (1685–1766), the French academic and chemist who joined the French factory at Vincennes in 1751.[23] These deep blue colors were difficult to apply and fire evenly; sometimes they have a mottled appearance.

This bowl served as a waste bowl for a tea service.[24] As in the East, the serving of tea in Europe was a ritual. Before offering a fresh cup of tea to a guest, the mistress of the house would dump the dregs of the previous serving into this bowl, give the cup a quick wash with hot water from a kettle, and then replenish it.

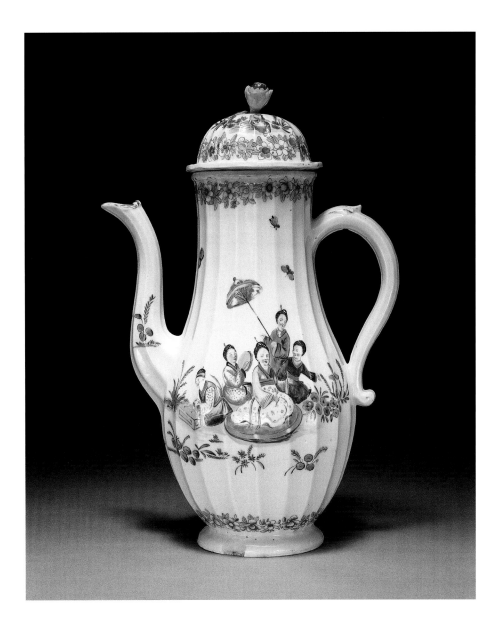

PL. 13.14

Coffeepot

English, Plymouth factory, c. 1770
Hard-paste porcelain with enamel colors and gilding
H. 11½ in. (29.2 cm)
Gift of Martha and Henry Isaacson, 76.203

By the time this coffeepot was painted, chinoiserie decoration was no longer in vogue on the Continent. Early English chinoiseries were often inspired by Meissen, the French factories, or by engravings after French artists. This coffeepot depicts chinoiserie as presented by an English artist. F. Severne Mackenna, one of this century's great collectors of European porcelain and the former owner of this rare coffeepot,[25] wrote about its decoration:

"It is a curious mixture of Oriental and European. The grouping and accessories are intended to suggest an Oriental scene, but the faces are strikingly European."

As a favored design on the swirling rococo forms of mid century, asymmetrical chinoiserie scenes often followed the shape of the ware and were painted in reserve on smooth surfaces. This scene is depicted on the more rigid, broadly molded fluting of the later neoclassical style, a surface not particularly suited to a painted scene. This coffeepot was produced at the first hard-paste porcelain manufactory in England, which was established at Plymouth in 1768.

The Age of Porcelain

14

THE ROCOCO EXPLOSION IN EUROPE

ROCOCO

European porcelain embodied the essence of taste for Europeans of the mid-eighteenth century. It was rare, costly, and had been attained through scientific and technological struggle. Furthermore its white translucent body, which could be molded or cast in wonderful sculptural forms and decorated with elegant enamels, was considered the epitome of refinement and beauty in the arts. Porcelain's evolution during the first half of the century coincided with the period of a new European modern style, called *genre pittoresque* at the time, which became known as rococo. The origin of the term is the word *rocaille* (rockery)—meaning the ornamental rock structures of French gardens and grottoes that became fashionable in the sixteenth century. Rococo is most commonly understood as the light, airy style in art that evolved in France in the 1720s, based on lively, asymmetrical curving lines, creating and encompassing rock, shell, water, and scrolling, foliated motifs from nature.

As an aesthetic movement, rococo emerged from and in reaction to the more ponderously severe baroque style that had developed during the final years of Louis XIV's reign. New generations in the eighteenth century, which embraced philosophical enlightenment and innovative scientific investigation, found baroque too measured and rigorous. Balanced arabesques, strong colors, and tight little landscape scenes of the late baroque period gave way to playful scrolling curves, the use of lighter, delicate pastel colors, and exuberant scenes in painting, sculpture, tapestry, metalwork, and ceramics. The baroque world of grand mythological, biblical, and formal court subjects changed to one of rollicking court fetes, idyllic rural settings inhabited by shepherds and shepherdesses rather than gods, fanciful foreign scenes, and portrayals of common, everyday folk. The latter, such as romanticized porcelain figures of street vendors or models of peasants'

cottages (see pl. 14.4), were popularized by a newly awakened interest in the individual, fostered by the Age of Enlightenment. They seem a strange homage to those far removed from the gilded trappings of the rococo.

Some scholars see the Chinese art conventions of asymmetry, curving patterns, naturalism, and flowing spaces, to which Europeans had been increasingly exposed, as preparation for their ability to embrace the nuances of the rococo style.[1] Others have viewed the rococo revolution as a reaction to the classical symmetry that had dominated the arts of Europe since the Renaissance. They view rococo as a return to abstract expressions of early northern Europe that found voice in undulating interlacing patterns. These earlier design idioms can be seen in the eighth-century illuminated manuscript, the Book of Kells, which derives from traditional Celtic metalwork, and also in Scandinavian wood carvings.[2] Whatever influences brought about the new dynamic era in design and color, pliant porcelain, which could be molded and sculpted into marvelously wild and energetic shapes, became a prime conveyance for manifestations of the style. Rococo taste was the catalyst for the greatest period of creativity in porcelain in Europe, the Age of Porcelain.

The new style emanated from the pacesetting French court and spread throughout all the courts of Europe in the 1730s and 1740s. Inspired by prints (the most common medium for the dispersal of style at this period), or their own imaginations freed from artistic dictates of the past, porcelain modelers and decorators explored a wealth of themes. Religious scenes, romanticized views of children, strange, encrusted marine life, exotic animals, chinoiseries, characters from the theater, allegorical and mythological subjects, and a riot of floral motifs all found expression in rococo-style European porcelain.

PL. 14.1

Shell basin

German, Meissen factory, c. 1730
Model by Gottlieb Kirchner (b. 1706)
Hard-paste porcelain
Mark: crossed swords in underglaze blue
W. 18 in. (45.8 cm)
Gift of Martha and Henry Isaacson, 83.222

Although modeled in a scallop-shell form that became so popular in the rococo period, this basin (*Muschelbecken*) still exhibits the symmetrical style of the baroque. Its designer, Kirchner, a court sculptor before he came to Meissen in 1727, had previously been occupied with a commission of baroque sculpture favored by Augustus the Strong for the courtyard of his palace, the Zwinger. At Meissen, Kirchner experimented with porcelain on a grand scale. Struggling with the limitations of porcelain paste in the modeling and firing of large works, he produced such vases and figures for the Japanese Palace, many of which exhibit a myriad of cracks. Also large for its time, the Seattle basin was nevertheless manageable. Its form has been identified in the Meissen inventory dated 1728 as a washbasin modeled by Kirchner.[3]

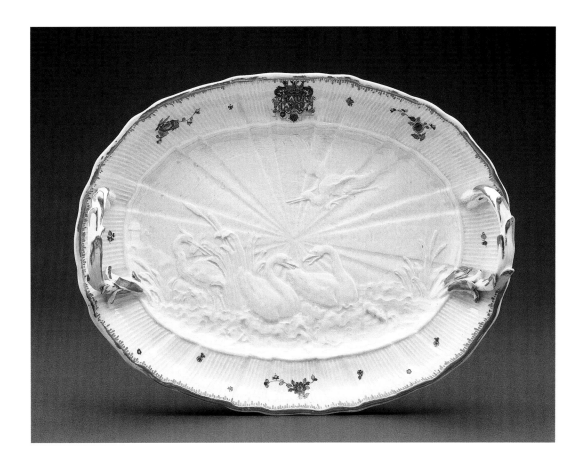

PL. 14.2

Platter

German, Meissen factory, c. 1736–38
Model by Johann Joachim Kändler (1706–1775) with the assistance
of J. G. Ehder (1717–1750) and J. F. Eberlein (1695–1749)
Hard-paste porcelain
Mark: crossed swords in underglaze blue
L. 15¼ in. (38.7 cm)
Gift of Martha and Henry Isaacson, 69.187

This platter features twisted, leafy, rococo-style handles and a
molded, low-relief scene of two swimming swans, two herons,
and diverse water plants. Porcelain was a perfect material for
molding the fluid water scenes that were popular rococo motifs.
The ribbed shape of this platter only alludes to a shell form, but
tureens, glass coolers, and candelabra from the same service,
known as the Swan Service, were modeled in a lively riot of
asymmetrical shells, dolphins, mermaids, and, of course, swans.[4]
The service was produced during the years 1736 to 1741 by one
of the great European porcelain modelers of the eighteenth cen-
tury, Johann Joachim Kändler, who replaced Kirchner in 1733
as the master sculptor at Meissen. He served in this role until his
death in 1775.

The coat of arms at the top of the platter is that of Count
Heinrich von Brühl (1700–1763), director of the Meissen factory
and a Saxon minister for Augustus III. His importance is under-
scored by a rare privilege accorded him; he was able to order
porcelain for his personal use at no cost. The count certainly
did not shy away from this opportunity. In 1736, three years af-
ter he became head of the factory, he commissioned a specially
designed dinner service reported to have 2200 pieces, including
this platter. The Swan Service, though the grandest service of
its time, nevertheless had plates for a limited number of diners,
thought to be fifty. They were used at the table of the highest-
ranking guests. In banquet paintings of the eighteenth century,
many lesser courtiers and guests are depicted milling around the
dining tables, watching the chosen few eat.[5]

The Swan Service remained intact, housed at Schloss Pförten,
home of the von Brühl family, until the last decades of the nine-
teenth century, when loans to museums and sales to private
collectors reduced it to 1400 pieces.[6] As a result of further sales
and the upheaval of World War II, the rest of the service was
also dispersed.

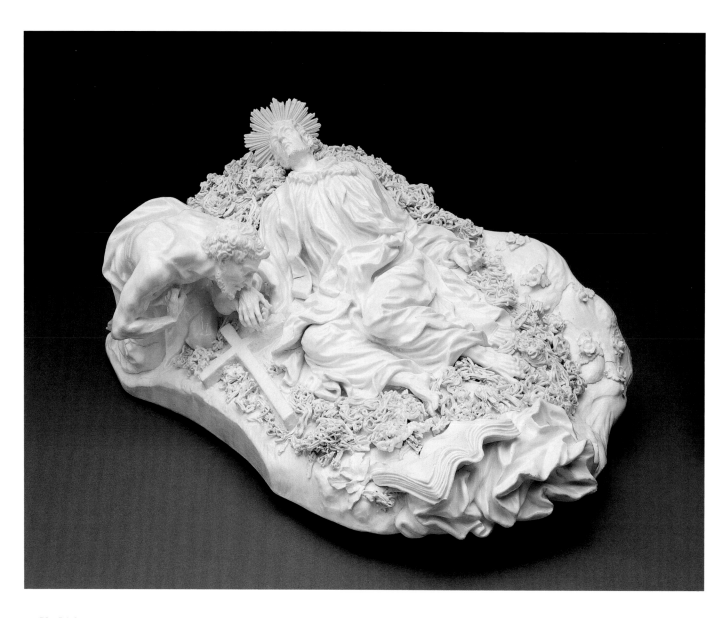

Figure of Saint Francis Xavier

German, Meissen factory, c. 1738–40
Model by Johann Joachim Kändler (1706–1775)
Hard-paste porcelain
Unmarked
L. 18¼ in. (46.4 cm)
Evelyn Clapp Collection, 54.135

This extraordinary sculptural work in porcelain was the key-
stone to a grand assemblage, *Death of Saint Francis Xavier* (see
fig. 1). Modeled by Kändler, this work reveals both his strong
baroque background and his awakening to a new world of ro-
coco. The figure of the saint is modeled on the stately, strong
diagonal line of the baroque, but he lies upon a scrambled lawn
of vermicelli-like grass, surrounded by a mob of figures, some in
exotic headdress, reacting emotionally to his passing. This event
takes place under an asymmetrical, swirling mass of angels,
amorini (putti represented as infant cupids), and clouds. The
actual account of his death says that he died in a simple hut at-
tended by one young Chinese companion. Kändler clearly found
this version of the story inadequate for his rococo extravaganza.

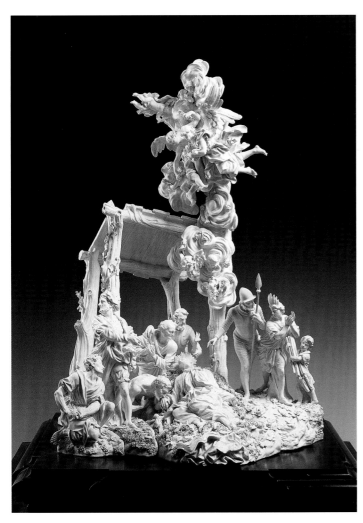

FIG. 1. *Death of Saint Francis Xavier,* c. 1738–40. Ensemble of fourteen pieces. Dresden, Staatliche Kunstsammlungen.

Rococo Modeling

Small figures produced during the rococo period were proudly displayed in cabinets or along the center axis of dining tables singly or clustered in groups. Large religious groups were most often created for private chapels.

Figures became the premier form of expression for Johann Joachim Kändler, and under his leadership, porcelain modeling took precedence over Höroldt's famous enameling workshop (see chap. 13). Kändler modeled a great many religious subjects at the request of the electoral court in the years 1738–42. He created more than 1000 figures and figural groups during his long tenure at Meissen.[7] Catholic

themes like the death of Saint Francis Xavier (pl. 14.3) would have been favored by Augustus III, Elector of Saxony and King of Poland. He was always eager to make known his Catholic training and conversion, a crucial element to his being crowned King of Poland.

The story of Saint Francis Xavier's death near China emphasizes the fact that not only European traders and merchants focused on the East. The call to spread the Gospel to vast new lands was sounded by both Christian rulers and the Church. A Spaniard, Father Francis Xavier (1506–1552), was one of the seven men who took the original Jesuit vows in 1543. He became the first Jesuit missionary, leading successful missions to India, Sri Lanka, and Japan; he was known as "the apostle of the Indies." While attempting to reach China, he contracted a fever and died on the island of Shangchuan, the doorway to the great empire he had long wished to convert to Christianity.

A centerpiece of rustic buildings probably accompanied by figures of a hunting party was not a standard Meissen production (see pl. 14.4). Early designs of such a setting were worked out in 1736 by Count Heinrich von Brühl, director of the Meissen factory, and Kändler but were set aside when the count's rival at court, Count von Sulkowsky, ordered a lavish dinner service. Von Brühl, not to be outdone, made plans for the Swan Service (see pl. 14.2). In the sweepstakes for grandest dinner service and court favoritism, Count von Brühl was the winner. His earlier plan for a table setting of porcelain cottages was revitalized. Meissen records state that an able assistant to Kändler, Johann Gottlieb Ehder (1717–1750), did several peasant huts for the count. The surviving works in this genre are attributed to him. Today these miniature porcelain buildings are exceedingly rare.

Ehder, who joined the factory in 1739, is credited with Kändler for introducing the rococo style to Meissen.[8] Rococo freedom from classical proportion and common sense in favor of amusement is evident in the Seattle work. A man emerges from his cottage into a world populated by huge chickens in his yard and enormous doves upon the roof.

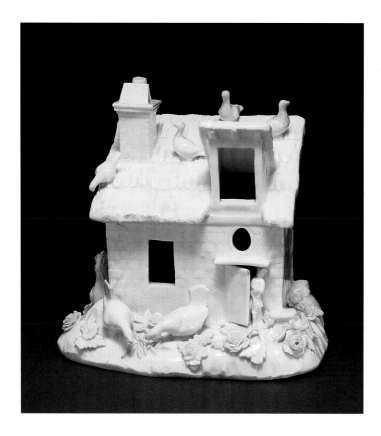

PL. 14.4

Cottage

German, Meissen factory, c. 1743–45
Hard-paste porcelain
Mark: crossed swords in underglaze blue
H. 5½ in. (14.1 cm)
Blanche M. Harnan Ceramic Collection, Gift of Seattle Ceramic
Society, Unit I, 56.278

At the time of Count von Brühl's death in 1763, the inventory of
his estate numbered sixty-seven miniature porcelain buildings.[9]
Charming farmhouses, barns, peasants' sheds, and churches,
ordered for the von Brühl confectionery, were illuminated from
within by candles and presented at elegant dinners as table deco-
ration during the dessert course. An account of such an event was
sent from Dresden in 1748 by Sir Charles Hanbury-Williams,
the English ambassador to Augustus III's court:

> I was once at a Dinner where we sat down at one table
> two hundred and six People ('twas at Count Brühl's).
> When the Dessert was set on, I thought it was the most
> wonderful thing I ever beheld. I fancy'd myself either in
> a Garden or at the Opera, But I could not imagine that
> I was at Dinner.[10]

PL. 14.5

Clock

German, Meissen factory, c. 1748
Hard-paste porcelain with enameled decoration and gilding; metal
clock face with white and black enamel
Marks: clock case, unmarked; clock stand, crossed swords in under-
glaze blue; clock face inscribed "Stalpp Dresden"
H. 15½ in. (39.4 cm)
Gift of Martha and Henry Isaacson, 78.13

This grand clock embodies the full-blown rococo style in Ger-
many at mid century. It leaves nothing unsaid. Lavishly molded
and gilded shellwork and scrollwork bracketed by pale-colored
leafy fronds from nature make up the body of the clock. Riding
a cresting wave at the top, a modeled mythological Venus is
offered a flower by a winged *amorino*. Two plump putti (young
boys) play below. Idyllic scenes of attentive, gallant young men
and their elegant women friends, inspired by the *fête galante*
paintings by Watteau and still popular chinoiseries, decorate the
front and sides of the clock case.

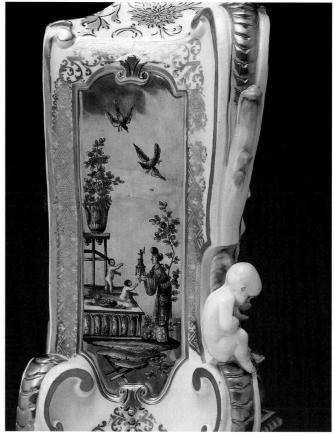

Detail of side panel, PL. 14.5

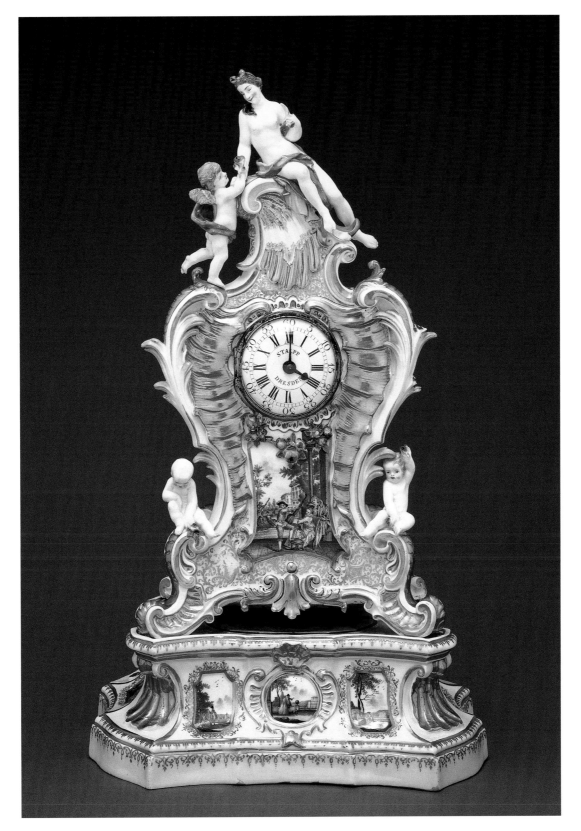

PL. 145

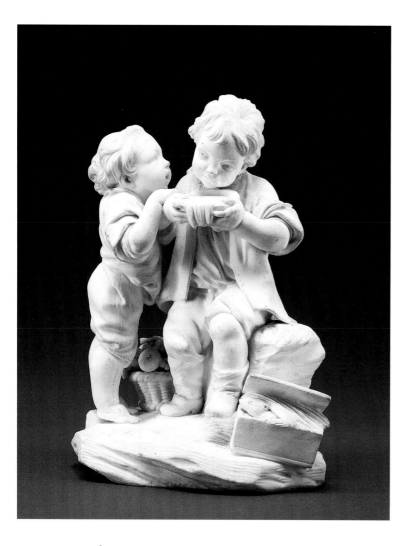

Children drinking milk

French, Sèvres factory, 1766
Model by Etienne-Maurice Falconet (1716–1791)
Soft-paste biscuit porcelain
Mark: incised cursive B for Bachelier, artistic director (1751–57) and
director of sculpture studio (1766–73)
H. 6⅝ in. (16.8 cm)
Blanche M. Harnan Ceramic Collection, Gift of the Seattle Ceramic
Society, Unit II, 56.179

The fashion for decorating the center of grand dining tables with porcelain figures in architectural or garden environments spread throughout Europe. Horace Walpole (1717–1797), the English author famous for his letters that charmingly document Georgian England, wrote in 1753 about the change in centerpieces: "Jellies, biscuits, sugar plums and creams have long given way to harlequins, gondoliers, Turks, Chinese and shepherdesses of Saxon china."[11]

Porcelain sculpture on the table was a modern substitute for table figures that had previously been produced in sugar paste, and occasionally in wax. Traced back to the court of a twelfth-century caliph of Egypt, the tradition arrived in Europe in the sixteenth century.[12] Until the advent of European porcelain, sculptors produced works in sugar, known as *trionfi* in Italy, *surtout de table* in France, and *Schauessen* in Germany, to decorate the tables at grand court dinners. Porcelain offered a precious and more durable solution.

Some of the most beautiful porcelains designed as special decorative treats to be admired over the dessert course were the unglazed biscuit porcelain figures produced at the Vincennes factory, and after its move, at Sèvres. Molded and sculpted French figures left in the biscuit revealed design details to admire, undiminished by pooling glaze. In Seattle's figural group (pl. 14.6), the older boy enjoying the bowl of milk slyly looks out of the corner of his eye at his younger brother, who anxiously asks for his turn. These white figures were a beautiful contrast to the colorfully enameled dessert plates and serving dishes of the period. Today they are often separated from their original groupings, but at Woburn Abbey in England, home of the dukes of Bedford, a fabulous display of Sèvres porcelain exhibits the original service with figures and vases that have belonged to the family since 1763. At that time, this service was recorded as comprising 120 works in biscuit porcelain.[13]

Seattle's group is from a model sculpted by the most famous of the modelers of biscuit porcelain, the court sculptor Etienne-Maurice Falconet (1716–1791), who served as chief modeler at the Sèvres factory from 1757 to 1766. It is one of the popular models adapted from a drawing by the artist François Boucher. Boucher's designs of small children were adapted from either drawings commissioned by the factory or engravings purchased from printsellers in Paris.[14] The Seattle group was produced during the tenure of Bachelier after Falconet left for Russia to work for Catherine the Great.

PL. 14.7
Figures of young boys
English, Chelsea factory, c. 1746
Soft-paste porcelain
Unmarked
H. 5½ in. (14 cm)
Gift of Martha and Henry Isaacson, 76.241

Depictions of young children, in both modeled figures and enamel painting, were important themes in rococo porcelain. Many were adapted from designs by Boucher. Seattle's mirror-image putti (particularly their heads) have their source in the popular reproductions of seventeenth-century marble sculpture by the Flemish sculptor François Duquesnoy (1596–1643), known as Il Fiammingo.[15] It was difficult to replicate in soft-paste porcelain the fine, detailed carving of marble. As the porcelain scholar Arthur Lane noted:

> The early Chelsea production of figures was based on sculptural models in stone and the fine details became swamped by the thick glaze, especially in the face. The brilliant paste reflected too much light, distorting the play of shadows. To overcome this difficulty, the modellers exaggerated details of the moulds, hence, perhaps, the accentuated chubby cheeks of the Chelsea putti [certainly noticeable in the Seattle figures], and finally had to abandon the world of sculpture modelling and turn to terracottas, plaster casts, and engravings.[16]

The early porcelain paste gave the factory other problems as well. The gritty, black-speckled appearance and texture of the body of the Seattle figures is similar to that of other early Chelsea figures dated 1746.[17] Like most Chelsea figures, these were produced by pouring slip (liquid porcelain clay) into plaster-of-paris molds. One figure was composed from a series of many different molds. The molds pulled moisture from the slip. Once a firm outer shell had formed, the extra slip was poured off, leaving a hollow molded form. "Repairers" using slip as glue assembled (luted) the various sections, cleaning away mold marks and adding finishing touches before firing. The Chelsea figures are light in weight and have smooth interiors, compared to the heavier French figural group of the boys drinking milk (pl. 14.6), which was created by pressing semisolid paste into molds. The Chelsea figures are missing the shell horns they originally held in their raised hands.

PL. 14.8

Goat and bee jugs

English, Chelsea factory, c. 1745–49
Soft-paste porcelain; one decorated with enamel colors, the other
in the white
Marks: incised triangle on each jug
Decorated jug: h. 4 in. (10.2 cm)
White jug: h. 4⅜ in. (11.1 cm)
Gift of Martha and Henry Isaacson, 69.162, 76.207

Goat and bee jugs, with two molded reclining goats supporting
the baluster-shaped jug, represent the earliest example of true
rococo porcelain in England. Shaggy goats, creeping bees, and
twisted, branch handles, combined with technical and aesthetic
sophistication into a cream jug, represent the stuff of rococo.
They are some of the earliest productions of Chelsea, the first

established English factory, illustrating that rococo was the
favored European style at the time the English began to produce
porcelain. These jugs have always been admired. The thin, frag-
ile legs of the bees have survived intact for 250 years, indicating
that enormous care was taken to preserve these two jugs.

 The jugs were created under the artistic guidance of Nicholas
Sprimont, silversmith turned porcelain factory founder and
ceramic artist; it is reasonable to assume that elements in design
and technical skill would flow between his silver and porcelain
designs. A large, basket-shaped centerpiece Sprimont produced
for the Earl of Ashburnham in 1747/48 is supported by two
standing goats.[18]

PL. 14.9

Figure of a fox

English, Bow factory, c. 1750
Soft-paste porcelain
Unmarked
H. 4⅜ in. (11.1 cm)
Gift of Martha and Henry Isaacson, 69.161

This figure came into Seattle's collection titled *Crouching Fox,* thus putting a good face on the fact that this early experimental work slumped in firing. Even so, the fox is so rare that only one other is known. Part of his appeal, especially to Bow aficionados, is the evidence of struggle in the early days of the factory. At the time the fox was made, Bow was working with a new paste, and it may have been part of trial firings. The other model of the fox also collapsed.[19]

Chelsea porcelain was more expensive and targeted the luxury market, but the Bow factory produced more innovative products that were available at better prices. They were the first to add bone ash to soft-paste porcelain to increase its whiteness and resilience. The specification for their new patent was enrolled on March 17, 1749/50. This addition was the basis for the bone china of the nineteenth century.

Shell forms encrusted with all manner of sea life became a celebrated expression of rococo porcelain in England. Shells, coral, seaweed, barnacles, crayfish, and dolphins come together as simple wavy forms of the shell-shaped sauceboats upon wavy bases (pl. 14.10) or as complicated piles of sculptural sea activity in the triple shell dish (pl. 14.12).

PL. 14.10

Sauceboats

English, Vauxhall factory, c. 1755
Soft-paste porcelain with polychrome floral transfer prints
and painted coat of arms of Hynde
Unmarked
L. 7½ in. (19 cm)
Gift of Martha and Henry Isaacson, 76.201.1–2

The elegant molded porcelain shell perched on a base of gentle
waves is from a silver shape of the period. Rococo designs for
molded and slip-cast porcelain and for cast silver were especially
interactive.

For years, the source for these sauceboats was a mystery. Be-
cause of their unusual bluish-gray glaze, they were thought to be
Italian. In the interest of research, Seattle collectors Martha and
Henry Isaacson took them around Italy, but no one recognized
the ware as Italian. After coming into Seattle's collection, the
sauceboats were categorized with a group of wares ascribed to
the English factory, Liverpool. In the late 1980s, archaeologists
from the Museum of London found wasters and fragments of
this porcelain, confirming the location of a third London factory,
Vauxhall; Chelsea and Bow were the other two documented at
the time.[20] Fragments of porcelain corresponding to the Seattle
sauceboats proved that they are Vauxhall porcelain. Soon there-
after, a fourth site was excavated, the Limehouse factory, and
another group of homeless wares could be attributed.

PL. 14.11

Sauceboat

English, Derby factory, c. 1750–52
Soft-paste porcelain
Unmarked
L. 6⅜ in. (16.2 cm)
Gift of Martha and Henry Isaacson, 76.224

This sauceboat is among the earliest wares of the English Derby
factory. Such early Derby wares are often unglazed or scantily
glazed around the lower edge of the base. They are known as
dry-edge Derby.

The sauceboat is probably from a design by André Planché,
originator of models at the factory during the early period. He
was born in London in 1728 into a French Huguenot émigré
family, but little else is known of him. New research suggests
that he may have traveled to the Continent and studied with the
great goldsmith Duplessis *père,* the leading designer of vases and
wares for the Vincennes-Sèvres porcelain factory from 1748 to
1768.[21] Whether Planché learned his style in France, gleaned it
from French goldsmiths, jewelers, and porcelain workers com-
ing to work in English porcelain factories, or was inspired by
examples from other factories, his work and other early shell-
encrusted porcelain works produced in England have a strong
affinity with French silver and porcelain in the *rocaille* taste.

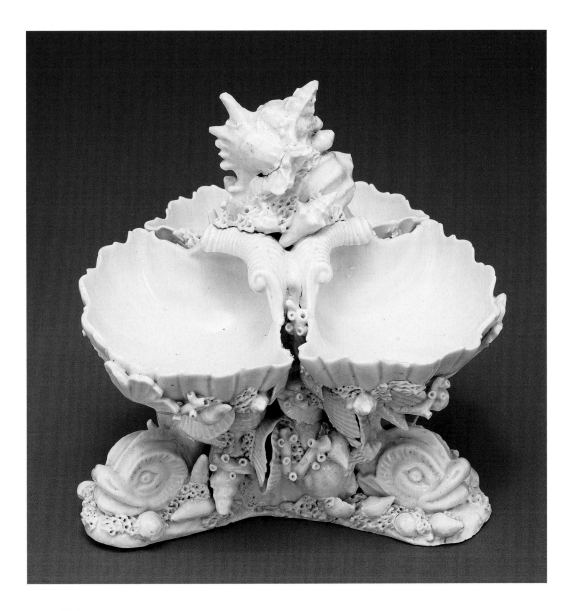

PL. 14.12

Triple shell dish

English, Plymouth-Bristol factory, c. 1770
Hard-paste porcelain
Unmarked
H. to top of bowls 6¾ in. (16.2 cm)
Blanche M. Harnan Ceramic Collection, Gift of Seattle Ceramic
Society, Unit I, 57.85

Massive, complicated structures such as the triple shell dish
are more stable, in both modeling and firing, when produced
in hard-paste rather than soft-paste porcelain. This dish was
produced at the first hard-paste factory in England, which was
established in 1768 by William Cookworthy (1705–1780), a
Quaker and noted chemist, who discovered the essential ingre-
dients of kaolin and porcelain stone in Cornwall. In *The Natural
History of Cornwall* (1758), William Borlase describes a moor
stone that is "of the nature with Oriental Granite." He tells of its
use in building projects and by William Cookworthy, "who has
tried many experiments this way and has found it most proper
for making porcelain."[22]

It is interesting to imagine the sites and layouts of early fac-
tories. The Plymouth enterprise was established at "Coxside ad-
joining the Sugar-House in Mr. Bishop's timber yard, with his
china shop in Nut Street."[23] The manufacture was transferred to
Bristol in 1770. Wares from both factories of this period are a bit
smoky in color.

THEMES IN ROCOCO PORCELAIN

The Menagerie

By the time Lorenzo de' Medici (see chap. 2) was accepting animals and Chinese porcelain as a royal gift from the Sultan of Egypt in 1487, the fashion for assembling collections of living rare animals and birds as status symbols was an ancient tradition. Menageries and aviaries date back to 4500 B.C. in the area of the Middle East that would become Persia.[24] In the eleventh century B.C., the Chinese lord Zhou Wenwang spent a vast sum to collect exotic animals (the stranger the better) as well as beautiful women, or so the story goes, as a royal bribe. He had been imprisoned by a Shang dynasty king who feared that Wenwang would overthrow him (which he did). Roman emperors kept rare wild animals in menageries for display and also for blood sport. King Henry III (r. 1216–1272) walked a huge white bear on a leash about London, and he received a gift of the first elephant in England from the revered French monarch, Louis IX (r. 1226–1270), who was canonized in 1297 as Saint Louis. Several decades after the Fonthill vase (see chap. 2, fig. 1) arrived in Europe (c. 1300), Philip VI of France (r. 1328–1350) was keeping his collection of animals at the Louvre.

As the trade routes developed and larger and faster ships plied the waters between Europe, Africa, and Asia, exotica from distant lands became more available. Over the next centuries, collecting the biggest, the rarest, the fiercest, and the most bizarre animals and birds became a symbol of power and prestige for many of the same princely collectors who were also amassing holdings in porcelain. Treasured animals were housed at Versailles and in the Tower of London. In 1683, the Polish king John III (r. 1674–1696) and his army, allied with the imperial forces of Emperor Leopold I, defeated the Turkish Ottoman Empire at Vienna. As the dust settled, John declared victory over the "barbarism" of Turkish troops, whom he accused of killing "a mass of innocent local Austrian people" and, adding insult to injury, of looting an ostrich from the menagerie of the Habsburg emperor.[25]

In the eighteenth century, Augustus the Strong, of Meissen porcelain fame, had a zoo in the Jägerhof at Dresden-Neustadt. He was so eager to add to his collection that he funded an expedition to Africa to bring back animals and birds. His son, Augustus III, carried on the passion for zoology and also maintained the large natural history collection, including stuffed animals and birds. Conceived as collections of living wonders, a contrast to the *objets* assembled for *Wunderkammern* (see chap. 11), menageries and aviaries offered rare and exotic animals and birds as models for artists. Thus Meissen porcelain modelers and decorators had access not only to prints of animals and birds available during this time but also to live animals, or at least to stuffed specimens.

These resources offered inspiration for the large porcelain animals and birds that Augustus the Strong desired for the Japanese Palace, and for smaller versions, popular for cabinet and table display. Even though live animals and realistic representations of animals in prints were available, decorators of Meissen services also delighted in making a fanciful array of imaginary animals and landscapes.

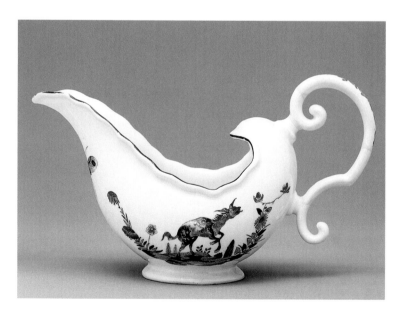

PL. 14.13

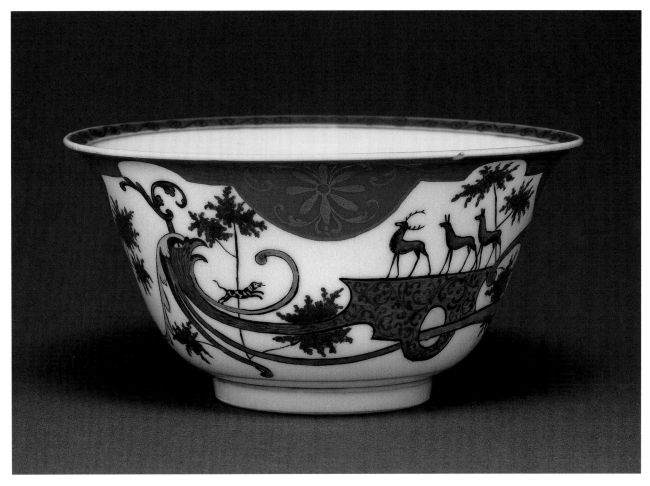

PL. 14.14

PL. 14.13

Sauceboat

German, Meissen factory, c. 1735
Hard-paste porcelain with enamel colors
Mark: crossed swords in underglaze blue
L. 8½ in. (21.6 cm)
Gift of Martha and Henry Isaacson, 69.212

This sauceboat is painted with fantastic imaginary animals (*Fabeltiere*) in a style attributed to the Meissen painter Adam Friedrich von Löwenfinck (see pl. 13.4). Several services with weird, splotchy-coated, heraldic-seeming animals strolling through flower-bedecked landscapes were produced between 1735 and 1740. The shape, scalloped edge, and scrolled handle of this sauceboat appeared in both porcelain and silver at this time.

PL. 14.14

Bowl

German, Meissen factory, c. 1725
Hard-paste porcelain with enamel colors, luster, and gilding
Mark: crossed swords in underglaze blue
Diam. 7 in. (17.9 cm)
Gift of Martha and Henry Isaacson, 69.213

One can imagine that the asymmetrical designs framing scenes of stags, hunting dogs, and fierce falcon heads on this bowl would have found favor during the emergence of rococo. There are, however, only about ten or so recorded Meissen works in this style.[26] Adapted from engravings of about 100 years earlier by Johann Schmischeck (1585–1650), they may have seemed too eccentric during this early period of transition from late baroque to rococo in Germany. This rare bowl is undoubtedly the waste bowl from the same service as a tea bowl and saucer in the Wark collection.[27]

Birds

For the Japanese Palace in Dresden, Johann Joachim Kändler produced large, elaborately modeled and sculpted birds early in the 1730s. He often sketched and modeled at the aviary of Augustus the Strong at Moritzburg. Meissen modelers also had access to Chinese models of birds, as well as prints and stuffed specimens. Meissen produced brilliantly colored, smaller figures of birds, initiating a genre of bird figures. Almost every European porcelain factory of the eighteenth century followed the factory's lead.

Meissen models inspired many of the early bird figures at Chelsea, Bow, and other English factories. A wealth of new images became available for the English modelers with the publication of George Edward's *A Natural History of Uncommon Birds* (1743–51). Seattle's lively porcelain birds arose victorious from the fire of the Bow factory kilns and date from the same time as the fox (see pl. 14.9). It was a time of experimentation by the factory as evidenced by the colors—the fox is grayish white, and these herons are creamy white. With their open beaks, twisting necks, and thinly modeled legs, they seem to have remained quite stable during firing, showing no signs of the slumping that plagued the fox. Extraordinarily sculptural for Bow, they may have been created by the same competent modeler.[28] These extremely rare herons are the only known pair.[29]

The Villeroy-Mennecy porcelain factory was founded in France around 1737, in the village of Villeroy, which was located on the grounds of the fourth duc de Villeroy (1695–1766). The Seattle parrot (pl. 14.16) was produced after the factory was relocated to a new establishment in Mennecy in 1750. We do not know if the Duc de Villeroy had an aviary, but the modeling of the parrot, although the figure is half the size of a real bird, is quite lifelike. The Prince de Condé, who was affiliated with the Chantilly porcelain manufactory and was a contemporary of Villeroy's, maintained a menagerie and aviary on the grounds of his château, in addition to his famous stables (see chap. 12). These noblemen had time for pleasurable pursuits, as both had been exiled to their estates for scandalous behavior at court.

French porcelain collections and menageries were among the aristocratic holdings that were dispersed during the French Revolution. At Versailles, a mob convened on the king's menagerie, intent on liberating creatures that they said had been caged by tyrants. Eyeing the rhinoceros, the keeper of the menagerie warned against it. The mob reconsidered and freed only animals considered to be tame.

PL. 14.15

Herons

English, Bow factory, c. 1750
Soft-paste porcelain
Unmarked
left: hen, h. 6⅝ in. (16.9 cm)
right: cock, h. 6¾ in. (17.2 cm)
Gift of Martha and Henry Isaacson, 69.396.1–2

These figures, recorded at the Bow factory as herons, closely resemble depictions of the mythical phoenix. Emblematically, these two birds were intertwined in many cultures and once again relate to alchemy, a continuing thread through the European story of porcelain. In ancient Egypt, the phoenix represented the solar cycle and was analogous to the purple heron, which implied the alchemist's 'red art' (making the Red Stone was an essential step in alchemy). The Chinese Daoists' name for the phoenix was 'cinnabar bird' (*tan-niao*), for the red mercury sulfide also associated with alchemy. According to Herodotus and Plutarch, the phoenix, which originated in Ethiopia, was burned on an altar, then rose again from its own ashes. An ancient emblem of rebirth and immortality, the phoenix symbolized Christ's resurrection in the early church and throughout the Middle Ages in Europe.

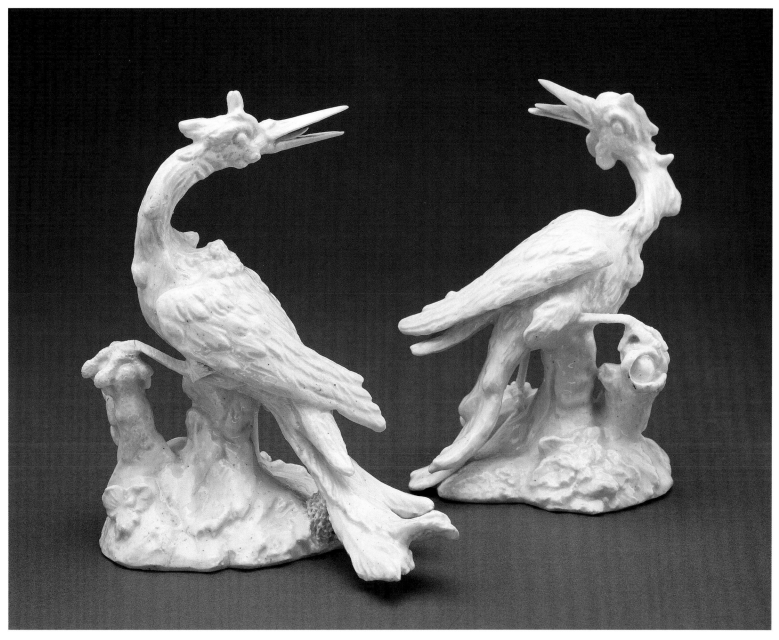

PL. 14.15

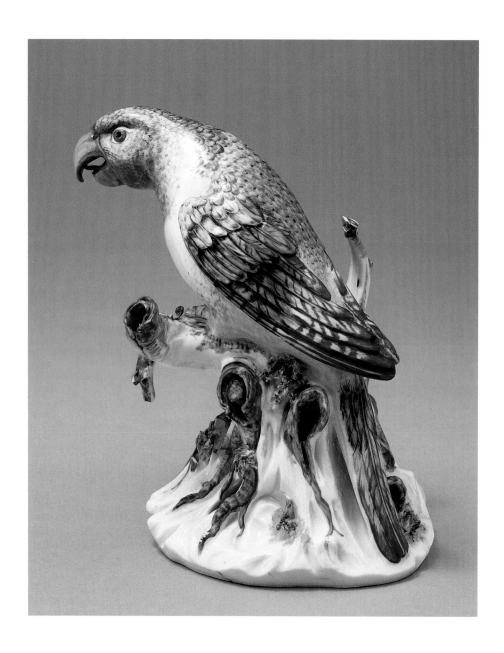

PL. 14.16

Parrot

French, Mennecy factory, c. 1750–60
Soft-paste porcelain with enameled colors
Mark: incised DV
H. 7 in. (17.9 cm)
Purchased with funds from the Guendolen Carkeek Plestcheeff
Endowment for the Decorative Arts, 98.33

With his forward-thrusting head, beady eyes, and raspy tongue
(remarkably still intact), this figure evokes the wild. An exotic
subject, the parrot on its foliated tree-stump base reflects a favor-
ite bird theme and energetic rococo modeling. The form is that
of an Amazon parrot, but while the rendering of the body shape
and feathering patterns is true to life, the color is invented.
Rather than the Amazon coloring of overall green, with accents
of yellow and blue, or lilac and red, the artist chose the distinc-
tive green, purple, and magenta palette of the Mennecy factory.
This figure could be male or female; parrots are one of the few
species in which both sexes share colorful plumage. This model,
one of only three known, is a rare addition to the porcelain me-
nagerie of the Seattle Art Museum.[30]

The Commedia Dell'Arte

Theater was one of the most important diversions of the eighteenth century. The most famous of all the theatrical presentations was the Italian commedia dell'arte, widely popularized as a form of farcical theater in the sixteenth and seventeenth centuries. It developed as scenarios with improvised dialogue performed by groups of strolling players, usually under the patronage of a nobleman. The best of the commedia dell'arte troupes performed at the royal courts, but as this style of theater spread, others performed in town squares, observed by all classes of society. Its stock characters —lovers, villains, and buffoons—were rooted in ancient Greek and Roman comedy and were also associated with the revels of traditional feast days, especially Carnival (just before Lent).

The plays usually center on the antics of lovers, old men, and servants from two aristocratic households involved in a feud over romantic peccadilloes and the intrigues of the servants. The most important of the characters are the *zanni,* or servants. It is their task to weave elaborate plots and arouse laughter. Harlequin (pl. 14.18) is primary among the *zanni* and, with his beloved Columbine (pl. 14.17), acts as servant to the aristocratic stock characters, the lovers. Isabella, the female lover, is forever trying to thwart the plans of her father, the old man Pantaloon (pl. 14.19), who constantly attempts to marry her off to some wealthy, senile suitor. Pantaloon's friend and rival is the learned gentleman from Bologna, the Doctor (pl. 14.18).

Depictions of characters from the commedia dell'arte were popular in all forms of the decorative arts of the late seventeenth and eighteenth centuries. Figures of stock characters were produced in most European porcelain factories.

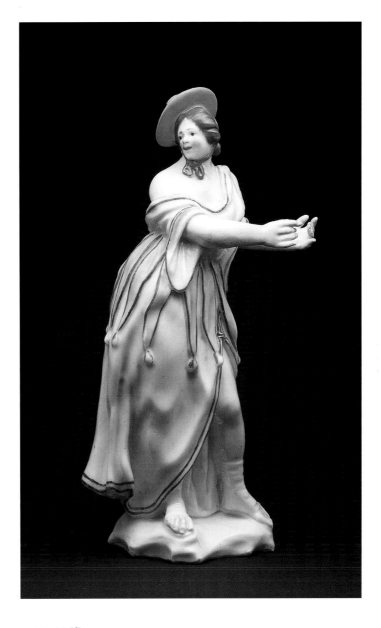

PL. 14.17

Figure of Columbine

Italian, Capodimonte factory, c. 1750
Soft-paste porcelain with enamel colors
Mark: impressed fleur-de-lis
H. 6 in. (15.2 cm)
Dorothy Condon Falknor Collection of European Ceramics, 87.142.65

The character of the servant Columbine is witty, bright, and full of intrigue. She is often portrayed dancing. The swirl of the rococo modeling seen in this figure features the beautiful milky white color of the porcelain articulated by reserved, well-placed enamel decoration.

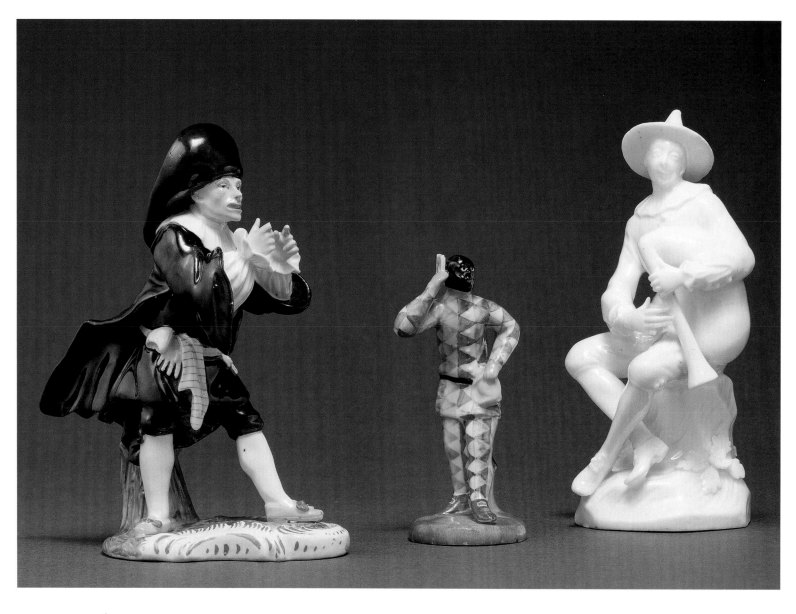

PL. 14.18

The Doctor

German, Fürstenberg factory, c. 1775
Model by Anton Carl Luplau (d. 1795)
Hard-paste porcelain with enamel colors
Mark: F in underglaze blue; incised F,
no: 270, C
H. 5 in. (12.7 cm)
Gift of Martha and Henry Isaacson, 76.103

Harlequin

German, Kloster-Veilsdorf factory, c. 1765
Hard-paste porcelain with enamel colors
Mark: faint painted numerals appear as 212
H. 3⅜ in. (8.6 cm)
Gift of Martha and Henry Isaacson, 76.278

Harlequin playing a musette

French, Mennecy factory, c. 1755–60
Soft-paste porcelain
Unmarked
H. 5 in. (12.7 cm)
Dorothy Condon Falknor Collection of
European Ceramics, 87.142.71

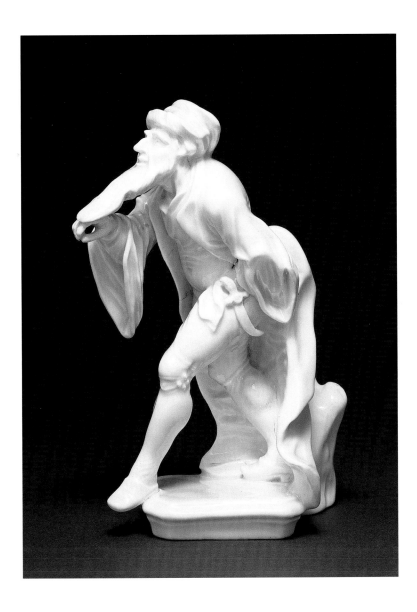

Pantaloon

German, Höchst factory, c. 1751–53
Model by Simon Feilner (d. 1798)
Hard-paste porcelain
Mark: incised RGI
H. 7 in. (17.8 cm)
Gift of Martha and Henry Isaacson, 76.88

PL. 14.18
opposite, left:
The character of the Doctor hailed from Bologna, home
to one of the oldest and most celebrated universities in
Europe. The Doctor's role is primarily a satire on learned
men; he is constantly misquoting Greek and Latin phrases.
As Pantaloon's friend, but also his rival as head of the
other household, the pompous Doctor always spies on his
young wife and daughter and falls into traps set by the
clever servants. Seattle's Doctor is dressed in a black aca-
demic robe and hat.

opposite, center:
Harlequin is the best known today of the commedia
dell'arte figures. His early costume of irregular colored
patches developed into the familiar diamond-shaped pat-
tern seen on the little Seattle figure. Harlequin's role is to
generate a lively pace on stage. To do so, he had to be able
to scale walls, walk on stilts, gobble down food, and sing.
This masked Harlequin holds a sealed letter behind his
ear, as if he were attempting to hide it.

opposite, right:
Unlike the more common slapstick depiction of Harlequin,
this pensive portrayal of him playing a musette—a type of
bagpipe that goes far back in Celtic history—evokes the
romantic commedia dell'arte figures made popular by
the French painter Antoine Watteau. This French model
derives from a Harlequin created for a famous Meissen
series of commedia dell'arte figures for the Duke of Weis-
senfels, a cousin of Augustus III, Elector of Saxony and
King of Poland, or from the same engraving that served
as Meissen's inspiration.[31]

PL. 14.19
this page:
All the characters, with the exception of the lovers, wore
stylized masks, usually of leather or papier-mâché. The
masks concealed the actors' facial expressions from the
audience, so gestures and mime were greatly exaggerated.
Even though the porcelain figures were often created
without masks, this figure of Pantaloon illustrates the
importance of the grand gesture.

Allegorical Themes

Allegorical themes, or symbolic representations, were important subjects in the arts of the eighteenth century. In porcelain, these themes were most often elaborated groups of sculptural figures representing the four elements, the four seasons, the four quarters of the globe, the cardinal virtues, the five senses, the seven liberal arts, the twelve months, or time and eternity (pl. 14.20). These subjects were also painted as scenes on porcelain.

The earliest European allegorical representations of the continents, or the four quarters of the globe, were personified by female figures representing Europe, Asia, Africa, and America (pl. 14.22). An early source for the image of a Native American was a watercolor by John White (active 1585–93), who accompanied Sir Walter Raleigh on several expeditions as an artist commissioned to depict life in the Americas. Theodore de Bry, a Flemish engraver and publisher working in Germany, produced twenty-five engravings after John White's works for inclusion in his collection of travel books, *Great Voyages,* published in the 1590s. A Native American with feathered headdress and short skirt was featured in an engraving produced for the Florida edition.

The iconography for the group of continents coalesced in the seventeenth century in an illustrated dictionary, *Iconologia,* by Cesare Ripa (published in Rome in 1603), and in the famous *Atlas maior* published as a set of eleven volumes in 1662, in Amsterdam. A Dutch family of cartographers, named Blaeu, produced it. A son in the family, Joan Blaeu (1596–1673) made the hand-colored engraving of America that served as the source for Seattle's porcelain figure.

PL. 14.20

Father Time

German, Meissen factory, c. 1745
Model by Johann Friedrich Eberlein (1695–1749)
Hard-paste porcelain with enamel colors and gilt
Mark: crossed swords in blue
H. 14½ in. (36.8 cm)
Gift of Martha and Henry Isaacson, 91.103

Meissen's version of Father Time strides relentlessly along, appropriately bearing a watch holder formed in an amorphous rococo shape. He also carries one of his familiar attributes, a scythe. This personification of Father Time came from early confusion between the Greeks' word for time, *chronos,* and their old god of agriculture, Cronus, who carried a scythe. During the Renaissance, artists added wings to Father Time and gave him an hourglass, an attribute not included in the Seattle figure. Instead he would have carried a modern 'hourglass,' a timepiece, in the watch holder.

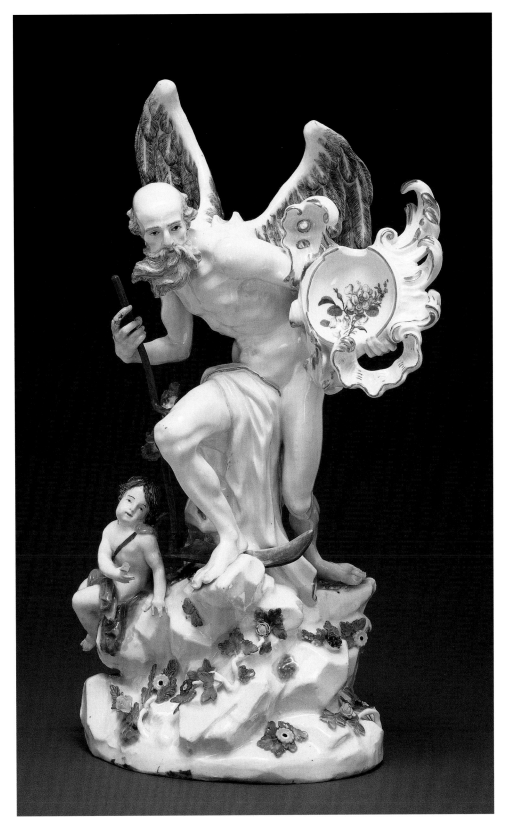

PL. 14.20

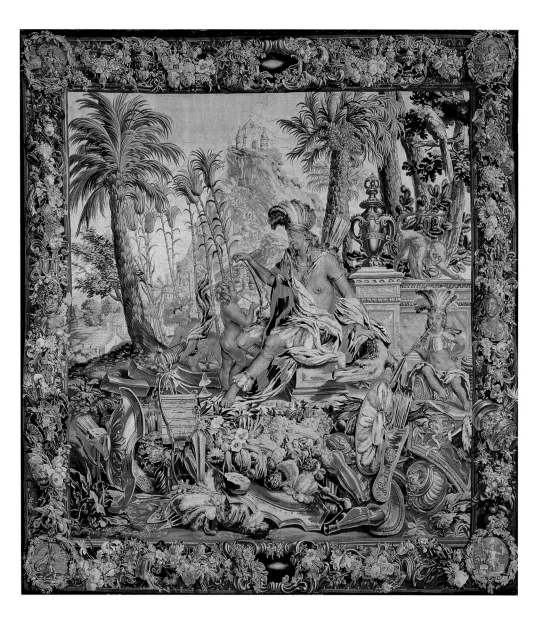

PL. 14.21

Tapestry of America

Flemish, Brussels, late 17th century
Jacques van der Borght the Elder and Jan Cobus
Wool
H. 156 in. (403 cm)
Gift of the Hearst Foundation, 62.199.1

Europeans were increasingly enthralled with the romance of far
distant lands as more and more wonders of the world arrived on
their doorstep. A vast array of metaphorical images depicted in
the arts of the seventeenth and eighteenth centuries evoked the
lush sights, exotic sounds, and rich smells of those distant places.
In this tapestry, a noble Indian calmly surveys a world filled
with allusions to the Americas, the New World. A parrot and
monkey look down upon two feather-crowned children smok-
ing beneficent tobacco. Armor and weapons of war have been
cast aside to serve as a cornucopia for ripe fruits and vegetables
that spill over in great abundance. An aura of tremendous
wealth is aroused by visions of gold doubloons spilling forth
from a silver pot at lower right and silver ingots littering the
ground under the palm tree. This scene unfolds well removed
from but probably still under the watchful eye of the Catholic
church perched high on a distant hill. The scene is allegory
embodied—it is America as paradise.

PL. 14.22

Allegorical figure of America

French, Strasbourg factory, 1752–54
Model by Paul Antoine Hannong (1700–1760)
Hard-paste porcelain with enamel colors
Mark: impressed PH (five times)
H. 10 in. (25.4 cm)
Gift of Martha and Henry Isaacson, 81.8

The figure of America benignly places her foot upon a stone rather than on the severed head that is shown in Blaeu's engraving (fig. 2). Ninety years separate these depictions of America; the passage of time has brought about great change in Europeans' views of nature, themselves, and the world. Jean-Jacques Rousseau (1712–1778) was the intellectual catalyst for much of the change. It is he whom we thank for our concepts of a social contract and the idea that a deep reconnection with a benevolent nature is mankind's salvation, while a focus on works based in science, industry, and cold logic will only hasten civilization's ruin. In this he differed from his contemporary, Denis Diderot, the encyclopedist who advocated the merits of science and intellectual discipline. Rousseau's thought influenced rulers, intellectuals, and artists and writers throughout Europe. In the figure

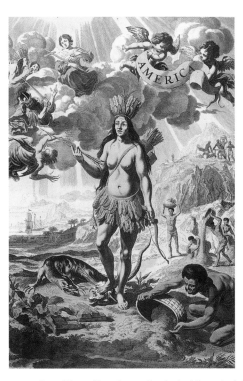

FIG. 2. Joan Blaeu (Dutch, 1596–1673). Allegorical figure of America. Frontispiece, *Geographia maior; sive, cosmographia blaviana*, vol. II. Amsterdam, 1662–65. New Hampshire, Dartmouth College Library.

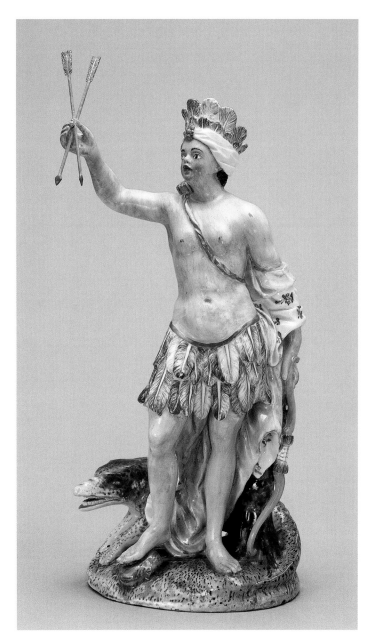

PL. 14.22

of America, the Indian's tranquillity, as she peacefully offers up her arrows while a caiman (a member of the alligator family found in Central and South America) curls about her feet, may be read as an allegory of innocence and unity with nature.

Paul Hannong, who made the model for this figure, produced the first hard-paste porcelain in France in about 1751 or 1752, with the assistance of two porcelain workers from Vienna. Royal sanctions protecting the porcelain monopoly of the Vincennes factory forced Hannong to leave France. He relocated in Frankenthal under the auspices of the Elector Palatine.

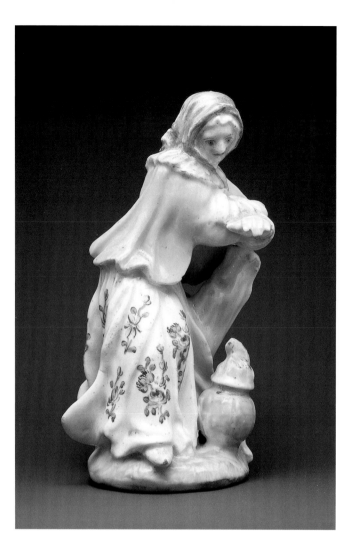

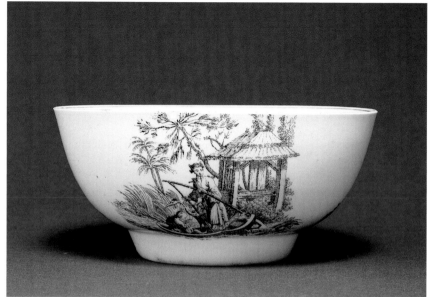

PL. 14.23
Figure of Winter

English, Derby factory, c. 1750
Model attributed to André Planché
Soft-paste porcelain with enamel colors
Unmarked
H. 6¼ in. (15.9 cm)
Gift of Martha and Henry Isaacson, 76.246

The beautifully modeled figure of an old woman warming
herself at a brazier symbolizes Winter in a group of the Four
Seasons. Allegorical representations of the seasons remained
remarkably unchanged from late antiquity to the eighteenth
century. Spring is a young woman holding flowers; Summer is
often thinly clad and has a sheaf of grain; Fall is draped in grape
vines; and Winter, bundled against the cold, huddles over a fire.

PL. 14.24
Bowl with the Elements

English, Worcester factory, c. 1756
Transfer-printed in black by Robert Hancock (1730–1817)
Soft-paste porcelain
Unmarked
Diam. 5¾ in. (14.6 cm)
Kenneth and Priscilla Klepser Porcelain Collection, 94.103.180

The concept that everything in existence is composed of four
elements—earth (solid), air (gas), fire (changeability), and water
(liquid)—was taught by the Greek philosopher Empedocles
(c. 490–c. 430 B.C.). Hypotheses in European alchemy evolved
from this ancient philosophy. In another interesting connection
between alchemy and the search for a European porcelain for-
mula, each of the four elements played a role in the production
of porcelain. Until 1784, when water was discredited as a true
element, the theory prevailed that all matter in the universe
was composed of these four elements.

Two of the chinoiserie scenes printed on this bowl, Earth
and Fire, are from engravings after François Boucher. Gabriel
Huquier engraved the print symbolizing Water.[32] This bowl is
the only known Worcester porcelain recorded with this scene.[33]

Botanicals

Rare plants as well as rare animals fascinated Europeans intent on attaining knowledge of the natural world during the Age of Enlightenment. In England, the plethora of un-identified and unnamed plants arriving from distant lands posed a problem for local nurserymen. Because of confusion in nomenclature, patrons purchased plants they already owned under another name, provoking them to call the nurserymen "Knaves and Blockheads."[34] It was not until 1737 that the Swedish botanist Carolus Linnaeus (1707–1778) published *Genera Plantarum,* a classification of plants based on the number of stamens and pistils in each plant's flower.

After Linnaeus's death, his famous collection of plants passed to his son, who expired shortly thereafter, leaving the collection to Linnaeus's widow. Too late, the Swedish government discovered that the precious collection had been sold and shipped to England; the legend that they sent a warship in pursuit is apparently unfounded, but there was a national outcry over its loss.

Linnaeus's system of nomenclature was welcomed by most, but Rousseau was critical in his *Lettres sur la botanique:* "Nothing could be more absurd . . . than if a woman asks the name of some herb or garden flower, to give by way of answer a long tirade of Latin names which sounds like a conjuration of hobgoblins."

Regardless of what they were called, flowers were the predominant decoration on eighteenth-century European porcelain.

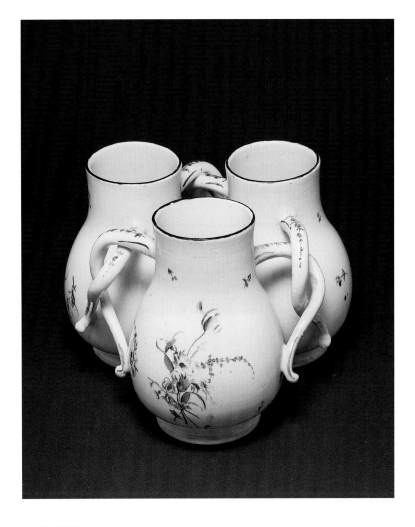

PL. 14.25

Triplicate mug

German, Höchst factory, c. 1755
Hard-paste porcelain with enamel colors
Mark: wheel in iron-red enamel on each jug
H. 4½ in. (11.4 cm)
Gift of Martha and Henry Isaacson, 69.175

The delicate, lightly colored floral decoration on this three-part mug (*Drillingskrug*) represents the factory's early painting style.[35] The factory was founded under the auspices of the Elector of Mayence, near Mainz, in 1750. The form was achieved by joining the three mugs with slip at their attachment point and piercing them with connecting holes before firing. When in use, as one mug was emptied, the beverage from the other two flowed into it. In England, this form was called a fuddling cup, because the drinker would become fuddled, or confused, after draining three mugs of an alcoholic beverage.

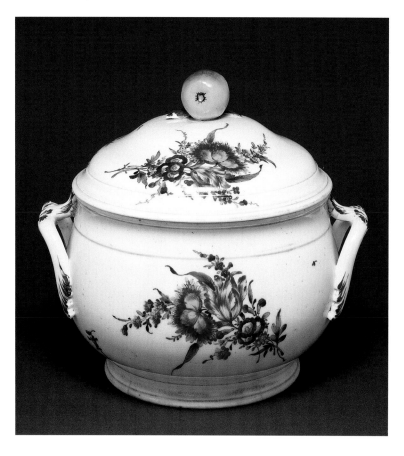

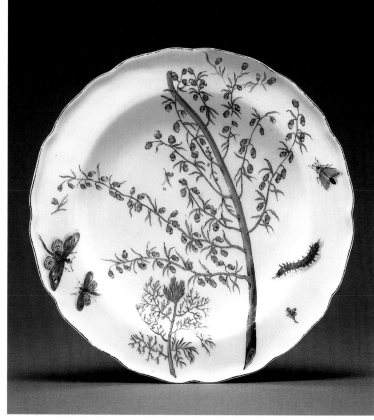

PL. 14.26

Tureen

French, attributed to the Orléans factory, 1753–70
Soft-paste porcelain with enamel colors
Marks: possible painter's mark in puce enamel and incised V
H. 8 in. (20.3 cm)
Gift of Blanche M. Harnan, 64.117

The exuberant style and deep rich colors of the floral decoration on this tureen compare to other works from the Orléans factory.[36] This tureen is extremely rare.

PL. 14.27

Plate

English, Chelsea factory, c. 1756–58
Soft-paste porcelain with enamel colors
Mark: red anchor
Diam. 8 in. (20.3 cm)
Gift of Martha and Henry Isaacson, 76.219

Seattle's botanical Chelsea plate is from a series dating after the introduction of a new clay formula that resulted in a more thinly potted ware and more translucent glaze than the earlier tin oxide formula.[37]

To protect and assist nurserymen during this period when new plants were arriving in Europe, a guild known as the Society of Gardeners formed in 1724. They held monthly meetings at Newell's Coffee House in Chelsea to share information on newly introduced plants.[38] One horticulturist in the group was Philip Miller, who first published his valuable *Gardener's Dictionary* in 1724. Between 1755 and 1760, he published *Figures of the Most Beautiful, Useful, and Uncommon Plants Described in the Gardener's Dictionary,* in two volumes.

An engraving from Miller's book (fig. 3) is after a painting by German-born Georg Dionysius Ehret (1708–1770), one of the most celebrated botanical artists of the eighteenth century. In 1736, Ehret settled permanently in London and became part of the horticultural group affiliated with the Chelsea Physic Garden. He was a friend of Sir Hans Sloane, who leased land to the Physic Garden, and he married the sister-in-law of Philip Miller, curator of the Physic Garden and author/organizer of *Figures of Plants.* Ehret produced paintings for this important work. All engravings after paintings by Ehret are found toward the beginning of volume I; it seems that only these illustrations were used as source material for botanicals on Chelsea porcelain (pl. 14.27).

Philip Miller included Dwarf Southernwood in his book not for its beauty but for its efficacy as a medicine. In its dictionary listing, he recorded:

> Southernwood is bitter and aromatic, with a very strong smell. It is not much in use, but promises considerable effects, outwardly in discussing contusions and tumours, inwardly for destroying worms, and in disorders peculiar to the female sex. . . . The branches dye wool a deep yellow.

FIG. 3. Dwarf Southernwood (*Abrotanum humile*). From *Figures of the Most Beautiful, Useful, and Uncommon Plants,* vol. I, pl. II; engraving. LuEsther T. Mertz Library of the New York Botanical Garden.

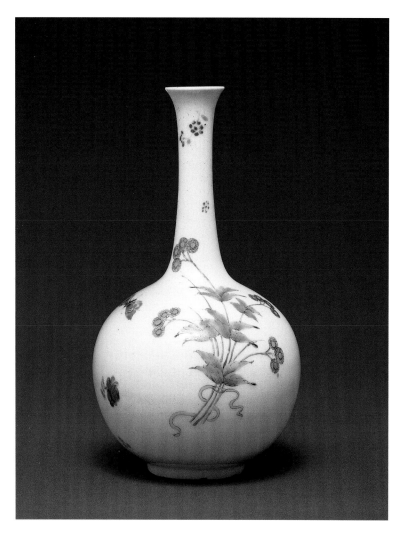

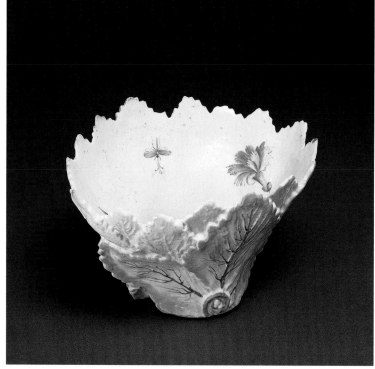

PL. 14.28

Vase

English, Bow factory, c. 1755–58
Soft-paste porcelain with enamel colors
Mark: B in underglaze blue
H. 7⅝ in. (19.4 cm)
Gift of Martha and Henry Isaacson, 55.85

Both the elegant floral bouquet and the spherical bottle shape of this vase were Asian-inspired. This floral pattern is very rare on Bow porcelain.[39]

PL. 14.29

Bowl

English, Longton Hall factory, c. 1755
Soft-paste porcelain with enamel colors
Unmarked
Diam. 5 in. (12.7 cm)
Gift of Martha and Henry Isaacson, 76.191

This bowl incorporates plant and floral decoration in its molded leaf form and the two pink gillyflowers beautifully painted inside.

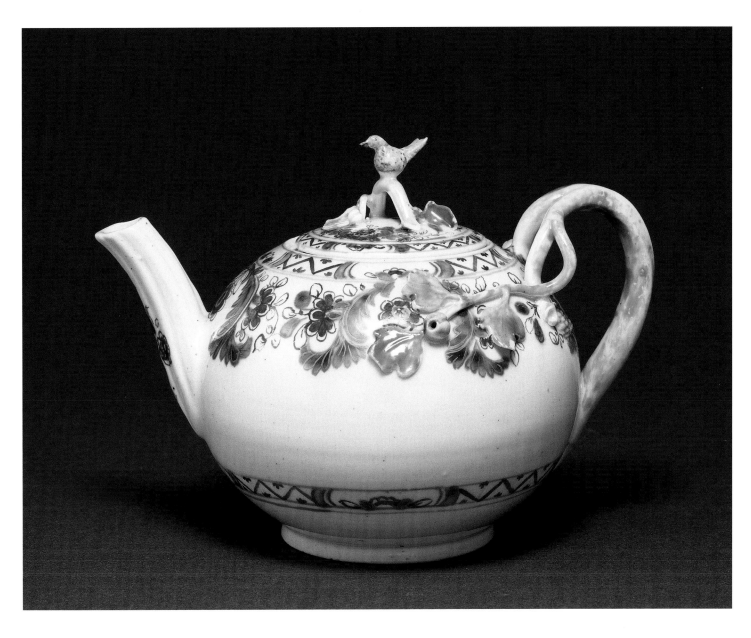

PL. 14.30

Teapot

Italian, Doccia factory, c. 1750–55
Hard-paste porcelain with underglaze blue and red, enamel colors,
and gilding
Unmarked
H. 4½ in. (11.4 cm)
Gift of Dr. Rex Palmer and family in memory of Kitty Palmer, 92.164

The Doccia factory, Florence's great porcelain manufactory, was
established in 1737 on the estate of the entrepreneurial Marchese
Carlo Ginori (1702–1757), which still produces porcelain today.
Doccia is classified as a hard-paste porcelain because it is high-
fired, although analysis indicates a paste rich in quartz, not
porcelain stone, and fine white clay, not kaolin.

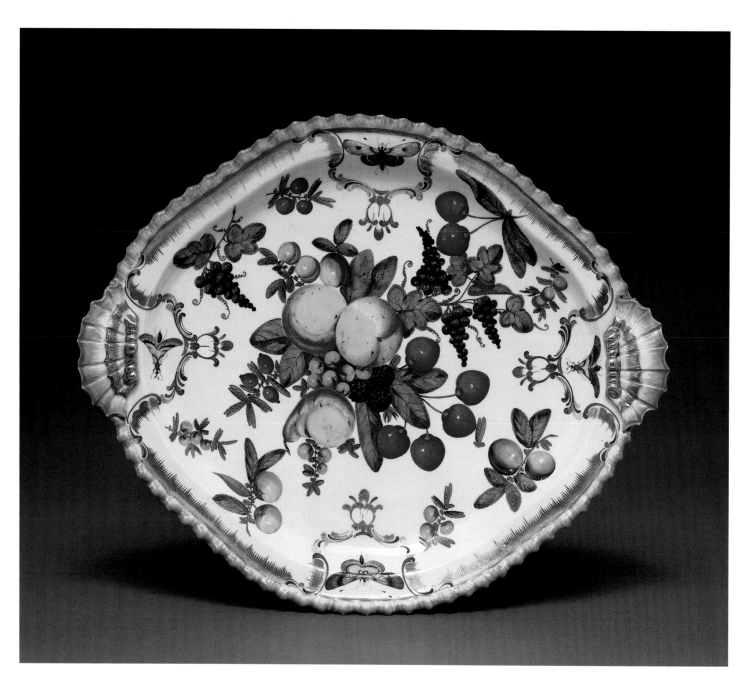

PL. 14.31

Tureen stand

English, Worcester factory, 1775–78
Soft-paste porcelain with enamel colors and gilding
Mark: crescent in gold
W. 11⅜ in. (28.9 cm)
Kenneth and Priscilla Klepser Collection, 94.103.64

This stand for a tureen is almost completely covered with fruits of flowers: peaches, cherries, grapes, berries. This ornate pattern decorates the Duke of Gloucester Service, named for William Henry (1743–1805), a grandson of George II. Whether he actually owned this service has not been proved, but a similar service is recorded as having been in the possession of his brother, the Duke of Cambridge.[40]

Potpourri Vases

Flowers and European porcelain enjoyed a decorative relationship throughout the eighteenth century, but they also came together in a serviceable association. Porcelain vases with pierced lids and shoulders were used as containers for aromatic mixtures of flowers. Potpourri was either a liquid scented with flower petals and herbs or a blend of dried flowers and herbs. Vases containing these mixtures were strategically placed in rooms throughout homes.

Three examples of potpourri vases from Seattle's collection illustrate a progression of styles in European porcelain explored in earlier chapters, and they introduce the closing chapters of the story of porcelain. A wonderful French version pierced with florettes and with applied foliate decoration recalls *blanc de chine* ware (pl. 14.32). A pair of ornate English vases decorated with trellislike lids, molded flowers, and bird painting (pl. 14.33) represents the rococo. A pair of rare German potpourri vases from the Höchst factory (pl. 14.34) is decorated with scenes signifying Europe's renewed interest in classical antiquity.

— J.E.

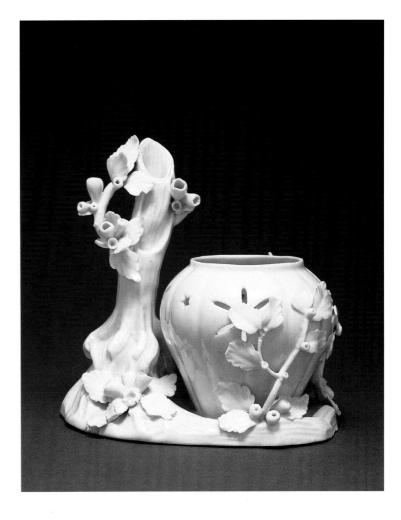

PL. 14.32

Potpourri vase

French, Chantilly factory, c. 1745
Soft-paste porcelain
Unmarked; cover missing
H. 6 in. (15.2 cm)
Gift of Dr. and Mrs. S. Allison Creighton, 92.35

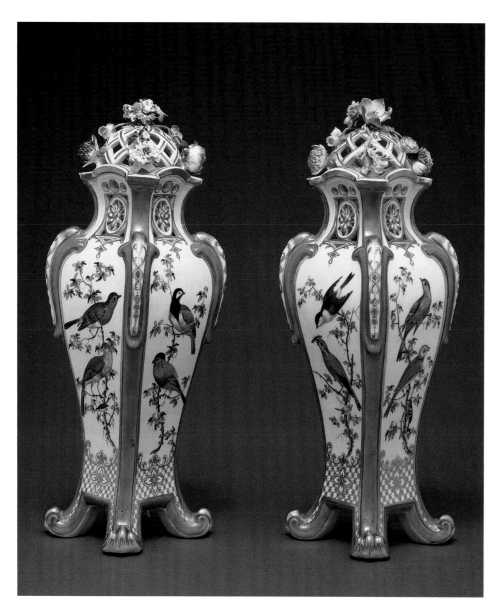

FIG. 4. *Nicholas Sprimont, His Family, and Chelsea Vases*. English, unattributed, c. 1760. Oil on canvas. Private collection, United States.

PL. 14.33

Pair of potpourri vases

English, Chelsea factory, c. 1765
Soft-paste porcelain with enamel colors and gilding
Unmarked
H. 13½ in. (34.3 cm)
Gift of Martha and Henry Isaacson, 76.237

Paintings that feature identifiable porcelain from a specific factory are rare. The Chelsea vases in this scene (fig. 4), painted and undecorated, offer the primary clue to the identification of the sitter, Nicholas Sprimont (1716–1771), the manager and proprietor of the Chelsea porcelain factory. Sprimont, an accomplished silversmith, holds scales for weighing gold. His wife Ann stands behind him. The couple is joined by Ann's sister, Susanna Protin, who holds a potpourri vase similar to Seattle's pair of Chelsea vases.[41]

PL. 14.34

Pair of potpourri vases

German, Höchst factory, c. 1784/85
Painted by Johann Heinrich Usinger (active 1782)
Hard-paste porcelain with enamel colors
Unmarked
H. 7 in. (17.9 cm)
Gift of Martha and Henry Isaacson, 69.176

Usinger painted classical settings in the taste of his time.[42] One of his painted plates, now in the History Museum of the City of Frankfurt, features a sacred ceremony of the ancient goddess Isis. He took his inspiration from the 1781 books by François Ange David, which featured the antiquities of Herculaneum and Pompeii. The source for the scenes on Seattle's potpourri vases has not been identified. They depict classically gowned figures surrounding a female idol amid the haze of a burning brazier and smoking censer, and Roman soldiers.

15

A Taste for Novelty: Qianlong the Collector

> The porcelains Tang Ying sent to the court this time are still of the
> old fashion. Why did he not follow the new models dispatched to him
> and produce new wares? All the cost and expenses of their production
> and transportation shall not be reimbursed from the court;
> instead they shall be borne by Tang himself.
>
> —Decree of the Qianlong emperor (r. 1736–1795)

This imperial decree was dispatched to Tang Ying, the famed superintendent of ceramics at the Imperial Ware Factory (Yuqichang) in Jingdezhen on the twenty-eighth day of the eleventh month, 1748.[1]

What the emperor desired, he should get, and possibly more. If such were the thoughts of Qianlong about his beloved porcelain, the task of translating his desires into reality fell on the shoulders of the Jingdezhen potters. The Imperial Ware Factory was charged with producing wares for the exclusive use of the imperial household, wares whose design was often chosen or even created by this extraordinary emperor himself. Whether it was to be an utterly original piece, or one imitating another material or combining designs from several samples, or whether new glaze colors or decorative motifs were to be added to an existing design, Qianlong dispatched his orders to the factory as specific instructions, if not always realistic ones. As this anecdote reveals, he was obviously furious at his subject's failure to carry out his wishes and dashed off a severe penalty. Nevertheless, this punishment was still somewhat reserved, for he could easily have dismissed Tang from his post, not at all an improbable outcome. Was it because, deep in his heart, he had sensed that maybe there was something wrong with his design?

This may have very well been the case, if we look at the matter from Tang Ying's viewpoint. At the time of this incident, Tang Ying had managed the Imperial Ware Factory for twenty years and was to direct the business there for

another eight years. During this long career, Tang Ying proved enormously dedicated to and diligent in carrying out his duties. He fulfilled every routine yearly order from the imperial court, which amounted to about 19,000 top-quality pieces (along with an extra group of second-quality pieces in large quantities) in the years before 1735, an amount that increased to 47,120 pieces in 1737.[2] He was also able to fulfill, by and large, the emperor's frequent wishes (which amounted to orders) or urgent demands, sometimes even in bad situations, as when the factory was closed for the season. Moreover, as a self-taught potter, Tang Ying was responsible not only for new porcelain forms and decorations but also for reviving and inventing at least fifty-seven glaze colors (not counting their various shades).[3] It is inconceivable that Tang would deliberately ignore Qianlong's order unless that specific order was so far beyond any realistic expectation that the potters were simply unable to fulfill it. This time, perhaps, much to the emperor's dismay, his own desire for novelty exceeded the range of possibility.

Highly intelligent and energetic, the Qianlong emperor inherited from his illustrious grandfather and father, the Kangxi and Yongzheng emperors, admirable perseverance, passion for learning, and tremendous love and enthusiasm for works of art. Enjoying the peace and prosperity that his ancestors had built and left for him, Qianlong ruled as a competent monarch and in his leisure time devoted himself to the cultivation of art and literature, and to amassing

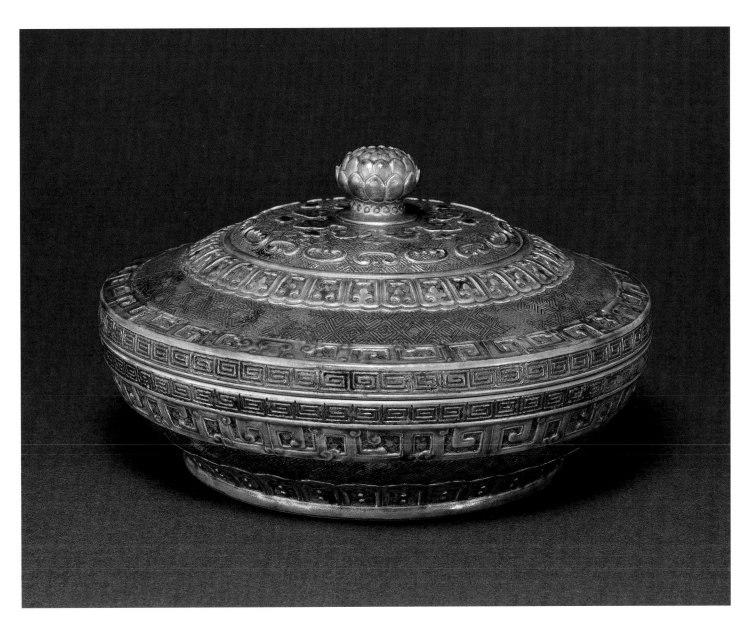

PL. 15.1

Covered box

Chinese, Qing dynasty, Qianlong reign mark and period (1736–1795)
Jingdezhen ware, porcelain with turquoise glaze imitating
ancient bronze
Diam. 6⅜ in. (16.2 cm)
Purchased in memory of the E. K. and Lillian Bishop Family, 73.5

Porcelain wares imitating ancient bronze vessels were popular
during the Qianlong period. They often had gilded surface pat-
terns. The interior of this box is gilded all over, creating the look
of uncorroded bronze, which would be golden in color.

collections of art and books that would be unsurpassed in the world as well as in history. His art collection included painting, calligraphy, bronzes, jades, ceramics, and a wide range of other objects, old and new. In addition, he commissioned a remarkable project, the cataloguing of his collections, and almost achieved scientific accuracy in doing so. The best works of each category were carefully recorded in detail, and objects were often illustrated by highly realistic pictures. *Gems of Porcelain* (Jingtao yungu), for example, records both the "Five Great Wares of Song" and porcelain of the Ming period in the imperial collection.[4] Each object was accurately measured and was then pictorially represented in colors that matched the glaze and meticulous details of surface decoration; they appear almost to be photographs. He showed the same ardent passion in his collection of antique ceramics as in his order of new creations to be generated at the Imperial Ware Factory, often through the overworked Tang Ying.

Qianlong also poured his knowledge and deep appreciation of art into verse—an abundance of poems extolling their enlightening beauty and virtue: he wrote about 200 for ceramics alone.[5] This enthusiastic emperor was never content with one poem for a favorite object. Instead he often composed new ones again and again whenever he saw it and felt inspired. For a Ding porcelain headrest in the form of a recumbent boy, Qianlong wrote at least eight poems; sometimes he even had his poems inscribed on the objects.[6]

Like his father Yongzheng, Qianlong's love for antiques resulted in imitations being made at the Imperial Ware Factory—inevitably, copies of the "Five Great Wares of Song" and revered ancient objects of other materials, such as bronze vessels and lacquerworks. It is in the creative imitation of other materials in porcelain that Qianlong demonstrated his sense of novelty to the best effect. The covered box in Seattle's collection is but one example (pl. 15.1). It cannot be identified with a particular model among ancient bronze vessel forms, but the realistically imitated bronze patina in turquoise blue, the rectilinear spirals typical of bronzes of the Shang period (16th–11th century B.C.), and the sharp profile of the object unmistakably affirm its inspiration from ancient bronzes. A strong flavor of ornamentation, characteristic of Qianlong porcelains, is evoked in the orderly layout of the surface patterns, the ornate knob, and the gilding that accentuates the patterns and divides the surface into layered registers.

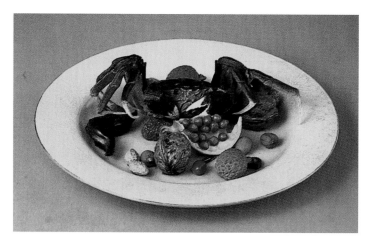

FIG. 1. Plate with sculptural elements, Qing dynasty, Qianlong reign mark and period (1736–1795). Beijing, Palace Museum.

Another freewheeling example took a familiar bottle form but was rendered in a three-lobed shape unnatural to thrown ceramic forms (pl. 15.2). The dark brownish-green color of its glaze imitated the unique appearance of ancient bronze vessels treated by wax polishing, the vogue of the time, but the vase was further embellished with modeled peach spray with *lingzhi* fungus, a three-dimensional version of the popular *famille rose* picture on porcelain.

Qianlong's fondness for porcelain wares that imitated other works of art was also expressed in faithful copies. Two pieces in the Seattle collection show a remarkable likeness to lacquerware (pls. 15.3, 15.4). The saucer not only realistically reproduces the front of a red lacquer prototype, it also copies the black lacquer usually reserved for the base. The covered bowl (pl. 15.4), on the other hand, was painstakingly carved with geometric patterns in imitation of a renowned lacquer technique, *tihong,* or carved red. For these kinds of novelties, Qianlong surely knew how to push the limit, to say nothing of driving the potters crazy. As a result, artificial objects as well as natural things such as stones, nuts, and small animals like shellfish were all rendered with uncanny verisimilitude. While some were painted only on the surface to replicate the texture, others were three-dimensional sculptures that reproduce in exact natural form both fruits and animals. One such tour de force is a plate containing an assortment of nuts and fruits, including a walnut, a pomegranate, and even a crab, all rendered so realistically in overglaze enamel as to fool the eye (fig. 1). The symbolic significance of its various three-

PL. 15.2

Vase

Chinese, Qing dynasty, Qianlong reign mark and
period (1736–1795)
Jingdezhen ware, porcelain with brownish-green
glaze and modeled decoration in overglaze enamels
H. 8¼ in. (20.1 cm)
Eugene Fuller Memorial Collection, 38.10

Five peaches and five *lingzhi* fungi circle the
neck of the vase. The motifs were symbols for
longevity; certain numerals, including 5 and 9,
were regarded as auspicious and betokened
abundance.

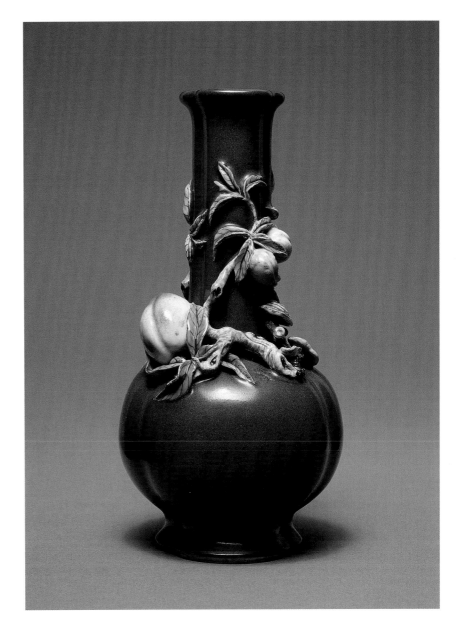

dimensional motifs is both intriguing and delightful. The
date, peanut, and melon seed, for example, form a pun for
zaosheng guizi: produce a son in no time. Floral decorations
on the wide rim of the plate are painted in white enamel
(*bianco sopra bianco,* see pl. 16.4), which was one of the basic
elements in the *famille rose* palette, an overglaze color scheme
introduced from Europe.

The potter's skill and ability were deployed at their fullest
in such objects. The plate was very likely presented to His
Majesty by Tang Ying, for it dates from his tenure at the
Imperial Ware Factory, and Tang Ying is known for the best
porcelain wares in organic forms that were produced under
his supervision. No doubt the plate must have been warmly
appreciated by the emperor for its marvelous novelty. He
would also have welcomed the auspicious meanings of the
creatures, both singly and in combination.

Qianlong was also keen on the functionality of his art.
His love for the *guaping* (hanging vase) is a good example.
The small hanging vase, with its flat back, was designed to
be hung on a sedan chair or the wall of a room. Qianlong
was so pleased with this form that he proudly compared it to
the great Song wares in one of his many poems for hanging

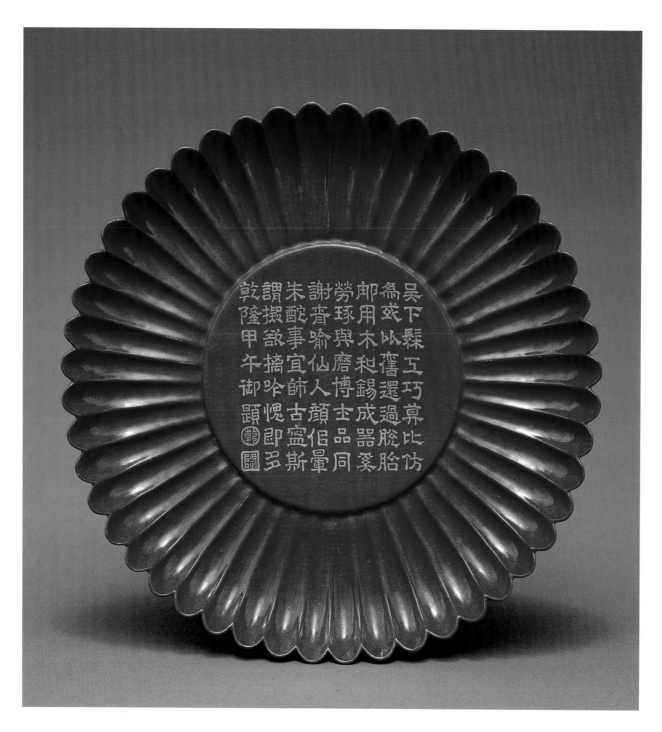

PL. 15.3

Saucer

Chinese, Qing dynasty, Qianlong reign mark and period (1736–1795)
Jingdezhen ware, porcelain with iron-red glaze and inscription in gold
Diam. 6¾ in. (17.1 cm)
Eugene Fuller Memorial Collection, 35.222

The fluted form evokes a chrysanthemum flower. It is fully covered with a smooth, unctuous, dark coral-red glaze, which imparts a strong sense of the thick layer of lacquer. The poem inscribed in the well was composed by Qianlong in praise of the superb workmanship of lacquerwares made in the Wu region, in today's Jiangsu province.

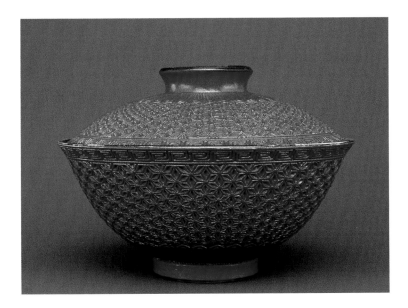

PL. 15.4
Covered bowl
Chinese, Qing dynasty, Qianlong reign mark and period (1736–1795)
Jingdezhen ware, porcelain with iron-red glaze and carved decoration
Diam. 4¼ in. (10.8 cm)
Eugene Fuller Memorial Collection, 53.41.1

vase.[7] He praised a newly made hanging vase whose superb
quality inspired him to compose that poem; it held flowers
found along the way, creating a warm and gentle atmosphere
in his sedan chair. Though the hanging vase existed before
his time, Qianlong characteristically sought novelty in this
peculiar object. His hanging vase orders to Tang Ying de-
manded a broad variety with a good many shapes, glaze col-
ors, and decorative motifs including his own poems, literally
turning this small vessel type into a richly varied form.[8]

Qianlong attached great importance to surface decora-
tion. Here, his pursuit of novelty was best illustrated in ex-
otic Western images, such as wholesome European women,
as seen, for example, on a snuff bottle in the Seattle collec-
tion (pl. 15.5). Qianlong's taste for European subjects or
European-influenced design was nurtured during his child-
hood by his grandfather, the Kangxi emperor, during whose
reign (1662–1722) many European objects started to arrive
in the Chinese court as gifts presented by Jesuit missionaries.
Kangxi had taken a hearty liking to European enamels, and

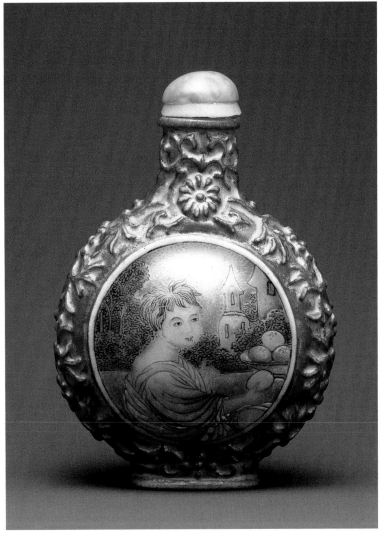

PL. 15.5
Snuff bottle
Chinese, Qing dynasty, Qianlong reign mark and period (1736–1795)
Jingdezhen ware, porcelain with molded and enameled decoration
H. 2⅝ in. (6.7 cm)
Gift of Eugene Sung, 98.49.324

The raised roundels on both sides suggest that the design may
derive from European enameled watches, favored gifts pre-
sented by the Jesuit missionaries. Porcelain snuff bottles were
among the orders Qianlong sent to Jingdezhen. Judging from its
subject and skilled painting, it is very likely that while this bottle
was made at Jingdezhen, the painting was added at the imperial
enameling workshop inside the palace.

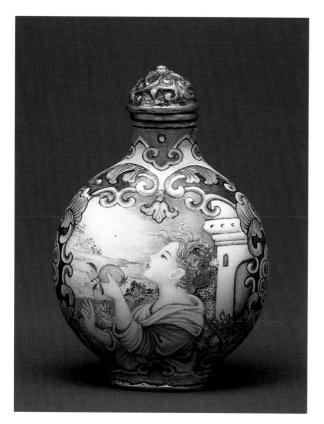

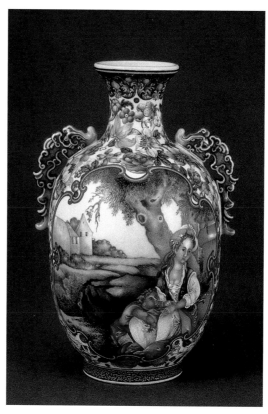

FIG. 2. Snuff bottle, copper with enamels, Qing dynasty, Qianlong reign mark and period (1736–1795). Eugene Fuller Memorial Collection, 33.117.

FIG. 3. Vase, porcelain with enamels, Qing dynasty, Qianlong reign mark and period (1736–1795). Taipei, National Palace Museum.

in around 1711, the enameling workshop in the palace began to decorate porcelain wares in overglaze enamels with designs reflecting European influences, and in European color schemes using colloidal-gold pink and arsenic white. The subject was, however, always Chinese.

Now Qianlong decided to adopt completely European-style paintings and subjects, changing the repertoire of imperial porcelain as well as other media, including copper wares (fig. 2), paintings, and even architecture. European women or a mother and child in a European landscape were the most favored motifs; they were often enclosed in panels with elaborate curved or scrolled borders (fig. 3). Such porcelain designs, together with their soft palette, impart an intimate and ornate feeling reminiscent of the rococo spirit that prevailed in Europe at the time. The rococo flavor is also clear in the so-called hundred-flower (*baihuadui* or millefleur) motif, seen in the background of the Taipei vase and, in

terms of motif and color palette, on a brush pot in the Seattle collection (pl. 15.6). The culmination of Qianlong's enthusiasm for European taste was undoubtedly embodied in the grandiose European buildings he ordered to be constructed in Yuanmingyuan, the imperial summer palace, where he ruled during most of his reign.[9] Some of them bear huge carved curves and shell ornaments typical of the rococo style (fig. 4). They were indeed a grand advertisement for novelty.

—J.C.

Brush pot

Chinese, Qing dynasty, Qianlong reign mark (late 19th century)
Jingdezhen ware, porcelain painted in overglaze enamels
H. 4⅝ in. (11.7 cm)
Eugene Fuller Memorial Collection, 39.6

This pot with straight wall was formed in the shape of
an open book rolled back into a cylinder, a clever design
appropriate for the function of the pot. The hundred-
flower motif originated in the Qianlong period. It was
appreciated for both its luxurious effect and its auspicious
connotation, implying that the great Qing empire would
last forever, just as the flowers would continue to bloom.
Though richly painted, the decoration of this brush pot
is of lesser quality and extravagance than that seen on
genuine Qianlong pieces. It is likely a copy made in the
late nineteenth century.

FIG. 4. Yuanmingyuan, the summer palace. Beijing.

16

MADE TO ORDER: CHINESE PORCELAIN FOR EUROPE

———————— ❖❖❖ ————————

The queen brought in the custom or humor, as I may call it, of furnishing houses with china-ware, which increased to a strange degree afterwards, piling their china upon the tops of cabinets, scrutores, and every chimney-piece, to the tops of the ceilings, and even setting up shelves for their china-ware, where they wanted such places.

—Daniel Defoe, *A Tour through England and Wales* (c. 1724)

Defoe's slightly amused comments on the porcelain furnishings of England's great houses vividly visualize the conspicuous status and usage of Chinese porcelains in Europe from around the turn of the eighteenth century.[1] Royal and fashionable collectibles, they were used for both interior decor and as practical utensils. The fashion that Queen Mary (r. 1689–1694) brought to England from the Continent on her accession to the English throne helped increase the total of Chinese pieces traded to Europe in the eighteenth century to at least 60 million. Among them, porcelains designed to particular tastes, needs, and customs lent their owners prestige as well as convenience.

The idea of having Chinese porcelains made for customers' tastes must have developed as soon as the porcelain trade settled into a stable business. For Europe, customizing first emerged as specific signs or decorative patterns added to already-made wares; next came the making of objects according to custom designs in both shape and decoration. In form and/or decoration, such Chinese porcelains bear distinct features clearly different from wares used by the Chinese. As they were intended and made only for the export market, they are known as Chinese export porcelain, or Chinese trade porcelain.

The earliest still-extant Chinese export porcelain with European signs is a group of ten or so blue-and-white wares made in around 1519 for the Portuguese market. Three signs are painted on already-made objects of Chinese form: the royal Portuguese arms (always painted upside down), an armillary sphere (the personal device of Portugal's King Manoel I; r. 1495–1521), and the sacred monogram, IHS, of the Society of Jesus.[2] The models for these signs may have been conveniently provided to the Chinese potters through maps, title pages, or ornamental bindings of prayer books, which the Portuguese would have taken with them while traveling. These blue-and-white porcelain wares, whether made for royalty or for the general Portuguese market, bear witness to the first European order for Chinese porcelain.

The specially ordered porcelain wares that the Portuguese acquired were exceptional for the time. Although the Portuguese were pioneers in establishing commercial relations with China and consequently played a principal role in sixteenth-century trade, they were more interested in trading porcelain within East and Southeast Asian countries than between Asia and Europe. A century later, the Dutch, rather than the Portuguese, recognized the great potential of porcelain trade in Europe and started exploiting the market with the large-scale importation of Chinese porcelains, a shrewd business decision spurred directly by their successful sales in 1602 and 1604 of Chinese porcelain wares from two captured Portuguese ships (see chap. 9). Less than fifty years after the formation of the Dutch East India Company in 1602, the Dutch had already shipped more than 3 million porcelain pieces to Europe. They achieved this

PL. 16.1

Plate

Chinese, Ming dynasty, c. 1625–50
Export ware, Kraak type, porcelain with underglaze-
blue decoration
Diam. 14¼ in. (36.2 cm)
Gift of Mr. and Mrs. Ford Q. Elvidge, 75.51

The shape of this plate was very likely modeled after a wide-rimmed Dutch wooden dinner plate. The decoration of tulip buds and radiating panels circling around a central medallion with stylized flowers also indicates Dutch influence and destination. In the central medallion, a Chinese gentleman is seated on a cushion before a large screen, but humorously, he appears to be floating. The figural designs in the four panels on the vessel wall represent the four noble pursuits: (clockwise) a farmer holding a hoe on his shoulder, a scholar sitting in meditation, a woodcutter carrying a bundle of firewood, and a fisherman with his rod and a fish. Together they represent the theme of eremitism, a cherished ideal lifestyle among Chinese scholar-officials. Such motifs became typical images of Chinese in Chinese export porcelain and popular prototypes for many European imitations.

success largely by stimulating the growing market with new Chinese products designed to cater to Europeans' lifestyles, instead of merely supplying whatever they could get from China.[3]

As early as 1635, wooden models in more than a dozen forms—large dishes, beakers, and wide-rimmed dinner plates—were sent to Jingdezhen, along with detailed instructions for their execution.[4] At that time, the decoration remained basically Chinese, but it was clearly preferable to incorporate European elements, like the stylized flowers seen on the Seattle plate (pl. 16.1). The tulip pattern seemed to be most desirable, and hence served as a national emblem for wares sent to or related to the Dutch market (pls. 16.1, 16.2). Once such a new form or decoration was introduced to the Chinese potter, it would become part of his own repertoire, and he could freely apply them or offer them as samples to other potential European customers. It was especially so in the eighteenth century, when direct trade with China ex-

panded to involve more European countries, among them England, France, and Sweden. In accordance with varied orders, new designs proliferated, opening possibilities for stylistic exchanges in form and decoration, not only between China and the importing countries, but also among the European countries themselves.

As a result, it is often impossible to isolate a single model source for Chinese export porcelain ware.[5] Plate 16.2, for example, is thinly formed with a molded tulip pattern on the wall reminiscent of metalwork, possibly Dutch silver or pewter. The palette of red and gold is Japanese Kakiemon-inspired, while the landscape scene is more of a European chinoiserie design but painted, together with bird-and-flower motifs, in a Chinese style of the Kangxi period. Cross-influence in style resulted in fascinating products, but today sometimes also confuses modern historians: it is not easy to ascertain the original destination or intended market for these hybrid wares.

PL. 16.2

Plate

Chinese, Qing dynasty, c. 1700–1750
Export ware, porcelain with molded and overglaze decoration
in iron red and gold
Diam. 9 in. (22.9 cm)
Gift of Mrs. Pauline Dehaart Adams in memory of her father,
Ir. Pieter de Haart, 75.1.1

The quasi-Chinese boat and the clearly Dutch drawbridge in
the central medallion suggest that the picture may have been a
Dutch design that combined Chinese landscape elements and a
Dutch bridge. The model was likely an engraving, as indicated
by the short horizontal and slanting hatched lines in the water
and hill areas. A similar plate dating from the same period,
without a drawbridge but whose colors also include black, is
published in Sheurleer 1974, plate 319.

One exception was armorial porcelain—wares decorated with coats of arms (pl. 16.3). The shapes of the Seattle tea set were clearly designed to suit the European custom of tea drinking, with its obvious differences from tea-taking customs in China. But the shapes themselves may still have been generic in the European context; it was the armorial bearing of two specific coats of arms joined together that indicates the set was made for a particular customer, in this case, an English royal couple, to commemorate their marriage. Such heraldry, when genuine, enables us to single out the original owner of an object as well as its probable date. The armorial porcelain wares thus provide important evidence for mapping out a general history of Chinese export porcelains.

Armorial porcelain wares became popular in Europe in the eighteenth century. Engraved bookplates, drawings of armorial bearings, or monograms were the usual models sent to Jingdezhen or to Canton (today's Guangzhou), the designated trade center of the Qing period, where numerous enameling workshops were open for business. The Canton workshops were able to fill special orders for armorial bearings or other designs within the two- to three-month trading

PL. 16.3

Armorial teapot, tea bowl, saucer, and milk jug

Chinese, Qing dynasty, c. 1744
Export ware, porcelain with overglaze enamels and gold
from left:
Teapot: h. including lid 5½ in. (14 cm)
Tea bowl: diam. 1½ in. (3.8 cm)
Saucer: diam. 4¾ in. (12.1 cm)
Milk jug: h. 3½ in. (8.9 cm)
Gift of Mr. and Mrs. Henry C. Isaacson, 76.115.1a–b; 76.115.2; 76.115.5a; 76.115.6b

These pieces are part of a tea set made in 1744 as a wedding gift for Lady Charlotte Beauclerk on her marriage to John Drummond. Charlotte was the daughter of Charles, Duke of Saint Albans and son of King Charles II and Nell Gwyn. The whole arms were those of Drummond and Beauclerk impaled. The Beauclerk arms, on the right of the shield, are identical to the arms of the Stuart king Charles II, with the addition of a short diagonal bar, the baton sinister, running from the upper right to the lower left corner. It indicates that the bearer of these arms was of royal but illegitimate birth.

season, so that custom-made wares could be ready in time for the return trip. If the order was to be completed in Jingdezhen, 500 miles north of Canton, at least two years were needed to ship a specially ordered service back to Europe, due to the seasonal monsoons. However, the advantage of placing an order with Jingdezhen was that only Jingdezhen was capable of producing such specially designed shapes. It also supplied plain porcelain wares for the Canton enameling workshops and was thus in control of the quality of wares. Judging from extant armorial wares, it seems that Chinese enamelers in both Canton and Jingdezhen were largely capable of copying designs with high accuracy, particularly when considering that those designs were totally beyond their experience in both form and meaning.

The English were especially fond of armorial porcelain; statistics have shown that armorial services destined for England accounted for almost half the total of such services sent to the European market. Even so, these armorial porcelain wares represent less than 1 percent of general unspecified export porcelains sent to that country (see pl. 16.4). On average, one service consisted of about 200 pieces, and there are so far 3000 recorded English armorial services. The enormous quantity is a powerful argument for the dominant status that the English enjoyed in the porcelain trade during the eighteenth century, as the Dutch had done a century earlier.

By the mid-eighteenth century, European-influenced forms and decoration were well established in Chinese export porcelains. In the meantime, the Chinese potters had become thoroughly familiar with those strange motifs, and were apparently trusted by their customers to generate creative designs in addition to simply copying a model. Assembling a picture from different images was a familiar if not widespread practice with export porcelain wares. A tea bowl and saucer in the Seattle collection provide a good example (pl. 16.5). Its decorative scheme is curious: while the iconography is clearly European, the composition differs from normal European conventions of the time. Perhaps the Chinese potter, being well versed in producing porcelain for the European market, was taking a liberty in designing this composite image.

The picture was evidently based on European engravings, as attested by a cluster of fine, dense, horizontal hatched lines painted on the rock on which a nude sits, at the upper part of the saucer. The full coverage of this plate and its lack of

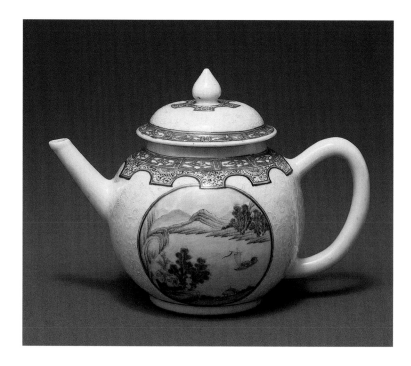

PL. 16.4

Teapot

Chinese, Qing dynasty, c. 1760
Export ware, porcelain with white slip decoration, overglaze enamels, and gold
H. 4¾ in. (12 cm)
Gift of Martha and Henry Isaacson, 76.109.ab

The background of this teapot is covered with floral scrolls painted in white enamel, the same pigment used in the *famille rose* palette dominant at that time. The decorative technique, known as *bianco sopra bianco* (white on white), was first used in Italian maiolica of the sixteenth century. It then disappeared in Europe but reemerged in the eighteenth century. In China, the white enamel arrived as part of the *famille rose* palette in the early eighteenth century, but the *bianco sopra bianco* may have been rediscovered independently there, given its two-hundred-year absence in Europe. The decorative style, in particular, was Chinese and was reintroduced into Europe.[6]

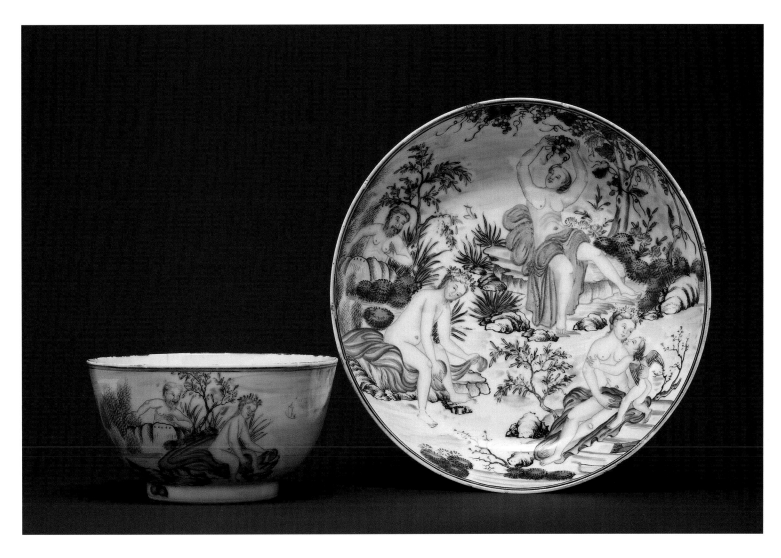

PL. 16.5

Tea bowl and saucer

Chinese, Qing dynasty, late 18th century
Export ware, porcelain painted with overglaze enamels and gold
Tea bowl: h. 2 in. (5.1 cm)
Saucer: diam. 5½ in. (14 cm)
Gift of Mrs. Frank Molitor in honor of the museum's 50th year,
84.66.a–b

The theme of love is illustrated by a figure who is apparently
Venus. She appears (from lower right) with Cupid, representing
love; at her bath, which symbolizes charity; and also reclining
and picking grapes, which symbolizes fertility. An old man is
depicted as an amazed onlooker beholding Venus becoming a
virgin again after she has bathed in the sea.

any decorative border pattern is also reminiscent of Italian *istoriato* maiolica plates, which often treated the entire surface as a canvas. Multiple independent images juxtaposed in one picture sometimes appeared in maiolica painted decoration, but the elements were nonetheless composed in the European convention, so as to provide a single unified picture. The painting on this saucer appears, on the contrary, to be composed of three juxtaposed and self-contained units with no strong structural coherence. Very likely the Chinese potter had selected three elements from larger compositions and rearranged them to decorate this saucer; it was clearly a re-creation of European originals. The picture is nevertheless coherent, with a striking sense of narrative depiction, and strongly suggests it relates to elements of a story about Venus. At any rate, such Western mythological or religious scenes, and scenes from European literary sources, were the main decorative subjects used on Chinese export porcelains in the second quarter of the eighteenth century; they are found mostly on tea or coffee services and plates.

Chinoiserie-inspired subjects designed by European artists, such as the one appearing on Seattle's small saucer, were also fashionable throughout the century (pl. 16.6). Earlier pieces with chinoiserie subjects are exemplified by designs attributed to Cornelis Pronk (1691–1759) or his studio. His figural designs were characterized by fantastic Oriental scenes featuring Oriental-looking or costumed figures. One of them was the well-known Parasol design, with an Oriental lady and her attendant holding a long-handled parasol and standing at a riverbank with several waterbirds.[7] A Dutch painter and designer, Pronk had been hired by the Dutch East India Company in 1734 to make designs and models for all the Dutch-ordered porcelains from China, and from Japan after 1750. The venture soon failed, largely because the Dutch thought the price demanded by Japanese merchants was too high to be profitable. In any event, designs taken from popular European engravings proved to be cheaper, easier to appropriate, and more marketable.[8]

Among the popular engravings, genre scenes were distinguished for their captivating depictions of daily life, such as the prime English field sport of foxhunting, seen on this punch bowl (pl. 16.7). Two panoramic views of the sport are brilliantly painted in two large cartouches, a faithful Chinese copy of a European design. Not only were the highlights, the

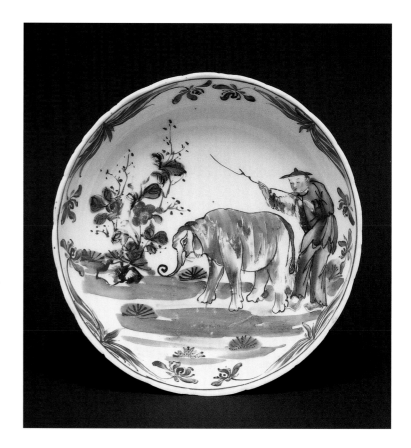

PL. 16.6

Saucer

Chinese, Qing dynasty, late 18th century
Export ware, porcelain with overglaze polychrome decoration
Diam. 4¾ in. (12.1 cm)
Gift of Mrs. Charles E. Stuart, 79.116.3

The motif of a man herding an elephant may have derived from the subject Eight Barbarians Presenting Tributes (*baman jinbao*), featuring foreign figures, exotic objects, and beasts such as the white elephant. Interestingly, the use of this motif in its variations on Chinese export porcelains seems to have been limited to the beginning and the end of the eighteenth century. Those decorating the early eighteenth-century pieces were more clearly influenced by the Eight Barbarians theme.[9] On this piece, replacing the foreigner with a Chinese farmer was apparently done to emphasize the Oriental flavor. The elephant echoed Europe's interest in India, raising the possibility that it was made for the Anglo-Colonial market.[10]

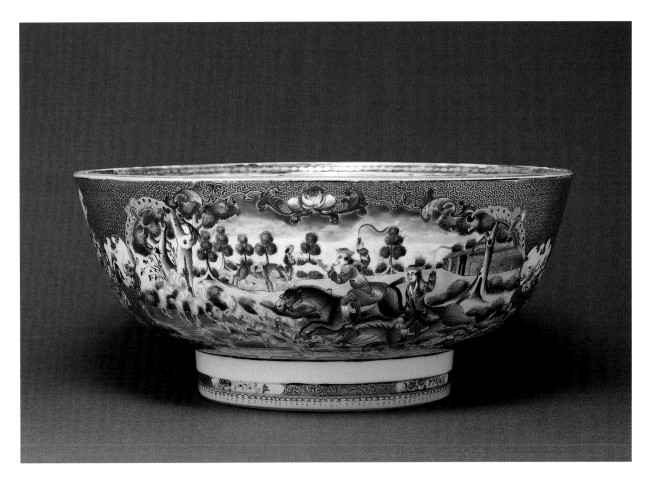

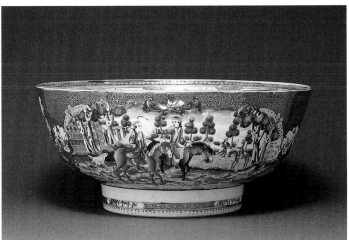

Reverse, showing the meet scene, PL. 16.7

PL. 16.7

Punch bowl

Chinese, Qing dynasty, c. 1780
Export ware, porcelain painted in overglaze enamels and gold
Diam. 11¼ in. (28.6 cm)
Gift of Mr. and Mrs. Herbert Brink, 86.280

The exterior wall of the bowl is decorated with a meet and a foxhunting scene, each framed in a large cartouche. In England, home of the sport, a day's hunt begins with a meet. The scene here depicts the master, his huntsman, and a pack of gray-colored hounds in the foreground; in the background, two figures represent guests. Then the search for the fox begins. Its finding is signaled by the cry of the hounds, the sounding of the master's long copper horn, and the followers' excited shouts, all depicted in the hunting scene. In choosing these two most important moments of the sport, the artist succinctly summarizes its basic process.

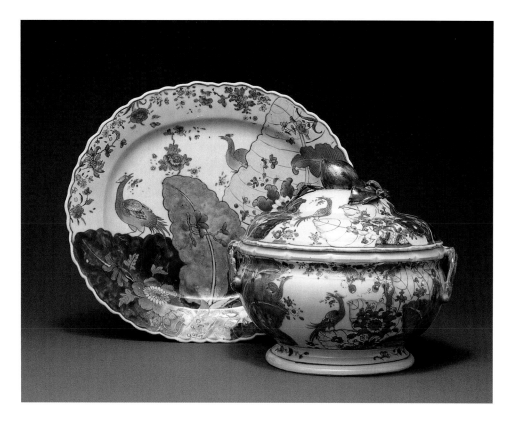

PL. 16.8

Covered tureen and stand

Chinese, Qing dynasty, late 18th century
Export ware, porcelain with underglaze blue and
overglaze enamels
Stand: w. 15 in. (38.1 cm)
Tureen: h. including lid 9¾ in. (24.5 cm)
Gift of the McCone Foundation, 92.4

Tureens as well as sauceboats have been indis-
pensable parts of a complete dinner service
since the eighteenth century. The size and num-
ber of tureens vary in each service, as does the
form. The most striking tureen forms are those
modeled on animals, such as goose or ox-head
tureens, all painted with persuasive colors and
formal features.

meet and the hunt, well represented, so were the colors of
the hunters' attire and equipment—for example, the bright
purplish-red coat and the black velvet cap, the usual fox-
hunting uniform reserved for the master.

Two other small cartouches were decorated with original
Chinese scenes showing boys and women at play in a Chi-
nese garden. One is particularly humorous, showing a boy
riding on a woman's shoulders, as if scared of the approach-
ing hounds. The well of the bowl is also decorated with a
hunting scene, but pheasants replace the fox as prey. One
pheasant is seen on the tree, while the other hides its head in
the low bushes. Such genre subjects never fail to convey the
joy and charming qualities of daily life. The elaborate border
and background patterns and the gilding further enhance
the splendor of the overall decoration.

The large form of the punch bowl provided an ideal for-
mat for depicting panoramic views. Many hunting scenes
and harbor scenes, like the well-known *hong* bowls, which
feature foreign trading offices, or *hong,* at the port of Can-
ton, were often painted in a continuous manner, wrapping
around a punch bowl so that the grandiose scope could be
brought out to best visual effect. Other depictions of favorite

pastimes were scenes featuring a seated European lady work-
ing on embroidery and scenes of courtship, showing a Eu-
ropean couple in varied courteous gestures. Genre scenes
proved popular for daily utensils such as tea and dinner
services.

The usual European dinner service included at least one
tureen, one sauceboat, and plates and dishes of several sizes,
all matching in form and decoration. The idea of having a
complete dinner service emerged around 1700, when better
table manners were advocated and came into vogue in Euro-
pean society.[11] Guests were seated at a well-ordered table,
and each had his or her own place setting, which has since
become a common Western custom. The exact sizes and va-
rieties of early dinner services are unknown, but it was not
unusual to find that a complete service of the early eigh-
teenth century could amount to 500 pieces. A tureen in the
Seattle collection (pl. 16.8), originally belonging to one such
dinner service, is decorated with a broad-leaf pattern widely
known as the tobacco-leaf design, a popular flower pattern
on Chinese export porcelain of the late eighteenth century.
An abiding theme in Chinese porcelain decoration as well as
in other media, flower patterns evolved through myriad

PL. 16.9

Dish

Chinese, Qing dynasty, c. 1795
Export ware, porcelain with overglaze enamels
Diam. 9¾ in. (24.8 cm)
Gift of Mrs. Prentice Bloedel,
84.164.2.a

The design in the central medallion, an urn and a willow tree, contains four secret profiles. King Louis XVI and Queen Marie Antoinette are outlined by the urn's stem on either side, and the profiles of the Dauphin and Madame Royale appear in the flanking willow branches above them. Similar designs combined with different borders are known on dinner services of this kind.

The design derives from a French print produced as a memorial to Louis XVI and his family, who were executed during the French Revolution.[12]

variations in form and palette, embodying changes in period, style, and individual taste; they thus provide important criteria for distinguishing the date or intended market of a given piece.

At the turn of the nineteenth century, artistic taste in Europe changed from the lighthearted rococo style to the sober neoclassical style. It, too, had its due expression on Chinese export porcelain, seen in the design on the Seattle plate (pl. 16.9). The simple border patterns, the symmetrical and centralized layout of the urn and other forms, as well as the cool colors are all expressive of neoclassical formal convention and successfully impart a sense of gravity and melancholy. Undoubtedly such services were cherished by French royalists and used to commemorate the death of their king. Political subjects are found throughout the century in the

decoration of Chinese export porcelain, but only in limited quantities because of the obvious danger of political persecution. The same was true for some sensitive historical subjects. Political subjects of a serious nature were also sometimes rendered in caricature, just as in a modern newspaper.

Also at the turn of the century, the business of making porcelain to European custom orders began to decline significantly. For the next fifty years or so, the Chinese potters turned their attention to the newly founded United States of America, and continued catering to this fast-growing market with made-to-order porcelains shaped and decorated with distinctive designs of particular interest to Americans.

—J.C.

17

THE NEOCLASSICAL TRANSFORMATION

———— ·:❧:· ————

The final story of eighteenth-century European porcelain is irrevocably caught up in reverberations of an ancient past and the heralding of an industrialized future. From the sculptural influences of Praxiteles (Athens, active c. 370–330 B.C.) to the innovative experiments by the English potter Josiah Wedgwood (1730–1795), it weaves together the art of ancient Greece and Rome, the end of the Enlightenment, and revolution both political and mechanical.

The ancient city of Herculaneum, buried along with Pompeii when Mount Vesuvius erupted in A.D. 79, was first excavated by accident. In 1709, during the occupation of Naples, an Austrian cavalry officer unearthed marble statues on the site, causing a stir in Europe. Three of the sculptures (Roman copies of female figures from the school of Praxiteles) were smuggled out of Naples and given to Prince Eugene of Savoy. Upon the prince's death in 1736, they became a sensational acquisition for Augustus III of Saxony, who added them to the museum of antiquities founded by his father, Augustus the Strong, the great patron of the Meissen factory in Germany.[1]

Called the "Vestal Virgins," these figures were extremely popular at the Dresden court and were much admired by Augustus's granddaughter, Maria Amalia Christina. In 1738, Maria Amalia left Saxony to marry Charles, King of Naples and the Two Sicilies (see chap. 11). That same year, Charles determined to open a museum of antiquities. He became the first to promote a planned and somewhat organized excavation of Herculaneum. In the mid 1740s, Charles and his Saxon queen were filling the palace at Portici with porcelain from their Capodimonte factory as well as with works of art from Herculaneum. The first excavations at neighboring Pompeii began in 1748. As European noblemen from England to Russia vied for excavated treasures, a renewed interest in the art of ancient Greece and Rome percolated through society.

JOHANN WINCKELMANN AND THE TRUE STYLE

Enter Johann Joachim Winckelmann (1717–1768), certainly one of the most important and most fascinating fomenters of the coming revolution in European arts and culture. He arrived in Dresden in 1754 intending to teach Greek, a notion that he soon abandoned. He was already embroiled in the art world and court life of Dresden when, in 1755, he published *Reflections on the Painting and Sculpture of the Greeks.* This work was the first to distinguish between Greek and Roman contributions to the classical tradition; it became a historical underpinning for what was called the "true style" that captivated Europe during the last quarter of the eighteenth century. Neoclassicism is the mid-nineteenth-century name given to the true style in art. In 1755, Winckelmann was awarded a stipend by Augustus III to study art in Rome and to report back to Dresden concerning the discoveries made at Herculaneum.

Mid-eighteenth-century Paris and Rome were the incubators for neoclassicism. From the 1660s, the French had supported academic study in the classical manner both at the French Academy in Rome, "to cultivate good taste and the manner of the ancients," and at the Academy of Architecture in Paris.[2] Artists were expected to study some years in Rome. France during the 1760s also experienced a renewed interest in the grand period of Louis XIV. It was not the more florid, early baroque years that were lauded, but the severe classical style based on symmetry and geometric ornamentation fashionable toward the end of Louis's reign (1643–1715), the last decades of the seventeenth century and the beginning of the eighteenth.

Rome, the center in Italy for those who wanted to study the ancient world, became the gathering place for artists and young scions of wealthy families who believed that a Grand Tour of Europe, culminating with studies in Rome, was the

crowning touch to a son's education. Winckelmann settled in Rome in 1755 and served in various posts, including Commissioner of Antiquities from 1764 to 1768. His interpretive writings encouraged the study of Greek civilization as a whole, not only its sublime architecture and sculpture, but also its moral culture. The enthusiasm for antiquity was rather like the earlier passion for what the philosophes had imagined to be a perfect Chinese society.

The increased interest in antiquities and classical style fostered by excavations and travel coincided with the culminating period of the Enlightenment, a time of great scientific inquiry, renewed interest in nature, faith in human reason, and the glorification of the individual. Since the mid 1750s, critical and theoretical writings of the Enlightenment had developed a more moralizing tone. An intellectual reaction against what was viewed as the frivolous and cynical life of the European courts and society began to build. In the arts, this path led to a rejection of the rococo.

Theorists, art critics, and artists voiced their rejection of the rococo style as being too flippant and undisciplined. The French designer Nicolas Cochin addressed two articles in the winter of 1754–55 to issues of the decorative arts, in which he stated his hope that their "inventiveness" would soon exhaust itself. The proponents of a harmonious, more restrained style looked to classical antiquity for models. They formulated principles for the true style. Winckelmann supplied a source for achieving this lofty goal: "For us, the only way to become great and, if possible, inimitable is by imitation of the ancients."[3] He did not advocate wholesale copying, but rather a distillation of the best the classical world had to offer.

The new movement, conceived as being based on time-honored truths, was to be a style for Everyman and for all time. Classical elements, such as columns and pediments in architecture, acanthus-leaf ornamentation, and heroic mythological themes, to name only a few, had persisted through time and were already part of Western vernacular. But now a new direction toward classicism in the arts, which also embraced classical virtues, was tied to social change. A more diverse society, built primarily on the profits of trade, developed an increasingly vocal bourgeoisie base that advocated the rights of man, humane compassion, moral restraint above corrupt frivolity, and democracy above despotic rule. In Europe, the last quarter of the eighteenth century was a time of revolt in art, government, and industry.

As a leading proponent of the neoclassical style, Winckelmann believed that serene expression in a work of art reflected a serene soul; experiencing Greek art would awaken beauty and nobility in the individual.[4] Just at the time that canons based on the glory of ancient Greece and Rome were being formulated, disturbing new findings began to emerge from the sites at Pompeii and Herculaneum. The large wall paintings, the most important works uncovered at the digs, were of mediocre quality. This surprising find was explained away by Winckelmann, who suggested that they probably dated from a period of decadence in Rome, the period of Nero's rule, when the historian Pliny recorded degeneration in the arts. And just as the neoclassical critics were casting stones at loose rococo morality and excesses, another breach in the dogma of a pure, uncorrupted classical world occurred. The Herculaneum Academy published a volume illustrating shocking images of phallic lamps and artifacts. Followers of the new canon believed that these ancient cities had clearly been experiencing a rare period of degradation when Vesuvius buried them. Nevertheless, the movement toward classical ideals and reaction against the rococo style remained firm. By the 1770s, artists, architects, and theorists throughout Europe claimed victory over the rococo, even though it survived in pockets in Germany and the north almost to the end of the century.

In the decorative arts, the architect and writer Pierre Patte described the shift in mood from rococo to neoclassical in the fifth volume of his 1777 publication, *Cours d'architecture:*

> Little by little we returned to sager, less eccentric forms, and at last the return of the Antique taste having extended its influence over all our decorative arts, especially during the last fifteen years or so, it can be said that the interior decoration of suites of rooms and the style of their furnishings have become in some sense a new art.

The neoclassical theories of Winckelmann were gaining a foothold in the European porcelain factories by the mid 1760s, when Johann Christian Wilhelm Beyer modeled Seattle's figural groups, Psyche revived by Cupid's kiss and Venus with Adonis (pl. 17.1). Winckelmann was outspoken in his distaste for frivolous porcelain figures in the rococo style but supported the use of antique statues as appropriate models for porcelain figures. That was the stricture followed by his acquaintance, the sculptor Beyer, when he modeled

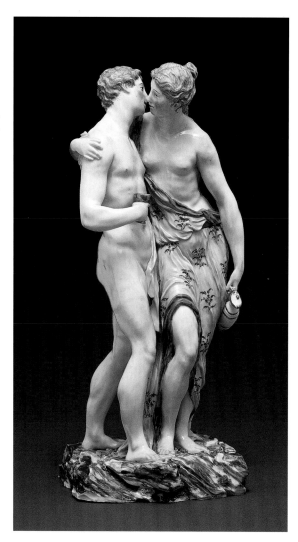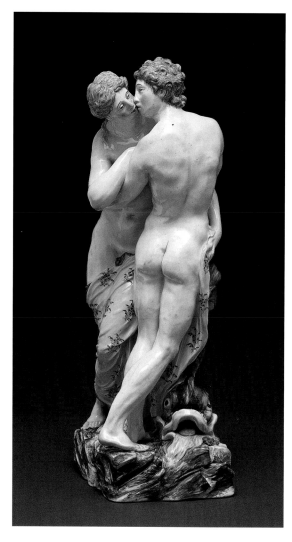

PL. 17.1

these classical figures. Rather than the amoral gods and goddesses of the rococo period, graceful representations of Olympians survived in the arts as depictions of physical beauty.

What were seen as the more lurid creatures of the classical idiom, a languishing Venus at the top of the Meissen clock (see pl. 14.5) or a satyr (see pl. 11.7), popular during the time of rococo, were replaced with subjects that honored domestic virtues. In Seattle's porcelain group, *Le Déjeuner* (Lunch), a mother enjoys bread and chocolate with her children (pl. 17.2). This group, produced in unglazed biscuit porcelain that resembles marble, is part of a set of three. The museum owns another from the set, *La Nourrice,* which

depicts a mother nursing a baby. In the third and central group, *La Toilette,* a young mother sits at her dressing table preparing for her day. Although the subjects of these at-home scenes are privileged, they do represent real people. Rather than energetic modeling of the rococo style, this view presents a frontal, serene, true-style portrayal of the figures.

The quest of the Sèvres factory for a hard-paste porcelain formula and the method for its manufacture was circuitous and eventually reconnected the factory with its former rival, Paul Hannong, who first produced hard-paste porcelain in France. Following Hannong's death in 1760, the factory negotiated with his youngest son, Pierre, to purchase his

PL. 17.1

Psyche and Cupid

Venus and Adonis

German, Ludwigsburg factory, 1765–67

Models by Johann Christian Wilhelm Beyer (1725–1806)

Hard-paste porcelain with enamel colors

Marks: interlaced C's in underglaze blue, enameled marks in red, and various incised numbers and letters

H. both 14 in. (35.6 cm)

Gift of Martha and Henry Isaacson, 76.89–.90

These figures were produced in the porcelain factory at Ludwigsburg under the patronage of Duke Carl Eugen of Württemberg (1728–1793). Johann Christian Wilhelm Beyer, who became the chief modeler at the duke's porcelain factory, had accompanied him on his Grand Tour.

PL. 17.2

Le Déjeuner

French, Sèvres factory, 1775

Model by Josse-François le Riche (active 1757–1806)

Biscuit hard-paste porcelain

Mark: incised 17

H. 8⅜ in. (21.2 cm)

Given in memory of Blanche M. Harnan by the Seattle Ceramic Society and Friends in cooperation with Mr. William H. Lautz, New York, 69.138

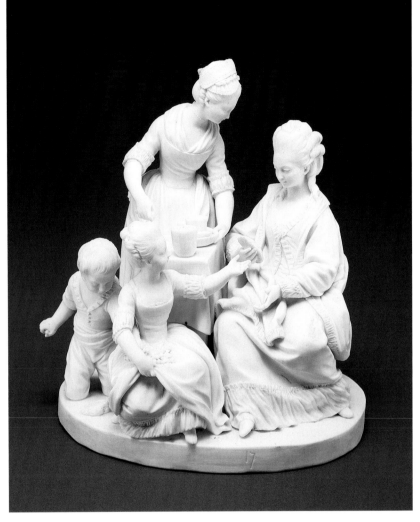

PL. 17.2

father's formula and working method. Pierre Hannong revealed essential procedures, such as how to wash the kaolin from the friable rock and reduce the atmosphere of the kiln at the end of the firing cycle.[5] This intriguing story, which includes echoes of Meissen's early trials involving runaway workers and accusations of attempts to sell the secrets to a foreign power (England this time), finally concluded with the making of hard-paste porcelain (*pâte dure*) at Sèvres in 1769. Within a decade, their wares were competing with the best of the hard-paste manufactories in Europe.

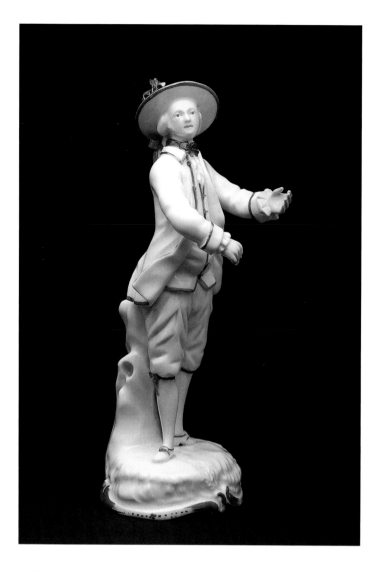

PL. 17.3

Figure of a boy

German, Fulda factory, 1780–88
Hard-paste porcelain with enamel accents and gilding
Mark: monogram FF surmounted by a crown in underglaze blue
H. 5¾ in. (14.6 cm)
Gift of Martha and Henry Isaacson, 76.274

This fine figure shows that elements of rococo lingered, for example, in the scrolled base. Earlier figures of this type had colored costumes. This boy is decorated with sparse gilding and ribbon accents in black and red, typical of the neoclassical simplicity of design and ornamentation. Well-modeled figures and an outstanding white porcelain paste are characteristics of the works produced at the Fulda factory (1764–89), established by the prince-bishop of this small German city.[6]

JOSIAH WEDGWOOD AND A NEW ERA

During the 1780s, when the Fulda cup and saucer (pl. 17.4) were made, radical developments were taking place in the field of European ceramics. A good facsimile of ancient Greek pottery was among the first ware produced by the factory of Josiah Wedgwood (1730–1795). They were decorated with terra-cotta colored figures in imitation of classical wares; he called them "Etruscan ware."

Truly a man of the Enlightenment, Josiah Wedgwood was a master potter, experimenter, and scientist. He was made a Fellow of the prestigious Royal Society of London in 1783. Interested in social reform, he was active in developing good roads, schools, and improved living conditions in the village he established for the potters employed in his factory.

With some justice, we might consider Wedgwood as a man both of and ahead of his time. He affirmed through his care for his employees' welfare Rousseau's belief in humanity's essential worth as well as Diderot's conviction that mankind could achieve progress through applying principles of science. He also brought to the village of potters a quality of benign authority and oversight, in a role not unlike that of his contemporary, the prince-bishop of Fulda.

Wedgwood, inspired by the taste for classicism that motivated him to produce his Etruscan ware, named his village Etruria, in honor of the Italian territory occupied by the ancient Etruscan civilization. Using rectilinear forms instead of rococo curves, and seeking perfect balance and uniformity, Wedgwood produced innovative flawless stonewares. His black basalt wares were dramatically solemn. In firing, they held their rigidly classical forms—double-handled amphorae (used in ancient times to store oil, wine, or pickled foods) and hydria (water vessels). Wedgwood's famous green and blue jasperware, also made in classical shapes, such as tall, stately urns, were developed in the early 1770s. The free hand of rococo modelers was gone; works that graced neoclassical interiors were to have a uniform look of mechanical precision.

With his development of cheaper wares that resembled porcelain, Wedgwood fulfilled another goal of the Enlightenment and neoclassicism, producing wares that were white in color and of good design in the true style, and making them available to a broader range of society. From a creamy-colored earthenware body called 'Queen's ware' (creamware) in honor of Queen Charlotte, wife of George III, who ordered a service of it in 1765, he developed pearlware, a white

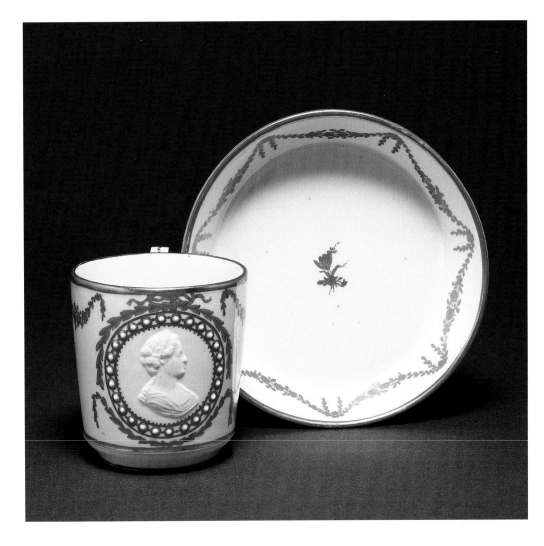

PL. 17.4

Cup and saucer

German, Fulda factory, 1780–88
Hard-paste porcelain with gilding
Mark: monogram FF surmounted
by a crown in underglaze blue
Cup: h. 3 in. (7.6 cm)
Saucer: diam. 5 in. (12.7 cm)
Gift of Martha and Henry Isaacson,
76.268

We end the European stories of porcelain much as we started, with an elegant work of white porcelain. The first such piece is an early Meissen white tea caddy (see pl. 2.2). Its Asian-inspired shape and molded flowering trees and phoenixes represent the earliest influence on European porcelain. This final piece, white porcelain of simple design and ornamented with elegant painted gilt swags and a molded cameo medallion of a woman, defines the classicism that was the last influence on porcelain in the eighteenth century.

ware made from fine ball clay and calcined flint. After 1775, kaolin and porcelain stone from Cornwall were added to it, producing a durable, desirable, and more affordable tableware by the late 1770s. By the time of his death in 1795, some 150 individual factories in Staffordshire alone were making competitive wares.

Porcelain continued to be costly to manufacture.[7] In addition to Wedgwood's innovative cheaper wares, the development of bone china brought about the end of European porcelain production as it had been established in the eighteenth century. By the mid 1790s, Josiah Spode II had developed a product of high quality and durability; it is essentially the same ware that is made today. This new formula added up to 50 percent bone ash to the hard-paste mixture of kaolin and porcelain stone, which meant that exacting neoclassical

forms, such as urns or clean-lined, boat-shaped sauceboats with rigid, Greek-key-shaped handles, could be produced in a material that survived firing with much less wastage than earlier formulas and tolerated changes in temperature without crazing or cracking. As the nineteenth century dawned, with its focus on the availability of less expensive ceramic wares and new mechanization that would revolutionize production, the European Age of Porcelain drew to a close.

—J.E.

FIG. 1. The kiln stacks of Jingdezhen.

FIG. 2. Field of shards, Jingdezhen.

FIG. 3. Saggars are prefired refractory clay containers that encase ware in the kiln to protect it from kiln debris, direct flame, and fluctuations in temperature and atmosphere.

PORCELAIN CAPITAL TO THE WORLD: JINGDEZHEN

———— ·❧· ————

Cities worldwide—from Arita, Japan, to Meissen, Germany—made exquisite porcelain, but the town of Jingdezhen is unique for its continuous production of immense quantities of porcelain for China's imperial palace and domestic market, and for export to world markets, where it was highly prized. The name derives from Jingde (1004–1008), the early Song dynasty reign period during which the town was named by imperial decree. As early as the tenth century, white and green wares were being produced there, and throughout the Song dynasty (960–1279), the town was famous for *qingbai* ware, porcelain dressed in a jadelike, transparent glaze with a pronounced bluish tint.[1] In the fourteenth century, when blue-and-white porcelain was first produced, Jingdezhen's reputation grew, and ever after, it was world renowned.

Dreaming of Jingdezhen, Henry Wadsworth Longfellow (1807–1882) wrote of "King-ke-tching" in his poem "Keramos":

> O'er desert sands, o'er gulf and bay
> O'er Ganges and o'er Himalay,
> Bird-like I fly, and flying sing
> To flowery kingdoms of Cathay,
> And bird-like poise on balanced wing
> Above the town of King-te-tching,
> A burning town, or seeming so,—
> Three thousand furnaces that glow
> Incessantly, and fill the air
> With smoke uprising, gyre on gyre,
> And painted by the lurid glare,
> Of jets and flashes of red fire.[2]

Unlike Longfellow, the eighteenth-century French missionary and Jesuit priest Père d'Entrecolles knew Jingdezhen and its porcelain industry firsthand. In a letter dated September 1, 1712, he describes the town as a massive furnace:

The whirling flames and smoke, which rise in different places, make the approach to Jingdezhen remarkable for its extent, depth, and shape. During a night entrance, one thinks that the whole city is on fire, or that it is one large furnace with many vent holes.[3]

Today a middle-size modern city with traffic congestion and air pollution, Jingdezhen still prides itself on the large-scale manufacture of porcelain, from cheap dinnerware to costly works of art, primarily reproductions of esteemed imperial wares of earlier centuries.[4] Tall, slender smokestacks fill the skyline of the city (fig. 1), attesting to the prominence of the porcelain industry in the twentieth century. Yet valuable evidence of the past exists in the millions of broken bits of porcelain buried beneath Jingdezhen and scattered in huge mounds on its outskirts (fig. 2). These shards are important primary historical material. When combined with information in textual records, they reveal, century by century, the history of an extraordinary industry.

Archaeologists, like those at the Jingdezhen Institute of Ceramic Archaeology, under the leadership of Liu Xinyuan, have undertaken the systematic investigation of porcelain's past, tremendously expanding our knowledge of the industry in recent decades. Fundamental to a sound and detailed history of China's porcelain industry is the identification and excavation of kiln sites and a determination of their time spans and of the types of porcelain they produced. Archaeologists examine carefully not only porcelain shards but also kiln furniture—the disks, rings, and spurs on which the porcelain was placed during firing—as well as saggars, the ceramic boxes for encasing and protecting the pieces (fig. 3).

Scientific analysis of the composition of porcelain bodies and glazes is also essential in establishing a sound knowledge

of the evolution of porcelain. It has the potential of helping to separate originals from more recent copies, which are often difficult to detect with the naked eye. One of the most significant recent discoveries is the fundamental difference between early northern and southern Chinese porcelain bodies. In the north, the basic material was a white-firing kaolin clay, while in the south, including Jingdezhen, porcelain stone was the basic ingredient.[5] Equally important, scientists have confirmed the soundness of the theory that prior to the Yuan dynasty (1279–1368), the bodies of Jingdezhen *qingbai* wares were made of stone. While porcelain stone was still primary, by the 1320s and thereafter, kaolin was added to the clay bodies of Jingdezhen ware to enhance its plasticity. Over time, more and more kaolin was added; by the early Qing dynasty, the late seventeenth and eighteenth centuries, top-quality porcelain was half porcelain stone and half kaolin.

Why was Jingdezhen the porcelain capital to the world? How is porcelain made, and how was the production process organized at Jingdezhen? What distinguishes Jingdezhen as one of the world's first industrial towns?

Among the factors that made Jingdezhen the prime center of porcelain production in China is ease of transport. Although it is inland in Jiangxi province (see map of the kiln sites of China, p. 46), Jingdezhen's location on the Chang River offers convenient water transport to Lake Boyang. This lake connects to a wide network of waterways, including the Yangzi River, which linked Jingdezhen with the Grand Canal, and to rivers going south to Guangzhou (Canton) and to other major seaports and cities. Large quantities of Jingdezhen porcelain for the domestic and international markets were distributed via these waterways.

Second and even more vital is the abundance of raw materials, the presence of the makings of porcelain, porcelain stone and kaolin, in the mountains surrounding Jingdezhen. Long ago, volcanic eruptions, it is believed, left deposits of white porcelain stone across East Asia—Japan, Korea, and scattered throughout southern China, most prominently in the area around Lake Boyang and Jingdezhen. Here, porcelain stone, composed of quartz, potassium mica (sericite), and feldspar (albite), exists in close association with white-burning kaolin, clay that is rich in alumina and poor in iron.[6] These geological riches, with which the Jingdezhen area is so well endowed, were instrumental in the success of the porcelain industry, which relied primarily on local materials to

produce superb porcelain.[7] Pine to fuel the kilns was also once in plentiful supply in the nearby hills.

The cycle of abundance and depletion of raw materials significantly impacted porcelain production throughout the centuries. From the tenth to the thirteenth century, when stone was the sole body material at Jingdezhen, porcelain stone was the decisive influence. After the thirteenth century, however, high-alumina kaolin clay, the so-called bone of porcelain, also played a critical role.

From the early fourteenth to the sixteenth century, imperial wares were made with porcelain stone and with high-quality kaolin mined at Macang, a kaolin deposit monopolized by the government. This monopoly ensured the superiority of official wares, as the privately owned commercial kilns were forced to use lesser clays. From the second half of the sixteenth to the late eighteenth century, however, Mount Gaoling, the mountain from which the name 'kaolin' derives, supplied superior kaolin for both official and commercial kilns, reenergizing porcelain production and enabling both imperial and commercial wares to flourish. In fact, by the seventeenth century, commercial wares were not only comparable to but frequently surpassed porcelain made for imperial use.[8] Not surprisingly, access to top-grade raw materials was critical to producing fine porcelain.

Two additional factors in Jingdezhen's success were the specialization of labor and the significant level of government support from the imperial court.[9] Not only was ceramics technology highly advanced in China, so, too, was the organization of the workforce. Jessica Rawson observes:

> China's most remarkable contribution was the creation of the first large-scale factories in which bronzes, lacquers, textiles, and ceramics were mass-produced, not using machines as in modern factories, but using workers among whom the required processes were subdivided.[10]

Jingdezhen was exemplary in this regard. The sixteenth-century *Jiangxi sheng dazhi* (Great Record of Jiangxi Province) describes in detail the organization of labor at the official kilns. Either a eunuch or a local official was appointed by the imperial court to provide overall control, while more than 500 masters and workers were divided among 21 to 23 departments, the most important being kiln masters, potters, painters, and writers of marks. In addition,

FIG. 4. Once porcelain stone is mined, water-powered trip hammers pulverize the rock into fine powder. Today, machines are rapidly replacing the traditional trip hammers.

FIG. 5. Porcelain stone is purified in settling tanks. The coarser material gathers on the bottom, and the fine particles are skimmed off the top and used to make porcelain.

FIG. 6. The fine particles of porcelain stone are formed into white bricks (*baitunzi*).

there was a host of other departments including clay mixers and saggar makers.

Expectations of output ranged from 100 per day for a man throwing small bowls and saucers to 10 per day for a man making large vessels.[11] Clearly, porcelain was mass-produced by a specialized workforce engaged in a highly organized process. While not a matter of individual inspiration, porcelain production provides an impressive precedent for large-scale manufacturing.

How did the Jingdezhen potters transform rock, clay, and ash into striking white porcelain unequaled anywhere else in the world?

In 1743, following an order of the Qianlong emperor (r. 1736–1795), Tang Ying (1682–1756), imperial supervisor at Jingdezhen from 1728 to 1756, traveled to Beijing and there annotated a now lost set of twenty paintings illustrating the manufacture of porcelain.[12] In the following summary, Tang Ying's words are excerpted and accompanied by contemporary photographs.

The porcelain-making process begins with what Tang Ying terms "Mining the Stone and Preparing the Paste." He writes:

> In the manufacture of porcelain the body is formed of molded earth. This earth is prepared from stone and must be mined and purified for the purpose. . . . The natives take advantage of the mountain torrents to erect wheels provided with crushers [fig. 4]. Having been finely pulverized, it is then purified by washing and levigation [separating fine particles from coarser by suspending the crushed stone in water; fig. 5], and made up in the form of bricks [fig. 6].
>
> Besides this there are several other kinds of earth called Kao-ling [fig. 7]. . . . They are dug out and prepared in the same way as the 'white bricks' [porcelain stone], and can only be used for mixing with this last.[13]

Tang Ying's next descriptive caption reads "Washing and Purification of the Paste: In porcelain-making the first requisite is that of washing and purifying the materials of the paste, so as to make it of fine homogeneous texture." He then describes mixing the materials with water so that the coarser impurities sink to the bottom, and pressing, pounding, and kneading the paste to free it of excess water and air to make it "compact and ductile. All the different kinds of paste are

FIG. 7. Kaolin, a yellowish clay, fires white. It is the other primary component of porcelain. From the 13th to 14th century on, it has been added to porcelain stone.

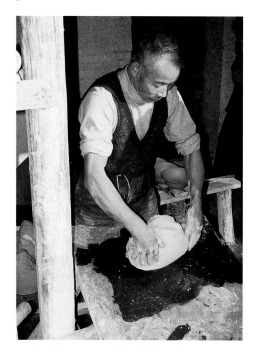

FIG. 8. After stone and kaolin have been combined and the mixture pressed and pounded to eliminate air and excess water, the paste is kneaded to ensure homogeneity and workability before being given to the potter.

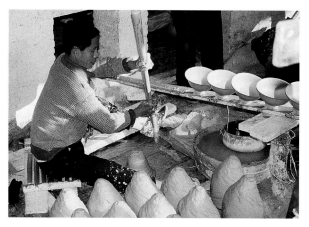

FIG. 9. The potter spins the wheel with a stick.

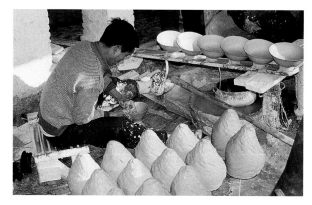

FIG. 10. Skillfully, the potter raises the clay on the wheel, forming bowls uniform in size. In imperial China, a potter working at the imperial kilns was required to produce 100 bowls a day.

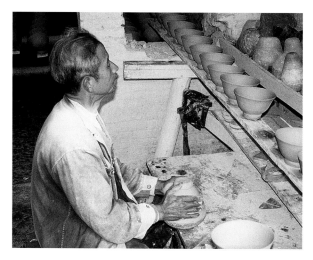

FIG. 11. Once the bowls are formed, a mold is applied and pressed gently with the hands, ensuring that all bowls are identical in size and thickness.

prepared in the same way, the various materials having been mixed in definite proportions according to their different properties."[14]

Glaze is made by mixing porcelain stone with smaller amounts of limestone and the ash of burned ferns. The two critical oxides in the composition of glazes are silica (silicon dioxide), the prime glass-forming oxide, and alumina (alumina oxide), the "stiffener," which prevents the glaze from running off the pot during firing.[15]

After captions on "Burning the Ashes and Preparing the Glaze," "Manufacture of the Cases or Saggars," and "Preparation of the Molds for the Round Ware," Tang Ying comes to "Fashioning the Round Ware on the Wheel." Noting that different shapes require different treatment, such as carving, engraving, and molding, he describes the potter at the wheel:

> Beside the wheel is an attendant workman, who kneads the paste to proper consistency and puts it on the table [fig. 8]. The potter . . . turns the wheel with a bamboo staff [fig. 9]. While the wheel is spinning round he works the paste with both hands; it follows the hands, lengthening or shortening, contracting or widening, in a succession of shapes [fig. 10]. It is in this way that the round ware is fashioned so that it varies not a hair's breadth in size.[16]

Once bowls and other "round wares" are formed on the wheel, the next step is "Molding the Porcelain and Grinding the Color":

> After the large and small round pieces have been shaped on the wheel, and have been sufficiently dried in the air, they are put into molds . . . and are pressed gently with the hands, until the paste becomes of regular form and uniform thickness [fig. 11]. . . . The piece is then taken out and dried in a shady place till it is ready to be shaped with the polishing knives. The damp paste must not be exposed to the sun, as the heat would crack it [fig. 12].[17]

To prepare cobalt-blue pigment, the ore was collected and roasted. Only the best pieces were selected for use. Ground and applied as a liquid suspension, the unfired cobalt appears "pale black" (fig. 13).[18] In "Painting the Round Ware in Blue," Tang Ying remarks:

> The different kinds of round ware painted in blue are each numbered by the hundred and thousand, and if the painted

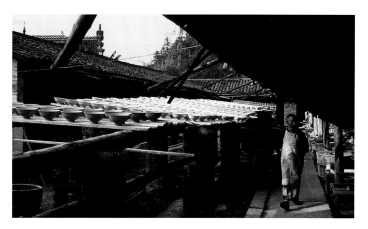

FIG. 12. After being formed and molded, the bowls, still damp, are set out in the air to dry before being decorated.

FIG. 13. When painted on the unfired porcelain, the cobalt pigment is pale black. When fired, it matures into brilliant blue.

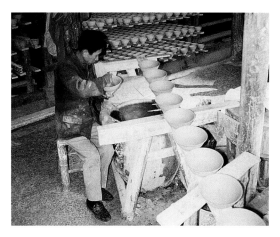

FIG. 14. Before porcelain is fired in the kiln, glaze is evenly applied to each vessel.

Glazing (fig. 14) is the next step. "Dipping into Glaze and Blowing in the Glaze" states:

> All the different kinds of round wares and vases, including the pieces decorated in blue . . . must have the glaze applied before they are fired. The ancient method of putting on the glaze was to apply it . . . with a goat's-hair brush filled with the liquid glaze but it was difficult to distribute it evenly in this way.[21]

Dipping into a vat of liquid glaze and blowing on the glaze are alternative methods of glazing. Once the vessel is painted and glazed, the surface is polished, the foot finished, and the mark neatly written underneath. After it is packed in a protective clay box or saggar, the porcelain is ready for the kiln.

The culmination of porcelain manufacture is firing, followed by the opening of the kiln. Tang Ying first describes the kiln (figs. 16, 17):

> The kiln is long and round and resembles the shape of a tall water-jar turned over on its side. It measures a little over ten feet in height and breadth, about twice as much in depth. It is covered with a large, tiled building which is called the 'kiln-shed.' The chimney, which is tubular, rises to a height of over twenty feet behind, outside the kiln-shed.

> The porcelain, when finished, is packed in saggars and sent out to the furnace men. When these men put it in the kiln they arrange the saggars in piles, one above the other, in separate rows, so as to leave an interspace between the rows for the free passage of the flames. The fire is distinguished as front, middle, and back; the front of the fire is fierce, the middle moderate, the back feeble. The different kinds of porcelain are placed in the furnace according to the hard or soft quality of the glaze with which they are coated. After the kiln has been fully charged the fire is lighted, and the entrance is then bricked up, leaving only a square hole, through which billets of pine wood are thrown in without intermission. When the saggars inside have attained a silvery red color (white heat) the firing is stopped, and after the lapse of another twenty-four hours the kiln is opened.[22]

> The perfection of the porcelain depends on the firing, which reckoning from the time of putting in to that of taking out, usually occupies three days. On the fourth day, early in the morning, the furnace is opened.[23]

decoration upon every piece be not exactly alike, the set will be irregular and spoiled. For this reason the men who sketch the outlines learn sketching, but not painting; those who paint study only painting, not sketching; by this means their hands acquire skill in their own particular branch of work, and their minds are not distracted. In order to secure a certain uniformity in their work, the sketchers and painters, although kept distinct, occupy the same house.

For painting flowers and birds, fishes and water-plants, and living objects generally, the study of Nature is the first requisite; in the imitation of Ming dynasty porcelain and of ancient pieces, the sight of many specimens brings skill. The art of painting in blue differs widely from that of decoration in enamel colors.[19]

In "Fashioning and Painting of Vases," after listing different decorative techniques, Tang elaborates on artistic sources, noting the importance of textiles and nature:

> In copies from antiquity artistic models must be followed; in novelty of invention there is a deep spring to draw from. In the decoration of porcelain correct canons of art should be followed; the design should be taken from the patterns of old brocades and embroidery, the colors from a garden as seen in springtime from a pavilion . . . the materials of the potter's art are derived from forests and streams, and ornamental themes are supplied by the same natural sources . . . and the artistic skill of the color-brush perpetuates on porcelain clever works of genius [fig. 15].[20]

Thus, the total firing time then as today was about thirty-six hours, and the kilns achieve maximum temperatures of well above 1300°C.

Enamel colors fluxed with lead were added on top of the transparent glaze after this first firing because they cannot withstand the high temperatures. The piece was painted, then underwent a second firing in a muffle kiln at temperatures of around 700°C. Lead enamels expanded the palette of porcelain, offering a wide range of color and the ability to achieve delicate shading.

After "Wrapping in Straw and Packing in Cases," Tang Ying concludes with a discussion of the devoutness in worship of the "immense number of people whose life hangs on the success or failure of the furnace fires." He relates the plight of Jingdezhen's deity potter Tong:

> Their god, named T'ung [Tong], was once himself a potter, a native of the place. Formerly, during the Ming dynasty, when they were making large dragon fish-bowls, they failed in the firing year after year, although the eunuchs in charge inflicted the most severe punishments, and the potters were in bitter trouble. Then it was that one of them, throwing away his life for the rest, leaped into the midst of the furnace, whereupon the dragon bowls came out perfect. His fellow-workmen, pitying him and marveling, built a temple within the precincts of the imperial manufactory, and worshiped him there under the title of 'Genius of Fire and Blast.' . . . He is worshiped here as the tutelary gods of agriculture and land are in other parts of the empire.[24]

In Tang Ying's time, Jingdezhen was flourishing under vigorous court patronage. Tang Ying exemplifies the extraordinary benefits of government support. A talented administrator with a deep understanding of the process of porcelain manufacturing, his control over the official kilns guaranteed a consistently high level of performance.

Today, Jingdezhen merits a visit by everyone with a strong interest in porcelain and its history. Museums, factories, and fields of shards preserve traces of its extraordinary past. This city, unique for the proximity of large deposits of both porcelain stone and kaolin, is renowned worldwide as the center of China's porcelain industry.

— M.G.G.

FIG. 16. Used exclusively at Jingdezhen since the late sixteenth century, this type of kiln is referred to as egg-shaped (*zhen-yao*) because its form resembles an egg (or water jar) lying on its side. Its shape and drafting make it possible to fire different types of wares at different temperatures in a single firing.

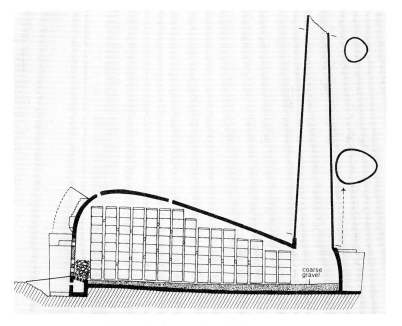

FIG. 17. Schematic of the Jingdezhen egg-shaped kiln.
The loaded saggars are neatly stacked inside the kiln in preparation for firing. Careful thought is given to the placement of each piece and the firing temperature it requires. The temperature varies: it is hottest in front, medium in the middle, and cooler at the far end near the chimney. A layer of coarse gravel insulates the floor of the kiln.

Appendix 2

Porcelain Marks on Objects Illustrated in This Book

——❖——

Pls. 2.4–9.6

PL. 2.4
69.198A

PL. 2.4
69.198B

PL. 2.5
69.193

PL. 3.1
59.121

PL. 3.2
59.120

PL. 5.4
49.154

PL. 5.5
48.167

PL. 5.7
51.85

PL. 5.8
51.89

PL. 5.9
48.163

PL. 5.10
51.86

PL. 5.10
51.87

PL. 5.11
54.120

PL. 9.4
54.81

PL. 9.6
91.101.6

PL. 9.6
91.101.3

PL. 9.6
91.101.8

PL. 9.6
91.101.10

PL. 9.6
91.101.1

PL. 9.6
91.101.2

PL. 9.6
91.101.7

PL. 9.7
91.102.6

PL. 9.7
91.102.9

PL. 9.7
91.102.4

PL. 9.7
91.102.1

PL. 9.7
91.102.2

PL. 10.4
70.42

PL. 10.7
53.23

PL. 10.8
70.38.1

PL. 10.8
37.72.2

PL. 10.9
35.239

PL. 10.10
44.118.2

PL. 10.11
70.37.1

PL. 10.12
65.60

PL. 10.13
37.109

PL. 10.14
56.166

PL. 10.15
36.60

PL. 10.16
T91.27

PL. 10.17
70.49

Pls. 11.3–12.26

PL. 11.3

69.201

PL. 11.4

69.184

PL. 11.5

69.202

PL. 11.6

87.142.62A

PL. 11.6

87.142.62B

PL. 11.6

87.142.63

PL. 11.6

87.142.49A

PL. 11.6

87.142.49B

PL. 11.8

87.142.43

PL. 11.9

87.142.84

PL. 11.10

99.8

PL. 11.11

85.215.1

PL. 11.11

85.215.2, .1

PL. 12.4

76.238A

PL. 12.4

76.238B

PL. 12.7

87.142.127

PL. 12.9

84.97

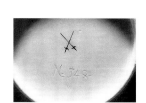

PL. 12.13

61.75B

PL. 12.15

69.166

PL. 12.18

69.200

PL. 12.19

76.98

PL. 12.20

87.142.106

PL. 12.26

95.103

278 APPENDIX 2

PL. 12.30
69.167

PL. 12.32
70.45

PL. 12.33
35.252.2

PL. 12.34
69.199

PL. 12.35
49.25

PL. 12.36
44.113

PL. 12.45
87.142.30 LID

PL. 12.45
87.142.30 BASE

PL. 13.1
87.142.101

PL. 13.2
95.95A

PL. 13.2
95.95B

PL. 13.4
58.100

PL. 13.7
87.142.48

PL. 13.8
87.142.69

PL. 13.12
97.167

PL. 13.13
76.236

PL. 14.1
83.222

PL. 14.2
69.187

PL. 14.4
56.278

PL. 14.5
78.13

PL. 14.8
69.162

PL. 14.8
76.207

PL. 14.14
69.213

PL. 14.16
98.33

PL. 14.17
87.142.65

PL. 14.18
76.103

PL. 14.19
76.88

PL. 14.20
91.103

PL. 14.22
81.8

PL. 14.25
69.175

PL. 14.26
64.117

PL. 14.26
64.117

PL. 14.27
76.219

PL. 14.28
55.85

PL. 14.31
94.103.64

PL. 15.1
73.5

PL. 15.2
38.10

PL. 15.3
35.222

PL. 15.5
98.49.324

PL. 15.6
39.6

chap. 15, fig. 2
33.117

PL. 17.1
76.89

PL. 17.1
76.89

PL. 17.2
76.90

PL. 17.2
76.90

PL. 17.4
76.274

PL. 17.5
76.268B

GLOSSARY

BISCUIT
The first firing of unglazed ceramic ware. Porcelain produced by this firing and left unglazed and undecorated is referred to as biscuit.

CHINA CLAY. See KAOLIN.

CLAY
A natural, fine-grained material formed by the decomposition of feldspathic rock. Its main component are minerals (aluminum silicates) in the form of tiny platelets that slip and slide over each other when wet, giving clay its plasticity.

COLD COLORS
Painted decoration on ceramics, such as lacquer or oil pigments, that has not been fired onto the ware.

CRACKLE
A deliberate glaze effect. See CRAZING.

CRAZING
A fine network of cracks in the glaze. Crazing may be caused by imbalance in the glaze formula, may result from aging or weathering, as from burial, or may be intentionally induced.

EARTHENWARE
A ceramic object made from clay that has not vitrified or fused during a low-temperature firing (around 600°C to 1100°C). It is porous and cannot hold liquids unless sealed with a glaze.

ENAMEL COLORS
Pigments deriving from metallic oxides, such as copper green, iron red, cobalt blue, and manganese purple, mixed with a glass FLUX. On porcelain, enamels are painted over a prefired glaze and fired again at a lower temperature, ranging from around 700°C to 900°C. This technique creates overglaze enamel decoration.

FLUX
An ingredient that lowers the melting point of the substance to which it has been added. In SOFT-PASTE porcelain, glass frit serves as the flux, or bonding agent. In glazes, a flux such as lead causes the glassy mixture to melt at a lower temperature than the body and cover and bond to the ceramic ware.

FRIT
A fused, glassy material that is powdered and added to a glaze or clay body.

GLAZE
A glassy layer on the surface of a ceramic ware.

HARD PASTE, also called true porcelain
Ceramic ware made from KAOLIN, a very fine white clay, and PORCELAIN STONE, a pulverized, refined, feldspathic rock. It is fired at a high temperature, a hard firing up to 1400°C. It often contains quartz as a flux.

KAOLIN
A fine white clay rich in aluminum silicate. Named after a mine site (Gaoling, or Kaoling) near Jingdezhen, kaolin is an essential component of hard-paste porcelain. It is also known as china clay.

LEAD GLAZE
A glaze in which lead oxide is the primary flux.

Leather hard
A condition of partly dried, unfired ceramic ware, firm enough to hold its shape, but still soft enough to incise with a carving tool or impress with a molded design.

Luster
An iridescent effect achieved by applying salts of silver and copper to a glazed surface. In a reduction firing, the salts reduce to a thin metallic coating.

Luting
Joining parts of a ceramic form with SLIP to assemble the complete shape. Molded or wheel-thrown elements can be so joined.

Modeling
Manually shaping clay.

Molding
Shaping moist clay by pressing it into a preformed mold. Complex ceramic forms were assembled from several molded elements. See LUTING.

Oxidation, oxidizing atmosphere
A condition in which the oxygen in the kiln's atmosphere is maintained at a level that develops the oxidized colors of the ceramic body and glaze. See REDUCTION.

Porcelain
A ceramic body very hard and dense in texture after being fired in the range of around 1250°C to 1400°C. It is white, translucent, and resonant when struck. In ancient China, porcelains were made from either KAOLIN or PORCELAIN STONE, or a mixture of the two. Porcelain made from the latter is also referred to in Europe as HARD PASTE.

Porcelain stone
Feldspathic rock containing alkali, alumina, and silica. It is used as a flux in making porcelain. In China, varieties of porcelain stone contained mica and sometimes KAOLIN; some could be used to create a dense porcelain body without the addition of clay.

Reduction, reducing atmosphere
A smoky kiln atmosphere resulting from fuel-rich and oxygen-depleted combustion. This deliberately induced, low-oxygen firing atmosphere affects the colors of the ceramic body and glaze. See OXIDATION.

Saggar
A prefired container that protects glazed and decorated wares from contact with flame, gases, ash, and other pots during firing.

Slip
Semiliquid clay that can be applied as a surface coating to a ceramic surface; also called engobe.

Slip-casting
Ceramic objects produced by pouring SLIP into plaster molds. The molds pull moisture from the slip, creating a firm outer shell. Extra slip is poured off, leaving a hollow molded form after the segments of the mold are removed. Also see LUTING and MOLDING.

Soft paste, also called artificial porcelain
Ceramic ware that contains a high-quartz to low-clay ratio. The body is vitrified by adding FRIT and lime or gypsum. It is fired at around 1050°C to 1250°C, a lower temperature (soft firing) than for hard-paste porcelain.

Stoneware
A ceramic body that has fused (vitrified) during a high firing, from 1200°C to 1300°C, and become impermeable, hard, and dense in texture and is resonant when struck. Stoneware can be made in various colors and is not translucent.

Tin glaze
Glaze that appears opaque white because of particles of suspended tin oxide that reflect the light.

Notes

Introduction

1. Finlay 1998, 143.

2. Rawson 1984.

3. Diamond 1997, 256.

4. The fact that "food tasted better" when eaten off of porcelain was noted in Europe as early as the sixteenth century. Richards 1999, 20 and notes 30, 32.

5. Clunas 1986–88, 47–48. See also Rawson 1992, 24–31.

6. Richards 1999, 4–5.

7. Finlay 1998, 171–72 and notes 111, 112. Ennès, Mabille, and Thiébaut 1994.

8. Richards 1999.

9. Spence 1990.

Chapter 1

1. Hunan Provincial Museum 1973, vol. 1, 127, 137–41; vol. 2, 216–19, 229–32.

2. More precisely, the kaolin of northern China is in a more mature stage (secondary kaolin), unlike primary kaolin, which is in a rough and less weathered state and lies deeper in the earth. Primary kaolin exists only in southern China and was found later, at the end of the thirteenth century.

3. The earliest northern porcelain so far known dates from 575, from the tomb of Fan Cui. It belongs to a group of porcelain objects found in dated tombs of the Northern Qi (550–577) and Sui (581–618) periods in Henan and Shaanxi provinces. See Henan Provincial Museum 1972, 57, pls. 33–37; and National Administration of Cultural Heritage 1995, 224–28, pls. 161, 164–74.

4. For studies on *kendi,* see Sullivan 1957 and Khoo 1991.

5. Lan Pu of the nineteenth century claimed in his book *Jingdezhen taolu* (An Account of Jingdezhen Ceramics) that in the early Tang period, the so-called Tang kilns and Huo kilns in Jingdezhen produced fine, thin, white wares that resembled jade. They were sent to the north and even to the Tang court as early as around the 620s. See Lan Pu, *juan* 5, "Jingdezhen lidai yaokao" (A Study of Jingdezhen Kilns through the Ages). The claim has not been substantiated by archaeological finds in Jingdezhen, however. For examples of Jingdezhen's early white wares, see Hong Kong 1992, pls. 8–13.

In 1996, archaeological investigation at the Yangong town of Jing county in Anhui province discovered another early southern porcelain kiln that has been identified as the Xuanzhou kiln renowned in historical writings. Judging by the findings, the white porcelains produced during the Five Dynasties period are to represent the heyday of production in the Xuanzhou kiln. These white porcelains appear to have a strong connection with the northern Xing and Ding wares. Zhang and Li 1997, 205–9; Li 1998, 39–41.

6. Chinese porcelains are depicted in a 1590 Mughal manuscript; see Smart 1975–77, pls. 69, 70. Large Chinese fourteenth-century blue-and-white dishes are prominent in Middle Eastern and Indian collections. Major Middle Eastern holdings include the collection of the Ottoman sultans in the Topkapi Saray Museum, Istanbul (Krahl 1986 vol. 2); the collection formerly in the Ardebil Shrine of the fourteenth-century Sheikh Safi and now in the Iran Bastan Museum, Tehran (Pope 1956); and porcelain excavated in the remains of a fourteenth-century Tughlaq Palace in Delhi (Smart 1975–77).

Chapter 2

1. Salgado Lobo Antunes 1998, 17.

2. Co-author Jennifer Chen notes that judging from the shape, decoration, and the *qingbai* color of the vase, it is datable to about 1300 because the style is typical of the early Yuan (1279–1368).

3. Lane 1961, 124–32. Watson and Whitehead 1991, 17–18.

4. Information from co-author Jennifer Chen.

5. Wood 1995, 65–66.

6. See Tite 1991, 283–84.

7. Arnold, Menzhausen, and Spitzer 1993, 7.

8. Cassidy-Geiger 1997, 69. In endnote 4, she observes that even though Augustus's primary period of collecting Asian porcelain began c. 1715, he had acquired porcelain in 1699, and a large number of wares in 1704.

9. Walcha 1981, 15.

10. Gleeson 1998, 53.

11. Menzhausen 1990, 195.

12. Nelson 1998, 34–43. This paper summarizes a current project analyzing the composition of Böttger stoneware in comparison to other red stoneware. The project is organized by the Nelson-Atkins Museum of Art in collaboration with the J. Paul Getty Museum and the Porcelain Collection of the State Art Collections, Dresden. Select stonewares were tested by several scientific methods outlined in the paper. The most important, an analytical technique, Particle or Proton Induced X-ray Emission (PIXE), measured elements in the stoneware. The study, which compares and contrasts various elements in stonewares, is in an early phase; future results will offer important information for attributing and dating Böttger stoneware.

13. Gutter 1998. Striations, perhaps from a sponge, are visible inside this work, but not on its exterior.

14. The Meissen factory remained in the Albrectsburg until 1865, when it was moved to a new location in the town of Meissen, where it continues in operation today.

15. Syz, Miller, and Rückert 1979, 54.

16. A description of the electors of Saxony hunting in Poland is in Schama 1996, 43–45.

17. Syz, Miller, Rückert 1979, 534–35.

18. Pietsch 1993, 112–13.

19. A similar heavily repaired cup and a saucer from the Porzellansammlung im Zwinger in Dresden are published in Arnold et al. 1991, 37. This catalogue entry quotes the 1779 inventory of the royal collection, which lists seven cups and saucers of this description. The Seattle cup and saucer do not bear the Japanese Palace inventory number incised and then blackened, or painted in black, which would identify them as part of the royal holdings.

20. The Porzellansammlung in Dresden has, in addition to the cup and saucer noted above, another saucer, two plates, and two goblets. A cup and saucer are in The Metropolitan Museum of Art, New York. A cup lacking both saucer and Japanese Palace inventory number is in the British Museum. It is published in London 1985, 8–9.

21. Artists joined the enterprise at Meissen as success with stoneware and porcelain formulas became a reality. The form of this work is attributed to the Dresden goldsmith Johann Jacob Irminger (see pl. 2.2), and the gilded lacework scroll painting is the style of Johann Georg Funcke, the chief gold painter at the Meissen factory from about 1713 until 1726.

22. Dating this tea caddy is a complicated process. Similar works in various collections have been given dates ranging from 1720 to 1730. Two chocolate beakers and saucers with similar gilding in the Berliner Kunstgewerbemuseum are dated c. 1720; see Bursche 1980, 46–47. For a beaker and saucer dated 1723–24 (the beaker is marked with the underglaze crossed-swords mark used from 1723), see Pietsch 1993, 54–55. For a coffeepot dated 1724–30, with molded acanthus leaf and gilded decoration most similar to the Seattle tea caddy, see Syz, Miller, and Rückert 1979, 54–55. This coffeepot bears the crossed-swords mark in underglaze blue, dating it after 1723. A nearly identical coffeepot, beaker, and tea bowl with saucers, all marked with crossed swords, are illustrated in Menzhausen 1990, cat. 35, where the ware and decoration are dated to 1723–24.

Chapter 3

1. Some kiln sites, like the Xing kilns in Neiqiu and Linchen in Hebei province, and the Xiangzhou and Gongxian kilns in Henan province, have also yielded white porcelain shards from earlier strata dating to the Northern Qi and Sui periods. The evidence, however, is still not sufficiently conclusive to pinpoint the exact sites where extant earlier porcelains were produced. Zhongguo guisuanyan xuehui 1982, 202; Neiqiuxian wenwu baoguansuo 1987, 3–5; Zhao 1993, 62; Li 1998, 25.

2. Li Zhao's *Guoshi bu* (Supplement to National History), cited in Zhongguo guisuanyan xuehui 1982, 203; Feng 1987, 187.

3. Lu 1987, 259.

4. Neigiuxian wenwu baoguansuo 1987, pl. 14.

5. Feng 1987, 191, pl. 11.

6. *Neiqiu xianzhi* (Gazetteer of Neiqiu County), cited in Wang and Zhang 1997, 8.

7. Meng Yuanlao, 17.

8. Ding County Museum 1972; Tokyo 1997.

9. Stated by Cao Zhao in his book *Gegu yaolun* (14th century). For an English translation and this citation, see David 1971, 141.

10. Tokyo 1997, pl. 13.

11. Zhongguo guisuanyan xuehui 1982, 233.

12. Ibid., 236.

13. The traditional way, placing an object upright in the saggar, allowed each saggar to hold either one object or a few objects stacked one inside the other. In stacking, the first object bore the weight of the others, thus limiting their number. This method was not conducive to making thin-walled objects because the small foot had to be

rather thick in order to bear the weight. By contrast, the inverted firing method evenly distributed the weight along the mouth rim. For a study of inverted firing technology at the Ding kilns, see Li and Bi 1987.

Chapter 4

1. For an English translation, see Carpenter 1974.

2. *Taoji* is included in *Fuliang xianzhi* (Gazetteer of Fuliang County) of both the Kangxi and the Qianlong periods. Cited in Jiang Jianxin, in Hong Kong 1992, 72.

3. For the interaction between molded decoration and inverted firing in Jingdezhen kilns, see Liu 1974.

4. Liu 1980, 55

5. A mortuary jar of similar type, dating to 1172, was unearthed in Jingdezhen. See National Administration of Cultural Heritage 1995, 284, pl. 383.

6. An example in the Shanghai Museum carries a date corresponding to 1251. National Administration of Cultural Heritage 1995, 289, pl. 402.

7. Jiujiangxian wenwu baoguansuo, "Jiangxi jiujiang beisong mu" (A Northern Song Tomb in Jiujiang County of Jiangxi Province), in *Wenwu* 1990, no. 9: 19, fig. 2; Chen 1991, 87; Peng Shifan 1998, pl. 1.

8. Archaeological investigation and trial diggings in Fanchang, Anhui province, yielded some *qingbai* wares datable to the Five Dynasties period. This finding makes the Fanchang kilns another likely site for the first *qingbai* porcelain, although further excavation and research are needed to substantiate such an assertion. Hu Yueqian, "Anhui jiangnan diqu de fanchangyao" (The Fanchang Kilns in Southern Anhui Province), in *Dongnan wenhua* 1994, special issue 1: 70–75; Yang Houli and Fan Fengmei, "Songyuan qingbaici gaishuo" (A summary of Qingbai Ware of the Song and Yuan Dynasties), in Peng Shifan 1998, 19.

9. Feng 1987, 45–46; Liu Xinyuan in Hong Kong 1992, 24.

10. See note 2.

11. In Wu Zimu's "Mengliianglu" of the late thirteenth century, and Naideweng's "Ducheng jishen" of the twelfth century. See entries under Wu, 240; Naideweng, 100.

12. *Songhuiyao jigao,* quoted in Liu Xinyuan, in Hong Kong 1992, 24–25; Chen Baiquan in Scott 1993, 17.

13. Lee and Ho 1968.

14. *Yuan shi* in Liu and Bai 1980, 45; Kanazawa 1998.

15. See National Administration of Cultural Heritage 1995, 348, pl. 602.

16. Chinese official histories such as *Yuan shi, Yuan dianzhang,* cited in Liu and Bai 1980, 45; Liu Xinyuan in Scott 1993, 33.

17. Zhou and Li 1982; Wood 1985–86, 44.

18. Liu Xinyuan 1974.

19. Lu 1990, 144.

20. Seoul 1977; 1985.

Chapter 5

1. Chinese ornament and its borrowings from and influence on Middle Eastern and Western ornament is discussed in Rawson 1984. For factors that stimulated large-scale production of blue-and-white in the fourteenth century, see Finlay 1998, 154–55; Krahl 1994, vol. 2, 10–11; Medley 1982, 47 ff.

2. This is the opinion of Liu Xinyuan, as stated to Jennifer Chen in January 1999. A discussion of Tang blue-and-white is given in Wang 1993, 1–3; Wood 1992, 149.

3. See chapter 7 for a discussion of tin-glazed frit ware in the Middle East. On types of cobalt used on Chinese blue-and-white, see Garner 1956 and Watt 1979.

4. Medley compares the Seattle plate to a similar one in the Ardebil Shrine (see Mikami, ed., 1981, vol. 13, 276, pls. 214–15). I am indebted to Yumi Douane for her translation of this Japanese text.

5. Liu Xinyuan in Scott 1993, 36; Hong Kong 1992, 47, 49; Carswell 1985, 24; Medley in Watson 1973, 2–3; A. Joseph in Hong Kong 1984, 44–49.

6. Stimulating debate centers on which elements of these plates are influenced by Middle Eastern traditions and which are indigenous to Chinese traditions. Margaret Medley emphasizes the strong influence of Middle Eastern metalwork (Medley 1972, 1973), while Jessica Rawson traces precedents in Chinese tradition for motifs and frames (Rawson 1984, 132–37). See also Hong Kong 1984, 150.

7. Finlay 1998, 158.

8. David 1971, 143.

9. Los Angeles 1989, no. 27; Medley 1974, 38.

10. Medley 1976, 186–90. A similar stem cup excavated in Gao'an Hoard bears an inscription indicating it was used for drinking wine; Wang 1993, 241, pl. 27.

11. Shortly thereafter, in 1374 and 1383, imperial envoys rediscovered the high prices that Chinese porcelain fetched on foreign markets, and trade in porcelain increased; Medley 1976, 193.

12. Yuan dynasty official wares are discussed by Liu Xinyuan in Scott 1993, 33–46; and Ming imperial kilns in Zhongguo guisuanyan xuehui 1982, 360–69.

13. C. Lau in Scott 1993, 86.

14. The connection between the meaning of 'Zhu' and red's designation as the basic color of all court robes may well be significant. Ming, the name chosen by Zhu Yuanzhang for the dynasty, also denotes red, or fire, and South. Rogers 1990, 64.

15. Wang 1993, 7.

16. See chapter 4, on *shufu* ware.

17. For a stem cup excavated from a 1371 tomb, see Wang 1993, no. 33. Some debate revolves around the dating of stem cups. When were they first produced? Over how long a period of time were they made? See also Medley 1974, 35; Wang 1993, 9.

18. Taipei 1996. For earlier debate on dating of this group of underglaze red, see Pope 1956, 78; Addis 1957–59; Medley 1973. For copper as a colorant, see N. Wood in Scott 1993, 47–68, and Tichane 1985.

19. Vainker 1991, 186.

20. Liu Xinyuan in Hong Kong 1989, 40–43, 74–76; Fu 1977, 143, pl. 26a.

21. Hong Kong 1989, 54, 59, fig. 3, 61, 62; Zhang 1937.

22. F. Mote in Chang 1977, 213–14; Hong Kong 1989, 70.

23. In the excavations of the Ming imperial kilns at Zhushan, Jingdezhen, 98 percent of the shards from the strata associated with the Yongle period are white. For a discussion of the Yongle emperor's fondness for the color white, see Hong Kong 1989, 72–73. Ming ceremonial monochrome wares are discussed in Lau 1993, 83–100.

24. For a discussion of the Imperial Painting Academy and Xuande's painting, see R. Barnhart in Fong and Watt 1996, 337–39, pl. 164; Barnhart 1993, 53–87.

25. Vainker 1991, 188; M. Neill in Bickford 1985, 223, 224.

26. Compare the Seattle *meiping* vase (69.80) with Barnhart 1993, 76, cat. 24.

27. Mote and Twitchett 1986, 343–70.

28. Liu Xinyuan details the excavated finds of the Chenghua imperial porcelain at the official kilns in the Zhushan area of Jingdezhen and divides production of this reign into three phases. See Hong Kong 1993. For the history of the appreciation of Chenghua porcelain, see Ts'ai Ho-pi in Krahl 1995, 16–25.

29. Hong Kong 1993, 75. As Liu Xinyuan explains, in some cases, imported and native cobalt were mixed.

30. Pierced and broken shards of Chenghua porcelain comprised a 1994–95 exhibition at Sotheby's, London. See Krahl 1995.

31. Chang 1986, 287.

32. For comparable *meiping,* see Wang 1993, nos. 87–89, especially no. 88. A fragment with similar clouds and features, excavated in the Zhushan area of Jingdezhen, is illustrated in Hong Kong 1992, no. 230.

33. Wang 1993, nos. 98, 122, 250.

34. Liu Xinyuan in Hong Kong 1993, 66, pl. 14a, 69, 70.

35. J. Thompson in Krahl 1995, 115.

36. Wang 1993, no. 123, 253–54.

37. M. Neill in Bickford 1985, 206–9; Bickford 1996, 52–53.

38. J. Geiss in Mote and Twitchett 1986, vol. 7, 489. Medley 1990, 12.

39. Scott and Kerr 1994, 5–9; Wang 1993, 19.

40. Yu 1995, 78–79.

41. Zhongguo guisuanyan xuehui 1982, 369; Hong Kong 1992, 52; Scott and Kerr 1994, 5.

42. M. Medley in Scott 1993, 80.

43. M. Rogers in Seattle 1988, 134, pl. 67.

Chapter 6

1. The existence of maritime trade at this early date is recorded in contemporary Chinese official chronicles, the *Han shu* (Book of Han), and in Roman writings; see Chen and Wu 1981, 4–6. See also Vollmer, Keall, and Nagai-Berthrong 1983, 26–30.

2. Shen 1985, 52.

3. *Song shi* (History of Song), *juan* 167, "Zhiguan zhi" (Record of officialdom), *juan* 185, "Shihuo zhi" (Record of Agriculture and Commerce); Chen and Wu 1981, 62–98; Shen 1985, 54–58.

4. *Song shi,* and *Yuan shi* (History of Yuan), cited in Chen and Wu 1981, 182, 187.

5. Guy 1986, viii.

6. Chen 1991, 57.

7. *Song shi,* "Shihuo zhi," in *Zhongguo lidai shihuo zhi zhengbian,* 466; *Yuan dianzhang,* 22, cited in Liu 1980, 59, n. 19.

8. Guy 1986, viii.

9. Li and Gao 1984.

10. Shen 1985, 207.

11. Chung 1998, 226; Kuwayama 1989, 107.

12. Chung 1986, 264.

13. Xu Jing (1091–1153), a Song imperial envoy to Koryŏ, described the fine quality of Koryŏ celadon in his book *Xuanhe fengshi gaoli tujing* (Illustrated Record of the Chinese Embassy to the Koryŏ Court during the Xuanhe Era) of 1124. *Xiuzhongjin,* a book published

in the Southern Song period, compiled a list of objects that were "first under Heaven," including ceramics like Ding ware and Koryŏ celadon; cited in Zhongguo guisuanyan xuehui 1982, 312.

14. Choi 1977, 292–94; Zhongguo guisuanyan xuehui 1982, 224, 311.

15. Seoul 1977, 261; Seoul 1985, 292–325. The number 6400 given in the report reflects only amounts found as of 1984.

16. Seoul 1977, pl. 150.

17. An extremely handsome celadon *maebyong* with incised lotus decoration is in the Seattle collection (Seattle 1991, 176); for many other examples of Korean porcelain and celadon *maebyong,* see Choi and Hasebe 1978.

18. Shen 1985, 217.

19. The license was first published in Japan in *Choya gunsai,* vol. 20. A revised version of its transcription is cited in Chen and Wu 1981, 75–78. The license permits a shipload of 200 *chuang* of bowls and 100 *chuang* of small dishes. A persuasive study by Zeng Fan reveals that 1 *chuang* of bowls was 20 pieces, and 1 *chuang* of small dishes was 50 pieces, hence the total of 9000 pieces; see Zeng Fan in Fujian Provincial Museum 1990, 147–48.

20. Zhongguo guisuanyan xuehui 1982, 308.

21. Japanese contemporary literature mentions white as the proper color for sutra writing; cited by Kamei Meitoku, in Hasebe 1977, 289. For examples of white and *qingbai* porcelain sutra containers, see Tokyo 1975, pls. 43–44, 47, 78.

22. Atil 1973, 2; Wilkinson 1974, xxvii; Gray 1976, 232; Li and Gao 1984, 76, 96.

23. Direct sailing from the Maldives in the middle of the Indian Ocean to Muqdisho was recorded in Chinese literature of the early fifteenth century and has been confirmed by Chinese ceramic finds in the Maldives. For Chinese literary sources, see "Zhenghe hanghai tu" (The Sea Route of Zhenghe's Expeditions), cited in Shen 1985, 196. A whole range of Chinese pottery dating from the Tang dynasty to the nineteenth century is found in Male, the capital of the Maldives, but no trace exists of any Islamic pottery. It indicates that Male was a transfer station for ships sailing from China toward the west only, probably due to the pattern of the monsoons. Carswell 1999, 4; 1975–77, 121–98.

24. For a brief review of the specific sites and wares in these areas, see Guy 1986, 20–21.

25. Zhao Rushi, in his book *Record of Various Barbarians,* wrote also about dining customs in several regions and countries of Southeast Asia. For example, in Sujidan (mid–Java Island), people placed their food on leaves; in Boni (Brunei), people used woven bamboo wares

or shells as containers. These were all thrown away after use. See Feng 1940, 28, 79.

26. Rita Tan in Brown 1989, 31; Tan 1993, 10.

27. Seoul 1977, pls. 333, 336.

28. For a summary of the sites, see Li and Gao 1984.

29. Scanlon 1970, 81.

30. For shards excavated in Sri Lanka, see Carswell 1999, 2, figs. 1a–b. For Fustat, see Tokyo 1984.

31. Liaoning Provincial Museum 1975, 26–36; Feng 1975, 44.

32. Chen and Wu 1981, 100.

33. For a discussion of Chinese ceramic finds in Fustat, see Scanlon 1970; Mikami 1981, 67–89; 1984, 84–99.

34. Gray 1976, 231; Atil 1973, 3.

Chapter 7

1. For Seattle's jug, see Wilkinson 1963, pl. 57; for a comparable jug, see Watson 1985, pl. 44.

2. Finlay 1998, 165.

3. The place and date of manufacture for this work were attributed by Wendy M. Watson, Curator, Mount Holyoke College Art Museum, 1991, with comments from Margaret Oppenheimer, The Hispanic Society of North America, August 1990.

4. Comments from Margaret Oppenheimer, August 1990.

5. Caiger-Smith 1985, 127.

6. The production of maiolica was described in a sixteenth-century treatise by Cipriano Piccolpasso and outlined in Watson 1986, 16.

7. From comments of Wendy M. Watson, 1991. She notes that other pieces with inscriptions to Alfonso Patanazzi are in the Victoria and Albert Museum (Rackham 1940, no. 896; signed and dated 1606) and in the Museo Civico di Pesaro (Mancini della Chiara 1979, nos. 18 and 23); both are inscribed, but like the Seattle work, neither is dated.

8. Finlay 1998, 166.

9. Ibid.

10. Mallet 1981, 162–64.

11. Comments from Wendy M. Watson, August 1990, citing Drey 1978, 198.

Chapter 8

1. Guy 1986, 34.

2. Shen 1985, 241–42; Guy 1986, 35–36, 38–39.

3. Shunzo 1964, 387.

4. Ibid., 388.

5. Shen 1985, 63.

6. Guy 1986, 33.

7. Mikami 1981, 87.

8. Vietnamese blue-and-white was also related to its local predecessor, wares painted with underglaze brown or black that appear to have been inspired by the Chinese Cizhou wares of the Song period painted in red iron oxide.

9. Guy 1986, 47; Tang 1997, 209.

10. Allison Diem in Gotuaco, Tan, and Diem 1997, 186.

11. Tang 1997, 217, fig. V15.

12. Allison Diem in Gotuaco, Tan, and Diem 1997, 186–87.

13. Oriental Ceramic Society of the Philippines 1993, pl. 107; Gotuaco, Tan, and Diem 1997, pl. Y37a.

14. The origin of the *kendi* remains a fascinating question. It appeared in China in the Tang period (618–906) and in Java at about the same time. The dramatic mammiform spout was a later development, again appearing in both China and Java at about the same time in the fourteenth century, and somewhat later in Vietnam and Thailand. See chapter 1, n. 4.

15. Guy 1986, 65–67.

16. Chung 1998, 246.

17. The Korean historical document *Sejong sillok* (The Veritable Record of Emperor Sejong), of 1450, illustrates a large blue-and-white porcelain bottle with dragon-and-cloud decoration for use at royal parties, though it is not clear whether this particular piece was made in Korea or China. Cited in Watanabe in Kyushu 1993, 149.

18. Ohashi 1993, 151.

19. Rathbun 1994, 57–58.

20. Ewers of such shape and dimensions were mostly made during the Longqing reign (1567–1572). Two examples with the imperial mark are in the Palace Museum, Beijing, and the National Palace Museum, Taipei. See National Administration of Cultural Heritage 1995, 399, pl. 785; Fong and Watt 1996, pl. 249.

21. Volker 1954, 125, 127–29; Impey 1989, 64.

22. For Fustat examples, see Tokyo 1984, pl. 195; Mikami 1984, figs. 15, 19, 20. For Seljuk examples, see Lane 1948; Atil 1973, pls. 13–15.

23. Atil 1973, 15.

24. Fehérvári 1973, 130.

25. Examples of Iznik "grape vine" wares can be seen in Atasoy and Raby 1989, figs. 184–87, 189–98, 308, 313, 317; Atil 1973, fig. 83.

Chapter 9

1. Schivelbusch 1992, 7.

2. Jardine 1996, 77–80.

3. Salgado Lobo Antunes 1998, 17.

4. Loureiro 1998, 48.

5. Pinto de Matos 1998, 116.

6. Jörg 1982, 91.

7. Rinaldi 1989, 45.

8. Ishikawa 1997, 66–69.

9. Sheaf and Kilburn 1988, 40, pl. 46.

10. Rinaldi 1989. This bowl shape with flaring, everted rim dates from c. 1570–1610; see Shape I, p. 138. The panel decoration with large peach sprays separated by narrow panels with beaded pendants was produced c. 1575–1605; see Border VI, 71.

11. Vainker 1991, 147.

12. Rinaldi 1989, 102. See chapter 12 on use of the dragon motif.

13. In 1613, the homeward-bound Dutch East Indiaman V.O.C. *Witte Leeuw* was sunk by the Portuguese near the island of Saint Helena. The size and decoration of the Seattle dish is similar to that of wide-rimmed dishes salvaged from the ship in 1976. Pijl-Ketel 1982, 54 (inv. no. 4), 56 (inv. no. 21), 57 (inv. no. 25).

14. Rinaldi 1989, 4b.

15. Ayers, Impey, and Mallet 1990, 71.

16. Ibid., 94.

17. Information from William J. Rathbun, former John A. McCone Foundation Curator of Asian Art. Previously published in Seattle 1987, 211–12.

18. J. D. van Dam, Keeper of Ceramics, Rijksmuseum, Amsterdam, dates this garniture c. 1710, from The Metal Pot factory that Lambertus van Eenhoorn supervised from 1691 to 1720. He noted that it was purchased by A. Vecht in 1954.

19. Information on Delft brewing from Dr. Richard W. Unger, Department of History, University of British Columbia, Canada.

20. Penkala 1951, 217.

21. Jullian 1969, 37.

22. Interestingly, two popular beverages of the twentieth century were also conceived as medicine. In 1886, John S. Pemberton, a pharmacist in Atlanta, marketed a brain tonic made from wine, the extract of coca leaves from South America, and the kola nut from Africa. It was called Coca-Cola syrup. In 1898, Pepsi Cola syrup was sold as a digestive aid.

23. Walcha 1981, 63–67.

24. Ducret 1962, 124–25.

25. Menzhausen 1990, no. 68.

26. Syz, Miller, and Rückert 1979, 106–9. This coffeepot also has a harbor scene on one side and a winter scene on the reverse.

Chapter 10

1. This same phenomenon can be observed in earlier periods of disunion and dynastic change, such as the Six Dynasties period (220–581) and the Five Dynasties period (907–960). Whether the twentieth century will also be viewed in this light remains for later generations to decide.

2. Medley 1990, 11–20.

3. C. Sheaf in Scott 1993, 165–82.

4. San Francisco 1982, 20, no. 16. On *kosometsuke,* Jenyns 1962–63, 13–50; Tadanori Mitsuoka in *Sekai tōji zenshū* 1979, vol. 14, 277 ff.

5. Wang 1993, 23.

6. Medley 1990, 13.

7. Clunas 1986–88, 48.

8. Japan and other major foreign markets are discussed more fully in chapters 6–9.

9. Sheaf 1993, 165–82.

10. Scholars' motifs are a third important category. Curtis 1995, 22–29.

11. It is often difficult to differentiate wares made for domestic and foreign markets. The shape is usually more telling than the design. In addition to the Chinese domestic market, porcelain with landscapes and narrative scenes were exported to foreign markets.

12. For an assessment of seventeenth-century Chinese painting and the seminal role of Dong Qichang, see Ho 1992; Cahill 1982a and 1982b.

13. Little 1995, 40.

14. This vase's similarities to two dated porcelains—one dated 1653, Shanghai Museum (Curtis 1995, fig. 4), and another dated 1646, Art Institute of Chicago (Little 1983, no. 42)—confirm a Shunzhi date. The landscape style is also comparable to a covered jar in the Butler Family Collection (Curtis 1995, no. 12; Butler, Little, and Medley 1990, no. 58). I would like to thank Julia Curtis and Stephen Little for their help in dating this important porcelain.

15. Medley 1990, 17.

16. Little 1995, 35–41; S. Little, letter to author of March 4, 1999.

17. The vase can be dated to 1635–44, the end of the Chongzhen reign, the last years of the Ming dynasty. Supporting this dating are the deep violet blue of the underglaze painting, incised lines barely visible around the shoulder and just above the base, the finely painted figures outlined and filled in with graded washes, the high quality of body and glaze, short V-shaped brush strokes to render grasses, the generous amount of blank space, and the descending leaves below the rim. See Little 1983, 8–15, and especially fig. 9. S. Little dated this vase in letter to author of March 4, 1999.

18. For translation, see Roberts 1976. The earliest-known dated representation on porcelain of a scene from *The Romance of the Three Kingdoms* is an incense burner dated 1625 in the British Museum; see S. Little in Butler, Little, and Medley 1990, 22.

19. Wang 1987, 57.

20. Ferris 1968, 184–90; Hsu 1986, 5–9; Kobayashi and Sabin 1981, 25–32; S. Little in Butler, Little, and Medley 1990, 21–32.

21. Hsu 1986, 29. For a summary of *The Romance of the Three Kingdoms,* see her Appendix C, 70.

22. Clunas 1986–88, 48.

23. Wang 1993, 25.

24. For a relevant excerpt from *The Dream of the Red Chamber* (Hongloumeng), see Clunas 1981–82, 78. Clunas notes the likely popularity of such dramas among the wealthy salt merchants of Yangzhou and Suzhou.

25. For background on *The West Chamber* by Wang Shifu, see translation of the drama in West and Idema 1995; also see Clunas 1981–82, 69–86; Hsu 1986, 1–146.

26. The single-diaper pattern and cartouches with floral sprays on the rim, Kangxi-type figural style, and spurious Chenghua reign mark written in a calligraphic style characteristic of the early Qing dynasty support a date of c. 1700.

27. I am indebted to Jan Wang for decoding this rebus.

28. I am indebted to Julia Curtis (letter of February 23, 1999) for establishing a date for this object. See Curtis 1995, no. 27, for a blue-and-white censer, dated 1708, painted in the same brush technique.

29. Despite a general similarity to illustrations of the Red Cliff theme, based on a poem by the Song scholar-official Su Shi (1036–1101), the landscape with scholars on this vase is apparently generic.

30. Curtis 1998, 15.

31. Wood 1988.

32. Tichane 1985; Scott 1992; N. Wood in Scott 1993, 47–68; Bower et al. 1998, 11, 12, 46–73.

33. Little et al. 1998, 11.

34. N. Wood in Scott 1993, 51.

35. Ibid., 57–58, 63. Little et al. 1998, 12.

36. Chen Liu, in his "Pottery Refinements" (*Taoya*) of 1906, states: "Green in the midst of red denotes kiln change. Where it takes the form of minute congealed fragments it is known as moss-spot green." Sayer 1959, 92.

37. Krahl 1994, vol. 2, 256.

38. Chait 1957, 130–37; Valenstein 1989, pls. 231–38, 236.

39. Krahl 1994, vol. 2, 178.

40. Archaism (*fang gu*) is explored by R. Scott in Kuwayama 1992, 80–88.

41. For a history of early celadons, Shang through Yuan dynasties, see Mino and Tsiang 1987. Also Tichane 1978; Kerr 1986, 81–86; Krahl 1994, vol. 2, 201.

42. Ts'ao 1981, 30.

43. For Ming ceremonial monochrome wares, see C. Lau in Scott 1993, 83–100; for Qing, see Medley 1957–59 and Kwan 1983, 26–29. For both Ming and Qing ceremonial wares, see Lu 1990.

44. Kwan 1983, 26–27.

45. Kerr 1986, 27.

46. L. Cort in Cort and Stuart 1993, 22.

47. Enamels are a glassy material with a low melting temperature. Chinese overglaze enamels, high in lead oxide to lower the melting point, were painted on glazed porcelain after it cooled, following the first firing at 1250°C and above. Once painted, the porcelain was fired a second time at about 700°C to fuse the enamels to the glaze. Harrison-Hall 1997, 198.

48. A primary difference between translucent *famille verte* enamels and earlier overglaze enamels was the introduction of an overglaze blue. Now the entire composition could be executed at one time on the unglazed, prefired body or on top of the glaze. One advantage of painting in enamels on top of a prefired glaze was that mistakes could be rectified by simply wiping the pigments off the prefired clear glaze and repainting. R. Scott in Scott and Hutt 1987, 152

49. *Famille jaune* (yellow family) and *famille noire* (black family) are generally considered subcategories of *famille verte* because the same colorants are used; the only difference is the dominant background color. Bower et al. 1998, 15.

50. Kingery and Vandiver 1986, 363–81; R. Scott in Scott and Hutt 1987, 156–59.

51. For further discussion of the advantages of *famille rose* in painting floral motifs on porcelain, see R. Scott in Scott and Hutt 1987, 164, 165. Influences of painting on Qing overglaze enameled porcelain are discussed by R. Scott in Los Angeles 1989, 115–24, and Stuart 1995.

52. This dating follows Lu Minghua's periodization of Kangxi imperial wares in four phases. This dish belongs to phase two. Lu 1996–97, fig. 5.

53. Cort and Stuart 1993, nos. 7, 8, 78, 79.

54. Ibid., 24.

55. Bartholomew 1985, 23, 24; J. Stuart in Cort and Stuart 1993, 54.

56. J. Stuart in Cort and Stuart 1993, 49.

57. The other poetic inscriptions read thus: Spring—"Sprouting willows appear in the scattering mist." Summer—"Green trees abound in village after village." Autumn—"Withering branches sit silent in the depth of night." I am indebted to Wang Ban for the translations.

58. This wintry landscape (pl. 10.18) relates generally to the orthodox style of landscape painting of the late seventeenth to early eighteenth centuries, for example, Wang Hui's landscape (Fong and Watt 1996, pl. 279b).

59. Stuart 1995.

60. Imperial orders for porcelain sent by the Qianlong emperor to Tang Ying, supervisor at the official kilns in Jingdezhen, were often accompanied by drawings for porcelain designs made by artists employed at court, or wooden models of forms, or even actual objects to be copied. Ho Chu-mei, forthcoming paper.

61. R. Scott in Scott 1993, 233–56. For type of bowl, see Stuart 1995, 45.

62. For late Qing imperial porcelain, see Kwan 1983.

Chapter 11

1. Washington, D.C., 1991, 132.

2. These plates are still installed in Lisbon in the Santos Palace, now the French Embassy.

3. Finlay 1998, 171–72.

4. Allen 1997, 18.

5. The French politician and churchman Louis René Edouard, Prince de Rohan (1734–1803), seems to be the only Prince Rohan affiliated with Vienna in the eighteenth century. He was French ambassador to Vienna in 1772, fifty years after this service was created.

6. For comparable work, see Chilton 1987, 25, pl. 5.

7. Information concerning the function of early Meissen services is from Maureen Cassidy-Geiger, curator of the Arnhold Collection, New York.

8. Rückert 1966, 110, nos. 453–56. Elaborate dinner services were often two to three years in production. With a delivery date of

1734, the commission for this service likely falls in the last years of Augustus the Strong's reign (d. 1733).

9. Pietsch 1993, 102.

10. Pazaurek 1925, vol. 1, 200–201, pl. 164. Pazaurek records two other plates from this service. Both are in Dresden, one at the Kunstgewerbemuseum and the other in the Dresdener Porzellansammlung. Like the Seattle plate, they have the same peculiar yellowish, burned-looking porcelain body.

11. Hull 1981, ix, 33.

12. For another satyr figure with a bald spot, see Caròla-Perrotti 1986, 221, pl. 161.

13. See Le Corbeiller 1985, 20, pl. 13, for a similar vase, also without its cover.

14. Frothingham 1955, 29–30, figs. 26, 17.

15. Savill 1988, vol. I, 42. This style of *cuvette* was made in three sizes. This is the largest size.

16. In the *Inventaire de biens de Madame de Pompadour* made after her death, the 1764 listing for porcelains at Saint-Ouen records no. 1310: "Une garniture de cinq vazes bleu celeste pour mettre des fleurs, à cartouche, trois avec des marines en miniature, les deux autres à enfans de Boucher. Le vaze du milieu a une grille repersée d'argent." See Cordey 1939, 96.

17. The provenance connecting this *cuvette* to Madame de Pompadour's inventory, the information concerning the factory sales register, and the connection of the *cuvette* to two *vases hollandais* with marine scenes represents important research by Dr. Ulrich Fritzsche of Seattle, Washington, while the *cuvette* was in his collection.

18. Grégory 1978, 127–28. Translated by Susan McCray.

19. These *vases hollandais* are also marked with the date letter C and crescent mark of Seattle's *cuvette*. One of the vases also bears the mark encountered on works decorated by C. N. Dodin. They are painted in *bleu céleste* with marine scenes, similar gilding, and trophies-of-war decoration. They are of the same size as the *vases hollandais* listed in Madame de Pompadour's after-death inventory. Armand was known as a bird painter. The distinctive vegetation along the sides of the trophy scene on the Seattle *cuvette* is similar to the leafy surrounds of his bird paintings. Though the *cuvette* bears his crescent mark, it is more difficult to attribute the marine scene to him.

Chapter 12

1. Honour 1973, 24

2. Ibid., 135.

3. Fujian Provincial Museum 1990.

4. Ayers 1986–87, 13.

5. Ibid., 16–17.

6. Lane 1960, 63.

7. Dawson 1994, 4; Hofmann 1932, 53.

8. Eighteenth-century French glass coolers for wine and liqueur were known generally as *seau à rafraîchir* (a bucket or pail for cooling). Although wine bottles were smaller at that time, porcelain coolers 5 inches or less in height seem to be in the range of glass coolers, or coolers for a small liqueur bottle. See Eriksen and de Bellaigue 1987, pls. 49 and 54. A similar Saint-Cloud *seau* appears in Dawson 1994, 14–15, pl. 12.

9. Nelson and Impey with Le Corbeiller 1994, 38.

10. Dawson 1994, 35–36, pl. 36; see Mallet 1965, 16, pl. 24b, for a marked example.

11. Le Duc 1998, 37.

12. Mallet 1994, 240.

13. Lane 1958, 17–18. This article published an extract from early spectrographic analyses by Mavis Bimson, British Museum Research Laboratory, which establish affinities with the porcelain formulas of two Venetian factories, Cozzi and Hewelcke.

14. Mallet 1994, 249, 255. Three leading candidates for authorship of the A-marked group are listed by date: Gorgie (c. 1749–50 or later) near Edinburgh, run by Alexander Lind between 1749 and 1756 under the patronage of the Duke of Argyll; the short-lived factory at Stourbridge, England (c. 1750–51); or the short-lived Kentish Town factory (c. 1755–56).

15. Freestone 1996. With a scanning electron microscope (SEM) to look at microstructure and composition of the porcelain body (a tiny core sample from the footring of an A-marked cup) and an X-ray analyzer attached to the SEM to analyze the compounds, the precise identities of the materials, such as silica, alumina, and lime, and the quantities used in the A-marked porcelain body, were determined.

16. Watney 1973, 9.

17. Ibid., 9–11.

18. Freestone 1996, 82.

19. Mallet 1994, 241.

20. A-marked porcelain as an early enterprise undertaken by Heylen and Frye, who would later establish the more commercial business of Bow, is an idea first proposed to the author by Errol Manners of London, England. The use of kaolin from the Americas fits with the early Bow patent and the most recent scientific analysis of A-marked porcelain. Thomas Frye was more than capable of supplying the talent evident in the painting of the high-style wares. Certainly,

porcelain decoration became a family occupation; his two daughters, their husbands, and probably his son as well were porcelain painters in the Bow factory.

21. Impey in Ayers, Impey, and Mallet 1990, 29.

22. A vase in Ayers, Impey, and Mallet 1990, 298, pl. 362, and two cups in the collection of the late Dr. Bernard Watney are decorated with blue quails missing their green wings.

23. Manning 1996, 184.

24. Ibid., 17.

25. Ibid.

26. Blancard 1806.

27. Picard, Kerneis, and Bruneau 1966.

28. Blancard 1806, 472.

29. For discussion and terminology of the Bourbon-Condé inventories, see Nelson and Impey with Le Corbeiller 1994, 36–43; J. V. G. Mallet in Ayers, Impey, and Mallet 1990, 49–50.

30. For quail pattern, see Tokyo 1984, 26, pls. 75–76; for banded hedge pattern, see Tokyo 1984, 34, pl. 106; for red dragon with two phoenixes swirling at center, see Reichel 1981, 49, pl. 30.

31. Even though there are no recorded Meissen productions of the crane pattern, an example from the late seventeenth to the early eighteenth century with underglaze-blue crane decoration entered the collection of Augustus the Strong of Saxony in 1723 and bears a Japanese Palace inventory number. See Reichel 1981, 11, pl. 4.

32. For a more detailed account of the von Hoym–Lemaire story, see Cassidy-Geiger 1994, 3–8.

33. Le Duc 1997, 46.

34. Number 348 on this cup and saucer is listed in the Japanese Palace inventory of 1770, on page 57 of Boltz 1996, 3–118.

35. Boltz 1980, 69.

36. Cassidy-Geiger 1994, 8.

37. Neill 1985, 206.

38. Vainker 1991, 150.

39. Neill 1985, 216.

40. Reichel 1981, 17, pl. 12.

41. Ibid., 37, pl. 17.

42. For comparison of Japanese, German, and English examples, see Tokyo 1984, 30.

43. The late ceramics specialist Professor Tsugio Mikami told this version of the tale to the author in 1979.

44. Austin 1977, 64–65, pl. 47; Charleston and Mallet 1971, 86–89.

45. Spero 1995, 5.

46. Spero 1984, 20, pl. 1.

47. Denvir 1983, 210–11.

48. For two typical examples of this type of ware, see Valenstein 1989, 247–53, pls. 253–54.

49. Dauterman 1975, 60.

50. This jar came into the Seattle collection catalogued as Capodimonte. The porcelain paste is whiter than Capodimonte and the floral decoration compares to early Vincennes examples. Initial indentification as Vincennes was made by Kate Davson.

Chapter 13

1. Watson and Whitehead 1991, 51.

2. Decorative Compositions for the Cabinet du Roi in the Château de La Muette. Posner 1984, 59–60. Camesaca 1968, 92–94.

3. Allen 1988, pls. 19, 20; Rückert 1966, no. 220.

4. The Schulz Codex is in the collection of the Museum der Kunsthandwerk in Leipzig. A facsimile edition was published by Rainer Behrends in 1978.

5. Rückert 1966, no. 222.

6. Interpretation of scene by co-author Jennifer Chen.

7. Later additions to this service, or works from a completely different service, bearing an impressed numeral (a former's mark) used after 1739, were produced after Adam von Löwenfinck was gone; see Allen 1988, pl. 22. Other painters in the factory continued to copy his style.

8. Attributed to Augsburg in a letter dated 1984 from Rainer Rückert to the author.

9. Syz, Miller, and Rückert 1979, nos. 333, 334.

10. Ducret 1960, Abb. 77.

11. Stazzi 1967, 91.

12. The door on loan to the Seattle Art Museum is one side of one door that was split in half. The other side is in the collection of the Art Institute of Chicago. One complete door is on view as a loan from the Gallerie dell'Accadèmia to the Ca' Rezzonico, and the final one is in the House Museum of Caramoor Estate in Bedford, N.Y.

13. For discussion of "turqueries," see Schnyder 1990, 23–28.

14. Romanelli and Pedrocco 1995, 29.

15. Avagnina 1995, 82.

16. Precerutti Garberi 1971, 333. By the time Goethe visited the villa in 1786, he was seeing the frescoes through the eyes of neoclassicism. In reaction to what were considered the excesses of the rococo style,

the new style was more calm and restrained in composition and color. Giandomenico's frescoes at Villa Valmarana were in the direction of the neoclassical style.

17. For frescoes, see Chiarelli 1994, pls. 30–33; for brush and ink drawing, see Wolk-Simon 1997, 18, pl. 23; and for oil on canvas, see ibid., 16, pl. 19. An important step in the ongoing research of the Ca' Rezzonico doors will be to compare all the door scenes with Giandomenico's drawings and sketches.

18. This compositional style is also evident in Giandomenico's monochrome work from the same period as the doors, c. 1757–60. See Wolk-Simon 1997, 22–24, pls. 30–33.

19. Precerutti Garberi 1971, 338.

20. Wardropper and Roberts 1991, 65.

21. Curtis 1996–97, 106.

22. Kansas City 1980, 271, pl. 207 S.

23. Eriksen and de Bellaigue 1987, 50–51.

24. This waste bowl appears to belong with a teapot in the collection of the National Gallery of Victoria, Australia. See Legge 1984, 80, no. 177.

25. Mackenna 1946, pl. 8.

Chapter 14

1. Finlay 1998, 157.

2. Honey 1949, 37.

3. Rückert 1966, 78, no. 194. A later version was produced in 1732 as a basin to be used in a table fountain. See Schmidt 1932, pl. 108; The Metropolitan Museum of Art 1987, 124, pl. 96.

4. Menzhausen 1990, pl. 110.

5. For period paintings of banquet scenes and table settings, see Mabille 1994, 124–48.

6. Pietsch 1993, 98.

7. For a good condensed description of figure modeling and firing, see Chilton 1992, 21–28.

8. Berling 1972, 43.

9. Walcha 1981, 478–79.

10. Honey 1946, 101.

11. Honey 1977, 9.

12. Le Corbeiller 1992, 9.

13. Savill 1988, 820.

14. Savill 1982, 162.

15. Lane 1961, 59; Hodgson 1994, 184–89.

16. Quoted in Hodgson 1994, 186.

17. Compare to figure of a sleeping boy incised with the date 1746 in the British Museum; Lane 1961, pl. 2.C; figure of a squirrel in the British Museum, London 1987, 6, pl. 2.

18. Austin 1977, 24. The centerpiece is in the collection of the Victoria and Albert Museum, London.

19. English Ceramic Circle *Transactions* 1968, pl. 1b; in the Dudley Delevingne collection at that time.

20. Watney, Seeley, Stevenson, and Bimson 1989, 212–27, pls. 206c, 207a; identified and dated by Dr. Bernard Watney.

21. Dragesco 1993, 17–18.

22. Watney 1973, 125–26.

23. Ibid., 127.

24. Marshall 1994, 78.

25. Schama 1996, 42.

26. Tait 1972, 32; Wark 1984, 116.

27. See Wark 1984, 117, no. 127, pl. 8.

28. Observation of Anton Gabszewicz, letter to author of March 1999.

29. Confirmed by Dr. Bernard Watney and Raymond Yarbrough. The two figures of Bow herons in the Katz collection, Museum of Fine Arts, Boston, are the same model.

30. Each of the other two examples was mounted on a base together with a small vase. One is in the collection of the Louvre; see De Plinval de Guilleron 1992, 71. The other is recorded in the Darblay Collection, Paris; see Duchon 1988, 131.

31. The series was modeled in 1743–44 by Peter Reinicke, supervised by Kändler, from engravings by François Joullain illustrating the 1727 edition of Luigi Riccoboni's *Histoire du théâtre italien*.

32. Watney 1988, 156.

33. Spero 1984, 155, pl. 180.

34. Blunt and Stearn 1994, 150.

35. Information courtesy of Daniela Kumpf, Wiesbaden, Germany.

36. Attributed by Aileen Dawson, Curator, Department of Medieval and Later Antiquities, British Museum, London.

37. Spero 1995, 11, 38.

38. Blunt and Stearn 1994, 150.

39. Letter from Anton Gabszewicz to author, March 1999. A vase in this shape is also recorded with large European-style flower decoration; Gabszewicz 1982, 93, pl. 137.

40. Spero 1995, 51. This stand is depicted in Spero 1984, 68, color pl. 19.

41. Mallet 1996, 76–95; notes from Errol Manners, London, 1992.

42. Usinger attribution by Daniela Kumpf.

Chapter 15

1. *Tangying ciwu nianpu changbian* (A Comprehensive Chronicle of Tang Ying's Ceramic Activities) gives a detailed account of Tang's work at the Imperial Ware Factory in Jingdezhen during the Yong-zheng and Qianlong reigns. The account was based on archival papers of the Qing court and was first published in *Jingdezhen taoci* (Jingdezhen Ceramics) 1982, 2. An excerpt of the chronicle is published and annotated by Geng Baochang, where this decree is also cited. The month and date given there are of the Chinese lunar calendar. See Geng 1993, 292.

2. Tang Ying, *Taocheng jishi bei,* cited in ibid., 288, 289.

3. Ibid.

4. Chang 1996, 17.

5. For an excerpt of Qianlong's poems about ceramics, see *Qinggao-zong yuzhi yongcishi lu* (Collection of Emperor Qianlong's Ceramic Poems), in Sang Xingzhi et al. 1993, 295–323.

6. For a Ding recumbent-child headrest and two examples inscribed with Qianlong's poems, see Fong and Watt 1996, pls. 111–13.

7. This "Poem to hanging vase" was written in 1742; *Qinggaozong yuzhi yongcishi lu,* in Sang Xingzhi et al. 1993, 296.

8. Many small hanging vases still hang on the wall of Sanxi Tang (Hall of Three Rarities), Qianlong's private studio in the Forbidden City, Beijing.

9. The European architecture in Yuanmingyuan was designed by the Italian Jesuit Giuseppe Castiglione (Lang Shining, 1688–1766), who was the most influential and favored European artist in the Qianlong court. The grandiose fountains that so pleased Qianlong were designed by the French Jesuit P. Michel Benôist (Jiang Youren, 1715–1774). The largest fountain was said to equal that at Versailles. Yuanmingyuan was destroyed by fire during the Franco-British sacking in 1860. A stone arch bearing rococo curve and shell ornaments can be seen in the ruins and has become the most photographed image of Yuanmingyuan.

Chapter 16

1. While admiring gentlemen's houses from Richmond to London, Defoe observed two universal features. One was the charming ever-green garden; the other the type of interior furnishings that the queen had brought in from Holland, including chinaware. He observed that the convention of displaying them in the house was

the same as at Queen Mary's palace, Hampton Court. Defoe 1927, 166, 175.

2. Examples can be seen in Le Corbeiller 1974, 12–16; Pinto de Matos 1998, 134–47, pls. 1–7.

3. Howard and Ayers 1978, 33. For the story of various European East India companies, see chapter 9.

4. Volker 1954, 37, 43.

5. Le Corbeiller in Gordon 1975, 82.

6. For reference and examples of the *bianco sopra bianco* style, see Howard and Ayers 1978, 152–53, pls. 132–33.

7. Examples of the Parasol pattern can be found in almost any book about Chinese export porcelain. For discussions of Cornelis Pronk and examples of his designs, see Volker 1959, 78–81; Howard and Ayers 1978, 292–96, pls. 290–99.

8. Le Corbeiller 1974, 57.

9. For examples of early eighteenth-century porcelain wares with the elephant motif, see Palmer 1976, pl. 5.

10. Le Corbeiller 1974, pl. 48.

11. Sheurleer 1974, 111.

12. The French print *L'Urne mystérieuse* was published in 1793–1800 in several editions. It shows an urn on a square pedestal swept by the branches of a weeping willow tree on the left, and a sorrowing woman with one hand across her breast on the right. See Phillips 1956, 188, fig. 57.

Chapter 17

1. Leppmann 1970, 103.

2. Thornton 1998, 151.

3. Honour 1991, 61.

4. Ettlinger 1973, xxxiii.

5. D'Albis 1998, 11.

6. Fulda, founded in A.D. 744, is contemporary with Charlemagne (742–814). It is the original Benedictine abbey from which Christianity eventually spread throughout what became central Germany. The abbey had feudal rights and obligations to the lay communities that clustered outside its walls to serve the monks' needs; they eventually cohered as a civic entity, the town of Fulda. The abbot of Fulda, however, retained governance of both town and monastery and, as late as 1752, received the title of prince-bishop of the Holy Roman Empire. Thus it came about that a churchman had the authority to involve the larger community in a commercial enterprise, establishing a porcelain factory of some distinction. (On Fulda, see Horn and Born 1979, vol. 1, 349 ff.)

7. D'Albis writes: "At today's prices, the cost of the porcelain paste amounts to only ten per cent of the total manufacturing cost. Labour costs, even for the simplest pieces, account for at least sixty per cent of each piece. The same is likely to have been the case in the eighteenth century, and more complex pieces may have incurred proportionally even higher labour charges" (1998, 20).

Appendix 1

1. Chen Baiquan in Scott 1993, 12–32. S. Vainker in Rawson 1992, 238–42. See also chapter 1 and chapter 4, in which Jennifer Chen discusses white and green wares and *qingbai* glazing.

2. Cited in Tichane 1983, facing page 1.

3. Translation by Robert Tichane. Full translation of Père d'Entrecolles's letters (September 1, 1712, and January 25, 1722), as well as the author's contemporary account of a trip to Jingdezhen, appears in Tichane 1983, 51–128.

4. After visiting Jingdezhen, Robert Tichane (ibid., 4) estimated that somewhere in the neighborhood of 300 million porcelains are produced there each year.

5. Pierson 1996, 11; Pollard and Wood 1986, 112.

6. Harrison-Hall 1997, 196.

7. N. Wood in Kuwayama 1992, 151.

8. Liu and Bai 1982.

9. Rawson 1992, 30–31.

10. Ibid.

11. M. Medley in Scott 1993, 75–78. The *Jiangxi sheng dazhi* (preface dated 1597), which Margaret Medley explicates in "Organisation and Production at Jingdezhen in the Sixteenth Century," provides extensive information on the official kilns and how they were organized. See also Tsing 1978 and Zhongguo guisuanyan xuehui 1982, 360–69.

12. Tang Ying's annotations for "The Twenty Illustrations of the Manufacture of Porcelain," translated and with comments by S. W. Bushell, are reprinted together with historical prints and contemporary photographs of porcelain-making in Tichane 1983, 131–70.

13. Ibid., 134.

14. Ibid., 136.

15. Wood 1988, 12.

16. Tichane 1983, 144.

17. Ibid., 150.

18. Père d'Entrecolles writes of painting in underglaze blue: "When one applies it, its color is just a pale black; when it is dry and covered with glaze, it is completely obscured, and the porcelain appears entirely white; the colors are then buried under the glaze; the fire clarifies them in all their beauty, the same as natural warmth changes a cocoon into the most beautiful of colored butterflies" (quoted in ibid., 87).

19. Ibid., 152. Père d'Entrecolles also notes: "The work of painting in any given laboratory is divided among a large number of workers" (quoted in ibid., 78).

20. Ibid., 154.

21. Ibid., 156.

22. Ibid., 160.

23. Ibid., 162.

24. Ibid., 170.

BIBLIOGRAPHY OF WORKS CITED

ADDIS, SIR JOHN
1980–81 "Porcelain Stone and Kaolin: Late Yuan Dynasty Developments." *Transactions of the Oriental Ceramic Society* 45: 54–66.

1957–59 "A Group of Underglaze Red." *Transactions of the Oriental Ceramic Society* 31: 15–37.

D'ALBIS, ANTOINE
1998 *The Creation of Hard-Paste Porcelain Production at Sèvres*, vol. 13. London: The French Porcelain Society.

ALLEN, ARMIN B.
1988 *Eighteenth Century Meissen Porcelain from the Collection of Gertrude J. and Robert T. Anderson.* Exh. cat. Orlando, Fla.: Orlando Museum of Art.

ALLEN, PHILLIP
1997 "Porcelain in the Clouds: Oriental Ceramics Depicted on the Ceilings at Charlottenburg." *The Oriental Ceramic Society Newsletter* 5 (January).

ARNOLD, DR. KLAUS-PETER, ET AL.
1991 *Ey! wie schmeckt der Kaffee Süsse* (Ah, How Does the Coffee Taste, My Darling?). Exh. cat. Dresden: Dresden Porzellansammlung.

ARNOLD, ULLI, JOACHIM MENZHAUSEN, AND GERD SPITZER
1993 *The Green Vault of Dresden.* Leipzig: Edition Leipzig.

ATASOY, NURHAN, AND JULIAN RABY
1989 *Iznik, The Pottery of Ottoman Turkey.* London: Alexandria Press.

ATIL, ESIN
1973 *Ceramics from the World of Islam.* Exh. cat. Washington, D.C.: Smithsonian Institution.

AUSTIN, JOHN C.
1977 *Chelsea Porcelain at Williamsburg.* Williamsburg, Va.: The Colonial Williamsburg Foundation.

AVAGNINA, MARIA ELISA
1995 *Villa Valmarana ai Nani at San Bastiano di Vicenza. Tiepolo: The Vicentine Villas.* Milan: Electa. Elemond Editori Associati.

AYERS, JOHN
1986–87 "Blanc-de-Chine: Some Reflections." *Transactions of the Oriental Ceramic Society* 51: 13–36.

AYERS, JOHN, OLIVER IMPEY, AND J. V. G. MALLET
1990 *Porcelain for Palaces: The Fashion for Japan in Europe, 1650–1750.* Exh. cat. London: British Museum and Oriental Ceramic Society.

BARNHART, RICHARD
1993 *Painters of the Great Ming: The Imperial Court and the Che School.* Exh. cat. Dallas, Tex.: The Dallas Museum of Art.

BARTHOLOMEW, TERESE TSE
1985 "Botanical Puns in Chinese Art." *Orientations* (September): 18–34.

BERLING, KARL, ED.
1972 *Meissen China: An Illustrated History.* New York: Dover Publications. (Unabridged reprint of the work originally published in English in 1910 with the title *Festive Publication to Commemorate the 200th Jubilee of the Oldest European China Factory, Meissen.* Meissen: Royal Saxon China Manufactory.)

BICKFORD, MAGGIE
1996 *Ink Plum, The Making of a Chinese Scholar-Painting Genre.* Cambridge: Cambridge University Press.

1985 *Bones of Jade, Soul of Ice, The Flowering Plum in Chinese Art.* Exh. cat. New Haven, Conn.: Yale University Art Gallery.

BLACKBURN, WILLIAM W.
1957 "The Length of J. G. Herold's Career as an Artist, and Other Notes." *Keramik-Freunde der Schweiz* (July): 33–37.

Blancard, Pierre
1806 *Manuel du commerce des Indes orientales et de la Chine.* Paris: n.p.

Blunt, Wilfrid, and William T. Stearn
1994 *The Art of Botanical Illustration.* Woodbridge, England: Antique Collector's Club.

Boltz, Claus
1996 "Japanisches Palais-Inventur 1770 und Turmzimmer-Inventor 1769." *Keramos* 153 (July): 3–118.

1980 "Hoym, Lemaire, und Meissen." *Keramos* 88 (April): 3–101.

Bower, Virginia, et al.
1998 *Decorative Arts, Part II: Far Eastern Ceramics and Paintings; Persian and Indian Rugs and Carpets.* Washington, D.C.: National Gallery of Art.

Brown, Roxanna M., ed.
1989 *Guangdong Ceramics from Butuan and Other Philippine Sites.* Exh. cat. Manila: Oriental Ceramic Society of the Philippines; Singapore: Oxford University Press.

Bursche, Stefan
1980 *Meissen Steinzeug und Porzellan des 18. Jahrhunderts* (Meissen Stoneware and Porcelain of the 18th Century). Kunstgewerbemuseum Berlin. Berlin: Staatliche Museen Preussischer Kulturbesitz.

Butler, Sir Michael, Stephen L. Little, and Margaret Medley
1990 *Seventeenth-Century Chinese Porcelain from the Butler Family Collection.* Exh. cat. Alexandria, Va.: Art Services International.

Cahill, James
1982a *The Compelling Image: Nature and Style in Seventeenth-Century Chinese Painting.* Cambridge, Mass.: Harvard University Press.

1982b *The Distant Mountains: Chinese Painting of the Late Ming Dynasty, 1570–1644.* Vol. 3 of *A History of Later Chinese Painting, 1279–1950.* New York: Weatherhill.

Cahill, James, ed.
1981 *Shadows of Mt. Huang.* Exh. cat. Berkeley, Calif.: University Art Museum.

Caiger-Smith, Alan
1985 *Lustre Pottery: Technique, Tradition, and Innovation in Islam and the Western World.* London: n.p.

Camesaca, Ettore
1968 *Watteau.* New York: Harry N. Abrams.

Cao, Jianwen
1993 "Guanyu *Taoji* zhuzuo shidai wenti de jidian sikao" (Some Thoughts on the Date of *Taoji*). *Jingdezhen taoci* 3, no. 4: 27–34.

Caròla-Perrotti, Angela
1986 *Le porcellane dei Barbone di Napoli: Capodimonte e real fabbrica Ferdinandea, 1743–1806* (Porcelain of the Bourbons in Naples: Capodimonte and Ferdinand's Factory). Exh. cat. Naples: Museo Archeologico Nazionale. Guida Editori.

Carpenter, Francis Ross
1974 *The Classic of Tea.* Hopewell, N.J.: The Ecco Press.

Carswell, John
1999 "China and the Middle East." *Oriental Art* 45, no. 1: 2–14.

1985 *Blue and White: Chinese Porcelain and Its Impact on the Western World.* Exh. cat. Chicago: David and Alfren Smart Gallery, University of Chicago.

1975–77 "China and Islam in the Maldive Islands." *Transactions of the Oriental Ceramic Society* 41: 119–98.

Cassidy-Geiger, Maureen
1997 "Forgotten Sources for Early Meissen Figures: Rediscovering the Chinese Carved Soapstone and Dutch Red Earthenware Figures from the Japanese Palace of Augustus the Strong." *American Ceramic Circle Journal* 10: 55–72.

1994 "Returning to 'Hoym, Lemaire, und Meissen.'" *Keramos* 146 (October): 3–8.

Chait, Ralph M.
1957 "The Eight Prescribed Peachbloom Shapes Bearing Kang-hsi Marks." *Oriental Art* 3 (Winter): 130–37.

Chang, Kwang-chih, ed.
1977 *Food in Chinese Culture, Anthropological and Historical Perspectives.* New Haven, Conn.: Yale University Press.

Chang, Lin-sheng
1996 "The National Palace Museum: A History of the Collection," in *Possessing the Past: Treasures from the National Palace Museum, Taipei,* by Fong Wen and James C.Y. Watt, eds. Exh. cat. New York: The Metropolitan Museum of Art, 3–25.

1986 "Early Ming Cloisonné Enamel Wares of China." *Soochow University Journal of Chinese Art History* 15: 265–306.

CHARLESTON, R. J., AND J. V. G. MALLET
1971 "A Problematical Group of Eighteenth-Century Porcelain." *English Ceramic Circle Transactions* 8, part 1: 80–121.

CHEN DINGRONG
1991 *Yingqing cishuo* (An Account of Yingqing Porcelain). Beijing: Forbidden City Publishing.

CHEN GAOHUA AND WU TAI
1981 *Songyuan shiqi de haiwai maoyi* (Maritime Trade of the Song and Yuan Periods). Tianjin: Tianjin People's Publishing.

CHIARELLI, RENZO
1994 *I Tiepolo a Villa Valmarana*. Milan: Scode Milano.

CHILTON, MEREDITH
1992 "Technical Masterpieces: Creating Porcelain Figures in the Eighteenth Century," in *Figures from Life: Porcelain Sculpture from The Metropolitan Museum of Art, ca. 1740–1780,* Cynthia Duval, ed. Exh. cat. Saint Petersburg, Fla.: Museum of Fine Arts, 21–28.

1987 "Hausmaler Decorated Porcelain." *The International Ceramics Fair and Seminar.* London: 20–29.

CHOI SUN-U
1977 "Sung Export Ceramics for Korea," *Sekai tōji zenshū* (Ceramic Art of the World). Vol. 12, *Sung Dynasty,* 292–94. Tokyo: Shogakukan.

CHOI SUN-U AND HASEBE GAKUJI, EDS.
1978 *Sekai tōji zenshū* (Ceramic Art of the World). Vol. 18, *Koryŏ Dynasty.* Tokyo: Shogakukan.

CHUNG YANG-MO
1998 "The Art of the Korean Potter: From the Neolithic Period to the Choson Dynasty," in *Arts of Korea,* Judith G. Smith, ed. Exh. cat. New York: The Metropolitan Museum of Art, 220–49.

1986 "Korean Pottery and Porcelain," in *Korean Art Treasures,* Roderick Whitfield and Pak Young-sook, eds. Seoul: Yekong Publications Company, 263–72.

CLUNAS, CRAIG
1986–88 "The Cost of Ceramics and the Cost of Collecting Ceramics in the Ming Dynasty." *Bulletin of the Hong Kong Oriental Ceramic Society* 8: 47–53.

1981–82 "The West Chamber: A Literary Theme in Chinese Porcelain Decoration." *Transactions of the Oriental Ceramic Society* 46: 69–86.

CORDEY, JEAN
1939 *Inventaire des biens de Madame de Pompadour* (Inventory of Madame de Pompadour's Goods). Paris: La Société des Bibliophiles François.

CORT, LOUISE ALLISON, AND JAN STUART
1993 *Joined Colors: Decoration and Meaning in Chinese Porcelain, Ceramics from Collectors in the Min Qiu Society, Hong Kong.* Exh. cat. Washington, D.C.: Arthur M. Sackler Gallery, Smithsonian Institution.

CROWE, YOLANDE
1977 "Early Islamic Pottery and China." *Transactions of the Oriental Ceramic Society* 41: 263–78.

CURTIS, JULIA B.
1998 "Glorious Dynasty Transmitting Antiquity: Chinese Porcelain Decorations and Politics, 1620–1700." *Oriental Art* 44, no. 2 (Summer): 11–15.

1996–97 "If Pots Could Speak: The Old Art History and the New." *Transactions of the Oriental Ceramic Society* 61: 101–19.

1995 *Chinese Porcelains of the Seventeenth Century: Landscapes, Scholars' Motifs, and Narratives.* Exh. cat. New York: China Institute Gallery.

DAUTERMAN, CARL C.
1975 "Chinese Porcelain Interchange," in *Chinese Export Porcelain,* Elinor Gordon, ed. New York: Universe Books, 58–60.

DAVID, SIR PERCIVAL
1971 *Chinese Connoisseurship. The Ko Ku Yao Lun. The Essential Criteria of Antiquities.* New York: Frederick A. Praeger.

DAWSON, AILEEN
1994 *The Catalogue of French Porcelain in the British Museum.* London: British Museum Press.

DEFOE, DANIEL
1927 *A Tour through England and Wales.* New York: J. M. Dent & Sons.

DENVIR, BERNARD
1983 *The Eighteenth Century: Art, Design, and Society, 1689–1789.* London: Longman Group.

DIAMOND, JARED M.
1997 *Guns, Germs, and Steel: The Fates of Human Societies.* New York and London: W. W. Norton.

DIEM, ALLISON I.
1997 "Vietnamese Blue and White Ceramics in the Philippines: Late 14th–16th Centuries," in *Chinese and Vietnamese Blue and White Wares Found in the Philippines,* by Larry Gotuaco, Rita C. Tan, and Allison I. Diem. Exh. cat. Makati City: Bookmark, 183–208.

DING COUNTY MUSEUM
1972 "Hebei Dingxian faxian liangzuo Songdai taji" (The Discovery of Two Song Pagoda Bases in Ding County, Hebei Province). *Wenwu* 8: 35–51.

DRAGESCO, BERNARD
1993 *English Ceramics in French Archives: The Writings of Jean Hellot, The Adventures of Jacques Louis Brolliet, and the Identification of the 'Girl-in-a-Swing' Factory.* London: Bernard Dragesco.

DREY, RUDOLF E.
1978 *Apothecary Jars: Pharmaceutical Pottery and Porcelain in Europe and the East.* London and Boston: Faber and Faber.

DUCHON, NICOLE
1988 *La manufacture de porcelain de Mennecy Villeroy.* Le Mée-sur-Seine: Editions Amatteis.

DUCRET, S.
1962 *German Porcelain and Faience.* New York: Universe Books.

1960 "Fruhmeissner Dekors" (Early Meissen Decorators). *250 Jahre Meissner Porzellan* (250 Years of Meissen Porcelain). *Keramik-Freunde der Schweiz* 50 (April): 21–30 (special edition).

ENGLISH CERAMIC CIRCLE
1968 "A Miscellany of Pieces." *English Ceramic Circle Transactions* 7, part 1: 1.

ENNÈS, PIERRE, GÉRARD MABILLE, AND PHILIPPE THIÉBAUT
1994 *Histoire de la table.* Paris: Flammarion.

ERIKSEN, SVEND, AND GEOFFREY DE BELLAIGUE
1987 *Sèvres Porcelain: Vincennes and Sèvres, 1740–1800.* London: Faber and Faber.

ETTLINGER, L. D.
1973 *Winckelmann. The Age of Neo-Classicism.* Exh. cat. London: Royal Academy of Arts and Victoria and Albert Museum. Arts Council of Great Britain.

FEHÉRVÁRI, GÉZA
1973 *Islamic Pottery, A Comprehensive Study Based on the Barlow Collection.* London: Faber and Faber.

FENG CHENGJUN
1940 *Zhufanzhi jiaozhu* (Annotation of "Description of Barbarian Peoples"). Beijing: Shangwu Yinshuguan.

FENG XIANMING
1987 *Essays on Chinese Old Ceramics by Feng Xianming.* Hong Kong: Forbidden City Publishing House and The Woods Publishing Company.

FENG YONGQIAN
1975 "Yemaotai Liaomu chutu de taociqi" (Ceramics Excavated from a Liao Tomb in Yemaotai). *Wenwu* 12: 40–48.

FERRIS, ALICE M.
1968 "17th Century Transitional Porcelains, The Development of Landscape Painting." *Oriental Art,* n.s. 14, no. 3: 184–93.

FINLAY, ROBERT
1998 "The Pilgrim Art: The Culture of Porcelain in World History." *Journal of World History* 9, no. 2 (Fall): 141–87.

FONG WEN AND JAMES C.Y. WATT, EDS.
1996 *Possessing the Past: Treasures from the National Palace Museum, Taipei.* Exh. cat. New York: The Metropolitan Museum of Art.

FREESTONE, IAN C.
1996 "A-marked Porcelain: Some Recent Scientific Work." *Transactions of the English Ceramic Circle* 16, part 1: 76–84.

FREESTONE, IAN, AND DAVID GAIMSTER, EDS.
1997 *Pottery in the Making, World Ceramic Traditions.* Exh. cat. London: British Museum.

FROTHINGHAM, ALICE WILSON
1955 *Capodimonte and Buen Retiro Porcelains: Period of Charles III.* New York: The Hispanic Society of America.

FU SHEN
1977 *Traces of the Brush, Studies in Chinese Calligraphy.* New Haven, Conn.: Yale University Art Gallery.

FUJIAN PROVINCIAL MUSEUM
1990 *Dehua yao* (Dehua Kilns). Beijing: Cultural Relics Publishing.

GABSZEWICZ, ANTON
1982 *Bow Porcelain: The Collection Formed by Geoffrey Freeman.* London: Lund Humphries.

GAGE, DEBORAH, AND MADELEINE MARSH
1988 *Tobacco Containers & Accessories: Their Place in Eighteenth-Century European Social History.* London: Gage Bluett & Company.

GARNER, HENRY
1956 "The Use of Imported and Native Cobalt in Chinese Blue and White." *Oriental Art,* n.s. 2, no. 2: 48–50.

GENG BAOCHANG
1993 *Mingqing ciqi jianding* (Connoisseurship of Ming and Qing Ceramics). Hong Kong: Forbidden City Publishing House and The Woods Publishing Company.

GIROUARD, MARK
1987 *A Country House Companion.* London: Century Hutchinson.

GLEESON, JANET
1998 *The Arcanum.* London: Bantam Press.

GORDON, ELINOR, ED.
1975 *Chinese Export Porcelain.* New York: Universe Books.

GOTUACO, LARRY, RITA C. TAN, AND ALLISON I. DIEM
1997 *Chinese and Vietnamese Blue and White Wares Found in the Philippines.* Exh. cat. Makati City: Bookmark.

GRAY, BASIL
1976 "The Export of Chinese Porcelain to the Islamic World: Some Reflections on Its Significance for Islamic Art before 1400." *Transactions of the Oriental Ceramic Society* 41 (1975–77): 231–61.

GRÉGORY, PIERRE
1978 "Une Nouvelle Lecture des marques de Vincennes et de Sèvres." *Encyclopédie connaissance des arts* (November): 127–28.

GUTTER, MALCOLM D.
1998 *Through the Looking Glass: Viewing Böttger and Other Red Stoneware.* San Francisco: Malcolm D. Gutter.

GUY, JOHN S.
1986 *Oriental Trade Ceramics in South-East Asia, Ninth to Sixteenth Centuries.* Singapore: Oxford University Press.

HARRISON-HALL, JESSICA
1997 "Chinese Porcelain from Jingdezhen," in *Pottery in the Making, World Ceramic Traditions,* Ian Freestone and David Gaimster, eds. Exh. cat. London: British Museum, 194–99.

HASEBE GAKUJI
1978 "Kogo no lekshi" (History of the Incense Box), in *Exhibition of Kogo, Japanese Ceramic Incense Boxes from the Georges Clemenceau Collection.* Exh. cat. Montreal: The Montreal Museum of Fine Arts, 224–26.

HASEBE GAKUJI, ED.
1977 *Sekai tōji zenshū* (Ceramic Art of the World). Vol. 12, *Sung Dynasty.* Tokyo: Shogakukan.

HAYWARD, J. F.
1952 *Viennese Porcelain of the Du Paquier Period.* London: Rockliff Publishing.

HEGEL, ROBERT E.
1981 *The Novel in Seventeenth-Century China.* New York: Columbia University Press.

HENAN PROVINCIAL MUSEUM
1972 "Henan anyang beiji fancuimu fajue jianbao" (Concise Excavation Report of Fancui's Tomb of the Northern Qi Period in Anyang Henan Province). *Wenwu* 188, no. 1: 47–57.

HO WAI-KAM, ED.
1992 *The Century of Tung Ch'i-ch'ang, 1555–1636.* 2 vols. Exh. cat. Kansas City, Mo.: Nelson-Atkins Museum of Art.

HODGSON, ZORKA
1994 "Chelsea Boy's Head after François Duquesnoy—Il Fiammingo." *English Ceramic Circle Transactions* 15, part 2: 184–89.

HOFMANN, FRIEDRICH H.
1932 *Das Porzellan der Europäischen Manufakturen im XVIII. Jahrhundert* (Porcelain of European Manufactories in the 18th Century). Berlin: Propyläen-Verlag.

HONEY, WILLIAM BOWYER
1977 *Old English Porcelain.* London: Faber and Faber.

1949 *European Ceramic Art from the End of the Middle Ages to About 1815: Illustrated Historical Survey.* London: Faber and Faber.

1946 *Dresden China: An Introduction to the Study of Meissen Porcelain.* New York: Tudor Publishing.

HONG KONG
1993 *A Legacy of Chenghua, Imperial Porcelain of the Chenghua Reign Excavated from Zhushan, Jingdezhen.* Exh. cat. Hong Kong: Tsui Museum of Art.

1992 *Ceramic Finds from Jingdezhen Kilns.* Exh. cat. Hong Kong: Jingdezhen Institute of Ceramic Archaeology and Fung Ping Shan Museum, University of Hong Kong.

1989 *Imperial Porcelain of the Yongle and Xuande Periods Excavated from the Site of the Ming Imperial Factory at Jingdezhen.* Exh. cat. Hong Kong: Urban Council of Hong Kong and Jingdezhen Museum of Ceramic History.

1984 *Jingdezhen Wares, The Yuan Evolution.* Exh. cat. Hong Kong: Oriental Ceramic Society of Hong Kong and Fung Ping Shan Museum, University of Hong Kong.

HONOUR, HUGH

1991 *Neo-Classicism.* London: Penguin Books (reprint of 1968 ed.).

1973 *Chinoiserie: The Vision of Cathay.* New York: Harper and Row (reprint of 1961 ed.).

HORN, WALTER, AND ERNEST BORN

1979 *The Plan of St. Gall. A Study of the Architecture and Economy of, and Life in a Paradigmatic Carolingian Monastery.* 3 vols. Berkeley: University of California Press.

HOWARD, DAVID, AND JOHN AYERS

1978 *China for the West.* London: Philip Wilson Publishers.

HSU WEN-CHIN

1986 "Fictional Scenes on Chinese Transitional Porcelain (1620–ca. 1683) and Their Sources of Decoration." *Bulletin of the Museum of Far Eastern Antiquities* 58: 1–146.

HULL, ANTHONY H.

1981 *Charles III and the Revival of Spain.* Boston: University Press of America.

HUNAN PROVINCIAL MUSEUM AND THE INSTITUTE OF ARCHAEOLOGY, CHINESE ACADEMY OF SCIENCES

1973 *Mangwangdui yihao hanmu* (Tomb One of the Han Period at Mangwangdui). 2 vols. Beijing: Wenwu Publishing.

IMPEY, OLIVER

1996 *The Early Porcelain Kilns of Japan.* New York: Oxford University Press.

1989 "Japanese Export Porcelain," in *Japanese Art from the Gerry Collection in The Metropolitan Museum of Art.* New York: The Metropolitan Museum of Art, 61–123.

ISHIKAWA, CHIYO

1997 *The Samuel H. Kress Collection at the Seattle Art Museum.* Seattle: Seattle Art Museum.

JARDINE, LISA

1996 *Worldly Goods: A New History of the Renaissance.* New York: Doubleday.

JENYNS, SOAME

1965 *Japanese Porcelain.* New York: Frederick A. Praeger.

1962–63 "Chinese Ko-sometsuke and Shonsui Wares." *Transactions of the Oriental Ceramic Society* 34: 13–30.

JÖRG, C. J. A.

1982 *Porcelain and the Dutch China Trade.* The Hague: Martinus Nijhoff.

JOSEPH, ADRIAN M.

1973 *Chinese and Annamese Ceramics Found in the Philippines and Indonesia.* London: Hugh Moss Publishing.

JULLIAN, PHILIPPE

1969 *Oscar Wilde.* New York: Viking Press.

KAMEI, MEITOKU

1977 "Sung Export Ceramics for Japan," *Sekai tōji zenshū* (Ceramic Art of the World). Vol. 12, *Sung Dynasty,* 206–92. Tokyo: Shogakukan.

KANAZAWA YOH

1998 "Genmatsu minsho no kētokuchin kanyō sēlitsu jyōken nitsuite shikō" (Conditions of the Establishment of the Jingdezhen Imperial Kilns in the Late Yuan–Early Ming Dynasty). *Idemitsu bijutsukan kenkyū* (Idemitsu Museum of Art, Journal of Art Historical Research) 4: 54–65.

KANSAS CITY

1980 *Eight Dynasties of Chinese Painting. The Collections of the Nelson Gallery–Atkins Museum, Kansas City, and The Cleveland Museum of Art.* Exh. cat. Cleveland, Ohio: The Cleveland Museum of Art in cooperation with Indiana University Press, Bloomington.

KERR, ROSE

1986 *Chinese Ceramics, Porcelain of the Qing Dynasty, 1644–1911.* London: Victoria and Albert Museum.

KHOO, JOO EE

1991 *Kendi: Pouring Vessels in the University of Malaya Collection.* Exh. cat. Singapore and New York: Oxford University Press.

KINGERY, W. D., AND P. B. VANDIVER

1986 "The Eighteenth-Century Change in Technology and Style from the Famille-Verte Palette to the Famille-Rose Palette." In *Technology and Style,* vol. 2, W. D. Kingery, ed. Columbus, Ohio: American Ceramic Society, 363–81.

KOBAYASHI, HIROMITSU, AND SAMANTHA SABIN

1981 "The Great Age of Anhui Printing," in *Shadows of Mt. Huang,* James Cahill, ed. Exh. cat. Berkeley, Calif.: University Art Museum, 25–33.

KRAHL, REGINA

1995 *The Emperor's Broken China: Reconstructing Chenghua Porcelain.* Exh. cat. London: Sotheby's and Jingdezhen Ceramic Archaeological Research Institute.

1994 *Chinese Ceramics from the Meiyintang Collection.* 2 vols. Hong Kong: Azimuth Editions.

1986 *Chinese Ceramics in the Topkapi Saray Museum, Istanbul.* 3 vols. John Ayers, ed. London: Sotheby's Publications.

KUWAYAMA, GEORGE, ED.

1992 *New Perspectives on the Art of Ceramics in China.* Los Angeles: Far Eastern Art Council, Los Angeles County Museum of Art (symposium held at the Los Angeles County Museum of Art, September 16–17, 1989).

1989 "The Significance of Chinese Ceramics in the East and West," in *Imperial Taste: Chinese Ceramics from the Percival David Foundation.* Exh. cat. Los Angeles: Los Angeles County Museum of Art, 105–14.

KWAN, SIMON

1983 *Imperial Porcelain of Late Qing from the Kwan Collection.* Exh. cat. Hong Kong: Chinese University of Hong Kong Art Gallery.

KYUSHU

1993 *Sekai no sometsuke* (World's Blue-and-White). Exh. cat. Kyushu: Kyushu Ceramics Museum.

LAN PU

c. early 19th cent. *Jingdezhen taolu* (An Account of Jingdezhen Ceramics), in *Shuo tao* (On Pottery), Sang Xingzhi et al., eds. Shanghai: Shanghai Science and Education Publishing, 158–239.

LANE, ARTHUR

1961 *English Porcelain Figures of the 18th Century.* London: Faber and Faber.

1960 "Meissen and the English Porcelain Factories." *250 Jahre Meissner Porzellan* (250 Years of Meissen Porcelain). *Keramik-Freunde der Schweiz* 50 (April): 63–66.

1958 "Unidentified Italian or English Porcelains: The A-Marked Group." *Keramik-Freunde der Schweiz* 43 (July): 15–18.

1948 "Sung Wares and the Saljuq Pottery of Persia." *Transactions of the Oriental Ceramic Society* 22: 1–12.

LAU, CHRISTINE

1993 "Ming Ceremonial Monochrome Wares," in *The Porcelains of Jingdezhen.* Colloquies on Art and Archaeology in Asia, Rosemary Scott, ed. London: Percival David Foundation of Chinese Art, no. 16: 83–100.

LE CORBEILLER, CLARE

1992 "Figures to Adorn the Middle of the Desert," in *Figures from Life: Porcelain Sculpture from The Metropolitan Museum of Art: ca. 1740–1780,* Cynthia Duval, ed. Exh. cat. Saint Petersburg, Fla.: Museum of Fine Arts.

1985 *Eighteenth-Century Italian Porcelain.* New York: The Metropolitan Museum of Art.

1975 "Crosscurrents in China Trade Porcelain," in *Chinese Export Porcelain,* Elinor Gordon, ed. New York: Universe Books, 52–57.

1974 *China Trade Porcelain: Patterns of Exchange.* New York: The Metropolitan Museum of Art.

LE DUC, GENEVIÈVE

1998 "The Rocaille Style at Chantilly: A Different Aspect of French Porcelain, c. 1750." *Apollo* 147, no. 431 (January): 37–41.

1997 "Rudolphe Lemaire und das Meissner Porzellan. Fernöstlicher Stil oder französischer Geschmack?" (Rudolph Lemaire and Meissen Porcelain. Far Eastern Style or French Taste?). *Keramos* 158 (October): 37–52.

1996 *Porcelaine tendre de Chantilly au XVIII siècle* (Eighteenth-Century Soft-Paste Porcelain from Chantilly). Paris: Editions Hazan.

LEE, SHERMAN E., AND WAI-KAM HO

1968 *Chinese Art under the Mongols: The Yuan Dynasty (1279–1368).* Exh. cat. Cleveland, Ohio: Cleveland Museum of Art.

LEGGE, MARGARET

1984 *Flowers and Fables.* Melbourne: National Gallery of Victoria.

LEPPMANN, WOLFGANG

1970 *Winckelmann.* New York: Alfred A. Knopf.

LI CHU-TSING AND JAMES C.Y. WATT, EDS.

1987 *The Chinese Scholar's Studio, Artistic Life in the Late Ming Period.* Exh. cat. New York: Asia Society Galleries.

LI HUIBING AND BI NANHAI

1987 "Lun dingyao shaoci gongyi de fazhan yu lishi fenqi" (A Study of Ding Firing Techniques through the Ages). *Kaogu* 12, no. 242: 1119–28.

LI XIJING AND GAO XIMEI

1984 *Taoci zhi lu* (Ceramic Road). Chinese translation of Mikami Tsujio's *Toji no michi* (reprinted Tokyo, 1972). Beijing: Wenwu Publishing. (Also see Mikami.)

Li Zhiyan

1998 "Lun tang song baici he qingbaici" (The Development and Background of White and *Qingbai* Wares from Tang to Song), in *Bright as Silver, White as Snow,* Kai-Yin Lo, ed. Hong Kong: Yungmingtang, 25–48.

Liaoning Provincial Museum

1975 "Faku yemaotai liaomu jilue" (A Brief Record of a Liao Tomb in Yemaotai, Faku County). *Wenwu* 12: 26–36.

Little, Stephen

1995 "Seventeenth-Century Landscape Painting and the Decoration of Chinese Ceramics," in *Chinese Porcelains of the Seventeenth Century: Landscapes, Scholars' Motifs and Narratives,* by Julia B. Curtis. Exh. cat. New York: China Institute in America.

1983 *Chinese Ceramics of the Transitional Period: 1620–1683.* Exh. cat. New York: China Institute in America.

Little, Stephen, et al.

1998 "Chinese Ceramic Techniques," in *Decorative Arts: Part II,* by Virginia Bower et al. Washington, D.C.: National Gallery of Art.

Liu Liang-yu

1978 "Chinese Painted and Cloisonné Enamel: Introduction, The Imperial Workshops." *Arts of Asia* 6 (November–December): 83–85.

Liu Xinyuan

1993 "Yuan Dynasty Official Wares from Jingdezhen," in *The Porcelains of Jingdezhen.* Colloquies on Art and Archaeology in Asia, Rosemary Scott, ed. London: Percival David Foundation of Chinese Art, no. 16: 33–46.

1992 "The Kiln Sites of Jingdezhen and Their Place in the History of Chinese Ceramics," in *Ceramic Finds from Jingdezhen Kilns.* Exh. cat. Hong Kong: Fung Ping Shan Museum and University of Hong Kong.

1991 *Songyuan shidai de jingdezhen shuike shouru yuqi xiangguan zhidu de kaoca—Jiangqi* taoji *zhuyu nansong zhi xinzheng* (A Study of Jingdezhen Taxation and the Related Policies of the Song and Yuan Periods). Jingdezhen: Jingdezhen Fangzhi, no. 3.

1980 "Jingdezhen hutianyao geqi dianxin wanlei de zhaoxing tezheng jiqi chengyin kao" (A Study of Typical Jingdezhen Hutian Bowls and Related Ceramic Techniques). *Wenwu* 11: 50–60.

1974 "Jingdezhen songyuan mangkou ciqi yu fushao gongyi chubu yanjiu" (An Investigation of Jingdezhen Inverted-Fired Wares with Unglazed Rims in the Song and Yuan Periods). *Kaogu* 229, no. 6: 386–93.

Liu Xinyuan and Bai Kun

1982 "Gaolingtu shikao" (A Historical Investigation of Kaolin). *Zhongguo taoci* 7: 141–70.

1980 "Jingdezhen hutianyao kaocha jiyao" (A Summary of the Investigation at Hutian Kiln in Jingdezhen). *Wenwu* 11: 39–49.

Lo Kai-yin, ed.

1998 *Bright as Silver, White as Snow.* Hong Kong: Yungmingtang.

London

1987 *Rare and Documentary 18th Century English Porcelain from the British Museum,* by Aileen Dawson. Exh. cat. The International Ceramics Fair and Seminar.

1985 *Documentary Continental Ceramics from the British Museum,* by Aileen Dawson. Exh. cat. The International Ceramics Fair and Seminar.

Los Angeles

1989 *Imperial Taste, Chinese Ceramics from the Percival David Foundation.* Exh. cat. Los Angeles County Museum of Art.

Loureiro, Rui Manuel

1998 "Portugal at the Gateway to China," in *The Porcelain Route: Ming and Qing Dynasties.* Exh. cat. Lisbon: Fundação Oriente, 45–58.

Lu Minghua

1996–97 "Kangxi (1662–1722) Imperial Porcelains and Related Questions." *Transactions of the Oriental Ceramic Society* 61: 65–73.

1990 "Ming qing huangjia cizhi jiqi yanjiu" (A Study of Ming and Qing Imperial Ritual Porcelains). *Shanghai bowuguan jikan* (The Bulletin of the Shanghai Museum) 5: 139–49.

1987 "Xingyao 'ying' zi ji dingyao 'yiding' kao" (A Study of Xing Ware's 'Ying' Mark and Ding Ware's 'Yiding' Mark). *Shanghai bowuguan jikan* (The Bulletin of the Shanghai Museum) 4: 257–62.

Mabille, Gérard

1994 "1690–1800: La Table à la française," in *Histoire de la table,* by Pierre Ennés, Gérard Mabille, and Philippe Thiébaut. Paris: Flammarion.

MACKENNA, F. SEVERNE
1946 *Cookworthy's Plymouth and Bristol Porcelain.* Leigh-on-Sea: F. Lewis.

MALLET, J. V. G.
1996 "A Painting of Nicholas Sprimont, His Family, and His Chelsea Vases." *Les Cahiers de Mariemont: Hommage à Mireille Jottrand* 24/25 (1993–94): 76–95.

1994 "The 'A' Marked Porcelains Revisited." *English Ceramic Circle Transactions* 15, part 2: 240–57.

1981 "Mantua and Urbino: Gonzaga Patronage of Maiolica." *Apollo* 113, no. 235 (September): 162–69.

1965 "A Chelsea Talk." *English Ceramic Circle Transactions* 6, part 1: 15–29.

MANCINI DELLA CHIARA, MARIA
1979 *Maioliche del Museo Civico de Pesaro* (Maiolica from the Civic Museum of Pesaro). Exh. cat. Bologna.

MANNING, CATHERINE
1996 *Fortunes à Faire: The French in Asian Trade, 1719–48.* Vermont: Ashgate Publishing.

MARSHALL, ANTHONY D.
1994 "Zoo Story." *Wildlife Conservation* 97, no. 3 (May–June): 78–79.

MEDLEY, MARGARET
1990–91 "Imperial Patronage and Early Ming Porcelain." *Transactions of the Oriental Ceramic Society* 55: 29–42.

1990 "Trade, Craftsmanship, and Decoration," in *Seventeenth-Century Chinese Porcelain from the Butler Family Collection,* by Sir Michael Butler, Stephen L. Little, and Margaret Medley. Alexandria, Va.: Art Services International, 11–20.

1982 "Islam and Chinese Porcelains in the 14th and Early 15th Centuries." *Oriental Ceramic Society of Hong Kong Bulletin* 6 (1982–84): 36–47.

1976 *The Chinese Potter, A Practical History of Chinese Ceramics.* Oxford: Phaidon Press.

1974 *Yuan Porcelain and Stoneware.* London: Thames and Hudson.

1973 "The Yuan-Ming Transformation in the Blue and Red Decorated Porcelains of China." *Ars Orientalis* 9: 89–101.

1972 *Metalwork and Chinese Ceramics.* Percival David Foundation Monograph Series, no. 2. London: Percival David Foundation of Chinese Art.

1957–59 "The Illustrated Regulations for Ceremonial Paraphernalia of the Ch'ing Dynasty" (paper read on March 18, 1959). *Transactions of the Oriental Ceramic Society* 31: 95–105.

MENG YUANLAO
12th cent. "Dongjing menghua lu" (The Eastern Capital in My Dreams), in *Dongjing menghua lu.* Taipei: Guting Shuwu, 1989.

MENZHAUSEN, INGELORE
1990 *Early Meissen Porcelain in Dresden.* New York: Thames and Hudson.

THE METROPOLITAN MUSEUM OF ART
1987 *Europe in the Age of Monarchy.* New York: The Metropolitan Museum of Art.

MIKAMI TSUJIO
1984 "Chūsē chūgoku to ejiputo" (Medieval China and Egypt), in *Inter-Influence of Ceramic Art in East and West.* Exh. cat. Tokyo: Idemitsu Museum of Art, 84–99.

1981 "China and Egypt: Fustat." *Transactions of the Oriental Ceramic Society* 45: 67–89.

1972 *Tōji no michi* (Ceramic Road). Tokyo: Iwanami. (First printed in Tokyo.)

MIKAMI TSUJIO, ED.
1981 *Sekai tōji zenshū* (Ceramic Art of the World). Vol. 13, *Liao, Chin and Yüan Dynasties.* Tokyo: Shogakukan.

MINO, YUTAKA, AND KATHERINE R. TSIANG
1987 *Ice and Green Clouds, Traditions of Chinese Celadon.* Exh. cat. Indianapolis, Ind.: Indianapolis Museum of Art.

MORLEY-FLETCHER, HUGO, ED.
1984 *Techniques of the World's Great Masters of Pottery and Ceramics.* Secaucus, N.J.: Chartwell Books.

MOTE, FREDERICK, AND DENIS TWITCHETT, EDS.
1986 *The Cambridge History of China.* Vol. 7, *The Ming Dynasty, 1368–1644, Part I.* Cambridge: Cambridge University Press.

NAIDEWENG
12th cent. "Ducheng jishen" (A Record of the Capital), in *Dongjing menghua lu* (The Eastern Capital in My Dreams), by Meng Yuanlao. Taipei: Guting Shuwu, 1989, 89–110.

NATIONAL ADMINISTRATION OF CULTURAL HERITAGE
1995 *Zhongguo wenwu jinghua dacidian, taocijuan* (Dictionary of Chinese Cultural Relics, Ceramics). Shanghai: Shanghai Dictionary Publishing.

NEILL, MARY GARDNER
1985 "The Flowering Plum in the Decorative Arts," in *Bones of Jade, Soul of Ice, The Flowering Plum in Chinese Art,* by Maggie Bickford. Exh. cat. New Haven, Conn.: Yale University Art Gallery, 193–243.

NEIQIUXIAN WENWU BAOGUANSUO (NEIQIN COUNTY INSTITUTE OF CULTURAL RELICS)
1987 "Hebeisheng neiqiuxian xingyao diaocha jianbao" (A Preliminary Investigation Report on Xing Kilns in Neiqiu County, Hebei Province). *Wenwu* 376, no. 9: 1–20.

NELSON, CHRISTINA
1998 "Boettger Stoneware: What Science Can Tell Us." *The International Ceramics Fair and Seminar.* London: 34–43.

NELSON, CHRISTINA, AND OLIVER IMPEY, WITH CLARE LE CORBEILLER
1994 "Oriental Art and French Patronage: The Foundation of the Bourbon-Condé Ceramics Collection." *The International Ceramics Fair and Seminar.* London: 36–43.

NEW YORK
1998 *Arts of Korea.* Judith G. Smith, ed. Exh. cat. New York: The Metropolitan Museum of Art.

OHASHI KŌJI
1993 "Nihon no sometsuke" (Japanese Blue-and-White), in *Sekai no sometsuke* (World's Blue-and-White). Exh. cat. Kyushu: Kyushu Ceramics Museum, 151–53.

ORIENTAL CERAMIC SOCIETY OF THE PHILIPPINES
1993 *Chinese and South-East Asian White Ware Found in the Philippines.* Exh. cat. Singapore: Oxford University Press.

OXFORD
1988 *Iron in the Fire, The Chinese Potters' Exploration of Iron Oxide Glazes.* Exh. cat. Oxford: Ashmolean Museum and Oriental Ceramic Society.

PALMER, ARLENE M.
1976 *A Winterthur Guide to Chinese Export Porcelain.* New York: Rutledge Books.

PAZAUREK, GUSTAV E.
1925 *Deutsche Fayence- und Porzellan-Hausmaler.* 2 vols. Leipzig: Karl W. Hiersemann.

PENG SHIFAN, ED.
1998 *Dated Qingbai Wares of the Song and Yuan Dynasties.* Hong Kong: Ching Leng Foundation.

PENKALA, MARIA
1951 *European Pottery.* London: A. Zwemmer.

PHILLIPS, JOHN GOLDSMITH
1956 *China-Trade Porcelain: An Account of Its Historical Background, Manufacture, and Decoration, and a Study of the Helena Woolworth McCann Collection.* Cambridge, Mass.: Harvard University Press.

PICARD, R., J. P. KERNEIS, AND Y. BRUNEAU
1966 *Les Compagnies des Indes route de la porcelaine* (The Porcelain Route of the East India Companies). Paris: B. Arthaud.

PIERSON, STACEY
1996 *Earth, Fire, and Water: Chinese Ceramic Technology, A Handbook for Non-specialists.* London: Percival David Foundation of Chinese Art.

PIETSCH, ULRICH
1993 *Early Meissen Porcelain: A Private Collection.* Exh. cat. Lübeck: Museum für Kunst und Kulturgeschichte der Hanestadt Lübeck.

PIJL-KETEL, CHRISTINE L. VAN DER, ED.
1982 *The Ceramic Load of the "Witte Leeuw" (1613).* Amsterdam: Rijksmuseum.

PINTO DE MATOS, MARÍA ANTÓNIA
1998 "Chinese Porcelain: From Royal Gifts to Commercial Products," in *The Porcelain Route: Ming and Qing Dynasties.* Exh. cat. Lisbon: Fundação Oriente.

DE PLINVAL DE GUILLERON, RÉGINA
1992 *Porcelaines françaises I.* Paris: Musée du Louvre, Editions de la réunion des musées nationaux.

POLLARD, A. M., AND N. D. WOOD
1986 "Development of Chinese Porcelain Technology at Jingdezhen," in *Proceedings of the 24th Archaeometry Symposium,* J. S. Olin and M. J. Blackman, eds. Washington, D.C.: Smithsonian Institution Press, 105–14.

POPE, JOHN ALEXANDER
1956 *Chinese Porcelains from the Ardebil Shrine.* Washington, D.C.: Smithsonian Institution.

POSNER, DONALD
1984 *Antoine Watteau.* Ithaca, N.Y.: Cornell University Press.

PRECERUTTI GARBERI, MERCEDES
1971 *Frescoes from Venetian Villas.* New York: Phaidon Publishers.

RACKHAM, BERNARD
1940 *Catalogue of Italian Maiolica.* London: Victoria and Albert Museum.

RATHBUN, WILLIAM J.
1994 "Seventeenth-Century Japanese Blue-and-White Porcelains." *Orientations* 25, no. 8 (August): 56–62.

RAWSON, JESSICA
1992 *The British Museum Book of Chinese Art.* London: Thames and Hudson.

1984 *Chinese Ornament. The Lotus and the Dragon.* London: British Museum Publications.

REICHEL, FRIEDRICH
1981 *Early Japanese Porcelain: Arita Porcelain in the Dresden Collection.* London: Orbis Publishing.

RICHARDS, SARAH
1999 *Eighteenth-Century Ceramics, Products for a Civilised Society.* Manchester and New York: Manchester University Press.

RINALDI, MAURA
1989 *Kraak Porcelain: A Moment in the History of Trade.* London: Bamboo Publishing.

ROBERTS, MOSS, TRANS. AND ED.
1976 *Three Kingdoms, China's Epic Drama by Lo Kuan-chung.* New York: Pantheon Books.

ROGERS, MARY ANN
1990 "In Praise of Errors." *Orientations* (September): 62–78.

ROMANELLI, GIANDOMENICO, AND FILIPPO PEDROCCO
1995 *Ca' Rezzonico.* Milan: Electa. Elemond Editori Associati.

RÜCKERT, RAINER
1966 *Meissner Porcelain, 1710–1810.* Exh. cat. Munich: Bayerisches Nationalmuseum.

SALGADO LOBO ANTUNES, MARY
1998 "The Porcelain Route," in *The Porcelain Route: Ming and Qing Dynasties.* Exh. cat. Lisbon: Fundação Oriente, 17–21.

SAN FRANCISCO
1982 *The Effie B. Allison Collection: Kosometsuke and Other Chinese Blue-and-White Porcelains.* Exh. cat. The Asian Art Museum of San Francisco.

SANG XINGZHI ET AL., EDS.
1993 *Shuo tao* (On Pottery). Shanghai: Shanghai Science and Education Publishing.

SAVILL, ROSALIND
1988 *The Wallace Collection: Catalogue of Sèvres Porcelain.* 3 vols. London: Trustees of the Wallace Collection.

1982 "François Boucher and the Porcelains of Vincennes and Sèvres." *Apollo* 115, no. 241: 162–69.

SAYER, G. R.
1959 *Pottery Refinements.* An English translation of "Tao ya" by Chen Liu, of 1905. London: Routledge and Kegan Paul.

SCANLON, GEORGE T.
1970 "Egypt and China: Trade and Imitation," in *Islam and the Trade of Asia,* D. S. Richards, ed. Oxford: Bruno Cassirer; Philadelphia: University of Pennsylvania Press, 81–95.

SCHAMA, SIMON
1996 *Landscape and Memory.* New York: Vintage Books.

SCHIVELBUSCH, WOLFGANG
1992 *Tastes of Paradise: A Social History of Spices, Stimulants and Intoxicants.* New York: Pantheon Books.

SCHMIDT, ROBERT
1932 *Porcelain as an Art and a Mirror of Fashion.* London: George G. Harrap.

SCHNYDER, RUDOLF
1990 "The Influence of Turkey and the Near East on 18th-Century European Ceramics." *The International Ceramics Fair and Seminar.* London: 23–28.

SCOTT, ROSEMARY E.
1992 *Chinese Copper Red Wares.* London: Percival David Foundation of Chinese Art.

SCOTT, ROSEMARY E., ED.
1993 *The Porcelains of Jingdezhen.* Colloquies on Art and Archaeology in Asia, no. 16 (held June 15–17, 1992). London: Percival David Foundation of Chinese Art.

SCOTT, ROSEMARY, AND GRAHAM HUTT
1987 *Style in the East Asian Tradition.* Colloquies on Art and Archaeology in Asia, no. 14. London: Percival David Foundation of Chinese Art.

SCOTT, ROSEMARY, AND ROSE KERR
1994 *Ceramic Evolution in Middle Ming.* Exh. cat. London: Percival David Foundation of Chinese Art and Victoria and Albert Museum.

SEATTLE
1991 *Selected Works.* Seattle Art Museum.

1988 *In Pursuit of the Dragon: Traditions and Transitions in Ming Ceramics, An Exhibition from the Idemitsu Museum of Art.* Exh. cat. Seattle Art Museum.

1987 *A Thousand Cranes: Treasures of Japanese Art,* by Henry Trubner, William J. Rathbun, Michael Knight, et al. Seattle Art Museum; San Francisco: Chronicle Books.

1972 *Ceramic Art of Japan.* Exh. cat. Seattle Art Museum.

SEKAI TŌJI ZENSHŪ
1979 *Sekai tōji zenshū* (Ceramic Art of the World). Tokyo: Shogakukan.

SEOUL
1985 *Relics Salvaged from the Seabed off Sinan.* Ministry of Culture and Information.

1977 *Special Exhibition of Cultural Relics Found off the Sinan Coast.* Exh. cat. National Museum of Korea. Samhwa Publishing Company.

SHEAF, COLIN D.
1993 "Chinese Ceramics and Japanese Tea Taste in the Late Ming Period," in *The Porcelains of Jingdezhen.* Colloquies on Art and Archaeology in Asia, Rosemary Scott, ed. London: Percival David Foundation of Chinese Art, no. 16: 165–82.

SHEAF, COLIN, AND RICHARD KILBURN
1988 *The Hatcher Porcelain Cargoes: The Complete Record.* Oxford: Phaidon and Christie's.

SHEN, GUANGYAO
1985 *Zhongguo gudai duiwai maoyi shi* (The History of Ancient Chinese Foreign Trade). Guangdong: Guangdong People's Publishing.

SHEURLEER, D. F. LUNSINGH
1974 *Chinese Export Porcelain (Chine de Commande).* New York: Pitman Publishing Corporation.

SHUNZO, SAKAMAKI
1964 "Ryukyu and Southeast Asia." *The Journal of Asian Studies* 23, no. 3: 383–89.

SMART, ELLEN S.
1975–77 "Fourteenth Century Chinese Porcelain from a Tughlaq Palace in Delhi." *Transactions of the Oriental Ceramic Society* 41: 199–230.

SPENCE, JONATHAN
1990 *The Search for Modern China.* New York and London: W. W. Norton.

SPERO, SIMON
1995 *The Bowles Collection of Eighteenth-Century English and French Porcelain.* Exh. cat. San Francisco: Fine Arts Museums of San Francisco.

1984 *Worcester Porcelain: The Klepser Collection.* Exh. cat. Minneapolis, Minn.: Minneapolis Institute of Arts; London: Lund Humphries.

STAZZI, FRANCESO
1967 *Italian Porcelain.* New York: G. P. Putnam's Sons.

STUART, JAN
1995 "Unified Style in Chinese Painting and Porcelain in the 18th Century." *Oriental Art* 41, no. 2: 32–46.

SU JIQING
1981 *Daoyi zhilue jiaoshi* (Annotation of "A Brief Description of Island Foreigners"). Beijing: Zhonghua Shuju.

SULLIVAN, MICHAEL
1957 "Kendi." *Archives of the Chinese Art Society of America* 11: 40–58.

SYZ, HANS, J. JEFFERSON MILLER II, AND RAINER RÜCKERT
1979 *Catalogue of the Hans Syz Collection.* Washington, D.C.: Smithsonian Institution Press.

TAIPEI
1996 *Imperial Hongwu and Yongle Porcelain Excavated at Jingdezhen.* Exh. cat. Taipei: Chang Foundation.

TAIT, HUGH
1972 *Porcelain.* Revised edition. London: Hamlin Publishing Group.

TAN, RITA
1993 "Development of Chinese White Ware with Reference to Philippine Finds," in *Chinese and South-East Asian White Ware Found in the Philippines.* Exh. cat. Singapore: Oriental Ceramic Society of the Philippines and Oxford University Press, 1–14.

1989 "Vestiges of the Nanhai Trade," in *Guangdong Ceramics from Butuan and Other Philippine Sites,* Roxanna M. Brown, ed. Exh. cat. Manila: Oriental Ceramic Society of the Philippines; Singapore: Oxford University Press, 29–33.

TANG, BA HOANH
1997 "Fifteenth- to Sixteenth-Century Vietnamese Blue-and-White Ceramic Production Centers," in Larry Gotuaco, Rita C. Tan, and Allison Diem, *Chinese and Vietnamese Blue and White Wares Found in the Philippines.* Exh. cat. Makati City: Bookmark, 209–19.

Thornton, Peter

1998 *Form and Decoration: Innovation in the Decorative Arts, 1470–1870.* New York: Harry N. Abrams.

Tichane, Robert

1985 *Reds, Reds, Copper Reds.* Painted Post, N.Y.: The New York State Institute for Glaze Research.

1983 *Ching-Te-Chen, Views of a Porcelain City.* Painted Post, N.Y.: The New York State Institute for Glaze Research.

1978 *Those Celadon Blues.* Painted Post, N.Y.: The New York State Institute for Glaze Research.

Tite, M. S.

1991 "Technological Investigations of Italian Renaissance Ceramics," in *Italian Renaissance Pottery,* Timothy Wilson, ed. London: British Museum.

Tokyo

1997 *Treasures from the Underground Palaces. Excavated Treasures from Northern Song Pagodas, Dingzhou, Hebei Province, China.* Exh. cat. Tokyo: Idemitsu Museum of Art.

1984 *Inter-Influence of Ceramic Art in East and West.* Exh. cat. Tokyo: Idemitsu Museum of Art.

1975 *Nihon shutsudo no chūgoku tōji* (Chinese Ceramics Excavated in Japan). Tokyo: Tokyo National Museum.

Ts'ao, Teresa

1981 *Catalogue of the Special Exhibition of K'ang-hsi, Yung-cheng, and Ch'ien-lung Porcelain Ware from the Ch'ing Dynasty in the National Palace Museum.* Exh. cat. Taipei: National Palace Museum.

Tsing Yuan

1978 "The Porcelain Industry at Ching-te-chen, 1550–1700." *Ming Studies* 6 (Spring): 45–53.

Vainker, S. J.

1991 *Chinese Pottery and Porcelain: From Prehistory to the Present.* London: British Museum Press; New York: George Braziller.

Valenstein, Suzanne

1989 *A Handbook of Chinese Ceramics.* New York: The Metropolitan Museum of Art.

Volker, T.

1959 *The Japanese Porcelain Trade of the Dutch East India Company after 1683.* Leiden: E. J. Brill.

1954 *Porcelain and the Dutch East India Company.* Leiden: E. J. Brill.

Vollmer, John E., E. J. Keall, and E. Nagai-Berthrong

1983 *Silk Roads, China Ships.* Exh. cat. Toronto: Royal Ontario Museum.

Walcha, Otto

1981 *Meissen Porcelain.* New York: G. P. Putnam's Sons.

Wang Dayuan

1915 *Daoyi zhilue.* See Su Jiqing 1981. For an English translation, see W. W. Rockhill, "Notes on the Relations and Trade of China with the Eastern Archipelago and the Coasts of the Indian Ocean during the Fourteenth Century," *T'oung-Pao* 16, part 2 (1915).

Wang Huimin and Zhang Zhizhong

1997 "Xingyao diaocha shijue zhuyao shouhuo" (Investigation and Preliminary Excavation at Xing Kilns). *Wenwu chuanqiu* 38: 8–14.

Wang Qingzheng

1993 *Underglaze Blue and Red: Elegant Decoration on Porcelain of Yuan, Ming and Qing.* Hong Kong: Multi-Art.

1987 "The Arts of Ming Woodblock-Printed Images and Decorated Paper Albums," in *The Chinese Scholar's Studio, Artistic Life in the Late Ming Period,* by Li Chu-tsing and James C.Y. Watt. Exh. cat. New York: Asia Society Galleries, 56–61.

Wang Qingzheng, ed.

1987 *Qinghua youlihong* (Underglaze Blue and Red). Hong Kong: Shanghai Museum and The Woods Publishing Company.

Wardropper, Ian, and Lynn Springer Roberts

1991 *European Decorative Arts.* Chicago: The Art Institute of Chicago.

Wark, Ralph H.

1956 "Adam Friedrich von Löwenfinck einer der bedeutendsten deutschen Porzellan-un Fayencemaler des 18. Jahrhunderts" (Adam Friedrich von Löwenfinck: An Important Painter of German Porcelain and Faience of the Eighteenth Century). *Keramik-Freunde der Schweiz* 34 (April): 11–19.

Wark, Ralph H., with Mary Campbell Gristina

1984 *The Wark Collection: Early Meissen Porcelain.* Jacksonville, Fla.: The Cummer Gallery of Art.

Washington, D.C.

1991 *Circa 1492: Art in the Age of Exploration.* Exh. cat. Jay A. Levenson, ed. Washington, D.C.: National Gallery of Art; New Haven and London: Yale University Press.

WATANABE YOSHIRŌ
1993 "Chūgoku, betonamu, chōsen hantō no sometsuke" (Chinese, Vietnamese, and Korean Blue-and-White Porcelain), in *Sekai no sometsuke* (World's Blue-and-White). Exh. cat. Kyushu: Kyushu Ceramics Museum, 147–50.

WATNEY, BERNARD
1988 "English Ceramics and Some Other Origins of Design." *English Ceramic Circle Transactions* 13, part 2: 156–57.

1973 *English Blue and White Porcelain of the Eighteenth Century.* 2nd ed. (reprinted 1979). London: Faber and Faber.

WATNEY, BERNARD, DEREK SEELEY, ROY STEVENSON, AND MAVIS BIMSON
1989 "Vauxhall China Works, 1757–1764: Description of Excavations on Vauxhall Site; Description of Ceramic Material Found on the Vauxhall Site; The Composition of Vauxhall Porcelain." *English Ceramic Circle Transactions* 13, part 3: 212–27.

WATSON, FRANCIS, AND JOHN WHITEHEAD
1991 "An Inventory Dated 1689 of the Chinese Porcelain in the Collection of the Grand Dauphin, Son of Louis XIV, at Versailles." *Journal of the History of Collections* 3, no. 1: 13–52.

WATSON, OLIVER
1985 *Persian Lustre Ware.* London: Faber and Faber.

WATSON, WENDY M.
1986 *Italian Renaissance Maiolica from the William A. Clark Collection.* London: Scala Books.

WATSON, WILLIAM
1973 *The Westward Influence of the Chinese Arts.* Colloquies on Art and Archaeology in Asia, no. 3. London: Percival David Foundation of Chinese Art.

WATT, JAMES C.Y.
1979 "Notes on the Use of Cobalt in Later Chinese Ceramics." *Ars Orientalis* 11: 63–85.

WEST, STEPHEN H., AND WILT L. IDEMA
1995 *The Story of the Western Wing,* by Wang Shifu (flourished 1295–1307). Edited, translated, and with an introduction by West and Idema. Berkeley and Los Angeles: University of California Press.

WHITFIELD, RODERICK, AND PAK YOUNG-SOOK, EDS.
1986 *Korean Art Treasures.* Seoul: Yekong Publications Company.

WILKINSON, CHARLES K.
1974 *Nishapur: Pottery of the Early Islamic Period.* New York: The Metropolitan Museum of Art.

1963 *Iranian Ceramics.* New York: Asia House.

WOLK-SIMON, LINDA
1997 *Domenico Tiepolo: Drawings, Prints, and Paintings in The Metropolitan Museum of Art.* Exh. cat. New York: The Metropolitan Museum of Art.

WOOD, FRANCES
1995 *Did Marco Polo Go to China?* London: Sedker and Warburg.

WOOD, NIGEL
1993 "Investigations into Jingdezhen Copper Red Wares," in *The Porcelains of Jingdezhen.* Colloquies on Art and Archaeology in Asia, Rosemary Scott, ed. London: Percival David Foundation of Chinese Art, no. 16: 47–48.

1992 "Recent Researches into the Technology of Chinese Ceramics," in *New Perspectives on the Art of Ceramics in China,* George Kuwayama, ed. Los Angeles: Far Eastern Art Council, Los Angeles County Museum of Art, 142–45.

1988 *Iron in the Fire: The Chinese Potters' Exploration of Iron Oxide.* Exh. cat. Oxford: Ashmolean Museum and Oriental Ceramic Society.

1985–86 "The Two International Conferences on Ancient Chinese Pottery and Porcelain." *Transactions of the Oriental Ceramic Society* 50: 37–57.

WU ZIMU
1274 "Mengliang lu" (A Memoir of the Capital), in *Dongjing minghua lu* (The Eastern Capital in My Dreams), by Meng Yuanlao. Taipei: Guting Shuwu, 1989.

YU P'EI-CHIN
1995 "The Manufacture of Imperial Porcelains at Civilian Kilns and the Stylistic Impact on Late Ming Period Wares." *Orientations* (October): 78–79.

ZENG FAN
1990 "Zaitan guanyu dehuayao de wenti" (Further Discussion of Dehua Kilns), in *Dehua yao* (Dehua Kilns). Beijing: Cultural Relics Publishing, 136–52.

ZHANG HUIYI
1937 *Jinling da baoen'si dazhi* (Record of the Great Bao'en Temple in Jinling). Beijing: Shangwu Yinshuguan.

ZHANG YONG AND LI GUANGNING
1997 "Xuanzhouyao baici de faxian yu tansuo" (The Discovery
 and a Study of Xuanzhou White Porcelain), in *Zhongguo
 gutaoci yanjiu* (Chinese Ancient Ceramics Research), vol. 4.
 Beijing: Forbidden City Publishing, 205–9.

ZHAO QINGYUN
1993 *Henan taoci shi* (History of Henan Ceramics). Beijing:
 Forbidden City Publishing.

ZHAO RUSHI
Zhufan zhi. See Feng Chengjun 1940. For an English translation,
 see R. Hirth and W. W. Rockhill, *Chau Ju-kua: His Work on
 the Chinese and Arab Trade in the Twelfth and Thirteenth Cen-
 turies, Entitled Chu-fan-chi*. Saint Petersburg: Imperial Acad-
 emy of Science, 1911.

ZHONGGUO GUISUANYAN XUEHUI
1982 *Zhongguo taoci shi* (The History of Chinese Ceramics).
 Beijing: Cultural Relics Publishing.

ZHOU REN AND LI JIAZHI
1982 "Zhongguo lidai mingyao taoci gongyi de chubu kexue zong-
 jie" (An Investigation on the Technical Aspects of Chinese
 Ancient Ceramics), in *Zhongguo gutaoci lunwenji* (Anthology
 of Chinese Ancient Ceramics). Beijing: Wenwu Publishing,
 287–306.

Index

Zhao Rushi, *Zhufan zhi* (Record of Various Barbarians), 71
Zhejiang province, production center, 15, 16
Zhou period, 68
Zhou Wenwang, 222
Zhufan zhi (Record of Various Barbarians), Zhao Rushi, 71
Zhushan kilns, 58
zi ware, 15. See also *ci* ware
zun form, 119